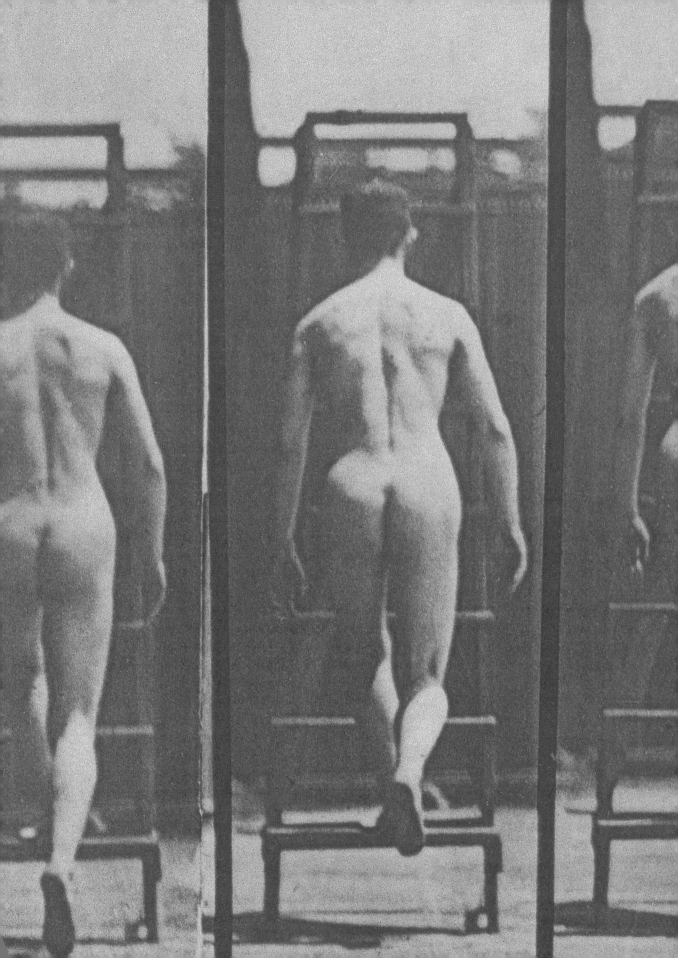

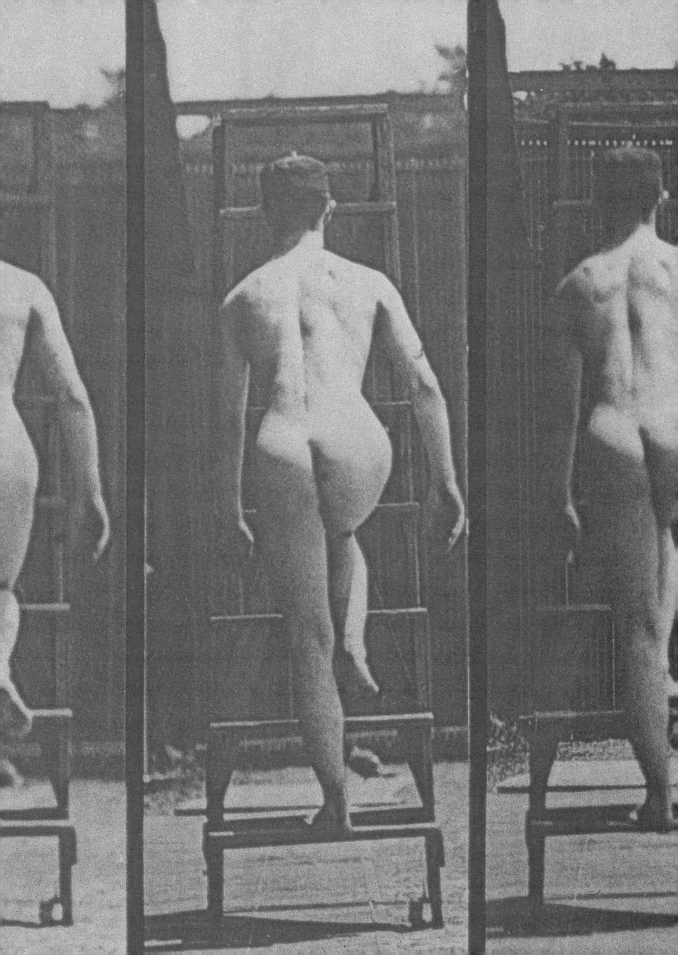

WORKS!

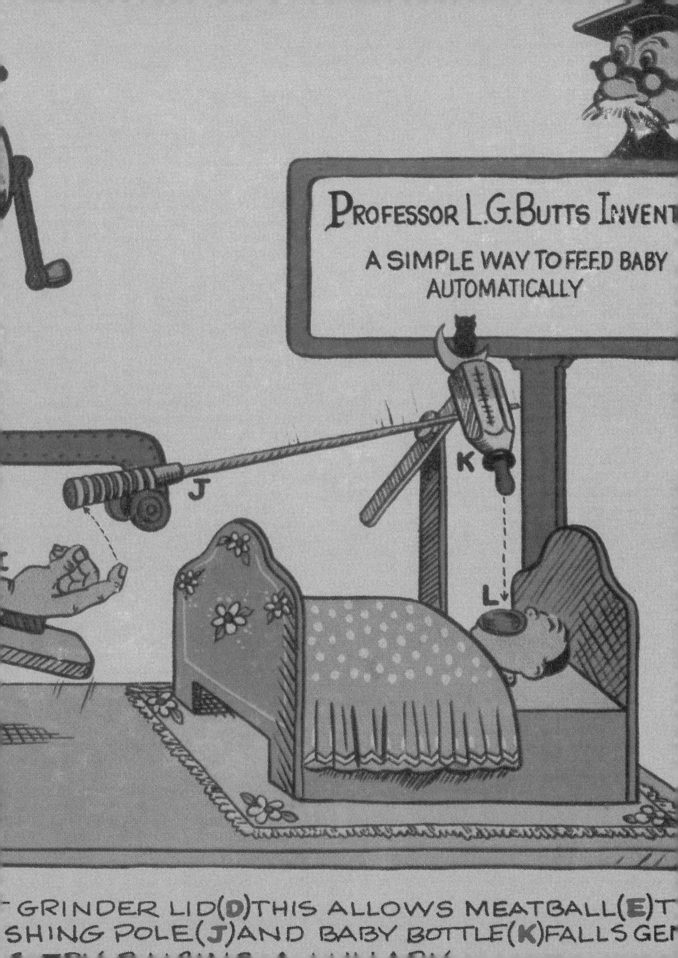

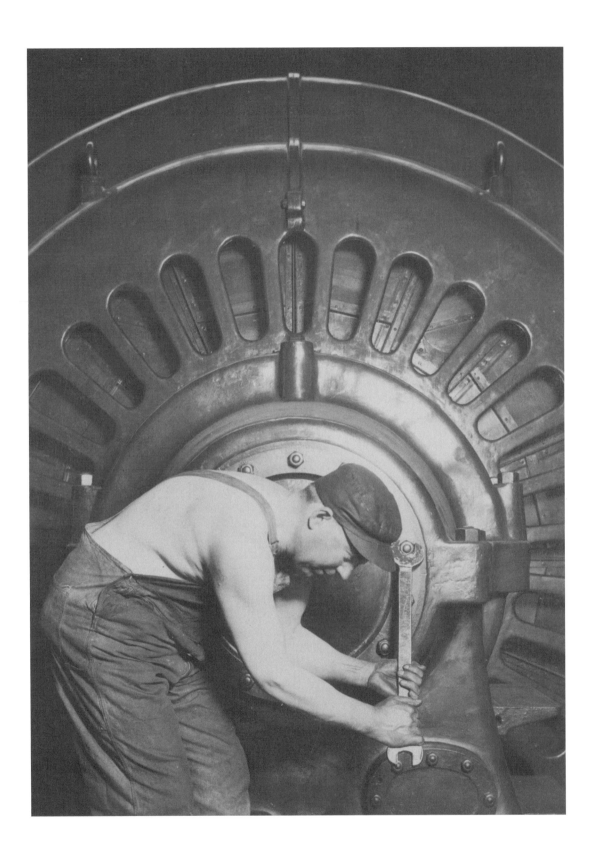

The Uncanny: Experiments in Cyborg Culture

Bruce Grenville, editor

Vancouver Art Gallery | Arsenal Pulp Press

Foreword

The diversity of expression in the exhibition *The Uncanny: Experiments in Cyborg Culture* is only one manifestation of artistic practice responding to the body as it is redefined by technology. In our century, the fields of science, visual arts, and popular culture have converged to reconstruct "humanness" within various complex systems that integrate flesh with machine with information. One of the principal mandates of the Vancouver Art Gallery is to examine and contextualize artistic practice at these intersections of change, and *The Uncanny* fulfills this mandate with great intelligence and vitality.

This wide-ranging survey exhibition explores the cybernetic body in contemporary and historical representations that are as diverse as they are disconcerting. From fascination to dread, western culture's uncanny relationship to the cyborg body reveals the significance of machines to our understanding of contemporary life.

We extend our appreciation to the artists who have participated in the exhibition, as well as to the lenders, institutional and private, who have generously supported this project. We are grateful to the various funding agencies who have helped make this exhibition and publication possible: the City of Vancouver, the Province of British Columbia through the BC Arts Council, the Department of Canadian Heritage through the Museum Assistance Program, the Greater Vancouver Regional District, the Vancouver Arts Stabilization program with funds from the Gerald Sheahan McGavin Capital grants to the Arts, the Japan Foundation, The Canada Council for the Arts, and the Japan-Canada Fund: a gift to The Canada Council for the Arts from the Government of Japan.

Kathleen Bartels, Director, Vancouver Art Gallery

Preface

The Uncanny: Experiments in Cyborg Culture is offered as a proposition on one of the most persistent cultural images of the past century. The cyborg is a cipher—an enigmatic figure that is human but is not human, that is a machine but is not a machine. The cyborg exists at the intersection of science, technology, and culture. For some, the cyborg is evident in the massive presence of technology. We are constantly aided by machines, whether they are computers, vehicles, and military weapons that extend and amplify our presence in the natural world, or by medical prosthetics, such as pacemakers, artificial limbs, and eyeglasses, that maintain and reinforce our existing physical body. An individual's threshold for acknowledgment of the uncanny cyborg body varies widely and shifts according to context. For some, it occurs only in the realm of science fiction or a dream; for others, it is a fact of their day-to-day existence.

That uncanny awareness came most recently for me when researching this project at the George Pearson Centre in Vancouver. The centre, once dedicated to the long-term care of patients who required respiratory support for their polio-infected bodies, now provides only out-patient support. We toured the wards, now empty, that were once filled with patients who lived for extended periods in the machinic embrace of an iron lung. The machine, no longer in use, was once the only means to respirate individuals whose chest muscles had become progressively atrophied by polio. The connotations evoked by the iron lung are almost endless—the mad scientist's surgical table from *Frankenstein* or *Metropolis* and its connotation of an immobilized and altered body; the coffin and its implication of the undead; the eternal cycle of the pumping bellows that, within the vacuum of the iron lung, expand and contract the chest. But the most uncanny moment came when I was invited to try on a portable version of the respirator developed in the 1970s that had, for the first time,

allowed patients to live outside of the hospital ward and to regain some of their mobility. Like a large, hardshell suitcase strapped to my chest, the respirator was ungainly and decidedly present. There was a moment of discomfort when this machine was so awkwardly strapped to my body, but the real sense of uncanniness occurred when the machine was turned on and the vacuum formed, seizing control of my diaphragm and creating an insistent rhythm of breathing. The feeling of the body seized and controlled by a force outside of its own physical and mental control was for me a frightening and disarming experience.

But fear and anxiety are not the only responses to the appearance of the cyborg. For some, the cyborg body offers a line of flight away from the oppression of the patriarchy and its narrative of the normal and natural body, for others it is adopted as a shield against a world that is too emotionally or sensorily intense, for others still, it offers a means to novel and unimagined erotic possibilities. Whatever the impulse, it is clear that the persistent reconfiguration of the image of the cyborg is an acknowledgment of its essential place in our cultural imagination.

How are we to understand the persistence of this image in the visual arts and popular culture, in science and literature, medicine and cultural theory? What do we imagine are its meanings and significance? My proposition is simple. The cyborg is an uncanny image that reflects our shared fascination and dread of the machine and its presence in modern culture. This proposition is rooted in Sigmund Freud's dictum that the uncanny ". . . is in reality nothing new or alien, but something familiar and old-established in the mind and which has become alienated from it only through the process of repression." I argue that the representation of the uncanny cyborg body allows for a return of the repressed in a controlled medium, within an imaginary form that permits us to safely disregard its real presence. The exhibition includes a wide range of art by historical and contemporary artists whose work directly or indirectly addresses the subject of the human machine. This book expands on this project by offering reprints of key historical texts in the representation of the uncanny cyborg body, each with a critical afterword, and a group of commissioned essays that examine the representation of the cyborg from a contemporary perspective. Two other themes crisscross this project. One is the significant link between the visual arts and popular culture in the evolving representation of the cyborg. There has been a conscious and persistent flow of images across these fields from the early 19th century through to the present. Many of the images share a common source, often across media

or disciplines. The second theme is an acknowledgment of the significance of contemporary Japanese art and cultural theory that is significantly different from that produced by Western cultures. A long history of animist belief and the political and social aftermath of World War II have produced a complex and unique vision of the cyborg body.

A project of this sort requires the goodwill and support of a wide range of people. I take this opportunity to acknowledge their part in the development of this project. More than ten years ago, Cheryl Meszaros and Dan Ring contributed to early discussions on this project. Their thoughts and enthusiasm for the subject are still evident in exhibition. Over the intervening years many other colleagues have generously offered advice, insight and support. Among them Peter White, Catherine Richards, Bernie Miller, Jeanne Randolph, Sylvie Fortin, Daina Augaitis, Alf Bogusky, Dwight Koss, Janet Cardiff, George Bures Miller, and Ihor Holubizky have shared their knowledge and endorsed this project at every phase of its development. Makiko Hara has not only contributed an important essay to this book but, during the research for this exhibition, opened the door to a wide range of Japanese artists whose work and ideas have given this project its present form. I am grateful for her thoughtful ideas and rich knowledge. The collaboration with Arsenal Pulp Press publisher Brian Lam has made it possible to publish the book in its present form. Our mutual admiration for the design work of Mark Timmings made him a natural choice as designer. The book's rich visual quality and coherence are products of his great skills. Trevor Mills photographed many of the artworks and related objects for this book and applied his thorough and considered knowledge of contemporary imaging to this project. I am grateful for his efforts. Deanna Ferguson has assisted with this project for several years. Her strong research skills and persuasive manner uncovered material that would otherwise have been lost to me and it is no exaggeration to say that this book could not have happened without her editing skills and commitment.

Many artists have generously supported this project not only with their work, but also with their thoughts and ideas that they shared so openly. I am grateful to Lee Bul, Gary Hill, Mariko Mori, Nina Levitt, Takashi Murakami, Mark Pauline of Survival Research Laboratories, Stelarc and Kenji Yanobe.

This success of this exhibition is dependent on generous loans from museums, galleries, and collections in Canada and the United States. I am grateful to Pierre Theberge and Diana Nemiroff of the National Gallery of Canada, Pierre Arpin and Lisa Baldiserra

of the Art Gallery of Greater Victoria; Andy Sylvester of Equinox Gallery, Vancouver; Brian Mehann, Barry Fair, and Robin Metcalfe of the London Regional Art Gallery; Dennis Wint and John Alviti of the Franklin Museum of Philadelphia; Howard Schickler of Howard Schickler Gallery, New York; Maho Kubota of SCAI The Bathhouse, Tokyo; Tim Blum of Blum & Poe, Los Angeles; Jean-Pierre and Rachael Lehmann, Geneva; Tsutomu Ikeuchi of Röntgen Gallery, Tokyo; Donald Young of Donald Young Gallery, Chicago; Gilbert Silverman, Southfield, Michigan; Rayne Wilder of Gary Hill Studio, Seattle; the University of Alberta; and the Vancouver Public Library.

Other exhibition materials were generously loaned by individuals. I am grateful to Hiroshi Kobayashi of Hara/Kobayashi Lab at the Science University of Tokyo; Stan G. Hyde, Vancouver; and Irene Hanley, Vancouver.

The staff of the Vancouver Art Gallery have contributed their collective skills to this project and its presentation. It is a privilege to work with people who can direct their knowledge and abilities to virtually any subject and always enhance it with their participation. To all of the staff I am grateful for their important part in the success of this project.

The research and presentation of this exhibition and publication were generously supported by several organizations. The Canada Council for the Arts, the Japan-Canada Fund: a gift to The Canada Council for the Arts from the Government of Japan, and the Japan Foundation provided direct support for this exhibition. We also acknowledge our ongoing support from the City of Vancouver, the Province of British Columbia through the BC Arts Council, the Department of Canadian Heritage through the Museum Assistance Program, the Greater Vancouver Regional District, and the Vancouver Arts Stabilization program with funds from the Gerald Sheahan McGavin Capital grants to the Arts.

Finally I am grateful to Elizabeth MacKenzie, who not only directed her critical insight and thoughtful comments to this subject but also endured my endless absences from our family for my travel and research toward this project.

Bruce Grenville, Senior Curator, Vancouver Art Gallery

The Uncanny: Experiments in Cyborg Culture

The story of the uncanny cyborg is that of a lasting cultural anxiety surrounding the birth of the machine and the machinic function in western culture. There can be no doubt that the machine as a powerful presence has not only shaped the socio-economic formation of the modern world but also acted as a cipher for larger cultural debates on the nature of being.

The story that I tell here is a chronicle of images and objects produced to represent the changing conception of the cyborg. It is an account that begins in the 17th century and continues through to the present, focusing primarily on the representation of the cyborg in the visual arts but also addressing the fluid exchange of images between the visual arts and diverse fields of production ranging from literature, philosophy, and science to cinema, cartoons, and toys. It is told almost exclusively from the perspective of the Western (meaning western European and North American) world, but with a conclusion that points to the important distinctions that have been made in recent years by contemporary Japanese artists and cultural theorists regarding a very different cultural conception of the cyborg. Finally, it is a story without a conclusion, for the cyborg is a shifting, ever evolving cipher of our own anxiety and desire to give meaning to the technological ethos.

Early Years: The Human Machine

Throughout the 17th century, an extended dialogue developed around the distinction between animals and humans. This debate was, in part, a result of the growing study of biological phenomena. William Harvey's study of the circulation of blood, for example, encouraged a mechanistic reading of the body rooted in an understanding of the principles

of hydraulics. While this research offered an opportunity to reiterate the commonality of humans and animals, it also raised a challenge to the understanding of the human soul. For many 17th-century philosophers and scientists, this debate was focused on establishing the parameters of a universal physics and the ordering of the physical world, but given the role of the Christian church in western culture at that time, the debate was also about the immortality of the soul and the nature of free will.

The most famous doctrine to arise from this debate was that of Rene Descartes' mind-body dichotomy, and his much-maligned dictum, *Cogito ergo sum:* "I think, therefore I am." Given the growing body of research that pointed to the overwhelming physical commonality between humans and animals, it became imperative to locate the immortality of the soul in the human mind. In his *Discourse on Method*, Descartes proposed that the human and the animal body could be understood to be governed by the same mechanistic principles and that these basic physiological functions occurred independently of will. But where animals were simply machines, humans were machines with minds. The human mind and its ability to think allowed humans to direct the course of their movements, and this in turn provided proof of the existence of the human soul.

There can be little doubt that the animal and human automata produced from the 17th century onward were in part influenced by those philosophical traditions that viewed the function of the human and animal body in mechanical terms. The automaton's simple movements were produced by a set of rods, gears, and levers that effectively mimicked human or animal movement. One of the most sophisticated examples of is that of the Franklin Institute automaton made by Henri Maillardet, c. 1810 (p. 50). This extraordinary figure not only moves with a life-like fluidity, but also writes poetry and draws pictures. The automaton was donated to the Franklin Institute in Philadelphia in 1928 and its uncanny character is best exemplified in the story of its rediscovery. Shortly before it was donated, the automaton had been burnt in a fire and disassembled. Though it had long been in the donor's family, little was known of its origins. When the automaton was reassembled and its mechanism engaged it proceeded to write a poem that concluded with the phrase, *Ecrit par L'Automate de Maillardet* (written by Maillardet's Automaton). While it is easy to attribute this skill to the proud character of the automaton's maker, there is a powerful uncanniness that is created by the automaton's access to language, which acknowledges the immortality and god-like character of its maker.

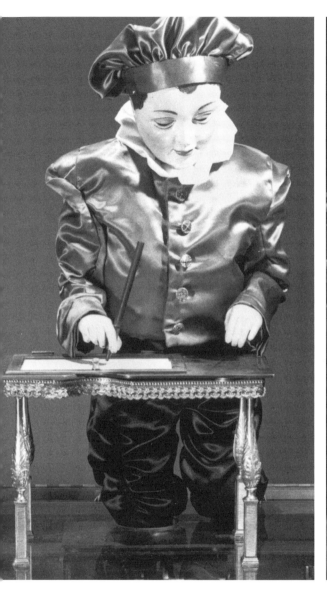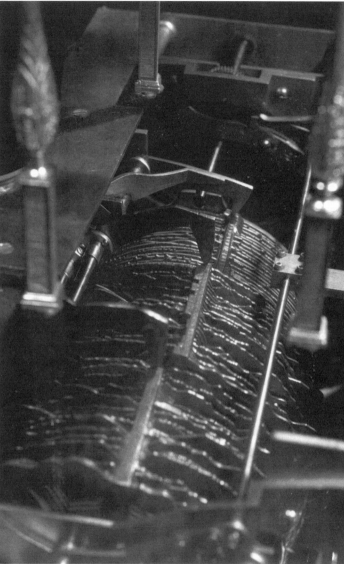

Henri Maillardet, *Automaton* and detail of mechanical parts, c.1810.
Mechanical parts, cloth, stylus, 91 x 86 x 147 cm.
The Historical and Interpretive Collections of The Franklin Institute,
Philadelphia (catalogue no. 1663). Photo: Charles Penniman

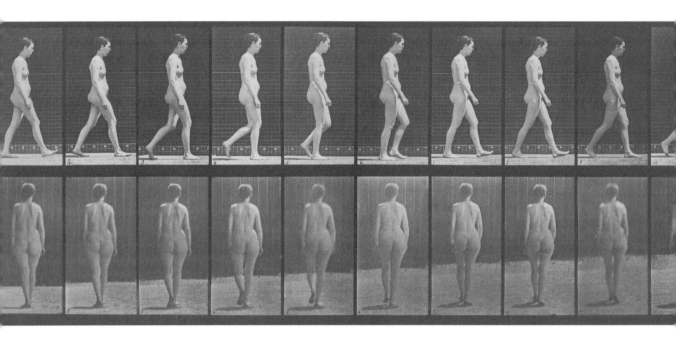

Eadweard Muybridge, *Animal Locomotion* [Plate 46], 1887.
Collotype, 48.3 x 60.9 cm.
Equinox Gallery, Vancouver.

Automata offered an opportunity to marvel at the complexity of mechanical representation and the remarkable human knowledge that produced that representation. But in reality, they also provided an opportunity to acknowledge the necessary difference between the mechanical automata produced by humans and the human machines produced by God. Whatever the skill and expertise of their makers, these automata lacked a mind that would enable them to reason, to think, to understand, and as such they were no more than animal machines—striking examples of both the complexity and the limitations of human knowledge.

The notion of the human body as machine has remained with us, in varying degrees and intensities, through to the present day. Among the most striking and persistent representations of the late 19th century are the photographs from Eadweard Muybridge's *Animal Locomotion* study (p. 16, 49). In a series of more than 20,000 photographic negatives taken between the spring of 1884 and the fall of 1885, Muybridge studied the everyday movements of women, men, children, and animals. In retrospect, it is clear that the study, supported by the University of Pennsylvania, was a research tool intended to enhance the public understanding of human and animal motion. But the persistence and breadth of Muybridge's representation suggests a desire to capture and to represent some heretofore-intangible aspect of human nature. I am drawn to this project through Muybridge's obsessive desire to utilize the new tool of photography to represent the human body and to employ that technology to represent the body as one that is defined by movement—consistent, repeatable, machinic.

By the late 19th century, the broad popularity of automata and the public fascination with images of the human body as represented within the new medium of photography would seem to suggest a benign public acceptance of the new human/machine paradigm. And yet it is hard to imagine that the convulsive change wrought by the new industrial age and the rise of the powerful new capitalist economies hadn't negatively affected the public perception of the machine and its place within modern culture. Certainly its most profound impact was on the lives of the working class who utilized and serviced those machines in the factory, and not on the lives of the middle and upper classes who had tangibly benefited from the new machine-driven economies and who enjoyed the new machines in their home and workplace.

Modern Times: Erotics and Violence

Among the most studied artistic responses to the machine and its growing cultural presence in the early 20th century was that of Marcel Duchamp. His convoluted narrative of the bachelor machines and the bride, fuelled by a libidinal economy and the threat of an imminent destruction, would seem to find its origins in a broader public fascination with the machine.[1] But for the first time, the representation also suggests an element of danger and an anxiety over control that threatens to overwhelm the potential relations.

Duchamp's *Nude Descending a Staircase* (1912) is a remarkable representation of the human machine. This painting, inspired as it was by the advent of cubism's compositional and spatial models, also seems to acknowledge a strong fascination with the new models of temporality proposed by the philosopher Henri Bergson and the sequential photographs of Eadweard Muybridge's French counterpart, Etienne-Jules Marey. It is certainly interesting to note that where Muybridge's photographs (among them a nude figure descending a staircase) gained a certain public popularity, Duchamp's painting set off a firestorm of controversy when it was exhibited at the New York Armory Show of 1913. While it is beyond the scope of this introduction to trace the origins and meanings of this response, it is worth acknowledging that Muybridge's photographs were delivered under the rubric of scientific research and the wonders of a new visual medium, whereas Duchamp's *Nude Descending a Staircase* was presented as art and utilized a traditional medium. There can be little doubt that Duchamp's allusion to the human machine was not only a threat to popular æsthetics but also a threat to the popular public perception of the human body and its physical limits. Here was a body virtually disassembled, its machinic function now the defining force in its representation.

Other works from this period, such as Pablo Picasso's *Mademoiselle Léonie* (1910, p. 51) and *Mademoiselle Léonie dans une chaise longue* (1910, p. 129) or Fernand Leger's *Femme nue assise* (1912) are more strongly influenced by the formal criteria of cubism and traditional figure study, but they nonetheless portray a notion of the human body at the very limits of representation. Significantly, it is a body defined by its mechanistic structure, a body that, at its very core, is a set of reductive, machinic components—an assemblage of cubes, spheres, and rectangles that together give shape and function.

Duchamp's later interest in the erotics of the machine and the notion of the ready-made act to shift the discourse around the human machine toward a new set of criteria. Here it is no longer a representation of the human body characterized or recognized as a machine, but now we can witness a shift toward a prefatory conception of the cyborg—a conception that will recognize the existence of a human body that is augmented or intersected by the machine.

Duchamp's vision of the erotics of the machine is, in part, an extension of the Italian Futurist's fascination with the machine and their anarchistic glorification of the machine-defined culture that threatened to erupt throughout the Western world. Where the Futurists identified the machine as the site and the model of a cultural revolution, Duchamp turned the model inward to the representation of the body and its sexuality. The *Traveller's Folding Item* (1916, p. 52) is, like the other readymades of this period, a provocative and enigmatic object. There is no direct representation of the human body nor the machine. But the Underwood typewriter cover has an unambiguous link to the typewriter and the placement of that cover on a stand connotes the image of a dressmakers stand or display mannequin for a dress. The unexpected conjunction of the two leads to an equally unexpected element of eroticism when the viewer, peeking under the cover to see if there is a machine or some other object beneath, has a moment of self-consciousness in recognizing their voyeuristic impulse.

Duchamp's influence on the modern conception of the machine and its erotic and artistic potential was immediate and widespread. Within his small circle of colleagues, Francis Picabia and Man Ray were most dramatically affected by Duchamp's notion of the machine as a distinct entity that invades, embraces, and re-forms the modern human body. Picabia's representation of the human machine took on a more emblematic and occasionally poetic form. His portrait of Alfred Steiglitz, *Ici, c'est ici Stieglitz. Foi et Amour* (1915, p. 133), as an impotent camera is a caustic characterization of his friend and supporter as an emblematic machine—the artist identified and formed by his tools. Picabia's *D'une jeune fille américaine dans l'état de nudité* (1915, p. 53) is a more complex representation of the human machine if only because it isn't constrained by the tradition and conventions of portraiture.

The advent of World War I in 1914 rapidly accelerated the evolution of the cyborg and substantially expanded its field of reference. If in the pre-war years there was a positively

perceived alignment between social progress and the ubiquitous machine, that perception shifted dramatically with the understanding of a new role for the machine as a powerful tool of death and destruction. The machine gun, the tank, the airplane, even the ability to mass produce rifles and artillery—all dramatically shifted the nature of warfare and the scale of the destruction. The frightening potential of the new machine age came to the forefront of public consciousness in a manner that had not been apparent in the pre-modern period.

In 1919, Sigmund Freud returned to his research, abandoned years earlier, on the notion of the uncanny perhaps as a sign of his own anxiety in the post-war period. "The Uncanny" is an essay on the nature of a formidable psychological force that, in extreme states, can produce neurosis. In his essay, Freud also identifies the uncanny as a powerful literary tool. He cites E.T.A. Hoffman's *The Sand-Man* as a remarkable representation of the uncanny and proceeds to give a close reading of that story and its characters. In relation to the uncanny cyborg body, I am particularly interested in Freud's assertion that, although Hoffman's character Olympia is an automaton, her appearance as such does not mark an uncanny occurrence. Instead, Freud argues, the uncanny occurs when something that is familiar is alienated, through a process of repression, and then returns to us in an uncanny form.

In his introduction to "The Uncanny," Freud cites some of the existing literature on the uncanny and particularly Ernst Jentsch's 1906 essay on that same subject. He also addresses the etymology of the term "heimlich," examining its complex and diverse definitions. "Heimlich" may be defined quite literally as, "the home," but as Freud shows it can be shown also to mean its exact opposite—"the unheimlich" or "unhomely." Freud uses this circuitous process of definition and citation to challenge the earlier definition offered by Ernst Jentsch. Jentsch had defined the uncanny as something that was new or foreign that suddenly entered a familiar or homely place. But Freud chastises Jentsch for failing to take the analysis to its logical conclusion and tie it to the familiar in an unexpected or unfamiliar form.

And so, my argument for the existence of the uncanny cyborg body starts from Freud's dictum: ". . . this uncanny is in reality nothing new or alien, but something which is familiar and old—established in the mind and which has become alienate from it only through the process of repression." I argue that the cyborg is uncanny not because it is unfamiliar or alien, but rather because it is all too familiar. It is the body doubled—doubled by the

machine that is so common, so familiar, so ubiquitous, and so essential that it threatens to consume us, to destroy our links to nature and history, and quite literally, especially in times of war, to destroy the body itself and to replace it with its uncanny double.

Like the character Nathanael in Hoffmann's *The Sand-Man*, we cannot see that thing which is so obvious that it threatens to destroy us. Despite his ability to see the malevolent intentions of the character Coppola while others could not, Nathanael could not see that Olympia was an automaton, and an ineffective one at that. So this, perhaps, is the greatest threat of all, the threat that we cannot see a danger even as it stands before us because it is too familiar and, worse yet, we may be unnaturally attracted to it. Freud fixed on the uncanny because it allowed him to address two increasingly fundamental concepts: the notions of the death drive and the castration complex, both of which he claimed were vividly illustrated in *The Sand-Man* and articulated within the motive of the uncanny.

It is within the realm of the literary æsthetic that the uncanny is most clearly articulated for Freud. He acknowledges that the uncanny is present in everyday life and can occur in a wide variety of contexts, but for Freud, Hoffman's tale offers the most articulate representation of that neurosis and the most instructive analysis of its origins. I would argue that the same might be said of the representation of the uncanny cyborg body in the visual arts and popular culture. The representation of the cyborg body allows for the return of the repressed in a controlled medium, in an imaginary form that permits us to safely disregard its real presence. Like Nathanael, we are unable (or unwilling) to see that which is in front of our eyes; we repress the recognition of its real form and instead remain fascinated by its beauty. Occasionally that uncanny body may be doubled in such a way that it becomes unacceptably visible — as in the case of Duchamp's *Nude Descending a Staircase* — but it is more likely that its uncanniness will be subsumed by the rhetoric of the alienated avant-garde and the æsthetic or moral challenges of modern art.

Jacob Epstein's *Rock Drill* (1913–15, p. 132) is an image of the human body transformed by a world of machines. The origins of this work can be read in the dramatic political events that swept across Europe at that time, in the artistic links to Italian Futurism, and in the widespread fascination with new technologies. But it is also possible to point to Freud's notion of the castration complex and their links to this uncanny cyborg body. Epstein's *Rock Drill* is a formidable sculpture that, in its initial presentation, took the form of a powerful figure astride a machine. The uncanny similarity between the components

of the drilling machine and the body of the driller made for a frightening, representation of modern labour.

In its final form, the *Rock Drill* is reduced to a compelling, but truncated, torso, a fragment of the original work now cast in bronze — æstheticized and distanced from its original form. Without wishing to be reductive, it is worth acknowledging that Epstein's decision to reduce the work to a traditional sculptural bust, and to remove the figure's lower body and the rock drill, carries with it a wealth of connotation. Epstein's enduring interest in the representation of sexuality and procreative force was a key component of his work. The phallic character of the original mechanical rock drill and its unity with the body of the driller suggest an aggressive sexuality and procreative vision that linked a new mechanical age with the future of human evolution. In the final version, Epstein lops off the trunk of the body and with it, its direct link to the machine; likewise, he amputates the figure's hand that held the drill's controls. Certainly this change in the work can be read against the shift in public consciousness that occurred in the realization of the actual toll of World War I, but it is also possible to read in this work a link to impulses that informed Freud's theory of the uncanny and specifically the castration complex. What could be more obvious than Epstein's decision to literally and figuratively castrate his rock drill, to reduce him to a melancholic and æstheticized figure — one that now told the full story of our complex relationship to the uncanny cyborg body.

If Epstein's *Rock Drill* may be said to fulfill Freud's diagnosis of a castration complex masked in an uncanny return of the repressed, then Marcel Duchamp's *Boite-en-valise* (1935–41, p. 130–131) may be said to mark the uncanny presence of the death drive in the artist's compulsive repetition of the act of creation through the reproduction of his own work. It is an act of reproduction that at once confirms Duchamp's identity as the artist whose work is retrospectively contained in this box, but at the same time, the work's function as a ready-made and its reliance on mechanical reproduction effectively destroys the idea of the artist as creator and replaces it with the notion of the artist as machine.

In the work of early modernists such as Duchamp and Picabia, the machine is often equated with sexuality and specifically female sexuality. It is possible to argue (as have Andreas Huyssen and Claudia Springer) that the female body and female sexuality have been used to represent a broad cultural anxiety surrounding the allure and the threat of the machine.[2] This is clearly evident in Fritz Lang's *Metropolis* (1926). Here, a robot, created

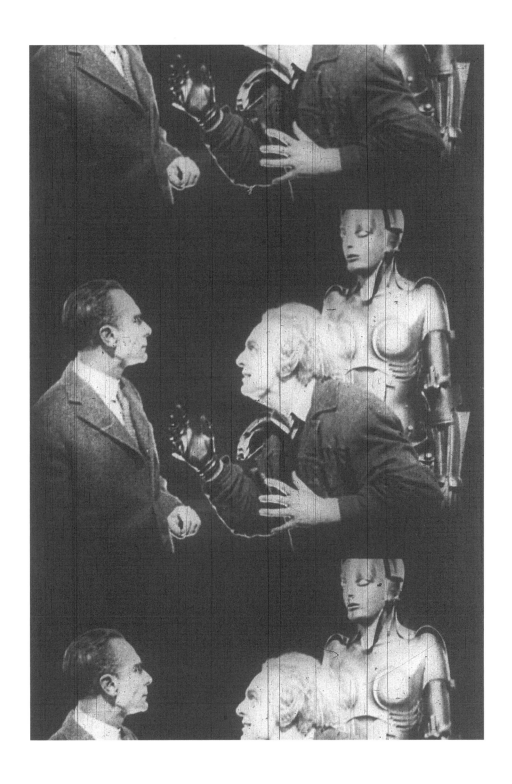

Film stills from *Metropolis*, 1927.
B/W, silent, 16 mm film.

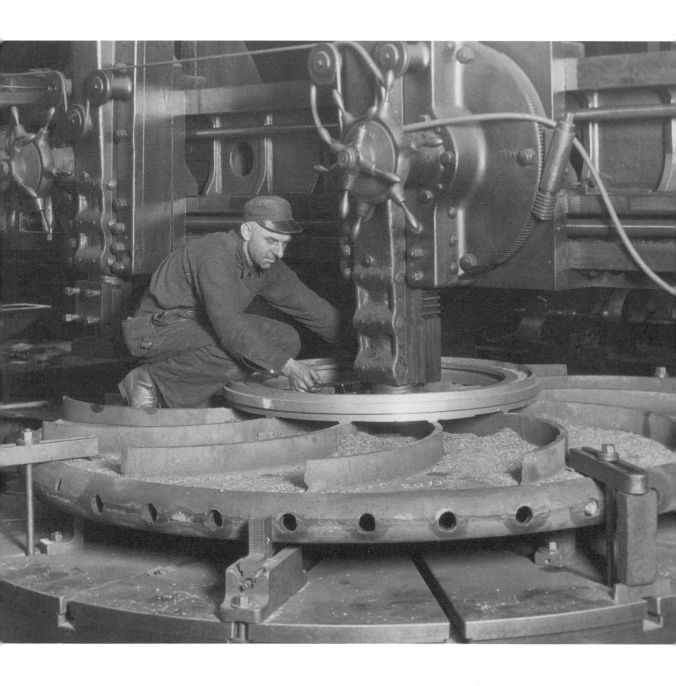

Lewis Hine, *Making a plate for an enormous turbine*, 1920.
Digital reproduction of gelatin silver print, 11.8 x 16.2 cm.
National Archives and Records Administration, Washington (69-RH, 4L-4).

from the human character Maria, wreaks havoc in the underground city. The construction of the robot or cyborg in the form of the female body represents a conventional patriarchal response to the growing presence of the machine in culture. Within the patriarchy the female body is a desirable object, a subject of visual and physical pleasure that can be manifest in many forms. But because the female body is the subject of desire, it is also a threat to the solidarity and unity of the patriarchy — where an acknowledgment of desire is an acknowledgment of lack. The resulting confusion between desire and repulsion may be read as a simple manifestation of the broader cultural confusion regarding the new and changing role of the machine in modern life.

When the robot or cyborg takes a masculine form, it is sometimes identified with a masculine body that labours in aid of the machine. Fernand Leger's *Le mécanicien* (1920, p. 55) or Lewis Hine's *Power house mechanic working on steam pump* (1925, p. 54) are compelling examples of a symbolic alignment between man and machine. These images signal the existence of a symbiotic relationship to the machine in which man (and specifically "man") works in close harmony with the machine, nurturing it and maintaining it while taking on the characteristics of its powerful shape and form.

In the years following World War I, and notably in the period 1919–20, there was substantial social protest and unrest in Paris in response to the political uncertainty and privation that followed the war. Leger's *Le mécanicien* was not only a call to recognize the role of the machine and the mechanic in the rebuilding of post-war Europe, but the painting was itself, quite literally, a call to order in art. Where Leger's earlier works on the theme of the human machine tended to offer a fragmentary and dynamic vision of machinic movement, *Le mécanicien* proposes a carefully structured composition, with a unified and stable figure at its centre. In retrospect, it is clear that this shift in Leger's thinking around the representation of the human machine was part of a larger movement toward classicism in modern art and a response to the rapidly evolving social environment of post-war Europe.

Certainly Leger and Hine were both well aware of the horrific toll that the modern machine had extracted from its labourers and yet both identified an underlying belief that the machine could not only provide the means to a better life but could in fact provide the model for a new worker.

Leger's belief in the potentially symbiotic relationship between man and machine is clearly articulated in his 1923–24 film *Ballet mécanique* (p. 134), produced in collaboration

with avant-garde composer George Antheil and filmmaker Dudley Murphy. This fourteen-minute film offers a compelling cinematic experience unconstrained by conventional narrative and formed by a modern machinic rhythm. The images that compose the film suggest a world in which the machines take on human characteristics and the humans become mechanized. Within the insistent rhythm of the film, Leger intercuts images of driving pistons and a washerwoman who trudges up the steps from the Seine with her load of laundry. She repeats this task again and again so that machine and human eventually become one. For Leger, the film not only provided the means to produce an avant-garde narrative, but the cinema was, in and of itself, a machine that could radically change the modern world. For the truly modern man, the movie camera lens could replace the human eye, much in the same way that modern cinema had replaced the theatre. "Cinema," Leger stated, "it is the age of the machine, Theatre, it is the age of the horse."[3]

There can be no doubt that Charlie Chaplin's 1936 film *Modern Times* is a cautionary tale about the dangers of the industrial age and the powerful machines that threaten, quite literally, to consume the worker and to render the manager obsolete. From its opening sequence onward, the workers are portrayed as sheep, herded toward the factory floor. Here they must maintain the machine according to its needs and schedule. Charlie, at an early point in the film, is quite literally fed into the maw of the machine. When he re-emerges, he is dazed and confused by his experience, to the point where he himself becomes an automaton, tightening or turning every bolt he sees. Throughout the film we witness the encroachment of machinic technology, including the new technologies of image and sound projection, portrayed here in the constant intervention of the manager, whose image and voice are piped throughout the factory. It is significant, not only with regard to the film's narrative but also to Chaplin's own feelings about the medium, that the only sound components in the film are those where voices are heard over loudspeakers, otherwise the narrative is carried by the printed subtitles and the images.

Here, only ten years after Fernand Leger's celebratory filmic image of the machine as a dynamic, liberating force, Chaplin portrays that same machine as a physical presence that constrains and threatens the very existence of the worker. Significantly, Chaplin's world is not portrayed as a future world like Fritz Lang's *Metropolis* of 2026, but is the present day. It is not surprising that only a few years later Chaplin produced *The Great Dictator*, a film that characterizes the rise of fascism as a similarly leveling and constraining social force.

Contemporary World: The Birth of the Cyborg

In the years between World War I and II, there appeared an ever widening gap between those who envisaged the machine as a liberating force that would produce new social and economic configurations and those who viewed the machine as uncontrollable monster that would crush the human spirit and transform its subjects into automatons. It is here, in this untenable gap between a utopian and dystopian vision of the machine, that the cyborg was born.

Klaus Theweleit, in his study of the men of the German Freikorps between the World Wars, reveals the planned production of a powerful human fighting machine that would encase itself in a body armour that provided both physical and psychological protection. In the men of the Freikorps, the Weimar government sought not only to produce a physically superior human machine, but also one that was tooled to resist psychological weakness and would see the self reaffirmed in acts of violence.[4] While in the 1920s this soldier was largely an imaginary being—more psychologically successful than bio-mechanically realized —it wasn't long until World War II provided the economic means and the political motivation to conceptualize and produce a real cyborg.

The conceptualization of the term *cybernetics* is generally attributed to Norbert Weiner and a group of scientists and theorists who gathered in Boston in 1946 for a series of meetings dedicated to a new interdisciplinary study on the role of information in systems. Along with John von Neumann, Gregory Bateson, Margaret Mead, and others, Weiner conceived of a new science called cybernetics, which had its etymological origin in the Greek, *kubernetes*, meaning "pilot" or "steersman," and the Latin equivalent that refers to governance. Specifically, it was characterized as a science devoted to describing the controller in all systems of information, including the mind that steers human behaviour and communication. Weiner speculated that the controller working with positive and negative feedback counteracts the general tendency toward entropy that occurs in the natural world. In humans, the mind acts as the controller that responds to feedback, adjusting the physical body's response to the natural world. In the world of machines, the servo-mechanism held the same function as the mind, adjusting and controlling the function of the machine. Through this reasoning, Weiner concluded that the calculated application of a feedback mechanism could allow for the production of a thinking machine. Weiner's thoughts on this subject had been formed by his research during the war, most notably

in his research for the production of an anti-aircraft predictor designed to anticipate and respond to the zig-zag flight of the enemy pilot.

With the development of the model of cybernetics, Weiner and his colleagues were responsible for articulating the significant role of feedback in the production of a thinking machine, but they also firmly established the possibility of a human machine, a human body enhanced and corrected by a machine that responds both to incoming and outgoing feedback. Weiner's research was widely accepted and even entered the public realm in the form of a book published in 1948 entitled *Cybernetics, or Control and Communication in the Animal and the Machine*.[5]

The notion of the human body controlled and corrected by a machine has a wide range of connotations. Certainly within the medical field, it has the positive implication of assisting and correcting a human body through prosthetics or implants. Yet the narrative of the successful application of cybernetic theory to medicine is rarely the subject of art and popular culture; instead, the narratives are largely grouped around the military and criminal applications of cybernetics.

In those instances where the narrative of the human machine in medicine does occur, it is invariably in the context of the diagnosis of a mental disorder in which the machine is said to inhabit the individual. The story of "Joey: A Mechanical Boy," published by the noted psychologist Bruno Bettelheim in *Scientific American* in 1959, offers a compelling insight into the persistence of Freud's notion of the uncanny and Descartes' mind-body dichotomy: "A human body that functions as if it were a machine and a machine that duplicates human functions are equally fascinating and frightening. Perhaps they are so uncanny because they remind us that the human body can operate without a human spirit, that body can exist without a soul. And Joey was a child who had been robbed of his humanity."[6] Bettelheim proposed that Joey's decision to represent himself as a human activated and controlled by machines offered a telling insight into our "understanding of emotional development in a machine age."[7]

Joey used machines to protect and insulate himself against the world. He adopted the machinic function describing himself as a car, his breathing controlled by a carburetor and exhaust pipes, and powered by electricity. The machine's existence was often tenuous and subject to spectacular crashes and explosions, but it could be rebuilt and restored so that Joey could maintain his internal integrity.

Bettelheim diagnosed Joey's condition as a product of infantile autism brought on by improper parenting. In retrospect, this seems as reductive a diagnosis as Freud's assertion that uncanny experience could be linked to a castration complex or the death drive. While Bettelheim's analysis may be linked to a long history of human machine representations, Joey points the way to future configurations of the cyborg. In their analysis of capitalism and schizophrenia, Deleuze and Guattari propose that autism may be represented as a line of flight leading away from the machine body toward a body without organs, a body that resists the narrative and the logic of capitalism.[8] But we will have to wait until Donna Haraway's narrative of the cyborg in order to witness the articulation of a similar line of flight.

Bettelheim's choice to publish his essay in *Scientific American* suggests a desire to build a broad audience for his ideas but is also an acknowledgment of an existing cultural engagement with this subject area and specifically with the challenges of "life in a mechanical age." Significantly, the official birth of the cyborg is almost simultaneous with the publication of this article. The first use of the term *cyborg*—a neologism of cybernetics and organism—was proposed by Manfred Clynes and Nathan Kline at New York's Rockland State Hospital in conjunction with their efforts to engineer a mouse that could withstand the harshness of an environment similar to that encountered in space travel. Their ultimate goal was to produce an astronaut who could adapt to that atmosphere. Thirty years earlier, the ambition of the German Freikorps had been to produce an armoured human machine through a rigorous psychological and physical hardening of the soldier's mind and body, but now the focus had shifted to augmentation of the human body through bio-engineering, allowing it to fight in adverse physical conditions or perform highly specialized tasks. For the military researchers and engineers, the effective application of information flow and feedback replaced brute mechanical force in the construction of the new human machine. Adaptability, intelligent application of information, and selective physical augmentation—these were the new measures of a cyborg, and yet they were virtually invisible within the broader cultural representations that appeared in the post-war period. Instead, the popular image of the heroic human machine largely remained modelled on the Freikorps soldier—a superhuman, who in everyday life could pass for an average citizen, but when needed could summon up an enhanced physical strength and a wide range of superpowers. Invariably, their enhanced abilities resulted from their origins in an alien race or from an accidental transformation, frequently the result of a scientific experiment gone awry. Superman,

Ironman, Spiderman, Flash, Captain America, etc. all assumed the desired physical attributes of the newly imagined cyborg, but they did so using an old cultural model.

Contemporary Experiments

The performances of Stelarc and Mark Pauline's Survival Research Laboratories (SRL) are among the first contemporary art projects that pose an extended response to the popular conception of the cyborg. Both address popular notions of the human machine and the terms of its existence in contemporary life. Viewed as a whole, Stelarc's performances propose an extended study of a body augmented by new technologies. *The Third Hand* (1976–80, p. 201) is an elaborate mechanical prosthesis that encases the artist's right arm and is activated by neural signals from the artist's abdomen and leg muscles. The intricately constructed apparatus acts to both enhance and to constrain his physical movements. The emphasis here is on a selective augmentation of the body similar to that proposed by military research to create a human body that could be successfully adapted to strategic needs. Stelarc's *Stomach Sculpture* (1993), while similarly mechanical in form, addresses the interior body with an apparatus that acts like a mechanical parasite, inhabiting the host body and affecting its function. Stelarc describes the *Stomach Sculpture* as a form of body adornment, a self-illuminating and sound-emitting mechanism that invites consideration of the role of æsthetic enhancement in the construction of the cyborg body.

Survival Research Laboratories is notorious for its elaborate performances that involve hybrid machines engaged in "useless mechanical activity."[9] Both the anthropomorphic character of many of the machines and the obvious presence of their human operators acknowledges their abiding concern with human machine interaction. Their dedication to the use of the machine in a performance context recalls the art of the Italian Futurists or the machine sculptures of Jean Tinguely, but as Mark Pauline acknowledges, theirs is a far more dystopic vision that contains a "bitter message of hopeless grief." The SRL performances are rooted in Nietzsche's critique of the will to power. Through their work, they seek to create a uncanny effect that will haunt or even frighten their audience into an acknowledgment of the will to power that is rooted in the everyday production of mechanical technology: "I think for some people it calls into question — reminds or even haunts them — of things that connect with their day to day relationship with technology."[10]

Stelarc, *Stomach Sculpture*, 1993. Still from video of performance.
Collection of Gilbert and Lila Silverman, Detroit

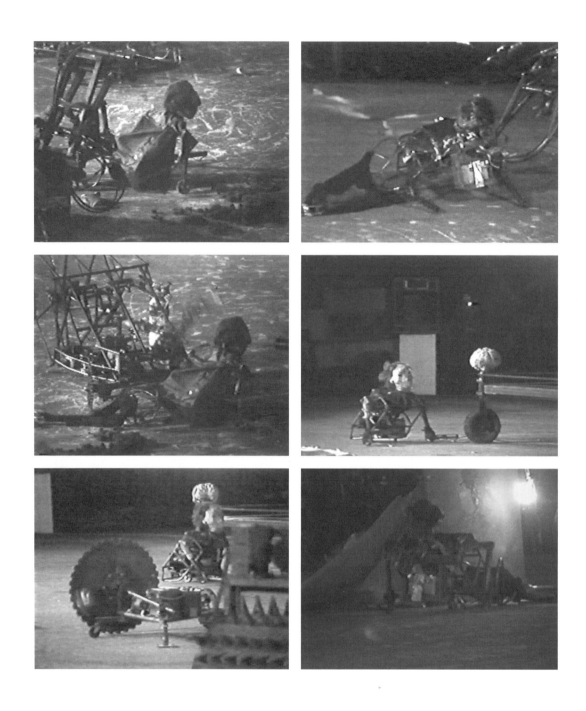

Video stills from "Extremely Cruel Practices," *Virtues of Nagative Fascination*, 1985–86.
Survival Research Laboratories.

Ronald Jones also seeks to acknowledge the persistent impulse toward a will to power that has accompanied the development of new technology. In his work, *Untitled (This trestle was used to hold . . .)* (1990, p. 203), he produces an improbable historical moment by creating an unexpected collision of pivotal historical events. The invention of the artificial heart and the events of Tiananmen Square are historically and topically distinct events and yet both are grounded in a will to power that recalls the long history of the cyborg body and the desire to engineer a new human society. The production and implantation of the Jarvik heart in 1982 marked the first attempt to replace the human heart with a mechanical pump. In the history of the human imaginary it was an extraordinary event rooted in a will to eternal life through the selective replacement of defective body organs. The juxtaposition of this mechanical heart with a trestle from the morgue that held the bodies of students and workers killed in Tiananmen Square in 1989 poses an impossible collision of events, except in the acknowledgement that both events share a will to power and desire to engineer—whether through bio-technology or social engineering—a better human.

More often than not, the critical analysis of the will to power is reduced to an argument around the opposing forces of good and evil. In contemporary films and science fiction literature, the uncanny cyborg body often figures as a persistent cipher in that narrative. James Cameron's *The Terminator* (1984), Paul Verhoeven's *Robocop* (1987), and the Borg of *Star Trek: The Next Generation* offer a dystopic future vision of the cyborg body. Each narrative revolves around an ambiguity in the delimitations of the human and the cyborg body and the struggle for a stable identity within that matrix. More often than not, the narrative is reduced to a struggle between good and evil that faintly echoes the moral arguments that Norbert Weiner posed in the final years of World War II when he realized the issues raised by his research into cybernetics.

Tony Oursler's work also draws on the theme of good and evil sited within the uncanny cyborg body. Oursler's video projections onto an inanimate dummy create an immediate and uncanny presence. In their scale, they recall the character of the 18th-century automaton, a miniature human with a very selective but utterly unnerving set of actions that create a doubt in the mind of the viewer as to the object's source of animation. Oursler's figures also recall the ventriloquist's dummy—a seemingly lifeless body capped with an animated head. While the heart is the symbolic centre of human emotion, the head is the site of the reasoning mind and the logical locus of any debate on the nature of good and

evil. Oursler's *Vanish* (2000, p. 202) eschews the lifeless body but leaves the head, now capped with devilish horns, as the locus of a rambling, stuttering soliloquy on the character of good and evil and the illusory nature of the material world. Moments of magical transformation are intercut with images from the world of cable television and telemarketing. Throughout the video Oursler's face moves in and out of a makeshift masking device that produces the illusion of the uncanny talking head. And so, the magic is constantly undermined, the illusory nature of good and evil is confirmed, and we are left to ponder the ever-shifting character of the will to power.

The image of the disembodied head is a compelling one with strong links to contemporary science fiction and the representation of artificial intelligence. The character of Johnny Mnemonic, in William Gibson's novella of the same name, is a courier carrying a computer chip in his head, a head that more than once seems destined to be separated from his body and a chip that threatens to override his consciousness. The impact of new technologies on the traditional unity of the human body is a constant theme in science fiction literature. The cyborg characters of Case and Molly, from William Gibson's novel *Neuromancer* (1984), are replete with a wide array of technological implants that allow them to effectively traverse both the physical world and the world of cyberspace. Gibson's image of cyberspace is that of a vast network of information held in a complex matrix outside the human body and accessible only through a dramatic shift in consciousness. As the plot of the novel develops, Case recognizes the presence of an Artificial Intelligence named Wintermute who is engineering a metamorphosis that will provide it with a god-like consciousness. Here, the image of the disembodied head is transformed into the ultimate cyborg, a machine with a spirit.

And so, through a circuitous route, we return to Descartes' debate, forged three centuries earlier, on the nature of being and the necessity to articulate the disposition of the spirit. It won't come as a great surprise that the debate still revolves around the mind/body dichotomy, though now the distinction is between the base human body, often described in contemporary science fiction as "meat" or "wetware," and the ethereal world of the mind, now characterized as artificial intelligence.

The emergence of artificial intelligence (AI) as a field of study is beyond the scope of this introduction, but it is important to acknowledge its role in the shifting representation of the cyborg body. Technically, artificial intelligence exists only outside of the human body and is produced through computer programs that simulate human intelligence.

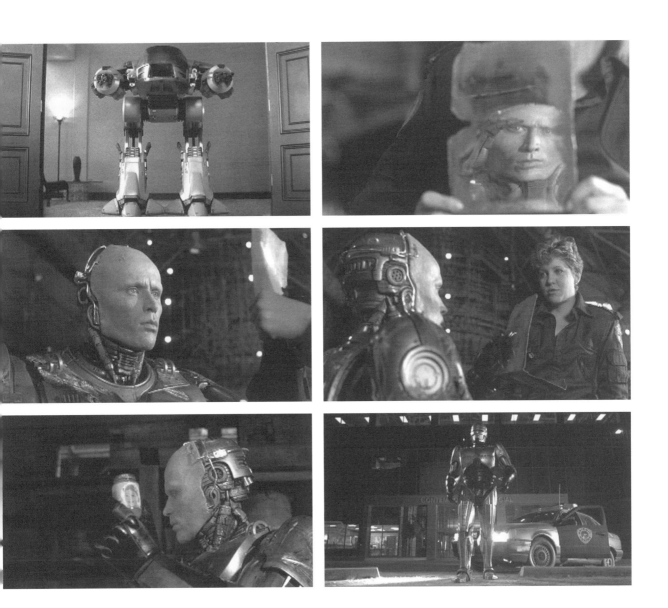

Film stills from *Robocop*, 1987.
Paul Verhoeven, MGM/UA.

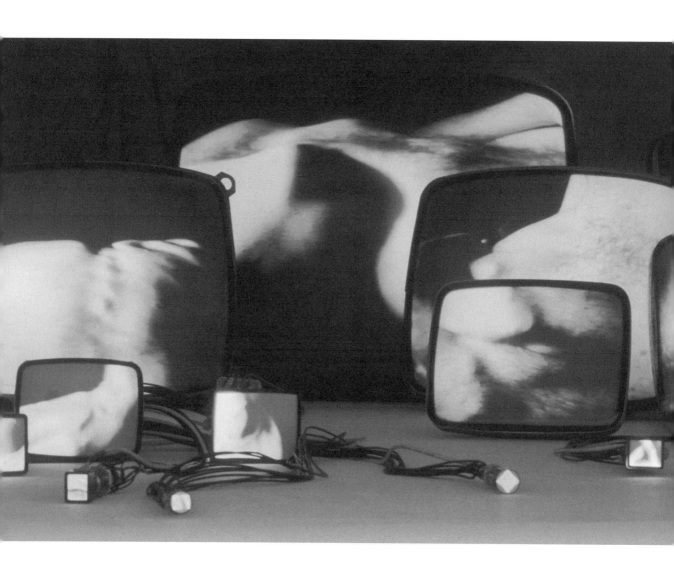

Gary Hill, *Inasmuch As It Is Always Taking Place*, 1990 (detail).
Sixteen-channel video/sound installation.
Courtesy of the artist.

But within the field of science fiction those divisions don't necessarily exist, and the conjoining of human consciousness and artificial intelligence has become a staple theme of that genre. Its occurrence marks a significant shift away from a narrative of anxiety and dread of the machine toward the production of a new line of flight, one that leads from the corporeal body toward transcendence. Certainly it is a story that is as old as any religion or other system of belief, but its reappearance at this time marks the onset of the digital age and a reconfiguration of the cyborg. Where once the machine was a massive presence equal to, and often greater than, human presence itself, now the development of digital technology, microprocessors, and even nanotechnology have shrunk the machine to a scale that is no longer a challenge to the physical body but does imply a threat to the integrity of human consciousness.

Gary Hill is one of the few contemporary artists to directly address the subject of being within new technologies. His video installations directly and indirectly approach this field through the representation of a body fragmented or dispersed across a series of monitors. But this is not a simple lamentation of a body lost to technology; on the contrary, it is an engaged and proactive search for a new sense of being within the technological ethos. Hill's *Inasmuch as it is already always taking place* (1990) and *Conundrum* (1995–98, p. 204–205) speak of duration and the temporal configuration of the body within technology. Within these works, we are conscious of a body held in time, slowed down or temporally displaced. Occasionally the body is aligned in a sequence that provides a sense of unity, but more often it is reconfigured and reshaped, adapting with surprising ease to its new state. Here there is no sense of loss, no will to power, only a persistent probing of the body in this new configuration.

The publication of Donna Haraway's *Cyborg Manifesto* (1985), and her proposition that "We are all cyborgs," marks yet another shift in Western culture's conception of the cyborg body. Haraway's proposition is a rejection of the fear and anxiety that informed many of the contemporary critiques of technology and an acknowledgment that contemporary medicine, tele-communications, biotechnology, expert systems, even simple labour-saving devices have already made us into cyborgs. Haraway calls on readers to proactively engage technology to produce a newly configured human that will resist those conventional models of being formed in patriarchal notions of capital, gender, sexuality, biological evolution, etc.

Haraway's manifesto was quickly seized (albeit selectively) by those who desired a new model for technology, unencumbered by the patriarchy and its reductive binaries of human and machine, fear and fascination, good and evil. Lee Bul's monsters and cyborgs offer a like-minded critique of the patriarchy and its abiding fear of the female body. In her early performances, Bul adopted the form of monstrous feminine presence in which body organs and decoration merged in a critique of traditional Korean notions of the feminine body. Bul's more recent monsters imply an unearthly presence, an alien form that offers a reconfigured body no longer defined by human notions of gender and sexuality. Bul's cyborg sculptures (p. 206) are aggressive figures modelled on a female form. In part, they recall the robot of Fritz Lang's *Metropolis*, a powerful, machinic presence in the shape of a human woman. They are also part comic-book superhero, part mannequin; a suitable companion, perhaps, for Robocop. But in reality they are companions to Bul's monsters, for the cyborg cannot be inscribed within a traditional model of heterosexual coupling or binary representation. With Bul's cyborg, the concepts of male and female, whole and part become arbitrary distinctions.

In her installation *Gravity* (1997–98, p. 207), Nina Levitt also questions arbitrary patriarchal notions of gender and sexuality within new technology. The image of the astronaut has a powerful cultural presence that speaks to a longstanding human desire to travel through outer space. The first experiments under the rubric of the "cyborg" were attempts to engineer a human that could survive the rigours of a non-earth atmosphere. The principal line of inquiry was to the search for drugs that would alter osmotic pressures within the body to allow for unprotected walks in space. Those experiments failed, and instead we are left with the enduring image of the astronaut in a bulky, helmeted space suit floating in a gravity-free environment. Among the images in Levitt's installation is that of the first female Russian cosmonaut, Valentina Tereshkova, as she waves to the camera on her first flight in 1963. The image is slowed and looped in a mesmerizing sequence that is echoed by the accompanying images of a spinning diver, a dancing lesbian couple, and the sound of a sonar ping that echoes across the space.

Mariko Mori's *Play with Me* (1998, p. 266–267) is one of a series of cyborg images produced almost as if documents of a performance set in the contemporary urban spaces of Tokyo. Mori is the cyborg of Haraway's manifesto, inhabiting the present, reforming and reshaping the patriarchy through her very presence. *Play with Me* is set in the precinct of Akihabara, the principal electronics district of Tokyo where the newest technology enters

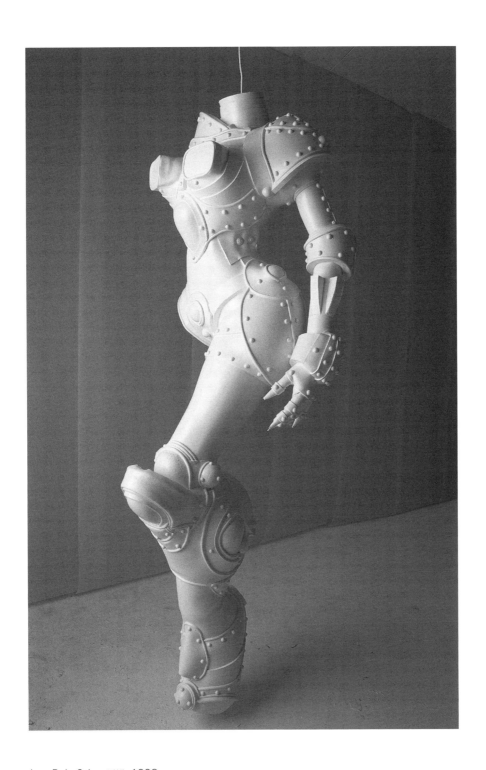

Lee Bul, *Cyborg WI*, 1998.
Cast silicone, polyurethane filling, paint pigment, 185 x 56 x 58 cm.
Artsonje Center, Seoul.

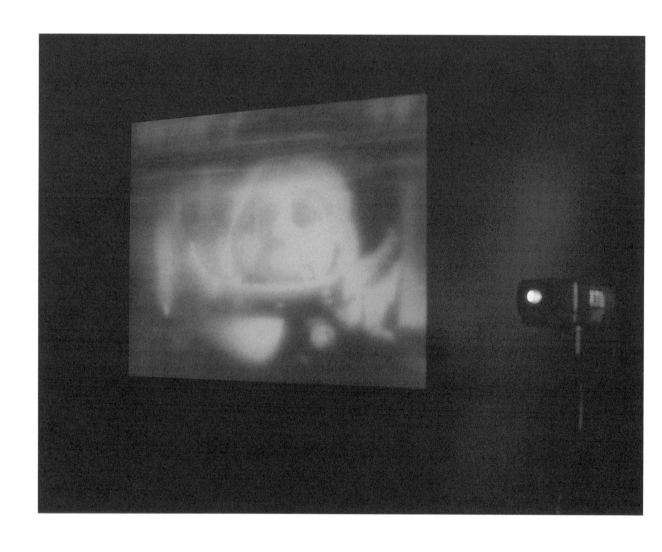

Nina Levitt, *Gravity*, 1997–98 (detail).
Courtesy of the artist.

the market as quickly as it is developed. Mori stands as if waiting for a friend, the only woman in vast community of men. She dresses as if a figure from a Japanese *anime*, a woman-child, an improbable hybrid of sexuality, innocence, and superpower. She waits virtually unnoticed, as if these men, even when confronted with their own fantasy, cannot see her. She is a cipher, an enigmatic, problematic projection of desire that, when made real, cannot be recognized by the patriarchy that spawned her.

Toshiya Ueno's essay, *Japanimation and Techno-Orientalism* (1999), is a provocative analysis of contemporary Japanese culture and the lingering presence of Western Orientalism, now recast as Techno-Orientalism. In a wide-ranging analysis, Ueno challenges the Western notion of Japan as a nation of automatons and techno-geeks. He proposes that just as the West invented the Orient to reaffirm its own religious, linguistic, economic, and cultural beliefs, so too has it invented the Techno-Orient as a land of the future. It is a convincing argument that sees Japan as a repository for all that is problematic in the Western conception of technology. In the eyes of the West, Japan becomes the new cyborg, an object of fascination and fear.

In his introduction, Ueno offers an extended analysis of the *anime* film *Ghost in the Shell*, directed by Oshii Mamoru, as a viable model of production within the problematic terrain of the Techno-Orient. It is a complex story set in the year 2029. The principal characters are the Puppet Master, an omnipresent artificial intelligence formed from a mutant computer virus, and a cyborg named Major Motoko Kusanagi, who struggles with the belief that she may lack the "ghost," that human spirit that distinguishes cyborg from the mechanical automaton. She heads up a squad charged with the task of tracking down the Puppet Master. In the course of her investigation, she encounters the Puppet Master who proposes that they merge so that he will gain mortality and she immortality. Motoko's decision to merge with the Puppet Master may be seen as a capitulation to woman's traditional reproductive role and sublimation of the self, but Ueno cites Donna Haraway's manifesto as the source of an alternative interpretation of her actions. He proposes that Motoko's decision is an act of transgression that rejects the binary of human/not human and the notion of the unitary self and embraces dispersion and survival within the diaspora.

Takashi Murakami has also adopted a model of dispersion that allows him to move in and out of a position of stable identity. In his recent *Superflat* project, he produced his own manifesto for a new movement. Citing a wide range of sources, from the 17th- and

Superflat book cover, MADRA Publishing Co. Ltd., 2000.

18th-century "Eccentric" painterly tradition to contemporary *manga* and *anime*, Murakami maps out a notion of artmaking that freely moves across all media and genre in search of like-minded devices that acknowledge relevance of the superflat. The exhibition included the work of a large number of artists from his studio, Hiropon Factory, who assist in various Murakami projects while carrying out their own independent practice.

Murakami's *S.M.P.Ko²* (1999–2000, p. 268–269) is a typical Factory project that draws together a wide range of collaborators and sources to create the work. Murakami describes the project as an attempt to produce ". . . a life-size transforming robot girl, something never seen before."[11] Certainly, Murakami's decision to transform a figure that would more comfortably occupy the diminutive, two-dimensional world of *manga* and *anime* was problematic, not only for the technical challenge that it raised, but also because Murakami's proposal to produce a life-size figure sculpture threatened to erase the traditional "æsthetic distance" that distinguished *otaku* figure sculpture from pornography. Murakami's decision to produce a female figure that transforms from a woman to an aircraft is linked, in part, to existing narratives within contemporary Japanese *anime* but must also be seen as an affirmation of the cyborg and its narrative of transformation and dispersion.

Kenji Yanobe's *Yellow Suit* (1991, p. 270–271) is one of a series of survival suits for use in the nuclear age. Each is a self-contained environment equipped with breathing apparatus and an internal Geiger counter. The *Yellow Suit* even allows for the companionable presence of a pet. Like Murakami, Yanobe draws from a wide range of sources to produce to his cyborg figures—part samurai warrior, *anime* figure, and deep-sea diver. Viewed from the Western vantage point, this is the cyborg of Ueno's Techno-Orient, a figure virtually immobilized by its own technological prowess; too ungainly to move on its own, it is mobilized only through the use of a cumbersome counterweight. Our fear that we will be subsumed by technology is realized here. But when viewed from within Japan, this may be the cyborg of Haraway's manifesto, a body that embraces new and old technologies in order to renegotiate the present. The figure connotes a body that must adapt to its environment through a strategic reconfiguration of its component parts, and its ungainliness is an element of resistance, a challenge to the expectation of a utopian future characterized by mobility and miniaturization.

Mori, Murakami, and Yanobe are part of diverse group of contemporary Japanese artists who have begun to reconceptualize the notion of the Techno-Orient, not simply

in opposition to Western stereotypes, but rather as a product of a history, very different from that which can be represented within the Western notion of the Techno-Orient.

The cyborg is a prominent figure in post-World War II Japan, but its character is not formed in a binary of fear and fascination, good and evil, human and machine. It is, in part, the product of a culture that successfully integrated a history of handcrafted production into the processes of industrialization. Within that notion of production the object retained its animistic spirit. It was not simply a tool or an object of detached contemplation, but an entity in its own right, worthy of respect and admiration. As artist and cultural anthropologist Masanori Oda has noted, in the post-war period this notion of the spirit of the machine became increasingly invisible until the Osaka Expo 70, where Taro Okamoto's monumental sculpture *Sun Tower* reawakened a national interest in animism, especially among a younger generation of artists who experienced that event. The gigantic sculpture offered a Buddhist-inspired vision of the past, present, and future universe. The 1970 world fair also provided an opportunity to symbolically announce the re-emergence of Japan onto the world stage as an influential producing nation with a strong economy and an increasingly indispensable manufacturing industry.

In the post-war period, the Japanese armed forces were eliminated and the production of nuclear weapons prohibited. This gap, both real and symbolic, was filled in part by the concerted development of new technologies and a new militarist symbolism. Many of the resources traditionally directed to military development were redirected into the development of new commercial products and technologies. The symbolic representation of the militaristic impulse was, in part, redirected into virtual war games for the computer and other new media. The impulse also found its locus in a wide range of *manga* and *anime* narratives that emerged in the early 1960s.

Among the most popular figures to materialize from that impulse was Astro Boy, a robotic child, with extraordinary strength and endurance. He was programmed by his maker to be protective and helpful, and his commitment to safeguard the human race was unflagging. While his intentions were sometimes misguided—usually the result of youthful exuberance and inexperience—his protective purpose was always evident. In the decades that followed, Astro Boy was quickly joined by a wide range of robot and cyborg figures that fulfilled a similar benevolent, though sometimes chaotic, purpose. While it is foolhardy to make sweeping generalizations about the nature of a post-war

Astro Boy book cover, Kodansha Ltd., 1999.

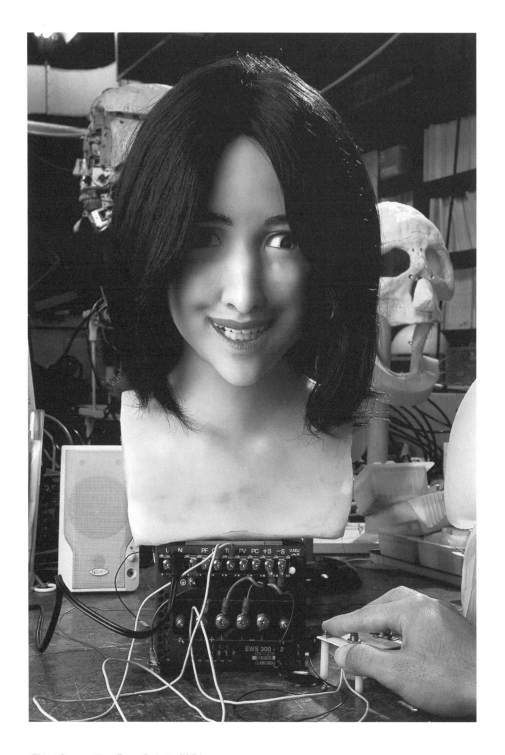

Third-Generation Face Robot, 2001.

Hara/Kobayashi Labs, Science University of Tokyo.

© Peter Menzel, from *Robo sapiens: Evolution of a New Science* (MIT Press, 2000).

Japanese cyborg, it is nonetheless enticing to point to the consistent production of a symbolic figure in post-war Japan, that links the human and the machine, both physically and spiritually, and to locate that figure's origins in animistic belief, rapid industrialization, and a redirected militaristic impulse. This history, when aligned with a desire to resist the Western-inspired impulse to constantly reproduce the Techno-Orient, has resulted in a line of flight away from the binary of fear and fascination toward a notion of the cyborg that embraces the possibility of becoming other.

By way of conclusion, I want to reiterate that this essay is not to be read as a narrative that simply maps the evolutionary emergence of a new species. It is better understood as an analysis, in the psychoanalytic sense, of a figure that has been produced and reproduced in direct response to a broader cultural need, specifically, a need to acknowledge the affect of the machine and the machinic function within modern culture. There can be little doubt that the fabrication of the cyborg is a sign of a collective anxiety around the ubiquitous presence of the machine.

For much of its history, the cyborg was contained within the narrative of the human/machine and the dichotomy engendered by its link to notions of the mind/body, good/evil, fear/fascination. When produced within this dichotomic structure, the cyborg invariably emerges as a melancholic and æstheticized figure, trapped within a utopian impulse that is doomed to failure.

The shift away from this dichotomy came in part through a reconceptualization of the machine and its role in the contemporary world. Like the new machine, the new cyborg, was no longer conceived as a brute mechanical force, but was now defined by adaptability, miniaturization, selective physical augmentation, and the intelligent application of information within a system of feedback. Within this reconfigured notion of the machine, the cyborg began to shift and mutate, shedding its rigid alignment with the values of capitalism and the patriarchy and pointing the way toward a very different conception of the body. Here the presence of the cyborg may mark a critique of the will to power, a line of flight away from the patriarchal body or a sign of resistance to the fabrication of the Techno-Orient.

It is tempting to imagine that this reconfiguration of the cyborg marks the emergence of a new ethos—one that actively resists objectification, binarism, instrumentalization and æstheticization. But history has shown us that it is unlikely that we can step outside

of the technological ethos long enough to look back and understand the configuration of our being, let alone change that configuration. Instead, we must look to the image of the cyborg as a cipher, effectively shifting and evolving with our own anxiety and desire so that we may give meaning to the technological ethos in which we live.

[1] See David Joslelit, *Infinite Regress: Marcel Duchamp 1910–1941* (Cambridge, Massachusetts: The MIT Press, 1998). [2] See Claudia Springer, *Electronic Eros: Bodies and Desire in the Post-industrial Age* (Austin: University of Texas Press, 1996) and Andreas Huyssen, "The Vamp and the Machine: Technology and Sexuality in Fritz Lang's Metropolis," *New German Critique: An Interdisciplinary Journal of German Studies*, New York, Vol. 24–25, 1981–1982 Fall–Winter, 221–237. [3] Leger as quoted in Standish D. Lawder, *The Cubist Cinema* (New York: New York University Press, 1975), 65. [4] Klaus Theweleit, *Male Fantasies, Vol. 1* (Minneapolis: University of Minnesota Press, 1987), *Male Fantasies, Vol. 2* (Minneapolis: University of Minnesota Press, 1989). [5] The book appears to have met its purpose of reaching a general audience as it went through four printings in the first six months and sold 21,000 copies in its first decade. [6] Bruno Bettelheim, "Joey: A Mechanical Boy," *Scientific American*, (March 1959), 117. [7] ibid [8] Gilles Deleuze and Feliz Guattari, *Anti-Œdipus: Capitalism and Schizophrenia* (New York: Viking Press, 1977). [9] This quote and the one below are titles of SRL performances mounted in 1980 and 1988 respectively. [10] Mark Pauline, "Beyond the Realm of Humans: a discussion with Mark Pauline of Survival Research Laboratories." *www.srl.org* [11] Takashi Murakami gives an extended description of the process and issues that surround the production of *S.M.P.Ko²* in his notes for the exhibition catalogue, *takashi murakami summon monsters? open the door? heal? or die?* (Tokyo: Museum of Contemporary Art, 2001), 138–143.

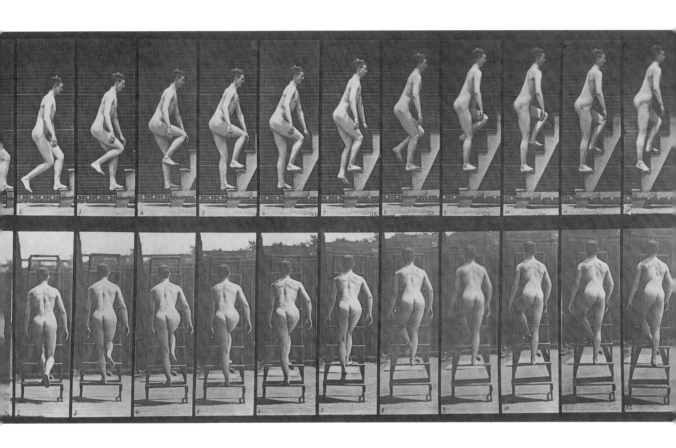

Eadweard Muybridge, *Animal Locomotion* [Plate 109], 1887.

Collotype on paper, 48.3 x 60.9 cm.

Vancouver Art Gallery (93.14.2), gift of Ian Davidson.

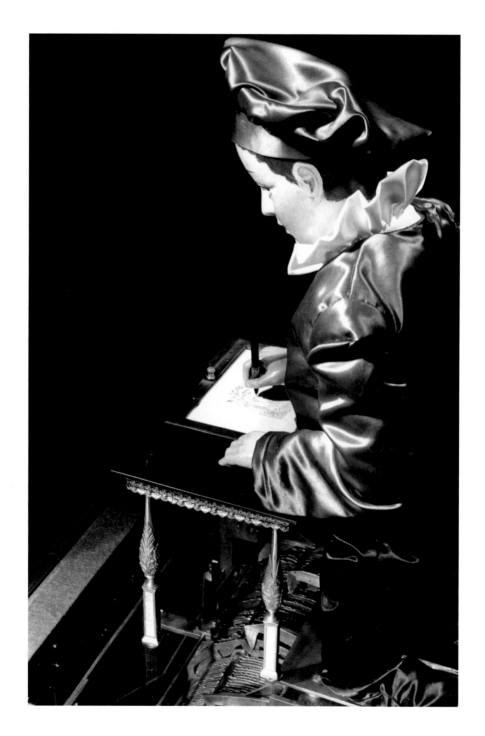

Henri Maillardet, *Automaton*, c.1810.

Mechanical parts, cloth, stylus, 91 x 86 x 147 cm.

The Historical and Interpretive Collections of The Franklin Institute, Philadelphia (1663).

Photo: Charles Penniman

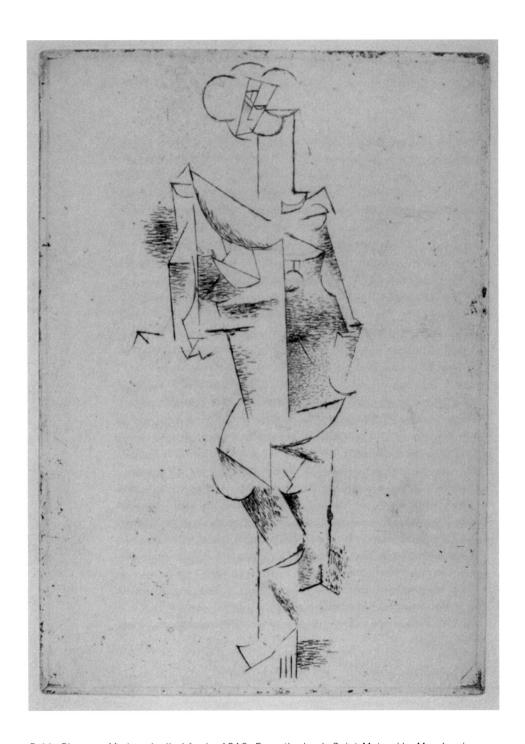

Pablo Picasso, *Mademoiselle Léonie*, 1910. From the book *Saint Matorel* by Max Jacob
(Paris: Henry Kahnweiler, 1911). Etching on van Gelder Holland laid paper, 19.8 x 14.2 cm.
Fine Arts Museums of San Francisco (2000.200.59.1), The Reva and David Logan Collection
of Illustrated Books © Estate of Pablo Picasso/ADAGP (Paris)/SODRAC (Montreal) 2001.

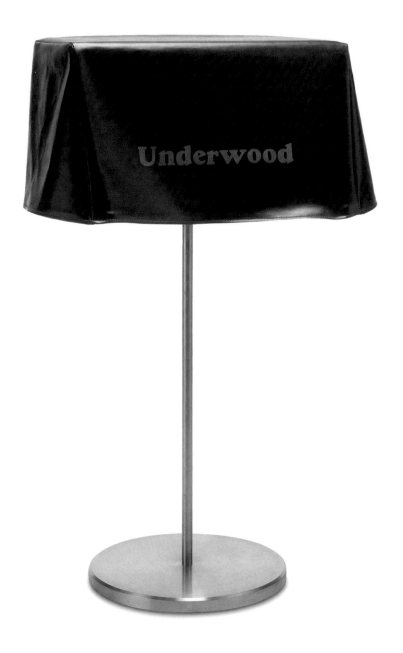

Marcel Duchamp, . . . *pliant, . . . de voyage*, 1916 (1964). Underwood black vinyl typewriter cover with gold paint on a painted wooden stand, 24 x 42.5 x 32 cm. National Gallery of Canada, Ottawa (29946) © Estate of Marcel Duchamp/ADAGP (Paris)/SODRAC (Montreal) 2001.

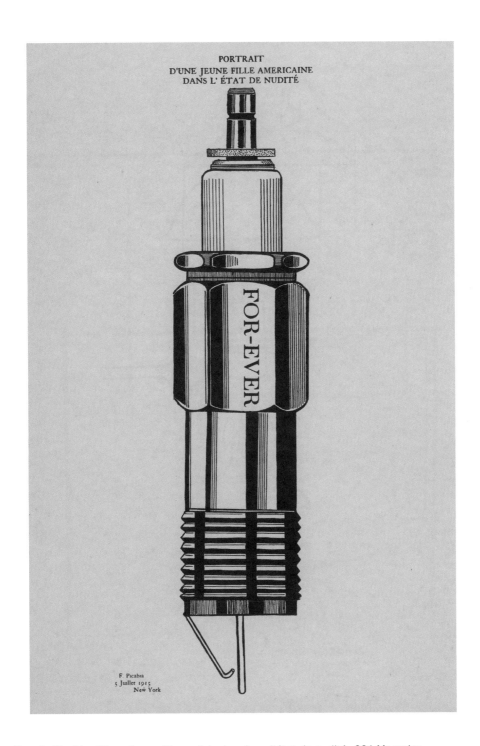

Francis Picabia, *D'une jeune fille américaine dans l'état de nudité*, *291* Magazine, nos. 5–6 July–August, 1915. Off-set lithography on wove paper, 28 x 43 cm. Art Gallery of Greater Victoria © Estate of Francis Picabia/ADAGP (Paris)/SODRAC (Montreal) 2001.

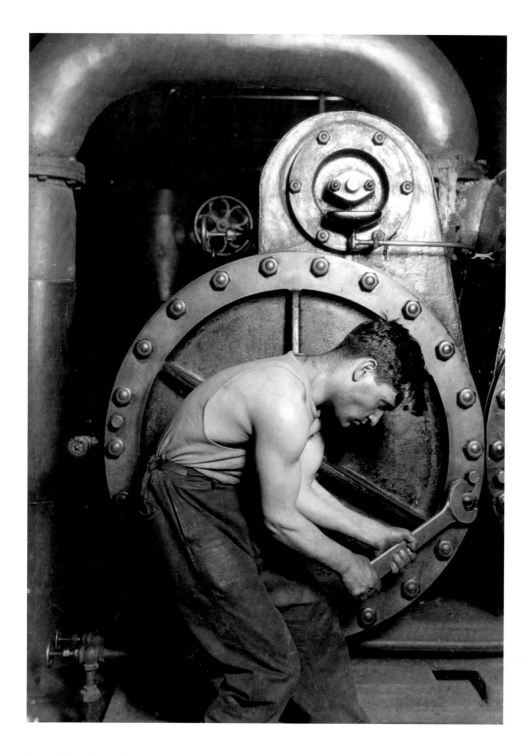

Lewis Hine, *Power house mechanic working on steam pump*, 1925.
Gelatin silver print (posthumous), 11.8 x 16.2 cm.
National Archives and Records Administration, Washington (69-RH, 4L-2).

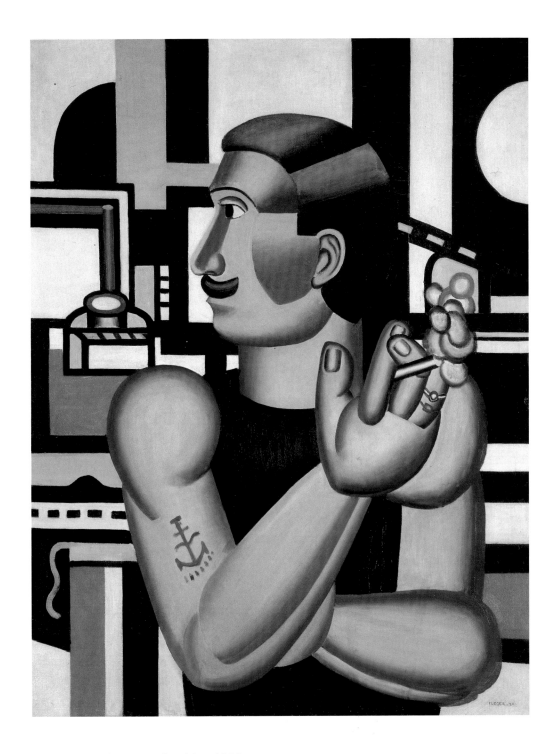

Fernand Léger, *Le mécanicien*, 1920.

Oil on canvas, 115.5 x 88.3 cm. National Gallery of Canada, Ottawa (14985)

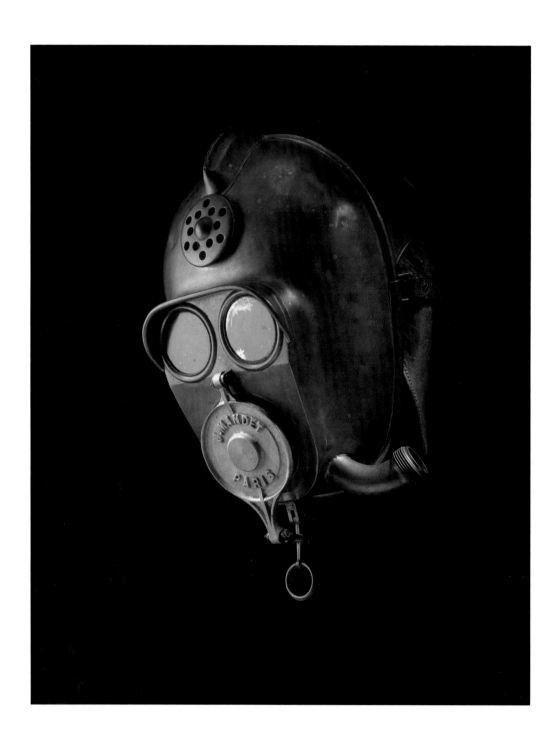

J. Mandet, *Firefighter's Respirator*, c. 1910.
Brass, glass, leather. Height 30.5 cm. Collection of William Greenspon.
Photo courtesy Lynton Gardiner Digital Photography.

The notion of the human machine held widespread popularity in early 20th-century industrial and commercial design. This firefighter's mask is a French design dating from the first decade of the 20th century. The mask maintains distinctly human features — binocular eye sockets, a nose, ears, and mouth — while adopting the hard and sleek features of the modern machine.

In spite of its up-to-date industrial design, the mask still reflects ancient masking traditions in which the wearer takes on the attributes of its subject. In this instance, the wearer was quite clearly to be transformed into a superior being, a mechanized human endowed with an enhanced physical strength and power to endure even the most harrowing environments.

The uncanny, talismanic character of the mask, and particularly the modern mask that linked human and machine, was recognized by the Surrealists when they reproduced images of this firefighter's mask and other industrial masks in a issue of the Belgian Surrealist magazine *Variétés: revue mensuelle illustrée de l'esprit contemporain* (January 1930).

By the mid-20th century, the link between the modern industrial mask and the ancient masking traditions had largely disappeared and been replaced by a contoured face shield that removed all facial features but the eyes and replacing those features with an abstracted form defined primarily by the object's function.

BG

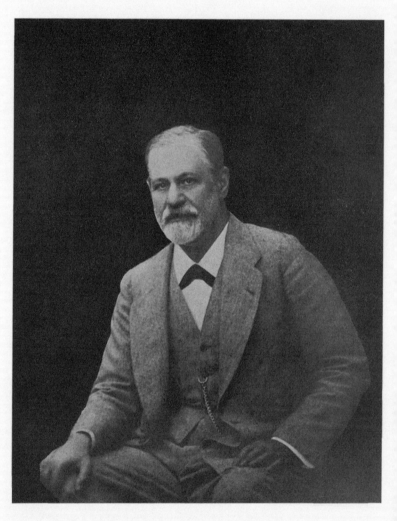

SIGMUND FREUD IN 1916

THE STANDARD EDITION

OF THE COMPLETE PSYCHOLOGICAL WORKS OF

SIGMUND FREUD

Translated from the German under the General Editorship of

JAMES STRACHEY

In Collaboration with

ANNA FREUD

Assisted by

ALIX STRACHEY and ALAN TYSON

VOLUME XVII

(1917–1919)

An Infantile Neurosis

and

Other Works

LONDON

THE HOGARTH PRESS

AND THE INSTITUTE OF PSYCHO-ANALYSIS

THE 'UNCANNY'

I

IT is only rarely that a psycho-analyst feels impelled to investigate the subject of aesthetics, even when aesthetics is understood to mean not merely the theory of beauty but the theory of the qualities of feeling. He works in other strata of mental life and has little to do with the subdued emotional impulses which, inhibited in their aims and dependent on a host of concurrent factors, usually furnish the material for the study of aesthetics. But it does occasionally happen that he has to interest himself in some particular province of that subject; and this province usually proves to be a rather remote one, and one which has been neglected in the specialist literature of aesthetics.

The subject of the 'uncanny'[1] is a province of this kind. It is undoubtedly related to what is frightening—to what arouses dread and horror; equally certainly, too, the word is not always used in a clearly definable sense, so that it tends to coincide with what excites fear in general. Yet we may expect that a special core of feeling is present which justifies the use of a special conceptual term. One is curious to know what this common core is which allows us to distinguish as 'uncanny' certain things which lie within the field of what is frightening.

As good as nothing is to be found upon this subject in comprehensive treatises on aesthetics, which in general prefer to concern themselves with what is beautiful, attractive and sublime—that is, with feelings of a positive nature—and with the circumstances and the objects that call them forth, rather than with the opposite feelings of repulsion and distress. I know of only one attempt in medico-psychological literature, a fertile but not exhaustive paper by Jentsch (1906). But I must confess that I have not made a very thorough examination of the literature, especially the foreign literature, relating to this present modest contribution of mine, for reasons which, as may

[1] [The German word, translated throughout this paper by the English 'uncanny', is '*unheimlich*', literally 'unhomely'. The English term is not, of course, an exact equivalent of the German one.]

easily be guessed, lie in the times in which we live;[1] so that my paper is presented to the reader without any claim to priority.

In his study of the 'uncanny' Jentsch quite rightly lays stress on the obstacle presented by the fact that people vary so very greatly in their sensitivity to this quality of feeling. The writer of the present contribution, indeed, must himself plead guilty to a special obtuseness in the matter, where extreme delicacy of perception would be more in place. It is long since he has experienced or heard of anything which has given him an uncanny impression, and he must start by translating himself into that state of feeling, by awakening in himself the possibility of experiencing it. Still, such difficulties make themselves powerfully felt in many other branches of aesthetics; we need not on that account despair of finding instances in which the quality in question will be unhesitatingly recognized by most people.

Two courses are open to us at the outset. Either we can find out what meaning has come to be attached to the word 'uncanny' in the course of its history; or we can collect all those properties of persons, things, sense-impressions, experiences and situations which arouse in us the feeling of uncanniness, and then infer the unknown nature of the uncanny from what all these examples have in common. I will say at once that both courses lead to the same result: the uncanny is that class of the frightening which leads back to what is known of old and long familiar. How this is possible, in what circumstances the familiar can become uncanny and frightening, I shall show in what follows. Let me also add that my investigation was actually begun by collecting a number of individual cases, and was only later confirmed by an examination of linguistic usage. In this discussion, however, I shall follow the reverse course.

The German word '*unheimlich*' is obviously the opposite of '*heimlich*' ['homely'], '*heimisch*' ['native']—the opposite of what is familiar; and we are tempted to conclude that what is 'uncanny' is frightening precisely because it is *not* known and familiar. Naturally not everything that is new and unfamiliar is frightening, however; the relation is not capable of inversion.

[1] [An allusion to the first World War only just concluded.]

We can only say that what is novel can easily become frightening and uncanny; some new things are frightening but not by any means all. Something has to be added to what is novel and unfamiliar in order to make it uncanny.

On the whole, Jentsch did not get beyond this relation of the uncanny to the novel and unfamiliar. He ascribes the essential factor in the production of the feeling of uncanniness to intellectual uncertainty; so that the uncanny would always, as it were, be something one does not know one's way about in. The better orientated in his environment a person is, the less readily will he get the impression of something uncanny in regard to the objects and events in it.

It is not difficult to see that this definition is incomplete, and we will therefore try to proceed beyond the equation 'uncanny' = 'unfamiliar'. We will first turn to other languages. But the dictionaries that we consult tell us nothing new, perhaps only because we ourselves speak a language that is foreign. Indeed, we get an impression that many languages are without a word for this particular shade of what is frightening.

I should like to express my indebtedness to Dr. Theodor Reik for the following excerpts:—

LATIN: (K. E. Georges, *Deutschlateinisches Wörterbuch*, 1898). An uncanny place: *locus suspectus*; at an uncanny time of night: *intempesta nocte*.

GREEK: (Rost's and Schenkl's Lexikons). ξένος (i.e. strange, foreign).

ENGLISH: (from the dictionaries of Lucas, Bellows, Flügel and Muret-Sanders). Uncomfortable, uneasy, gloomy, dismal, uncanny, ghastly; (of a house) haunted; (of a man) a repulsive fellow.

FRENCH: (Sachs-Villatte). *Inquiétant, sinistre, lugubre, mal à son aise.*

SPANISH: (Tollhausen, 1889). *Sospechoso, de mal agüero, lúgubre, siniestro.*

The Italian and Portuguese languages seem to content themselves with words which we should describe as circumlocutions. In Arabic and Hebrew 'uncanny' means the same as 'daemonic', 'gruesome'.

Let us therefore return to the German language. In Daniel Sanders's *Wörterbuch der Deutschen Sprache* (1860, **1**, 729), the following entry, which I here reproduce in full, is to be found

under the word '*heimlich*'. I have laid stress on one or two passages by italicizing them.[1]

Heimlich, adj., subst. *Heimlichkeit* (pl. *Heimlichkeiten*): I. Also *heimelich, heimelig*, belonging to the house, not strange, familiar, tame, intimate, friendly, etc.

(*a*) (Obsolete) belonging to the house or the family, or regarded as so belonging (cf. Latin *familiaris*, familiar): *Die Heimlichen*, the members of the household; *Der heimliche Rat* (Gen. xli, 45; 2 Sam. xxiii. 23; 1 Chron. xii. 25; Wisd. viii. 4), now more usually *Geheimer Rat* [Privy Councillor].

(*b*) Of animals: tame, companionable to man. As opposed to wild, e.g. 'Animals which are neither wild nor *heimlich*', etc. 'Wild animals . . . that are trained to be *heimlich* and accustomed to men.' 'If these young creatures are brought up from early days among men they become quite *heimlich*, friendly' etc. —So also: 'It (the lamb) is so *heimlich* and eats out of my hand.' 'Nevertheless, the stork is a beautiful, *heimelich* bird.'

(*c*) Intimate, friendlily comfortable; the enjoyment of quiet content, etc., arousing a sense of agreeable restfulness and security as in one within the four walls of his house.[2] 'Is it still *heimlich* to you in your country where strangers are felling your woods?' 'She did not feel too *heimlich* with him.' 'Along a high, *heimlich*, shady path . . ., beside a purling, gushing and babbling woodland brook.' 'To destroy the *Heimlichkeit* of the home.' 'I could not readily find another spot so intimate and *heimlich* as this.' 'We pictured it so comfortable, so nice, so cosy and *heimlich*.' 'In quiet *Heimlichkeit*, surrounded by close walls.' 'A careful housewife, who knows how to make a pleasing *Heimlichkeit* (*Häuslichkeit* [domesticity]) out of the smallest means.' 'The man who till recently had been so strange to him now seemed to him all the more *heimlich*.' 'The protestant land-owners do not feel . . . *heimlich* among their catholic inferiors.' 'When it grows *heimlich* and still, and the evening quiet alone watches

[1] [In the translation which follows in the text above, a few details, mainly giving the sources of the quotations, have been omitted. For purposes of reference, we reprint in an Appendix the entire extract from Sanders's Dictionary exactly as it is given in German in Freud's original paper except that a few minor misprints have been put right. (Cf. p. 253.)]

[2] [It may be remarked that the English 'canny', in addition to its more usual meaning of 'shrewd', can mean 'pleasant', 'cosy'.]

over your cell.' 'Quiet, lovely and *heimlich*, no place more fitted for their rest.' 'He did not feel at all *heimlich* about it.'—Also, [in compounds] 'The place was so peaceful, so lonely, so shadily-*heimlich*.' 'The in- and outflowing waves of the current, dreamy and lullaby-*heimlich*.' Cf. in especial *Unheimlich* [see below]. Among Swabian Swiss authors in especial, often as a trisyllable: 'How *heimelich* it seemed to Ivo again of an evening, when he was at home.' 'It was so *heimelig* in the house.' 'The warm room and the *heimelig* afternoon.' 'When a man feels in his heart that he is so small and the Lord so great—that is what is truly *heimelig*.' 'Little by little they grew at ease and *heimelig* among themselves.' 'Friendly *Heimeligkeit*.' 'I shall be nowhere more *heimelich* than I am here.' 'That which comes from afar . . . assuredly does not live quite *heimelig* (*heimatlich* [at home], *freundnachbarlich* [in a neighbourly way]) among the people.' 'The cottage where he had once sat so often among his own people, so *heimelig*, so happy.' 'The sentinel's horn sounds so *heimelig* from the tower, and his voice invites so hospitably.' 'You go to sleep there so soft and warm, so wonderfully *heim'lig*.' —*This form of the word deserves to become general in order to protect this perfectly good sense of the word from becoming obsolete through an easy confusion with* II [see below]. Cf: ' "*The Zecks* [a family name] *are all 'heimlich'*." (in sense II) " '*Heimlich'? . . . What do you understand by 'heimlich'?*" "*Well, . . . they are like a buried spring or a dried-up pond. One cannot walk over it without always having the feeling that water might come up there again.*" "*Oh, we call it 'unheimlich'; you call it 'heimlich'. Well, what makes you think that there is something secret and untrustworthy about this family?*" ' (Gutzkow).

(*d*) Especially in Silesia: gay, cheerful; also of the weather.

II. Concealed, kept from sight, so that others do not get to know of or about it, withheld from others. To do something *heimlich*, i.e. behind someone's back; to steal away *heimlich*; *heimlich* meetings and appointments; to look on with *heimlich* pleasure at someone's discomfiture; to sigh or weep *heimlich*; to behave *heimlich*, as though there was something to conceal; *heimlich* love-affair, love, sin; *heimlich* places (which good manners oblige us to conceal) (1 Sam. v. 6). 'The *heimlich* chamber' (privy) (2 Kings x. 27.). Also, 'the *heimlich* chair'. 'To throw into pits or *Heimlichkeiten*.'—'Led the steeds *heimlich* before Laomedon.'—'As secretive, *heimlich*, deceitful and malicious towards cruel masters . . . as frank, open, sympathetic and

helpful towards a friend in misfortune.' 'You have still to learn what is *heimlich* holiest to me.' 'The *heimlich* art' (magic). 'Where public ventilation has to stop, there *heimlich* machinations begin.' 'Freedom is the whispered watchword of *heimlich* conspirators and the loud battle-cry of professed revolutionaries.' 'A holy, *heimlich* effect.' 'I have roots that are most *heimlich* I am grown in the deep earth.' 'My *heimlich* pranks.' 'If he is not given it openly and scrupulously he may seize it *heimlich* and unscrupulously.' 'He had achromatic telescopes constructed *heimlich* and secretly.' 'Henceforth I desire that there should be nothing *heimlich* any longer between us.'—To discover, disclose, betray someone's *Heimlichkeiten*; 'to concoct *Heimlichkeiten* behind my back'. 'In my time we studied *Heimlichkeit*.' 'The hand of understanding can alone undo the powerless spell of the *Heimlichkeit* (of hidden gold).' 'Say, where is the place of concealment . . . in what place of hidden *Heimlichkeit*?' 'Bees, who make the lock of *Heimlichkeiten*' (i.e. sealing-wax). 'Learned in strange *Heimlichkeiten*' (magic arts).

For compounds see above, *I*c. Note especially the negative '*un-*': eerie, weird, arousing gruesome fear: 'Seeming quite *unheimlich* and ghostly to him.' 'The *unheimlich*, fearful hours of night.' 'I had already long since felt an *unheimlich*, even gruesome feeling.' 'Now I am beginning to have an *unheimlich* feeling.' . . . 'Feels an *unheimlich* horror.' '*Unheimlich* and motionless like a stone image.' 'The *unheimlich* mist called hill-fog.' 'These pale youths are *unheimlich* and are brewing heaven knows what mischief.' ' "*Unheimlich*" *is the name for everything that ought to have remained . . . secret and hidden but has come to light*' (Schelling).— 'To veil the divine, to surround it with a certain *Unheimlichkeit*.' —*Unheimlich* is not often used as opposite to meaning II (above).

What interests us most in this long extract is to find that among its different shades of meaning the word '*heimlich*' exhibits one which is identical with its opposite, '*unheimlich*'. What is *heimlich* thus comes to be *unheimlich*. (Cf. the quotation from Gutzkow: 'We call it "*unheimlich*"; you call it "*heimlich*".') In general we are reminded that the word '*heimlich*' is not unambiguous, but belongs to two sets of ideas, which, without being contradictory, are yet very different: on the one hand it means what is familiar and agreeable, and on the other, what is con-

cealed and kept out of sight.[1] '*Unheimlich*' is customarily used, we are told, as the contrary only of the first signification of '*heimlich*', and not of the second. Sanders tells us nothing concerning a possible genetic connection between these two meanings of *heimlich*. On the other hand, we notice that Schelling says something which throws quite a new light on the concept of the *Unheimlich*, for which we were certainly not prepared. According to him, everything is *unheimlich* that ought to have remained secret and hidden but has come to light.

Some of the doubts that have thus arisen are removed if we consult Grimm's dictionary. (1877, **4**, Part 2, 873 ff.)

We read:

Heimlich; adj. and adv. *vernaculus, occultus*; MHG. heimelîch, heimlîch.

(P. 874.) In a slightly different sense: 'I feel *heimlich*, well, free from fear.' . . .

[3] (*b*) *Heimlich* is also used of a place free from ghostly influences . . . familiar, friendly, intimate.

(P. 875: *β*) Familiar, amicable, unreserved.

4. *From the idea of 'homelike', 'belonging to the house', the further idea is developed of something withdrawn from the eyes of strangers, something concealed, secret; and this idea is expanded in many ways* . . .

(P. 876.) 'On the left bank of the lake there lies a meadow *heimlich* in the wood.' (Schiller, *Wilhelm Tell*, I. 4.). . . Poetic licence, rarely so used in modern speech . . . *Heimlich* is used in conjunction with a verb expressing the act of concealing: 'In the secret of his tabernacle he shall hide me *heimlich*.' (Ps. xxvii. 5.) . . . *Heimlich* parts of the human body, *pudenda* . . . 'the men that died not were smitten on their *heimlich* parts.' (1 Samuel v. 12.) . . .

(*c*) Officials who give important advice which has to be kept secret in matters of state are called *heimlich* councillors; the adjective, according to modern usage, has been replaced by *geheim* [secret] . . . 'Pharaoh called Joseph's name "him to whom secrets are revealed"' ' (*heimlich* councillor). (Gen. xli. 45.)

[1] [According to the Oxford English Dictionary, a similar ambiguity attaches to the English 'canny', which may mean not only 'cosy' but also 'endowed with occult or magical powers'.]

(P. 878.) 6. *Heimlich*, as used of knowledge—mystic, allegorical: a *heimlich* meaning, *mysticus, divinus, occultus, figuratus*.

(P. 878.) *Heimlich* in a different sense, as withdrawn from knowledge, unconscious . . . *Heimlich* also has the meaning of that which is obscure, inaccessible to knowledge . . . 'Do you not see? They do not trust us; they fear the *heimlich* face of the Duke of Friedland.' (Schiller, *Wallensteins Lager*, Scene 2.)

9. *The notion of something hidden and dangerous, which is expressed in the last paragraph, is still further developed, so that 'heimlich' comes to have the meaning usually ascribed to 'unheimlich'.* Thus: 'At times I feel like a man who walks in the night and believes in ghosts; every corner is *heimlich* and full of terrors for him'. (Klinger, *Theater*, 3. 298.)

Thus *heimlich* is a word the meaning of which develops in the direction of ambivalence, until it finally coincides with its opposite, *unheimlich*. *Unheimlich* is in some way or other a sub-species of *heimlich*. Let us bear this discovery in mind, though we cannot yet rightly understand it, alongside of Schelling's [1] definition of the *Unheimlich*. If we go on to examine individual instances of uncanniness, these hints will become intelligible to us.

II

When we proceed to review the things, persons, impressions, events and situations which are able to arouse in us a feeling of the uncanny in a particularly forcible and definite form, the first requirement is obviously to select a suitable example to start on. Jentsch has taken as a very good instance 'doubts whether an apparently animate being is really alive; or conversely, whether a lifeless object might not be in fact animate'; and he refers in this connection to the impression made by wax-work figures, ingeniously constructed dolls and automata. To these he adds the uncanny effect of epileptic fits, and of manifestations of insanity, because these excite in the spectator the impression of automatic, mechanical processes at work behind the ordinary appearance of mental activity. Without entirely accepting this author's view, we will take it as a starting-point for our own investigation because in what follows he reminds us

[1] [In the original version of the paper (1919) only, the name 'Schleiermacher' was printed here, evidently in error.]

of a writer who has succeeded in producing uncanny effects better than anyone else.

Jentsch writes: 'In telling a story, one of the most successful devices for easily creating uncanny effects is to leave the reader in uncertainty whether a particular figure in the story is a human being or an automaton, and to do it in such a way that his attention is not focused directly upon his uncertainty, so that he may not be led to go into the matter and clear it up immediately. That, as we have said, would quickly dissipate the peculiar emotional effect of the thing. E. T. A. Hoffmann has repeatedly employed this psychological artifice with success in his fantastic narratives.'

This observation, undoubtedly a correct one, refers primarily to the story of 'The Sand-Man' in Hoffmann's *Nachtstücken*,[1] which contains the original of Olympia, the doll that appears in the first act of Offenbach's opera, *Tales of Hoffmann*. But I cannot think—and I hope most readers of the story will agree with me—that the theme of the doll Olympia, who is to all appearances a living being, is by any means the only, or indeed the most important, element that must be held responsible for the quite unparalleled atmosphere of uncanniness evoked by the story. Nor is this atmosphere heightened by the fact that the author himself treats the episode of Olympia with a faint touch of satire and uses it to poke fun at the young man's idealization of his mistress. The main theme of the story is, on the contrary, something different, something which gives it its name, and which is always re-introduced at critical moments: it is the theme of the 'Sand-Man' who tears out children's eyes.

This fantastic tale opens with the childhood recollections of the student Nathaniel. In spite of his present happiness, he cannot banish the memories associated with the mysterious and terrifying death of his beloved father. On certain evenings his mother used to send the children to bed early, warning them that 'the Sand-Man was coming'; and, sure enough, Nathaniel would not fail to hear the heavy tread of a visitor, with whom his father would then be occupied for the evening. When questioned about the Sand-Man, his mother, it is true, denied

[1] Hoffmann's *Sämtliche Werke*, Grisebach Edition, **3**. [A translation of 'The Sand-Man' is included in *Eight Tales of Hoffmann*, translated by J. M. Cohen, London, Pan Books, 1952.]

that such a person existed except as a figure of speech; but his nurse could give him more definite information: 'He's a wicked man who comes when children won't go to bed, and throws handfuls of sand in their eyes so that they jump out of their heads all bleeding. Then he puts the eyes in a sack and carries them off to the half-moon to feed his children. They sit up there in their nest, and their beaks are hooked like owls' beaks, and they use them to peck up naughty boys' and girls' eyes with.'

Although little Nathaniel was sensible and old enough not to credit the figure of the Sand-Man with such gruesome attributes, yet the dread of him became fixed in his heart. He determined to find out what the Sand-Man looked like; and one evening, when the Sand-Man was expected again, he hid in his father's study. He recognized the visitor as the lawyer Coppelius, a repulsive person whom the children were frightened of when he occasionally came to a meal; and he now identified this Coppelius with the dreaded Sand-Man. As regards the rest of the scene, Hoffmann already leaves us in doubt whether what we are witnessing is the first delirium of the panic-stricken boy, or a succession of events which are to be regarded in the story as being real. His father and the guest are at work at a brazier with glowing flames. The little eavesdropper hears Coppelius call out: 'Eyes here! Eyes here!' and betrays himself by screaming aloud. Coppelius seizes him and is on the point of dropping bits of red-hot coal from the fire into his eyes, and then of throwing them into the brazier, but his father begs him off and saves his eyes. After this the boy falls into a deep swoon; and a long illness brings his experience to an end. Those who decide in favour of the rationalistic interpretation of the Sand-Man will not fail to recognize in the child's phantasy the persisting influence of his nurse's story. The bits of sand that are to be thrown into the child's eyes turn into bits of red-hot coal from the flames; and in both cases they are intended to make his eyes jump out. In the course of another visit of the Sand-Man's, a year later, his father is killed in his study by an explosion. The lawyer Coppelius disappears from the place without leaving a trace behind.

Nathaniel, now a student, believes that he has recognized this phantom of horror from his childhood in an itinerant optician, an Italian called Giuseppe Coppola, who at his university town, offers him weather-glasses for sale. When Nathaniel

refuses, the man goes on: 'Not weather-glasses? not weather-glasses? also got fine eyes, fine eyes!' The student's terror is allayed when he finds that the proffered eyes are only harmless spectacles, and he buys a pocket spy-glass from Coppola. With its aid he looks across into Professor Spalanzani's house opposite and there spies Spalanzani's beautiful, but strangely silent and motionless daughter, Olympia. He soon falls in love with her so violently that, because of her, he quite forgets the clever and sensible girl to whom he is betrothed. But Olympia is an automaton whose clock-work has been made by Spalanzani, and whose eyes have been put in by Coppola, the Sand-Man. The student surprises the two Masters quarrelling over their handiwork. The optician carries off the wooden eyeless doll; and the mechanician, Spalanzani, picks up Olympia's bleeding eyes from the ground and throws them at Nathaniel's breast, saying that Coppola had stolen them from the student. Nathaniel succumbs to a fresh attack of madness, and in his delirium his recollection of his father's death is mingled with this new experience. 'Hurry up! hurry up! ring of fire!' he cries. 'Spin about, ring of fire—Hurrah! Hurry up, wooden doll! lovely wooden doll, spin about—.' He then falls upon the professor, Olympia's 'father', and tries to strangle him.

Rallying from a long and serious illness, Nathaniel seems at last to have recovered. He intends to marry his betrothed, with whom he has become reconciled. One day he and she are walking through the city market-place, over which the high tower of the Town Hall throws its huge shadow. On the girl's suggestion, they climb the tower, leaving her brother, who is walking with them, down below. From the top, Clara's attention is drawn to a curious object moving along the street. Nathaniel looks at this thing through Coppola's spy-glass, which he finds in his pocket, and falls into a new attack of madness. Shouting 'Spin about, wooden doll!' he tries to throw the girl into the gulf below. Her brother, brought to her side by her cries, rescues her and hastens down with her to safety. On the tower above, the madman rushes round, shrieking 'Ring of fire, spin about!'—and we know the origin of the words. Among the people who begin to gather below there comes forward the figure of the lawyer Coppelius, who has suddenly returned. We may suppose that it was his approach, seen through the spy-glass, which threw Nathaniel into his fit of madness. As the onlookers prepare to go

up and overpower the madman, Coppelius laughs and says: 'Wait a bit; he'll come down of himself.' Nathaniel suddenly stands still, catches sight of Coppelius, and with a wild shriek 'Yes! "Fine eyes—fine eyes"!' flings himself over the parapet. While he lies on the paving-stones with a shattered skull the Sand-Man vanishes in the throng.

This short summary leaves no doubt, I think, that the feeling of something uncanny is directly attached to the figure of the Sand-Man, that is, to the idea of being robbed of one's eyes, and that Jentsch's point of an intellectual uncertainty has nothing to do with the effect. Uncertainty whether an object is living or inanimate, which admittedly applied to the doll Olympia, is quite irrelevant in connection with this other, more striking instance of uncanniness. It is true that the writer creates a kind of uncertainty in us in the beginning by not letting us know, no doubt purposely, whether he is taking us into the real world or into a purely fantastic one of his own creation. He has, of course, a right to do either; and if he chooses to stage his action in a world peopled with spirits, demons and ghosts, as Shakespeare does in *Hamlet*, in *Macbeth* and, in a different sense, in *The Tempest* and *A Midsummer-Night's Dream*, we must bow to his decision and treat his setting as though it were real for as long as we put ourselves into his hands. But this uncertainty disappears in the course of Hoffmann's story, and we perceive that he intends to make us, too, look through the demon optician's spectacles or spy-glass—perhaps, indeed, that the author in his very own person once peered through such an instrument. For the conclusion of the story makes it quite clear that Coppola the optician really *is* the lawyer Coppelius[1] and also, therefore, the Sand-Man.

There is no question therefore, of any intellectual uncertainty here: we know now that we are not supposed to be looking on at the products of a madman's imagination, behind which we, with the superiority of rational minds, are able to detect the sober truth; and yet this knowledge does not lessen the impression of uncanniness in the least degree. The theory of

[1] Frau Dr. Rank has pointed out the association of the name with '*coppella*' = crucible, connecting it with the chemical operations that caused the father's death; and also with '*coppo*' = eye-socket. [Except in the first (1919) edition this footnote was attached, it seems erroneously, to the first occurrence of the name Coppelius on this page.]

intellectual uncertainty is thus incapable of explaining that impression.

We know from psycho-analytic experience, however, that the fear of damaging or losing one's eyes is a terrible one in children. Many adults retain their apprehensiveness in this respect, and no physical injury is so much dreaded by them as an injury to the eye. We are accustomed to say, too, that we will treasure a thing as the apple of our eye. A study of dreams, phantasies and myths has taught us that anxiety about one's eyes, the fear of going blind, is often enough a substitute for the dread of being castrated. The self-blinding of the mythical criminal, Oedipus, was simply a mitigated form of the punishment of castration—the only punishment that was adequate for him by the *lex talionis*. We may try on rationalistic grounds to deny that fears about the eye are derived from the fear of castration, and may argue that it is very natural that so precious an organ as the eye should be guarded by a proportionate dread. Indeed, we might go further and say that the fear of castration itself contains no other significance and no deeper secret than a justifiable dread of this rational kind. But this view does not account adequately for the substitutive relation between the eye and the male organ which is seen to exist in dreams and myths and phantasies; nor can it dispel the impression that the threat of being castrated in especial excites a peculiarly violent and obscure emotion, and that this emotion is what first gives the idea of losing other organs its intense colouring. All further doubts are removed when we learn the details of their 'castration complex' from the analysis of neurotic patients, and realize its immense importance in their mental life.

Moreover, I would not recommend any opponent of the psycho-analytic view to select this particular story of the Sand-Man with which to support his argument that anxiety about the eyes has nothing to do with the castration complex. For why does Hoffmann bring the anxiety about eyes into such intimate connection with the father's death? And why does the Sand-Man always appear as a disturber of love? He separates the unfortunate Nathaniel from his betrothed and from her brother, his best friend; he destroys the second object of his love, Olympia, the lovely doll; and he drives him into suicide at the moment when he has won back his Clara and is about to

be happily united to her. Elements in the story like these, and many others, seem arbitrary and meaningless so long as we deny all connection between fears about the eye and castration; but they become intelligible as soon as we replace the Sand-Man by the dreaded father at whose hands castration is expected.[1]

[1] In fact, Hoffmann's imaginative treatment of his material has not made such wild confusion of its elements that we cannot reconstruct their original arrangement. In the story of Nathaniel's childhood, the figures of his father and Coppelius represent the two opposites into which the father-imago is split by his ambivalence; whereas the one threatens to blind him—that is, to castrate him—, the other, the 'good' father, intercedes for his sight. The part of the complex which is most strongly repressed, the death-wish against the 'bad' father, finds expression in the death of the 'good' father, and Coppelius is made answerable for it. This pair of fathers is represented later, in his student days, by Professor Spalanzani and Coppola the optician. The Professor is in himself a member of the father-series, and Coppola is recognized as identical with Coppelius the lawyer. Just as they used before to work together over the secret brazier, so now they have jointly created the doll Olympia; the Professor is even called the father of Olympia. This double occurrence of activity in common betrays them as divisions of the father-imago: both the mechanician and the optician were the father of Nathaniel (and of Olympia as well). In the frightening scene in child-hood, Coppelius, after sparing Nathaniel's eyes, had screwed off his arms and legs as an experiment; that is, he had worked on him as a mechanician would on a doll. This singular feature, which seems quite outside the picture of the Sand-Man, introduces a new castration equivalent; but it also points to the inner identity of Coppelius with his later counterpart, Spalanzani the mechanician, and prepares us for the interpretation of Olympia. This automatic doll can be nothing else than a materialization of Nathaniel's feminine attitude towards his father in his infancy. Her fathers, Spalanzani and Coppola, are, after all, nothing but new editions, reincarnations of Nathaniel's pair of fathers. Spalanzani's otherwise incomprehensible statement that the optician has stolen Nathaniel's eyes (see above, [p. 229]), so as to set them in the doll, now becomes significant as supplying evidence of the identity of Olympia and Nathaniel. Olympia is, as it were, a dissociated complex of Nathaniel's which confronts him as a person, and Nathaniel's enslavement to this complex is expressed in his senseless obsessive love for Olympia. We may with justice call love of this kind narcissistic, and we can under-stand why someone who has fallen victim to it should relinquish the real, external object of his love. The psychological truth of the situation in which the young man, fixated upon his father by his castration com-plex, becomes incapable of loving a woman, is amply proved by numerous analyses of patients whose story, though less fantastic, is hardly less tragic than that of the student Nathaniel.

Hoffmann was the child of an unhappy marriage. When he was

We shall venture, therefore, to refer the uncanny effect of the Sand-Man to the anxiety belonging to the castration complex of childhood. But having reached the idea that we can make an infantile factor such as this responsible for feelings of uncanniness, we are encouraged to see whether we can apply it to other instances of the uncanny. We find in the story of the Sand-Man the other theme on which Jentsch lays stress, of a doll which appears to be alive. Jentsch believes that a particularly favourable condition for awakening uncanny feelings is created when there is intellectual uncertainty whether an object is alive or not, and when an inanimate object becomes too much like an animate one. Now, dolls are of course rather closely connected with childhood life. We remember that in their early games children do not distinguish at all sharply between living and inanimate objects, and that they are especially fond of treating their dolls like live people. In fact, I have occasionally heard a woman patient declare that even at the age of eight she had still been convinced that her dolls would be certain to come to life if she were to look at them in a particular, extremely concentrated, way. So that here, too, it is not difficult to discover a factor from childhood. But, curiously enough, while the Sand-Man story deals with the arousing of an early childhood fear, the idea of a 'living doll' excites no fear at all; children have no fear of their dolls coming to life, they may even desire it. The source of uncanny feelings would not, therefore, be an infantile fear in this case, but rather an infantile wish or even merely an infantile belief. There seems to be a contradiction here; but perhaps it is only a complication, which may be helpful to us later on.

Hoffmann is the unrivalled master of the uncanny in literature. His novel, *Die Elixire des Teufels* [*The Devil's Elixir*], contains a whole mass of themes to which one is tempted to ascribe the uncanny effect of the narrative;[1] but it is too obscure and

three years old, his father left his small family, and was never united to them again. According to Grisebach, in his biographical introduction to Hoffmann's works, the writer's relation to his father was always a most sensitive subject with him.

[1] [Under the rubric 'Varia' in one of the issues of the *Internationale Zeitschrift für Psychoanalyse* for 1919 (**5**, 308), the year in which the present paper was first published, there appears over the initials 'S.F.' a short note which it is not unreasonable to attribute to Freud. Its insertion

intricate a story for us to venture upon a summary of it. To-
wards the end of the book the reader is told the facts, hitherto
concealed from him, from which the action springs; with the
result, not that he is at last enlightened, but that he falls into a
state of complete bewilderment. The author has piled up too
much material of the same kind. In consequence one's grasp of
the story as a whole suffers, though not the impression it makes.
We must content ourselves with selecting those themes of un-
canniness which are most prominent, and with seeing whether
they too can fairly be traced back to infantile sources. These
themes are all concerned with the phenomenon of the 'double',
which appears in every shape and in every degree of develop-
ment. Thus we have characters who are to be considered
identical because they look alike. This relation is accentuated
by mental processes leaping from one of these characters to
another—by what we should call telepathy—, so that the one
possesses knowledge, feelings and experience in common with
the other. Or it is marked by the fact that the subject identifies
himself with someone else, so that he is in doubt as to which his
self is, or substitutes the extraneous self for his own. In other
words, there is a doubling, dividing and interchanging of the
self. And finally there is the constant recurrence of the same
thing [1]—the repetition of the same features or character-traits
or vicissitudes, of the same crimes, or even the same names
through several consecutive generations.

The theme of the 'double' has been very thoroughly treated
by Otto Rank (1914). He has gone into the connections which

here, though strictly speaking irrelevant, may perhaps be excused. The
note is headed: 'E. T. A. Hoffmann on the Function of Consciousness'
and it proceeds: 'In *Die Elixire des Teufels* (Part II, p. 210, in Hesse's
edition)—a novel rich in masterly descriptions of pathological mental
states—Schönfeld comforts the hero, whose consciousness is temporarily
disturbed, with the following words: "And what do you get out of it?
I mean out of the particular mental function which we call conscious-
ness, and which is nothing but the confounded activity of a damned
toll-collector—excise-man—deputy-chief customs officer, who has set up
his infamous bureau in our top storey and who exclaims, whenever any
goods try to get out: 'Hi! hi! exports are prohibited . . . they must stay
here . . . here, in this country. . . .' " ']

[1] [This phrase seems to be an echo from Nietzsche (e.g. from the last
part of *Also Sprach Zarathustra*). In Chapter III of *Beyond the Pleasure
Principle* (1920g), *Standard Ed.*, **18**, 22, Freud puts a similar phrase 'the
perpetual recurrence of the same thing' into inverted commas.]

the 'double' has with reflections in mirrors, with shadows, with guardian spirits, with the belief in the soul and with the fear of death; but he also lets in a flood of light on the surprising evolution of the idea. For the 'double' was originally an insurance against the destruction of the ego, an 'energetic denial of the power of death', as Rank says; and probably the 'immortal' soul was the first 'double' of the body. This invention of doubling as a preservation against extinction has its counterpart in the language of dreams, which is fond of representing castration by a doubling or multiplication of a genital symbol.[1] The same desire led the Ancient Egyptians to develop the art of making images of the dead in lasting materials. Such ideas, however, have sprung from the soil of unbounded self-love, from the primary narcissism which dominates the mind of the child and of primitive man. But when this stage has been surmounted, the 'double' reverses its aspect. From having been an assurance of immortality, it becomes the uncanny harbinger of death.

The idea of the 'double' does not necessarily disappear with the passing of primary narcissism, for it can receive fresh meaning from the later stages of the ego's development. A special agency is slowly formed there, which is able to stand over against the rest of the ego, which has the function of observing and criticizing the self and of exercising a censorship within the mind, and which we become aware of as our 'conscience'. In the pathological case of delusions of being watched, this mental agency becomes isolated, dissociated from the ego, and discernible to the physician's eye. The fact that an agency of this kind exists, which is able to treat the rest of the ego like an object—the fact, that is, that man is capable of self-observation —renders it possible to invest the old idea of a 'double' with a new meaning and to ascribe a number of things to it—above all, those things which seem to self-criticism to belong to the old surmounted narcissism of earliest times.[2]

[1] [Cf. *The Interpretation of Dreams, Standard Ed.*, **5**, 357.]
[2] I believe that when poets complain that two souls dwell in the human breast, and when popular psychologists talk of the splitting of people's egos, what they are thinking of is this division (in the sphere of ego-psychology) between the critical agency and the rest of the ego, and not the antithesis discovered by psycho-analysis between the ego and what is unconscious and repressed. It is true that the distinction between these two antitheses is to some extent effaced by the circumstance that foremost among the things that are rejected by the criticism of the ego

But it is not only this latter material, offensive as it is to the criticism of the ego, which may be incorporated in the idea of a double. There are also all the unfulfilled but possible futures to which we still like to cling in phantasy, all the strivings of the ego which adverse external circumstances have crushed, and all our suppressed acts of volition which nourish in us the illusion of Free Will.[1] [Cf. Freud, 1901b, Chapter XII (B).]

But after having thus considered the *manifest* motivation of the figure of a 'double', we have to admit that none of this helps us to understand the extraordinarily strong feeling of something uncanny that pervades the conception; and our knowledge of pathological mental processes enables us to add that nothing in this more superficial material could account for the urge towards defence which has caused the ego to project that material outward as something foreign to itself. When all is said and done, the quality of uncanniness can only come from the fact of the 'double' being a creation dating back to a very early mental stage, long since surmounted—a stage, incidentally, at which it wore a more friendly aspect. The 'double' has become a thing of terror, just as, after the collapse of their religion, the gods turned into demons.[2]

The other forms of ego-disturbance exploited by Hoffmann can easily be estimated along the same lines as the theme of the 'double'. They are a harking-back to particular phases in the evolution of the self-regarding feeling, a regression to a time when the ego had not yet marked itself off sharply from the external world and from other people. I believe that these factors are partly responsible for the impression of uncanniness, although it is not easy to isolate and determine exactly their share of it.

The factor of the repetition of the same thing will perhaps not appeal to everyone as a source of uncanny feeling. From

are derivatives of the repressed.—[Freud had already discussed this critical agency at length in Section III of his paper on narcissism (1914c), and is was soon to be further expanded into the 'ego-ideal' and 'super-ego' in Chapter XI of his *Group Psychology* (1921c) and Chapter III of *The Ego and the Id* (1923b) respectively.]

[1] In Ewers's *Der Student von Prag*, which serves as the starting-point of Rank's study on the 'double', the hero has promised his beloved not to kill his antagonist in a duel. But on his way to the duelling-ground he meets his 'double', who has already killed his rival.

[2] Heine, *Die Götter im Exil.*

what I have observed, this phenomenon does undoubtedly, subject to certain conditions and combined with certain circumstances, arouse an uncanny feeling, which, furthermore, recalls the sense of helplessness experienced in some dreamstates. As I was walking, one hot summer afternoon, through the deserted streets of a provincial town in Italy which was unknown to me, I found myself in a quarter of whose character I could not long remain in doubt. Nothing but painted women were to be seen at the windows of the small houses, and I hastened to leave the narrow street at the next turning. But after having wandered about for a time without enquiring my way, I suddenly found myself back in the same street, where my presence was now beginning to excite attention. I hurried away once more, only to arrive by another *détour* at the same place yet a third time. Now, however, a feeling overcame me which I can only describe as uncanny, and I was glad enough to find myself back at the piazza I had left a short while before, without any further voyages of discovery. Other situations which have in common with my adventure an unintended recurrence of the same situation, but which differ radically from it in other respects, also result in the same feeling of helplessness and of uncanniness. So, for instance, when, caught in a mist perhaps, one has lost one's way in a mountain forest, every attempt to find the marked or familiar path may bring one back again and again to one and the same spot, which one can identify by some particular landmark. Or one may wander about in a dark, strange room, looking for the door or the electric switch, and collide time after time with the same piece of furniture—though it is true that Mark Twain succeeded by wild exaggeration in turning this latter situation into something irresistibly comic.[1]

If we take another class of things, it is easy to see that there, too, it is only this factor of involuntary repetition which surrounds what would otherwise be innocent enough with an uncanny atmosphere, and forces upon us the idea of something fateful and inescapable when otherwise we should have spoken only of 'chance'. For instance, we naturally attach no importance to the event when we hand in an overcoat and get a cloakroom ticket with the number, let us say, 62; or when we find that our cabin on a ship bears that number. But the impression is altered if two such events, each in itself indifferent, happen

[1] [Mark Twain, *A Tramp Abroad*, London, 1880, **1**, 107.]

close together—if we come across the number 62 several times
in a single day, or if we begin to notice that everything which
has a number—addresses, hotel rooms, compartments in rail-
way trains—invariably has the same one, or at all events one
which contains the same figures. We do feel this to be uncanny.
And unless a man is utterly hardened and proof against the lure
of superstition, he will be tempted to ascribe a secret meaning to
this obstinate recurrence of a number; he will take it, perhaps,
as an indication of the span of life allotted to him.[1] Or suppose
one is engaged in reading the works of the famous physiologist,
Hering, and within the space of a few days receives two letters
from two different countries, each from a person called Hering,
though one has never before had any dealings with anyone of
that name. Not long ago an ingenious scientist (Kammerer,
1919) attempted to reduce coincidences of this kind to certain
laws, and so deprive them of their uncanny effect. I will not
venture to decide whether he has succeeded or not.

How exactly we can trace back to infantile psychology the
uncanny effect of such similar recurrences is a question I
can only lightly touch on in these pages; and I must refer the
reader instead to another work,[2] already completed, in which
this has been gone into in detail, but in a different connection.
For it is possible to recognize the dominance in the unconscious
mind of a 'compulsion to repeat' proceeding from the instinctual
impulses and probably inherent in the very nature of the in-
stincts—a compulsion powerful enough to overrule the pleasure
principle, lending to certain aspects of the mind their daemonic
character, and still very clearly expressed in the impulses of
small children; a compulsion, too, which is responsible for a
part of the course taken by the analyses of neurotic patients.
All these considerations prepare us for the discovery that what-
ever reminds us of this inner 'compulsion to repeat' is perceived
as uncanny.

Now, however, it is time to turn from these aspects of the
matter, which are in any case difficult to judge, and look for
some undeniable instances of the uncanny, in the hope that

[1] [Freud had himself reached the age of 62 a year earlier, in 1918.]
[2] [This was published a year later as *Beyond the Pleasure Principle*
(1920*g*). The various manifestations of the 'compulsion to repeat'
enumerated here are enlarged upon in Chapters II and III of that

an analysis of them will decide whether our hypothesis is a valid one.

In the story of 'The Ring of Polycrates',[1] the King of Egypt turns away in horror from his host, Polycrates, because he sees that his friend's every wish is at once fulfilled, his every care promptly removed by kindly fate. His host has become 'uncanny' to him. His own explanation, that the too fortunate man has to fear the envy of the gods, seems obscure to us; its meaning is veiled in mythological language. We will therefore turn to another example in a less grandiose setting. In the case history of an obsessional neurotic,[2] I have described how the patient once stayed in a hydropathic establishment and benefited greatly by it. He had the good sense, however, to attribute his improvement not to the therapeutic properties of the water, but to the situation of his room, which immediately adjoined that of a very accommodating nurse. So on his second visit to the establishment he asked for the same room, but was told that it was already occupied by an old gentleman, whereupon he gave vent to his annoyance in the words: 'I wish he may be struck dead for it.' A fortnight later the old gentleman really did have a stroke. My patient thought this an 'uncanny' experience. The impression of uncanniness would have been stronger still if less time had elapsed between his words and the untoward event, or if he had been able to report innumerable similar coincidences. As a matter of fact, he had no difficulty in producing coincidences of this sort; but then not only he but every obsessional neurotic I have observed has been able to relate analogous experiences. They are never surprised at their invariably running up against someone they have just been thinking of, perhaps for the first time for a long while. If they say one day 'I haven't had any news of so-and-so for a long time', they will be sure to get a letter from him the next morning, and an accident or a death will rarely take place without having passed through their mind a little while before. They are in the habit of referring to this state of affairs in the most

. work. The 'compulsion to repeat' had already been described by Freud as a clinical phenomenon, in a technical paper published five years earlier (1914*g*).]

[1] [Schiller's poem based on Herodotus.]

[2] 'Notes upon a Case of Obsessional Neurosis' (1909*d*) [*Standard Ed.*, **10**, 234].

modest manner, saying that they have 'presentiments' which 'usually' come true.

One of the most uncanny and wide-spread forms of superstition is the dread of the evil eye, which has been exhaustively studied by the Hamburg oculist Seligmann (1910–11). There never seems to have been any doubt about the source of this dread. Whoever possesses something that is at once valuable and fragile is afraid of other people's envy, in so far as he projects on to them the envy he would have felt in their place. A feeling like this betrays itself by a look[1] even though it is not put into words; and when a man is prominent owing to noticeable, and particularly owing to unattractive, attributes, other people are ready to believe that his envy is rising to a more than usual degree of intensity and that this intensity will convert it into effective action. What is feared is thus a secret intention of doing harm, and certain signs are taken to mean that that intention has the necessary power at its command.

These last examples of the uncanny are to be referred to the principle which I have called 'omnipotence of thoughts', taking the name from an expression used by one of my patients.[2] And now we find ourselves on familiar ground. Our analysis of instances of the uncanny has led us back to the old, animistic conception of the universe. This was characterized by the idea that the world was peopled with the spirits of human beings; by the subject's narcissistic overvaluation of his own mental processes; by the belief in the omnipotence of thoughts and the technique of magic based on that belief; by the attribution to various outside persons and things of carefully graded magical powers, or '*mana*'; as well as by all the other creations with the help of which man, in the unrestricted narcissism of that stage of development, strove to fend off the manifest prohibitions of reality. It seems as if each one of us has been through a phase of individual development corresponding to this animistic stage in primitive men, that none of us has passed through it without preserving certain residues and traces of it which are still capable of manifesting themselves, and that everything which now strikes us as 'uncanny' fulfils the condition of touching

[1] ['The evil eye' in German is '*der böse Blick*', literally 'the evil look'.]

[2] [The obsessional patient referred to just above—the 'Rat Man' (1909*d*), *Standard Ed.*, **10**, 233f.]

those residues of animistic mental activity within us and bringing them to expression.[1]

At this point I will put forward two considerations which, I think, contain the gist of this short study. In the first place, if psycho-analytic theory is correct in maintaining that every affect belonging to an emotional impulse, whatever its kind, is transformed, if it is repressed, into anxiety, then among instances of frightening things there must be one class in which the frightening element can be shown to be something repressed which *recurs*. This class of frightening things would then constitute the uncanny; and it must be a matter of indifference whether what is uncanny was itself originally frightening or whether it carried some *other* affect. In the second place, if this is indeed the secret nature of the uncanny, we can understand why linguistic usage has extended *das Heimliche* ['homely'] into its opposite, *das Unheimliche* (p. 226); for this uncanny is in reality nothing new or alien, but something which is familiar and old-established in the mind and which has become alienated from it only through the process of repression. This reference to the factor of repression enables us, furthermore, to understand Schelling's definition [p. 224] of the uncanny as something which ought to have remained hidden but has come to light.

It only remains for us to test our new hypothesis on one or two more examples of the uncanny.

Many people experience the feeling in the highest degree in relation to death and dead bodies, to the return of the dead, and to spirits and ghosts. As we have seen [p. 221] some languages in use to-day can only render the German expression 'an *unheimlich* house' by 'a *haunted* house'. We might indeed have begun our investigation with this example, perhaps the most striking of all, of something uncanny, but we refrained from doing so because the uncanny in it is too much intermixed with what is purely gruesome and is in part overlaid by it. There is scarcely any other matter, however, upon which our

[1] Cf. my book *Totem and Taboo* (1912–13), Essay III, 'Animism, Magic and the Omnipotence of Thoughts', where the following footnote will be found: 'We appear to attribute an "uncanny" quality to impressions that seek to confirm the omnipotence of thoughts and the animistic mode of thinking in general, after we have reached a stage at which, in our *judgement*, we have abandoned such beliefs.' [*Standard Ed.*, **13**, 86.]

thoughts and feelings have changed so little since the very earliest times, and in which discarded forms have been so completely preserved under a thin disguise, as our relation to death. Two things account for our conservatism: the strength of our original emotional reaction to death and the insufficiency of our scientific knowledge about it. Biology has not yet been able to decide whether death is the inevitable fate of every living being or whether it is only a regular but yet perhaps avoidable event in life.[1] It is true that the statement 'All men are mortal' is paraded in text-books of logic as an example of a general proposition; but no human being really grasps it, and our unconscious has as little use now as it ever had for the idea of its own mortality.[2] Religions continue to dispute the importance of the undeniable fact of individual death and to postulate a life after death; civil governments still believe that they cannot maintain moral order among the living if they do not uphold the prospect of a better life hereafter as a recompense for mundane existence. In our great cities, placards announce lectures that undertake to tell us how to get into touch with the souls of the departed; and it cannot be denied that not a few of the most able and penetrating minds among our men of science have come to the conclusion, especially towards the close of their own lives, that a contact of this kind is not impossible. Since almost all of us still think as savages do on this topic, it is no matter for surprise that the primitive fear of the dead is still so strong within us and always ready to come to the surface on any provocation. Most likely our fear still implies the old belief that the dead man becomes the enemy of his survivor and seeks to carry him off to share his new life with him. Considering our unchanged attitude towards death, we might rather enquire what has become of the repression, which is the necessary condition of a primitive feeling recurring in the shape of something uncanny. But repression is there, too. All supposedly educated people have ceased to believe officially that the dead can become visible as spirits, and have made any such appearances

[1] [This problem figures prominently in *Beyond the Pleasure Principle* (1920*g*), on which Freud was engaged while writing the present paper. See *Standard Ed.*, **18**, 44 ff.]

[2] [Freud had discussed the individual's attitude to death at greater length in the second part of his paper 'Thoughts for the Times on War and Death' (1915*b*).]

dependent on improbable and remote conditions; their emotional attitude towards their dead, moreover, once a highly ambiguous and ambivalent one, has been toned down in the higher strata of the mind into an unambiguous feeling of piety.[1]

We have now only a few remarks to add—for animism, magic and sorcery, the omnipotence of thoughts, man's attitude to death, involuntary repetition and the castration complex comprise practically all the factors which turn something frightening into something uncanny.

We can also speak of a living person as uncanny, and we do so when we ascribe evil intentions to him. But that is not all; in addition to this we must feel that his intentions to harm us are going to be carried out with the help of special powers. A good instance of this is the '*Gettatore*',[2] that uncanny figure of Romanic superstition which Schaeffer, with intuitive poetic feeling and profound psycho-analytic understanding, has transformed into a sympathetic character in his *Josef Montfort*. But the question of these secret powers brings us back again to the realm of animism. It was the pious Gretchen's intuition that Mephistopheles possessed secret powers of this kind that made him so uncanny to her.

> Sie fühlt dass ich ganz sicher ein Genie,
> Vielleicht sogar der Teufel bin.[3]

The uncanny effect of epilepsy and of madness has the same origin. The layman sees in them the working of forces hitherto unsuspected in his fellow-men, but at the same time he is dimly aware of them in remote corners of his own being. The Middle Ages quite consistently ascribed all such maladies to the influence of demons, and in this their psychology was almost correct. Indeed, I should not be surprised to hear that psychoanalysis, which is concerned with laying bare these hidden forces, has itself become uncanny to many people for that very reason. In one case, after I had succeeded—though none too rapidly—in effecting a cure in a girl who had been an invalid

[1] Cf. *Totem and Taboo* [*Standard Ed.*, **13**, 66].

[2] [Literally 'thrower' (of bad luck), or 'one who casts' (the evil eye). —Schaeffer's novel was published in 1918.]

[3] [She feels that surely I'm a genius now,—
 Perhaps the very Devil indeed!
 Goethe, *Faust*, Part I (Scene 16),
 (Bayard Taylor's translation).]

for many years, I myself heard this view expressed by the patient's mother long after her recovery.

Dismembered limbs, a severed head, a hand cut off at the wrist, as in a fairy tale of Hauff's,[1] feet which dance by themselves, as in the book by Schaeffer which I mentioned above—all these have something peculiarly uncanny about them, especially when, as in the last instance, they prove capable of independent activity in addition. As we already know, this kind of uncanniness springs from its proximity to the castration complex. To some people the idea of being buried alive by mistake is the most uncanny thing of all. And yet psycho-analysis has taught us that this terrifying phantasy is only a transformation of another phantasy which had originally nothing terrifying about it at all, but was qualified by a certain lasciviousness—the phantasy, I mean, of intra-uterine existence.[2]

There is one more point of general application which I should like to add, though, strictly speaking, it has been included in what has already been said about animism and modes of working of the mental apparatus that have been surmounted; for I think it deserves special emphasis. This is that an uncanny effect is often and easily produced when the distinction between imagination and reality is effaced, as when something that we have hitherto regarded as imaginary appears before us in reality, or when a symbol takes over the full functions of the thing it symbolizes, and so on. It is this factor which contributes not a little to the uncanny effect attaching to magical practices. The infantile element in this, which also dominates the minds of neurotics, is the over-accentuation of psychical reality in comparison with material reality—a feature closely allied to the belief in the omnipotence of thoughts. In the middle of the isolation of war-time a number of the English *Strand Magazine* fell into my hands; and, among other somewhat redundant matter, I read a story about a young married couple who move into a furnished house in which there is a curiously shaped table with carvings of crocodiles on it. Towards evening an intolerable and very specific smell begins to pervade the house; they

[1] [*Die Geschichte von der abgehauenen Hand* ('The Story of the Severed Hand').]

[2] [See Section VIII of Freud's analysis of the 'Wolf Man' (1918*b*), above p. 101 ff.]

stumble over something in the dark; they seem to see a vague form gliding over the stairs—in short, we are given to understand that the presence of the table causes ghostly crocodiles to haunt the place, or that the wooden monsters come to life in the dark, or something of the sort. It was a naïve enough story, but the uncanny feeling it produced was quite remarkable.

To conclude this collection of examples, which is certainly not complete, I will relate an instance taken from psychoanalytic experience; if it does not rest upon mere coincidence, it furnishes a beautiful confirmation of our theory of the uncanny. It often happens that neurotic men declare that they feel there is something uncanny about the female genital organs. This *unheimlich* place, however, is the entrance to the former *Heim* [home] of all human beings, to the place where each one of us lived once upon a time and in the beginning. There is a joking saying that 'Love is home-sickness'; and whenever a man dreams of a place or a country and says to himself, while he is still dreaming: 'this place is familiar to me, I've been here before', we may interpret the place as being his mother's genitals or her body.[1] In this case too, then, the *unheimlich* is what was once *heimisch*, familiar; the prefix *'un'* ['un-'] is the token of repression.[2]

III

In the course of this discussion the reader will have felt certain doubts arising in his mind; and he must now have an opportunity of collecting them and bringing them forward.

It may be true that the uncanny [*unheimlich*] is something which is secretly familiar [*heimlich-heimisch*], which has undergone repression and then returned from it, and that everything that is uncanny fulfils this condition. But the selection of material on this basis does not enable us to solve the problem of the uncanny. For our proposition is clearly not convertible. Not everything that fulfils this condition—not everything that recalls repressed desires and surmounted modes of thinking belonging to the prehistory of the individual and of the race—is on that account uncanny.

Nor shall we conceal the fact that for almost every example

[1] [Cf. *The Interpretation of Dreams* (1900*a*), *Standard Ed.*, **5**, 399.]
[2] [See Freud's paper on 'Negation' (1925*h*).]

adduced in support of our hypothesis one may be found which rebuts it. The story of the severed hand in Hauff's fairy tale [p. 244] certainly has an uncanny effect, and we have traced that effect back to the castration complex; but most readers will probably agree with me in judging that no trace of uncanniness is provoked by Herodotus's story of the treasure of Rhampsinitus, in which the master-thief, whom the princess tries to hold fast by the hand, leaves his brother's severed hand behind with her instead. Again, the prompt fulfilment of the wishes of Polycrates [p. 239] undoubtedly affects us in the same uncanny way as it did the king of Egypt; yet our own fairy stories are crammed with instantaneous wish-fulfilments which produce no uncanny effect whatever. In the story of 'The Three Wishes', the woman is tempted by the savoury smell of a sausage to wish that she might have one too, and in an instant it lies on a plate before her. In his annoyance at her hastiness her husband wishes it may hang on her nose. And there it is, dangling from her nose. All this is very striking but not in the least uncanny. Fairy tales quite frankly adopt the animistic standpoint of the omnipotence of thoughts and wishes, and yet I cannot think of any genuine fairy story which has anything uncanny about it. We have heard that it is in the highest degree uncanny when an inanimate object—a picture or a doll—comes to life; nevertheless in Hans Andersen's stories the household utensils, furniture and tin soldiers are alive, yet nothing could well be more remote from the uncanny. And we should hardly call it uncanny when Pygmalion's beautiful statue comes to life.

Apparent death and the re-animation of the dead have been represented as most uncanny themes. But things of this sort too are very common in fairy stories. Who would be so bold as to call it uncanny, for instance, when Snow-White opens her eyes once more? And the resuscitation of the dead in accounts of miracles, as in the New Testament, elicits feelings quite unrelated to the uncanny. Then, too, the theme that achieves such an indubitably uncanny effect, the unintended recurrence of the same thing, serves other and quite different purposes in another class of cases. We have already come across one example [p. 237] in which it is employed to call up a feeling of the comic; and we could multiply instances of this kind. Or again, it works as a means of emphasis, and so on. And once more: what is the origin of the uncanny effect of silence, darkness and solitude?

Do not these factors point to the part played by danger in the genesis of what is uncanny, notwithstanding that in children these same factors are the most frequent determinants of the expression of fear [rather than of the uncanny]? And are we after all justified in entirely ignoring intellectual uncertainty as a factor, seeing that we have admitted its importance in relation to death [p. 242]?

It is evident therefore, that we must be prepared to admit that there are other elements besides those which we have so far laid down as determining the production of uncanny feelings. We might say that these preliminary results have satisfied *psycho-analytic* interest in the problem of the uncanny, and that what remains probably calls for an *aesthetic* enquiry. But that would be to open the door to doubts about what exactly is the value of our general contention that the uncanny proceeds from something familiar which has been repressed.

We have noticed one point which may help us to resolve these uncertainties: nearly all the instances that contradict our hypothesis are taken from the realm of fiction, of imaginative writing. This suggests that we should differentiate between the uncanny that we actually experience and the uncanny that we merely picture or read about.

What is *experienced* as uncanny is much more simply conditioned but comprises far fewer instances. We shall find, I think, that it fits in perfectly with our attempt at a solution, and can be traced back without exception to something familiar that has been repressed. But here, too, we must make a certain important and psychologically significant differentiation in our material, which is best illustrated by turning to suitable examples.

Let us take the uncanny associated with the omnipotence of thoughts, with the prompt fulfilment of wishes, with secret injurious powers and with the return of the dead. The condition under which the feeling of uncanniness arises here is unmistakable. We—or our primitive forefathers—once believed that these possibilities were realities, and were convinced that they actually happened. Nowadays we no longer believe in them, we have *surmounted* these modes of thought; but we do not feel quite sure of our new beliefs, and the old ones still exist within us ready to seize upon any confirmation. As soon as something *actually happens* in our lives which seems to confirm the old,

discarded beliefs we get a feeling of the uncanny; it is as though
we were making a judgement something like this: 'So, after all,
it is *true* that one can kill a person by the mere wish!' or, 'So the
dead *do* live on and appear on the scene of their former activ-
ities!' and so on. Conversely, anyone who has completely and
finally rid himself of animistic beliefs will be insensible to this
type of the uncanny. The most remarkable coincidences of wish
and fulfilment, the most mysterious repetition of similar experi-
ences in a particular place or on a particular date, the most
deceptive sights and suspicious noises—none of these things will
disconcert him or raise the kind of fear which can be described
as 'a fear of something uncanny'. The whole thing is purely an
affair of 'reality-testing', a question of the material reality of the
phenomena.[1]

The state of affairs is different when the uncanny proceeds
from repressed infantile complexes, from the castration com-
plex, womb-phantasies, etc.; but experiences which arouse this
kind of uncanny feeling are not of very frequent occurrence in
real life. The uncanny which proceeds from actual experience
belongs for the most part to the first group [the group dealt with
in the previous paragraph]. Nevertheless the distinction be-
tween the two is theoretically very important. Where the

[1] Since the uncanny effect of a 'double' also belongs to this same
group it is interesting to observe what the effect is of meeting one's own
image unbidden and unexpected. Ernst Mach has related two such
observations in his *Analyse der Empfindungen* (1900, 3). On the first
occasion he was not a little startled when he realized that the face
before him was his own. The second time he formed a very unfavourable
opinion about the supposed stranger who entered the omnibus, and
thought 'What a shabby-looking school-master that man is who is
getting in!'—I can report a similar adventure. I was sitting alone in my
wagon-lit compartment when a more than usually violent jolt of the
train swung back the door of the adjoining washing-cabinet, and an
elderly gentleman in a dressing-gown and a travelling cap came in. I
assumed that in leaving the washing-cabinet, which lay between the
two compartments, he had taken the wrong direction and come into my
compartment by mistake. Jumping up with the intention of putting him
right, I at once realized to my dismay that the intruder was nothing but
my own reflection in the looking-glass on the open door. I can still
recollect that I thoroughly disliked his appearance. Instead, therefore,
of being *frightened* by our 'doubles', both Mach and I simply failed to
recognize them as such. Is it not possible, though, that our dislike of
them was a vestigial trace of the archaic reaction which feels the
'double' to be something uncanny?

uncanny comes from infantile complexes the question of material reality does not arise; its place is taken by psychical reality. What is involved is an actual repression of some content of thought and a return of this repressed content, not a cessation of *belief in the reality* of such a content. We might say that in the one case what had been repressed is a particular ideational content, and in the other the belief in its (material) reality. But this last phrase no doubt extends the term 'repression' beyond its legitimate meaning. It would be more correct to take into account a psychological distinction which can be detected here, and to say that the animistic beliefs of civilized people are in a state of having been (to a greater or lesser extent) *surmounted* [rather than repressed]. Our conclusion could then be stated thus: an uncanny experience occurs either when infantile complexes which have been repressed are once more revived by some impression, or when primitive beliefs which have been surmounted seem once more to be confirmed. Finally, we must not let our predilection for smooth solutions and lucid exposition blind us to the fact that these two classes of uncanny experience are not always sharply distinguishable. When we consider that primitive beliefs are most intimately connected with infantile complexes, and are, in fact, based on them, we shall not be greatly astonished to find that the distinction is often a hazy one.

The uncanny as it is depicted in *literature*, in stories and imaginative productions, merits in truth a separate discussion. Above all, it is a much more fertile province than the uncanny in real life, for it contains the whole of the latter and something more besides, something that cannot be found in real life. The contrast between what has been repressed and what has been surmounted cannot be transposed on to the uncanny in fiction without profound modification; for the realm of phantasy depends for its effect on the fact that its content is not submitted to reality-testing. The somewhat paradoxical result is that *in the first place a great deal that is not uncanny in fiction would be so if it happened in real life; and in the second place that there are many more means of creating uncanny effects in fiction than there are in real life.*

The imaginative writer has this licence among many others, that he can select his world of representation so that it either coincides with the realities we are familiar with or departs from them in what particulars he pleases. We accept his ruling in

every case. In fairy tales, for instance, the world of reality is left behind from the very start, and the animistic system of beliefs is frankly adopted. Wish-fulfilments, secret powers, omnipotence of thoughts, animation of inanimate objects, all the elements so common in fairy stories, can exert no uncanny influence here; for, as we have learnt, that feeling cannot arise unless there is a conflict of judgement as to whether things which have been 'surmounted' and are regarded as incredible may not, after all, be possible; and this problem is eliminated from the outset by the postulates of the world of fairy tales. Thus we see that fairy stories, which have furnished us with most of the contradictions to our hypothesis of the uncanny, confirm the first part of our proposition—that in the realm of fiction many things are not uncanny which would be so if they happened in real life. In the case of these stories there are other contributory factors, which we shall briefly touch upon later.

The creative writer can also choose a setting which though less imaginary than the world of fairy tales, does yet differ from the real world by admitting superior spiritual beings such as daemonic spirits or ghosts of the dead. So long as they remain within their setting of poetic reality, such figures lose any uncanniness which they might possess. The souls in Dante's *Inferno*, or the supernatural apparitions in Shakespeare's *Hamlet*, *Macbeth* or *Julius Caesar*, may be gloomy and terrible enough, but they are no more really uncanny than Homer's jovial world of gods. We adapt our judgement to the imaginary reality imposed on us by the writer, and regard souls, spirits and ghosts as though their existence had the same validity as our own has in material reality. In this case too we avoid all trace of the uncanny.

The situation is altered as soon as the writer pretends to move in the world of common reality. In this case he accepts as well all the conditions operating to produce uncanny feelings in real life; and everything that would have an uncanny effect in reality has it in his story. But in this case he can even increase his effect and multiply it far beyond what could happen in reality, by bringing about events which never or very rarely happen in fact. In doing this he is in a sense betraying us to the superstitiousness which we have ostensibly surmounted; he deceives us by promising to give us the sober truth, and then after all overstepping it. We react to his inventions as we would

have reacted to real experiences; by the time we have seen through his trick it is already too late and the author has achieved his object. But it must be added that his success is not unalloyed. We retain a feeling of dissatisfaction, a kind of grudge against the attempted deceit. I have noticed this particularly after reading Schnitzler's *Die Weissagung* [*The Prophecy*] and similar stories which flirt with the supernatural. However, the writer has one more means which he can use in order to avoid our recalcitrance and at the same time to improve his chances of success. He can keep us in the dark for a long time about the precise nature of the presuppositions on which the world he writes about is based, or he can cunningly and ingeniously avoid any definite information on the point to the last. Speaking generally, however, we find a confirmation of the second part of our proposition—that fiction presents more opportunities for creating uncanny feelings than are possible in real life.

Strictly speaking, all these complications relate only to that class of the uncanny which proceeds from forms of thought that have been surmounted. The class which proceeds from repressed complexes is more resistant and remains as powerful in fiction as in real experience, subject to one exception [see p. 252]. The uncanny belonging to the first class—that proceeding from forms of thought that have been surmounted— retains its character not only in experience but in fiction as well, so long as the setting is one of material reality; but where it is given an arbitrary and artificial setting in fiction, it is apt to lose that character.

We have clearly not exhausted the possibilities of poetic licence and the privileges enjoyed by story-writers in evoking or in excluding an uncanny feeling. In the main we adopt an unvarying passive attitude towards real experience and are subject to the influence of our physical environment. But the story-teller has a *peculiarly* directive power over us; by means of the moods he can put us into, he is able to guide the current of our emotions, to dam it up in one direction and make it flow in another, and he often obtains a great variety of effects from the same material. All this is nothing new, and has doubtless long since been fully taken into account by students of aesthetics. We have drifted into this field of research half involuntarily, through the temptation to explain certain instances which

contradicted our theory of the causes of the uncanny. Accordingly we will now return to the examination of a few of those instances.

We have already asked [p. 246] why it is that the severed hand in the story of the treasure of Rhampsinitus has no uncanny effect in the way that the severed hand has in Hauff's story. The question seems to have gained in importance now that we have recognized that the class of the uncanny which proceeds from repressed complexes is the more resistant of the two. The answer is easy. In the Herodotus story our thoughts are concentrated much more on the superior cunning of the master-thief than on the feelings of the princess. The princess may very well have had an uncanny feeling, indeed she very probably fell into a swoon; but *we* have no such sensations, for we put ourselves in the thief's place, not in hers. In Nestroy's farce, *Der Zerrissene* [*The Torn Man*], another means is used to avoid any impression of the uncanny in the scene in which the fleeing man, convinced that he is a murderer, lifts up one trap-door after another and each time sees what he takes to be the ghost of his victim rising up out of it. He calls out in despair, 'But I've only killed *one* man. Why this ghastly multiplication?' We know what went before this scene and do not share his error, so what must be uncanny to him has an irresistibly comic effect on us. Even a 'real' ghost, as in Oscar Wilde's *Canterville Ghost*, loses all power of at least arousing *gruesome* feelings in us as soon as the author begins to amuse himself by being ironical about it and allows liberties to be taken with it. Thus we see how independent emotional effects can be of the actual subject-matter in the world of fiction. In fairy stories feelings of fear—including therefore uncanny feelings—are ruled out altogether. We understand this, and that is why we ignore any opportunities we find in them for developing such feelings.

Concerning the factors of silence, solitude and darkness [pp. 246–7], we can only say that they are actually elements in the production of the infantile anxiety from which the majority of human beings have never become quite free. This problem has been discussed from a psycho-analytic point of view elsewhere.[1]

[1] [See the discussion of children's fear of the dark in Section V of the third of Freud's *Three Essays* (1905*d*), *Standard Ed.*, **7**, 224 *n.*]

Transgressed Boundaries, Potent Fusions and Dangerous Possibilities[1]

JEANNE RANDOLPH

At ten o'clock, after supper, the professor "would take a walk, with his wife, his sister-in-law, or, later on, with a daughter. Sometimes they would go to a café: in the summer the Café Landmann, in the winter the Café Central . . . On returning home he would retire at once to his study to concentrate . . . He was never in bed before one in the morning and often much later," until the fearful hours of the night.[2]

Free of any companion, he pauses at the massive doorway, grasps one of the handles for passage into his study. His unwavering gaze ignores the darkness as he takes the five steps necessary to reach his desk, whispering, *"In stiller Heimlichkeit, umzielt von engen Schranken."*[3] Once he is seated beside the only window, a white web of city lights is visible across his hands, across the moss-green blotter. At first, paradoxically, this illumination veils an alabaster, ovoid sphere: breathing yet bodiless, Osiris looms forward into a shadow. His glaucous, egg-shaped head is bigger than the professor's fist. Osiris then begins to gather the light; another five identical incarnations are distributed throughout the occluded study, enhancing, not diluting, the majesty of this divinity. Osiris is the god who waits for the verdict on a dead man's heart.

In a gesture of bravado the professor reaches past a globular stone paperweight, itself the eroded likeness of a decapitated Egyptian's face. A gentle ochre light appears, suffused from beneath a parchment lampshade, illuminating the features of the other deities who are now also gathering around The King of the Dead. Near the base of the lamp, a cachectic god steps up. His hat is shaped like two flattened forefingers as tall as his own gaunt legs. He is bare-chested, a bundled beard his only human adornment. Tonight he is a singular spirit, the fusion of two Demiurges, *Nether Wa*, an essence from Heliopolis; and Amun, from Thebes, a green faience idol on whose lap the priestess swoons.[4] Just in

front of this fused Amun-Re' stands sweet, voluptuous Bastet, whose lithe female body has the head and mind of a cat.

At a distance from Bastet's right hand is the ornamental lid of a canopic jar, the jars in which organs of the mummified dead were stored, lest they be stolen and used to cast spells. The heart is the only organ that will be left untouched in the mummy's corpse. The lid of this canopic jar is in the form of the head of Horus, son and avenger of Osiris. Suddenly Horus himself, the sky-god, flies up embodied as a falcon, and then he alights on the blotter. He stands clothed, as a human with the falcon's head. Horus it is who will usher the dead man closer to Osiris, to hear the verdict upon the dead man's heart: immortality, or into the jaws of the Devourer, hound of the underworld.[5] The professor reminisces: "I remember one anxiety dream from my seventh or eighth year . . . I saw my beloved mother, with a peculiarly peaceful, sleeping expression on her features, being carried into the room by two (or three) people with birds' beaks and laid upon the bed . . . strangely draped and unnaturally tall figures with birds' beak . . ."[6]

He remembers as well his childish recitation, "*Das ist as wahre Heimelig, wenn der Mensch so von Herzen fühlt, wie wenig er ist, wie groß der Herr ist.*"[7]

Of the six incarnations of Anubis in the room, the tiniest, with the most exquisite luminosity, is present on the desk. He moves toward the professor in colouration exactly as depicted on the New Kingdom, Nineteenth Dynasty papyrus *Book of the Dead of Hunefer*.[8] Anubis the jackal-headed, god of embalming, will lead the dead man to have his heart weighed and judged. During the weighing, the dead man will make an oath: "I have begun no evil against any man, I have ill-treated no beast . . . nor have I blasphemed . . ."[9]

The professor remembers his own words in a letter to his friend Putnam: "I have always behaved honorably, ready to spare others and to be kind wherever possible."[10] The professor reaches for his fountain pen, always in the same place, at the foot of a cast-iron pedestal. His hand almost unseats "One of the Sixty-Four,"who has taken the pedestal for a chair. The professor taps his pen, then lays it down and reflects, "So it was this interrogator-god's voiceless accusation that evoked my remembrance of the letter!"

Digging an old sheaf of papers out of a drawer without looking up, the professor knows the mummiform figure of Ptah has entered the study, this time without his wig. At the professor's sudden glance, Ptah halts, his left leg thrust forward "in the typical walking

pose, the arms parallel with the axis of the body, giving it the structure of an automaton. This is a typical attitude of the *Ka* . . . a funerary apparition belonging to the world of the dead."[11] "The Egyptians thought that in every human frame there dwelt a sort of double known as the *Ka* . . . [who] accompanied the individual both in life and in death . . . Recitation and inscription of the proper magical and religious formulæ were believed capable of imparting life to a *Ka* statue . . ."[12]

The jottings Freud pulled out of the drawer at that fearful hour of the night had lain there already six years, in a fractured state, hidden from view, amounting to no more than a jumble of "properties of persons, things, sense-impressions, experiences and situations."[13] Yet surely wrapped within these, an embodiment of Œdipal impulses might be uncovered, if only its form could be found. Even so, a scientific *Weltanschauung* always requires so much more: if a hypothesis is to become viable, medical science requires citations; without citations, it is clinically dead. Only "a slow, painful travail"[14] would revive it.

The final 1919 essay titled "The Uncanny" reads inelegantly. Indiscriminate conjunctions between hypotheses, possible evidence, and numerous illustrative digressions are just barely stitched together. Freud gives the reader Jentsch's vivid images and ideas in such detail that, unless times have changed more drastically than one could possibly comprehend, Freud's hypothesis about uncanny experiences is so layered and, ironically, familiar, that we offer much resistance. It is the insistence on the eyes, as repositories of the fear of castration, that is unconvincingly rote, too much like a lecture and not enough like a discovery. Freud's convoluted reprise of Otto Rank's psychoanalysis of the image of "the double," doesn't intrigue any curiosity, possibly because it is applied to an observed (Coppelius/Coppola) figure, rather than to any experience of one's own *doppelgänger*.

But how, in 1919 could Freud have possibly ever centred his apprehension of the uncanny on the one *Imago* he rarely explored? — the Maternal. Nor could Freud have imagined his own resistance to the first psychoanalyst who gave the maternal contribution priority in the infant's early experience. Within a decade of the publication of "The Uncanny," the discoveries of Melanie Klein (1882–1960), psychoanalyst of children, truly did lead psychoanalytic theory back to "what is known of old and long familiar"[15] — the mother-infant embrace. By 1929, Melanie Klein was demanding that pre-Œdipal, emotionally cataclysmic mother-infant predicaments be honoured in psychoanalysis. To the orthodox Freudian brethren, Melanie Klein was an apostate who required refutation. Perhaps, yet

again, in 1932,[16] Freud might have met Klein's challenge with a new, third version of his essay on the uncanny, but his heart was not in it. Refutation was left to his daughter Anna. A third version of "The Uncanny" would have had to drain Klein's theory of its vivacity. To do so, certain of Freud's speculative remarks would have needed disguising. To avoid any allusion to Klein's work, it is very likely that the following passage in particular would no longer remain in "The Uncanny" appended *en passant* to the lore of "the double":

"The other forms of ego-disturbance exploited by Hoffman . . . are a harking-back to particular phases in the evolution of the self-regarding feeling, a regression to a time when the ego had not yet marked itself off sharply from the external world and from other people. I believe that these factors are partly responsible for the impression of uncanniness, although it is not easy to isolate and determine exactly their share of it."[17]

What Freud had described as "the self-regarding feeling," later Kleinians would overtly term, in a kind of British existential baby-talk, "the Me." Also, the earliest maternal-infant couple would be emphasized as a relationship in which the mother was experienced as "an environment . . . that involves:

"1. Holding
2. Handling
3. Object-presenting."[18]

In 1919, all Freud could imagine was that this maternal environment was "not marked off sharply." For whatever reasons, however, both Freud and his daughter-avenger Anna refused to condone Klein's naming of the mother herself as the infant's "external world." Melanie Klein gave the mother her due, while Freud could only speak vaguely of "other people." For Freud, the maternal aspects of infant survival, the crucible of infantile identity, were "not easy to isolate and determine."

Like all monuments to the intellect, psychoanalytic theory has accreted slowly. Since 1919, neither automatons, computers, nor cyborgs have hurried psychoanalytic theory along that much. Another twenty-five years beyond Freud's death, the object relations branch of psychoanalysis (Melanie Klein developed the seeds, D.W. Winnicott became its most brilliant gardener) elaborated upon their origin myth of the "Me and the Not-Me." Before Œdipal dread, so they would say, the very first encounter with the Not-Me ushers in the possibility of hovering between living and the dead.

[1] This phrase is from Donna Haraway, "A Cyborg Manifesto: Science, Technology, and Socialist-Feminism in the Late Twentieth Century," *Simians, Cyborgs and Women: The Reinvention of Nature* (New York: Routledge, 1991), 154. [2] Ernest Jones, *The Life and Work of Sigmund Freud*, ed. Lionel Trilling and Steven Marcus (New York: Basic Books, 1953), 358. [3] Sigmund Freud, "The Uncanny," *The Standard Edition of the Complete Psychological Works of Sigmund Freud*, tr. James Strachey (London: Hogarth Press, 1917–19), 253. [4] Boris de Rachewiltz, *Egyptian Art: An Introduction*, tr. R.H. Boothroyd (New York: The Viking Press, 1960), 118. [5] Hayes and Moon, *Ancient and Medieval History* (New York: Macmillan, 1957), 65–66. [6] Sigmund Freud, *The Interpretation of Dreams* (New York: Macmillan, 1933). [7] Freud, "The Uncanny," 254. [8] P.P. Kahane, *20,000 Years of World Painting* (New York: Henry N. Abrams, 1967), 68. [9] P.P. Kahane, 68. [10] Ernest Jones, 376. [11] Boris de Rachewiltz, 82–83. [12] Peter H. Brieger et al. *Art and Man Book One: ancient and medieval* (Toronto: Holt, Rinehart and Winston, 1964), 10. [13] "The Uncanny," 220. [14] Ernest Jones, 365. [15] "The Uncanny," 220. [16]. Klein published *The Psycho-Analysis of the Child* (London: Hogarth Press) in 1932. [17] "The Uncanny," 236. [18] D.W. Winnicott, *Playing and Reality* (Markham, Ontario: Penguin Books Canada, 1982), 130.

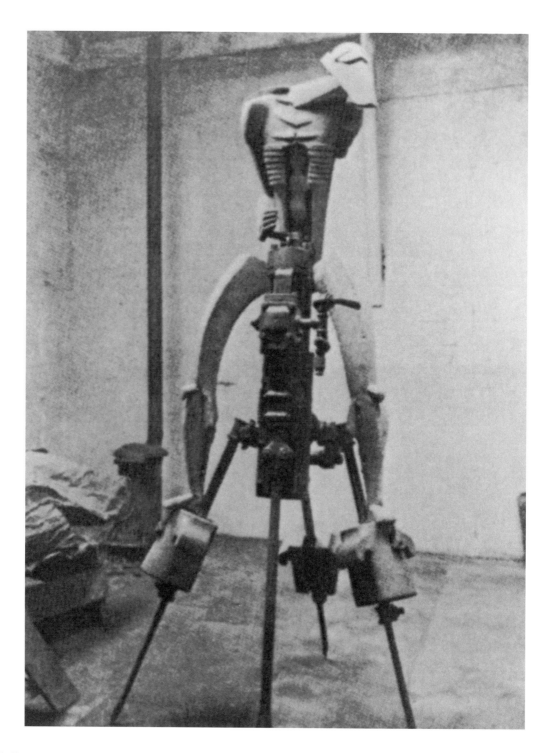

Jacob Epstein, *Rock Drill*, c. 1913.

Plaster and rock drill. Height in original state 205 cm.

Dismantled by artist in 1915.

Egoist Cyborgs

ALLAN ANTLIFF

for Richard Mock

In March 1915, the Vorticist sculptor Jacob Epstein exhibited one of early modernism's most well-known "cyborgs" — the *Rock Drill* (1913–15) — at London's Goupil Gallery. The work consisted of an ungainly rock drill on a tripod with a machine-like figure straddling it. Critical response was overwhelmingly negative: the sculpture was ridiculed as a "futurist abortion"; "unutterably loathsome"; and a "hideous thing."[1] Only one reviewer saw any merit, writing, "Mr. Epstein has accepted the rock drill . . . One can see how it fascinated him; the three long, strong legs, the compact assembly of cylinder, screws, and valve, with its control handles decoratively at one side, and especially the long, straight cutting drill like a proboscis — it all seems the naked expression of a definite force. Mounted upon it Mr. Epstein has set a figure of the spirit of the drill — an idea of what a man might be who existed only for rock drilling."[2]

Indeed, Epstein's creation was a stunning reworking of the human form on a machine's terms. The sharp angularity of the driller's legs, arms, and neck resembled metal girders, an effect accentuated by bolt-like knee caps and elbows. These features, combined with the heavily ridged chest and helmet-like head, transformed a being that was ostensibly human into a mechanistic extension of the drill and its menacing power to blast through solid rock. A barely formed fœtus sheltered inside the driller's chest cavity, completing, on a metaphorical level, the man-machine fusion.

Vorticism, which coalesced as a movement in 1913, was founded on a desire to liberate the artist from societal artistic conventions, notably, the imperative to imitate nature. Instead, the Vorticists developed a new means of expression, devoid of mimesis, in which formal abstraction prevailed over representation. To this end they seized on the angular,

hard-edged features of machinery and the industrial man-made environment. A case in point is Edward Wadsworth's painting, *Short Flight* (1914), which was derived from an ærial photograph. Taking this machine-dependent perspective as his starting point, Wadsworth merged a plane's whirling propeller with the landscape below and then abstracted the entire ensemble into a two-dimensional "composition of surfaces and masses."[3] Similarly, Epstein's *Rock Drill* was a three-dimensional creation extrapolated from the inorganic features of a machine, features that served as the foil for what was, in essence, an exercise in expressive formalism. In the words of Vorticism's leading critic, Ezra Pound, the work was admirable "not for the subject-matter, but for the creative power of the artist; for that which he is capable of adding to his subject from himself; or, in fact, his capability to dispense with external subjects altogether."[4]

The politics of the *Rock Drill*, therefore, resided primarily in the attainment of artistic freedom through a formalism keyed to modern industrialism. I call these politics "egoist" because the Vorticists were followers of Max Stirner, author of the anarchist polemic, *The Ego and its Own* (1845). Stirner argued that humanity's liberation could only be accomplished if all subservience to metaphysical concepts and social norms ended and each "individual ego" became self-determining and value-creating. "Self-realization of value" from oneself, he wrote, inevitably led to a "self-consciousness against the state" that enforced norms and values amenable to the rulers' interests. Stirner speculated a working-class revolution would usher in his brand of anarchism, because workers were an oppressed group who owed nothing to the reigning order and were therefore capable of realizing *en masse* the anti-statist egoistic consciousness of "intellectual vagabonds" such as himself. From the onset, the Vorticists politicized their æsthetics in Stirnerist terms, arguing abstraction was a means of realizing unfettered "egoism" in art. And, in keeping with Stirner's prognosis for revolution, they aligned Vorticism with working-class revolution. Typical of this rhetoric was Pound's assertion that the "combative energy" of Wyndham Lewis's abstract composition, *Timon of Athens* (1914) paralleled the struggle of "labour and anarchy" against "capital and government"—a reference to the surge in anarchist-led strikes that proceeded the British declaration of war in early August, 1914.[5]

World War I, of course, destroyed this heady combination of artistic individualism and anarchist revolution. The vast majority of the populace fell in line with the command structures of the state, and the Vorticists suddenly faced the horrific reality of a

Edward Wadsworth, *A Short Flight*, c. 1914.

Reproduced in *Blast* #1 (July 1914).

Medium and dimensions unknown.

Wyndham Lewis, *A Battery Shelled*, 1919.
Oil on canvas, 182.7 x 317.7 cm.
Imperial War Museum, London (2748).

war machine capable of mobilizing and chewing up thousands in a single day. Industrial society, which had once served as the foil for abstraction, now threatened the anarchist politics of individualism out of which the Vorticist æsthetic was constituted. The artists' response was to turn this æsthetic's meaning on its head, transforming abstraction from the index of anarchic freedom into a sign of alienation from the society of total war. Commissioned as a war artist, Lewis, for example, took to portraying soldiers in the field as machine-like creatures who have lost all semblance of humanity.[6] The more dehumanized their appearance, the more divorced they are from free agency and independent initiative. Thus, in *A Battery Shelled* (1919), Lewis depicts troops under attack as mechanistic abstractions, devoid of any distinguishing qualities, that react to their predicament on instinct. This makes for a telling contrast with the three soldiers observing the salvo, who retain their individuality — at least for the moment. However, they too wear the uniforms that mark them as the state's militarized automata — "war material" "manufactured" by women to feed the maw of "endless unabating murder."[7]

Epstein also underwent a profound change. As we have seen, the *Rock Drill* was originally conceived as an unproblematic Vorticist abstraction from the man-made and industrial. In early 1915, when it was first exhibited, Epstein still thought of the sculpture in these terms, however, as the conflict dragged on, his attitude changed.[8] The driller became, for him, a "sinister figure" symbolizing "the terrible Frankenstein's monster we have made ourselves into."[9] Seeking to communicate the horror of his realization, Epstein dismantled the *Rock Drill*, leaving the truncated torso that survives today (p. 132). The once powerful driller was reduced to a mutilated body fragment with its controlling arm lobbed off at the elbow: spewed up from the trenches, it regained its humanity at the price of becoming a war victim.

Under threat of war, therefore, the Vorticist cyborg metamorphosed, from an æsthetic exercise in individualistic egoism into the embodiment of the depersonalizing forces of industrialism and authoritarianism marshalled by the modern state to prosecute war. Individualism was defended, however the defence was rearguard, and it was conducted in a spirit of profound pessimism.

While England's Vorticists mounted their anti-war critique, the Franco-Spanish artist Francis Picabia spearheaded a second variation of the "cyborg" in New York. Picabia was a Paris-based painter who first visited America's greatest metropolis in January–April 1913

to promote his career on the occasion of a spectacular large-scale exhibition of European modernism, the Armory Show. As fate would have it, he was then undergoing a transition very similar to the Vorticists. Know as a Cubist, he decided while in New York to reject that style. In its stead he resolved to "express the mysterious feelings of his ego" in free-flowing abstractions devoid of pictorial referents.[10]

Picabia's terminology suggests Stirner was on his mind and, in fact, he was already familiar with Stirner's philosophy prior to his New York excursion.[11] Picabia was a rebellious individual with an arch sense of humour who engaged in extramarital affairs and excessive drug taking. These predilections undoubtedly made him receptive to anarchist libertarianism, particularly in the realm of morality.[12] Appropriately, his first full-scale exercise in "egoist" iconoclasm poked fun at a Dominican priest whom he had witnessed during the sea voyage back to Paris furtively watching the rehearsals of an exotic dancer, Stacia Napierkowska. The imposing 302 x 300.5 cm composition, *Edtaonist (ecclésiastique)*, exhibited at the Salon d'Automne in November 1913, fused impressions of the "rhythm of the dancer, the beating heart of the clergyman, the bridge [of the ocean-liner] . . . and the immensity of the ocean" rendered as form and colour.[13] Rooted in bodily sensations, the painting played havoc with artistic conventions and the priest's vow of chastity.[14] Thus Picabia brought the moral cornerstone of Catholicism into disrepute while at the same time leaving the critics dumb-struck before one of modernism's earliest examples of full-blown abstraction.[15]

When World War I broke out, Picabia initially avoided the trenches by arranging enlistment as a chauffeur for a French general behind the lines, first at Bordeaux and then Paris. Feeling increasingly endangered by the war's progression (Picabia was deemed fit for the infantry), he next secured an assignment as an army purchasing agent and was sent overseas in the summer of 1915 to procure supplies in the Caribbean.[16] Promptly abandoning the mission upon reaching New York in June 1915, Picabia plunged into the local art scene with a mechanomorphic drawing, *Fille née sans mère* [Girl Born Without a Mother] (1915), published in the short-lived (March 1915–January 1916) New York art journal, *291*. This loosely sketched depiction of rods and springs erupting in ill-defined activity filled an entire page of *291*'s June 1915 issue and was followed, in July–August, by a number of meticulously executed machine "portraits," including a drawing of a spark plug entitled, *D'une jeune fille américaine dans l'état de nudité* [Young American Girl in a State of Nudity] (1915, p. 53). Asked to comment on his work, Picabia related that, inspired by "the vast

mechanical development of America," he had "enlisted the machinery of the modern world, and introduced it into my studio." "The machine," he asserted, is "more than a mere adjunct to life. It is really a part of human life—perhaps the very soul."[17]

Ascribing such significance to machines underlines the multifaceted complexity of Picabia's egoistic "cyborg." A portrait is an artistic exercise intended to capture the sitter's features and personality, but the *D'une jeune fille* was completely art-less. This was a diagrammatically drawn spark plug—the sort of thing one could find in any auto-parts catalogue, newspaper, or magazine advertisement.[18] However, if it was advertising, what of the content? Stripped of art's aura, the patina of beauty encapsulated by the "state of nudity" became something else: a marketing ploy. As such, it invited a cascade of accusations—Pornography! Obscenity! Prostitution!—that were all too familiar in the United States, where a veritable army of censors combed everything from high art reproductions to pulp fiction in a drive to repress the mass marketing of "vice."[19] Picabia's *Portrait* exposed the puritanical grease facilitating the capitalization of sex for profit at the same time as he asserted his own creative licence. Success in American terms, after all, *demanded* good advertising, even, if you will, in "art."[20] Hence the shameless quality of the young girl's "state of nudity" with its standard manufacturer's guarantee—FOREVER—of flawless sexual performance in perpetuity.[21]

A second portrait gracing the cover of *291* (p. 133) addressed a more hermetic theme. Here Picabia depicted a broken camera with lens extended, whose bellows has become detached from the armature and is collapsing. Attached to the side of the camera is an automobile brake set in park and a gearshift resting in neutral. The camera lens strains toward a slogan "Ideal" printed above it in Gothic script while beside the apparatus is stencilled, "Ici, c'est ici Stieglitz. Foi et Amour" [Here, This is Stieglitz/Faith and Love]. The protagonist of this work was the American photographer Alfred Stieglitz, whom Picabia had befriended during his first New York excursion in 1913.[22] Stieglitz had a long history of opposing modernism's commercialization, which he feared would compromise the artist's creative integrity. For over a decade he had run a non-commercial gallery of "experimental art" at 291 Fifth Avenue where New Yorkers could gain exposure to modern photography, sculpture, and painting and, if Stieglitz deemed them sincere in their admiration, purchase a work for prices that varied widely according to the means of the admirer and other considerations.[23] Picabia had exhibited in this gallery and was intimately familiar with its workings.[24] So too was Maurice de Zayas, editor of *291* and another friend

from Picabia's earlier sojourn.[25] Indeed, de Zayas had named his journal after Stieglitz's gallery to signal his allegiance to the latter's ideals, however in the summer of 1915 he was rethinking his position.

De Zayas saw a need for a more conventional approach to running Stieglitz's gallery, believing modernists of quality could maintain their independence regardless of comercial pressures if their art was effectively promoted by sympathetic professionals who respected their freedom and paid them well for sales.[26] When Picabia arrived in New York he joined the debate on the side of de Zayas and as a result a rift developed, with Stieglitz on the one side and Picabia and de Zayas on the other. By July, de Zayas had decided to usurp the pre-eminence of *291* and embark on a new venture, to be located in mid-town Manhattan and christened the "Modern Gallery" (the gallery was eventually established in October 1915).[27] Exasperated by Stieglitz's continuing hostility toward the project, Picabia and de Zayas decided to call him to account in the pages of *291*. The machine portrait on the cover of the July–August issue was Picabia's way of thumbing his nose at the photographer, suggesting Stieglitz's efforts to popularize modernism on his terms were as exhausted as the broken camera. There was also a tweak at propriety: the sagging bellows resemble a slackened and impotent penis, incapable of achieving an erection.

From 1915 until September 1917, Picabia divided his time between New York and Barcelona, Spain, an exile broken by one perfunctory visit to Cuba to keep the French authorities at bay. Plagued by several nervous breakdowns, estrangement from his wife, and the threat of court marshal for desertion after the U.S. joined the war in the summer of 1917, he relocated to Europe, moving from Spain to Switzerland, where he participated in Dada-related activities before returning to Paris in March 1919.

During this period his temperament became more biting and caustic; he produced a wide range of "cyborgs" mocking the industrial-capitalist commodification of humanity, many of which were reproduced in his privately-printed journal, *391*.[28] *Universal Prostitution* (1916–17) encapsulates the tenure of this work. An upright "male" machine exchanges an electrical charge with a prone "female" mechanism labelled "ideological feminine sex." Simultaneously a string of abbreviated declarations — "to bring together . . . to ignore . . . the human body" — broadcasts from the "male's" penile projectile. Love-making, mechanized, has been divorced from corporeal experience and prostituted under capitalism's ideological banner of universal exchange value.

Francis Picabia, *Hermaphrodisme*, c. 1918. From *Poèmes et dessins de la fille née sans mère* (Lausanne, Switzerland: Imprimeries, 1918). Off-set lithography on wove paper, 23.5 x 15.5 cm. © Estate of Francis Picabia/ADAGP (Paris)/SODRAC (Montreal) 2001.

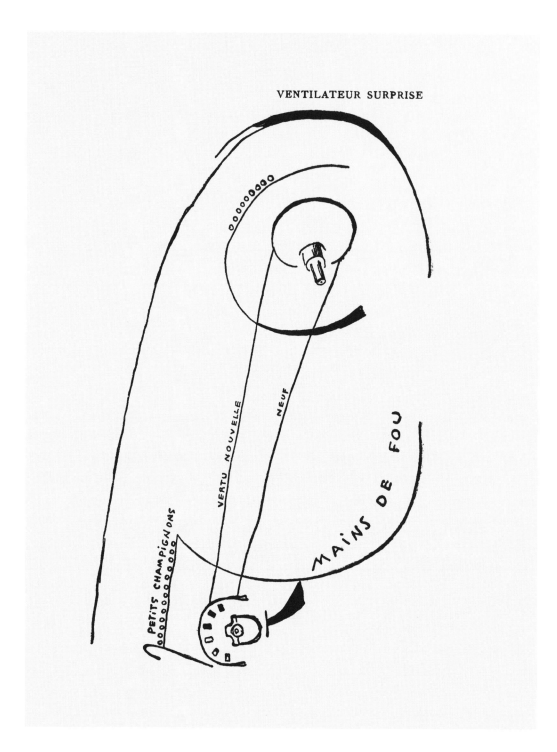

Francis Picabia, *Ventilateur Surprise*, c.1918. From *Poèmes et dessins de la fille née sans mère* (Lausanne, Switzerland: Imprimeries, 1918). Off-set lithography on wove paper, 23.5 x 15.5 cm. ©Estate of Francis Picabia/ADAGP (Paris)/SODRAC (Montreal) 2001.

But what of the war? In 1918 Picabia published a book, *Poèmes et desssins de la fille née sans mère* [Poems and Drawings for a Girl Born Without a Mother], to mark his tumultuous exile.[29] Disturbing and enigmatic machine images — *Machines sans but* [Machines Without a Purpose]; *Hermaphrodisme* [Hermaphroditism]; *Ventilateur Surprise* [Ventilator Surprise] — accompanied poems suffused with melancholy, including "Wireless":

> "My malady listens to my heart
> Closed button of lost joys
> I wish impishly to grow gloomy in the arms
> Of my pretty mother
> Memory of blue sky
> Where I could have snuggled up
> One must try to forget everything
> The agony of the world in vertigo
> Heroes who spin the hideous waltzes of the war
> In the atmosphere enigmatic
> And masked."[30]

Picabia's cyborgs had evolved, if only through juxtaposition, from ciphers of humanity's capitalization into a nightmarish echo of the war he longed to escape from.[31]

After returning to Paris, Picabia was at the forefront of the Dada movement, slinging mud at militarism, capitalism and the French cultural establishment.[32] However, during the 1920s his free-wheeling iconoclasm grew out of step with Marxist demands for a class-oriented art. Ever the individualist, he responded by retreating from the fray, leaving behind a scattering of cyborgs — the mute signatories of past engagements.[33]

[1] The critics' comments are cited in Richard Cork, *Vorticism 2: Synthesis and Decline* (Berkeley, California, and Los Angeles: University of California Press, 1976), 476. [2] *Manchester Guardian*, 15 March, 1915, 3 cited in Cork, 476. [3] Henri Gaudier-Brzeska, "Allied Artists' Association Ltd.," *The Egoist* 1 (15 June, 1914), 228. [4] Ezra Pound, "Affirmations III. Jacob Epstein," *The New Age* 16 (21 January, 1915), 311. [5] See my discussion of Stirner and Vorticism in *Anarchist Modernism: Art, Politics, and the First American Avant-Garde* (Chicago: University of Chicago Press, 2001), 74–79. Over the years 1910–14, anarchists in the United Kingdom union movement

were at the forefront of a dramatic rise in labour unrest which saw strike actions grow from 531 to 1,497 in 1913. Only the war shut down this militancy, which was linked to an anarchist union-based program ("syndicalism") of defeating capitalism through a general strike in which workers would seize the means of production and replace the state a with a federal system of local governance, with communal management at the point of production. See John Quail, *The Slow Burning Fuse* (London: Granada Publishing, 1978), 255–284; 319–320. **6** Tom Normand, "Wyndham Lewis, the Anti-War Artist," *Wyndham Lewis and the Art of Modern War* ed. Peter Corbett (Cambridge, Massachusetts: Cambridge University Press, 1998), 52. **7** I am paraphrasing Wyndham Lewis's comments on the war in "The European War and the Great Communities," *Blast* no. 2 (July, 1915), 16. **8** Cork, 479. **9** Jacob Epstein, *Let There be Sculpture* (New York: G.P. Putnam's Sons, 1940), 49. **10** Francis Picabia cited in William A. Camfield, *Francis Picabia: His Art, Life and Times* (Princeton, New Jersey: Princeton University Press, 1979), 51. **11** Marcel Duchamp was immersed in Stirner's philosophy in the summer of 1912 and likely discussed it with Picabia during a trip to Jura, France in October of that year, just prior to Picabia's trip to the United States. See Camfield, 35. On Stirner's influence on Duchamp at this juncture see Francis M. Naumann, "Marcel Duchamp: A Reconciliation of Opposites," *Marcel Duchamp: Artist of the Century*, Rudolf E. Kuenzli and Francis M. Naumann, eds. (Cambridge, Massachusetts: MIT Press, 1990), 29–32. **12** In 1913 Picabia signed a petition circulated by a Stirnerist-oriented artists' collective—the Artistocrats—which condemned the French government's censorship of a monument to the early 20th-century's most notorious homosexual, Oscar Wilde. The monument was carved by Jacob Epstein and featured prominent genitalia. Several Vorticists also signed the petition. See Mark Antliff, "Cubism, Futurism, Anarchism: The 'Æstheticism' of the Action d'art Group, 1906–1920," *Oxford Art Journal* no. 21 (1998), 109. **13** This is the description of the painting given by Picabia's friend, Georges Isarlov, cited in Camfield, 61. **14** The fusion of mind and body was a central tenet of Stirner's refutation of the "soul," a concept that fostered self-alienation and the suppression of corporal inclinations by institutions such as the church. See Antliff, *Anarchist Modernism*, 77. **15** The critical reception is discussed in Camfield, 59. **16** Ibid, 71. **17** "French Artists Spur on an American Art," *New York Tribune*, October 24, 1915, 2. **18** William Innes Homer has traced Picabia's advertisement sources. See William Innes Homer, "Picabia's 'Jeune fille américaine dans l'é tat de nudité' and Her Friends," *Art Bulletin* 58 (March 1975), 110–115. **19** I explore this issue in my book-in-progress, *Reconfiguring New York Dada*. **20** In the same issue *291*'s editor, Maurice de Zayas, commented that art could only succeed in the United States if it adopted the features of commercialism and then praised Picabia for inventing such an art. See Maurice de Zayas, "New York At First Did Not See," *291* nos. 5–6 (July–August 1915), n.p. **21** The distinctively American stamp of the *Young Girl's* sexuality would have been transparent for those in the *291* circle who were familiar with the satirical (and certainly by United States standards obscene) novel *The Supermale* (1902), penned by the Parisian anarchist Alfred Jarry. The book tells the story of an American scientist who creates a "perpetual motion food" which will allow for, among other things, non-stop sex. The

scientist's young daughter—"a little slip of a girl"—achieves the same results through sheer force of will with a machine-like "supermale," André Marcueil. Eventually Marcueil, who is abnormally lacking in emotion, dies while hooked up to another invention, the love-inspiring machine. See Alfred Jarry, *The Supermale* trans. Ralph Gladstone and Barbara Wright (New York: New Directions, 1964). Picabia's drawing plays off Jarry's satire, but also takes aim at the state repression of sex—a central concern of anarchists in France and the United States. [22] Richard Whelan, *Alfred Stieglitz: A Biography* (New York: Little, Brown, 1995), 320. [23] Antliff, *Anarchist Modernism*, 32–33. [24] Stieglitz staged exhibitions of Picabia's work in March–April, 1913 and again in January, 1915. See Camfield, 51, 68. [25] Camfield, 42. [26] Maurice de Zayas, *How, When, and Why Modern Art Came to New York*, Francis M. Naumann, ed. (Cambridge: Massachusetts: MIT Press, 1996), 90. I discuss the exploitive pressures on American modernists and various attempts to overcome them in *Anarchist Modernism*, 24, 32–33, 54–55. [27] Whelan, 348–349. [28] *391* was published from 1917 to 1924. [29] Francis Picabia, *Poèmes et dessins de la fille née sans mère* (Lausanne, Switzerland: Imprimeries Réunies, 1918). [30] Francis Picabia, "Télégraphie sans fils," *Poèmes et dessins*, 69. [31] At the time Picabia was undergoing treatment for a dual addiction to cocaine and alcohol—the likely "malady" that had once serviced his escape into an infantile state of contentment and security. [32] The "Dada Cannibalistic Manifesto," in which Picabia berates the bourgeoisie for treating money as a God while mindlessly defending the nationalism that had brought nothing but "Death! Death! Death!," typifies his post-war polemics. The manifesto was first read publicly in Paris in March, 1920 and later reprinted in the *Dada Almanac* (1920). See Francis Picabia, "Dada Cannibalistic Manifesto," *Dada Almanac*, Richard Huelsenbeck, ed. (London: Atlas Press, 1993), 55–56. [33] In the mid-1920s, Picabia moved to the south of France and distanced himself decisively from political controversy. See Camfield, 221–222.

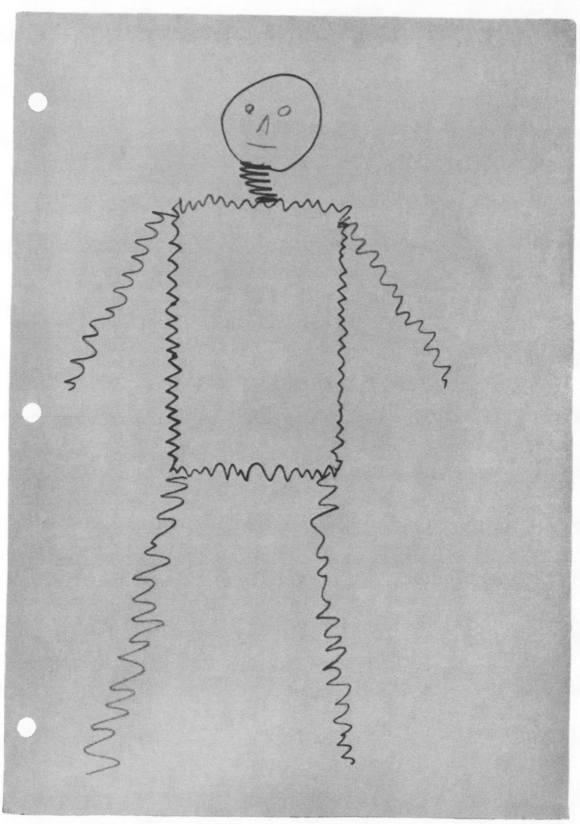

EARLY SELF-PORTRAIT by Joey shows a robot made of electrical wires. The figure symbolizes the child's rejection of human feelings. Reared by his parents in an utterly impersonal manner, he denied his own emotions because they were unbearably painful.

Joey: A "Mechanical Boy"

A case history of a schizophrenic child who converted himself into a "machine" because he did not dare be human. His story sheds light on emotional development in a mechanized society

by Bruno Bettelheim

Joey, when we began our work with him, was a mechanical boy. He functioned as if by remote control, run by machines of his own powerfully creative fantasy. Not only did he himself believe that he was a machine but, more remarkably, he created this impression in others. Even while he performed actions that are intrinsically human, they never appeared to be other than machine-started and executed. On the other hand, when the machine was not working we had to concentrate on recollecting his presence, for he seemed not to exist. A human body that functions as if it were a machine and a machine that duplicates human functions are equally fascinating and frightening. Perhaps they are so uncanny because they remind us that the human body can operate without a human spirit, that body can exist without soul. And Joey was a child who had been robbed of his humanity.

Not every child who possesses a fantasy world is possessed by it. Normal children may retreat into realms of imaginary glory or magic powers, but they are easily recalled from these excursions. Disturbed children are not always able to make the return trip; they remain withdrawn, prisoners of the inner world of delusion and fantasy. In many ways Joey presented a classic example of this state of infantile autism.

At the Sonia Shankman Orthogenic School of the University of Chicago it is our function to provide a therapeutic environment in which such children may start life over again. I have previously described in this magazine the rehabilitation of another of our patients ["Schizophrenic Art: A Case Study"; SCIENTIFIC AMERICAN, April, 1952]. This time I shall concentrate upon the illness, rather than the treatment. In any age,

when the individual has escaped into a delusional world, he has usually fashioned it from bits and pieces of the world at hand. Joey, in his time and world, chose the machine and froze himself in its image. His story has a general relevance to the understanding of emotional development in a machine age.

Joey's delusion is not uncommon among schizophrenic children today. He wanted to be rid of his unbearable humanity, to become completely automatic. He so nearly succeeded in attaining this goal that he could almost convince others, as well as himself, of his mechanical character. The descriptions of autistic children in the literature take for their point of departure and comparison the normal or abnormal human being. To do justice to Joey I would have to compare him simultaneously to a most inept infant and a highly complex piece of machinery. Often we had to force ourselves by a conscious act of will to realize that Joey was a child. Again and again his acting-out of his delusions froze our own ability to respond as human beings.

During Joey's first weeks with us we would watch absorbedly as this at once fragile-looking and imperious nine-year-old went about his mechanical existence. Entering the dining room, for example, he would string an imaginary wire from his "energy source"—an imaginary electric outlet—to the table. There he "insulated" himself with paper napkins and finally plugged himself in. Only then could Joey eat, for he firmly believed that the "current" ran his ingestive apparatus. So skillful was the pantomime that one had to look twice to be sure there was neither wire nor outlet nor plug. Children and members of our staff spontaneously avoided stepping on the

"wires" for fear of interrupting what seemed the source of his very life.

For long periods of time, when his "machinery" was idle, he would sit so quietly that he would disappear from the focus of the most conscientious observation. Yet in the next moment he might be "working" and the center of our captivated attention. Many times a day he would turn himself on and shift noisily through a sequence of higher and higher gears until he "exploded," screaming "Crash, crash!" and hurling items from his ever present apparatus—radio tubes, light bulbs, even motors or, lacking these, any handy breakable object. (Joey had an astonishing knack for snatching bulbs and tubes unobserved.) As soon as the object thrown had shattered, he would cease his screaming and wild jumping and retire to mute, motionless nonexistence.

Our maids, inured to difficult children, were exceptionally attentive to Joey; they were apparently moved by his extreme infantile fragility, so strangely coupled with megalomaniacal superiority. Occasionally some of the apparatus he fixed to his bed to "live him" during his sleep would fall down in disarray. This machinery he contrived from masking tape, cardboard, wire and other paraphernalia. Usually the maids would pick up such things and leave them on a table for the children to find, or disregard them entirely. But Joey's machine they carefully restored: "Joey must have the carburetor so he can breathe." Similarly they were on the alert to pick up and preserve the motors that ran him during the day and the exhaust pipes through which he exhaled.

How had Joey become a human machine? From intensive interviews with his parents we learned that the process had begun even before birth. Schizo.

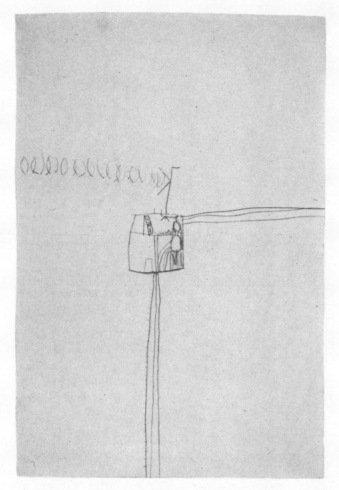

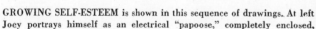

GROWING SELF-ESTEEM is shown in this sequence of drawings. At left Joey portrays himself as an electrical "papoose," completely enclosed, suspended in empty space and operated by wireless signals. In center drawing his figure is much larger, though

phrenia often results from parental rejection, sometimes combined ambivalently with love. Joey, on the other hand, had been completely ignored.

"I never knew I was pregnant," his mother said, meaning that she had already excluded Joey from her consciousness. His birth, she said, "did not make any difference." Joey's father, a rootless draftee in the wartime civilian army, was equally unready for parenthood. So, of course, are many young couples. Fortunately most such parents lose their indifference upon the baby's birth. But not Joey's parents. "I did not want to see or nurse him," his mother declared. "I had no feeling of actual dislike—I simply didn't want to take care of him." For the first three months of his life Joey "cried most of the time." A colicky baby, he was kept on a rigid four-hour feeding schedule, was not touched unless neces-

sary and was never cuddled or played with. The mother, preoccupied with herself, usually left Joey alone in the crib or playpen during the day. The father discharged his frustrations by punishing Joey when the child cried at night.

Soon the father left for overseas duty, and the mother took Joey, now a year and a half old, to live with her at her parents' home. On his arrival the grandparents noticed that ominous changes had occurred in the child. Strong and healthy at birth, he had become frail and irritable; a responsive baby, he had become remote and inaccessible. When he began to master speech, he talked only to himself. At an early date he became preoccupied with machinery, including an old electric fan which he could take apart and put together again with surprising deftness.

Joey's mother impressed us with a fey

quality that expressed her insecurity, her detachment from the world and her low physical vitality. We were struck especially by her total indifference as she talked about Joey. This seemed much more remarkable than the actual mistakes she made in handling him. Certainly he was left to cry for hours when hungry, because she fed him on a rigid schedule; he was toilet-trained with great rigidity so that he would give no trouble. These things happen to many children. But Joey's existence never registered with his mother. In her recollections he was fused at one moment with one event or person; at another, with something or somebody else. When she told us about his birth and infancy, it was as if she were talking about some vague acquaintance, and soon her thoughts would wander off to another person or to herself.

still under wireless control. At right he is able to picture the machine which controls him, and he has acquired hands with which he can manipulate his immediate environment.

When Joey was not yet four, his nursery school suggested that he enter a special school for disturbed children. At the new school his autism was immediately recognized. During his three years there he experienced a slow improvement. Unfortunately a subsequent two years in a parochial school destroyed this progress. He began to develop compulsive defenses, which he called his "preventions." He could not drink, for example, except through elaborate piping systems built of straws. Liquids had to be "pumped" into him, in his fantasy, or he could not suck. Eventually his behavior became so upsetting that he could not be kept in the parochial school. At home things did not improve. Three months before entering the Orthogenic School he made a serious attempt at suicide.

To us Joey's pathological behavior seemed the external expression of an overwhelming effort to remain almost nonexistent as a person. For weeks Joey's only reply when addressed was "Bam." Unless he thus neutralized whatever we said, there would be an explosion, for Joey plainly wished to close off every form of contact not mediated by machinery. Even when he was bathed he rocked back and forth with mute, engine-like regularity, flooding the bathroom. If he stopped rocking, he did this like a machine too; suddenly he went completely rigid. Only once, after months of being lifted from his bath and carried to bed, did a small expression of puzzled pleasure appear on his face as he said very softly: "They even carry you to your bed here."

For a long time after he began to talk he would never refer to anyone by name, but only as "that person" or "the little person" or "the big person." He was un-

able to designate by its true name anything to which he attached feelings. Nor could he name his anxieties except through neologisms or word contaminations. For a long time he spoke about "master paintings" and "a master painting room" (*i.e.*, masturbating and masturbating room). One of his machines, the "criticizer," prevented him from "saying words which have unpleasant feelings." Yet he gave personal names to the tubes and motors in his collection of machinery. Moreover, these dead things had feelings; the tubes bled when hurt and sometimes got sick. He consistently maintained this reversal between animate and inanimate objects.

In Joey's machine world everything, on pain of instant destruction, obeyed inhibitory laws much more stringent than those of physics. When we came to know him better, it was plain that in his moments of silent withdrawal, with his machine switched off, Joey was absorbed in pondering the compulsive laws of his private universe. His preoccupation with machinery made it difficult to establish even practical contacts with him. If he wanted to do something with a counselor, such as play with a toy that had caught his vague attention, he could not do so: "I'd like this very much, but first I have to turn off the machine." But by the time he had fulfilled all the requirements of his preventions, he had lost interest. When a toy was offered to him,

he could not touch it because his motors and his tubes did not leave him a hand free. Even certain colors were dangerous and had to be strictly avoided in toys and clothing, because "some colors turn off the current, and I can't touch them because I can't live without the current."

Joey was convinced that machines were better than people. Once when he bumped into one of the pipes on our jungle gym he kicked it so violently that his teacher had to restrain him to keep him from injuring himself. When she explained that the pipe was much harder than his foot, Joey replied: "That proves it. Machines are better than the body. They don't break; they're much harder and stronger." If he lost or forgot something, it merely proved that his brain ought to be thrown away and replaced by machinery. If he spilled something, his arm should be broken and twisted off because it did not work properly. When his head or arm failed to work as it should, he tried to punish it by hitting it. Even Joey's feelings were mechanical. Much later in his therapy, when he had formed a timid attachment to another child and had been rebuffed, Joey cried: "He broke my feelings."

Gradually we began to understand what had seemed to be contradictory in Joey's behavior—why he held on to the motors and tubes, then suddenly de-

MACHINE-LIKE CONSTRUCTIONS controlled Joey's life. Shown here is the apparatus he built to "live him" as he slept. Other "machines" controlled his eating and elimination.

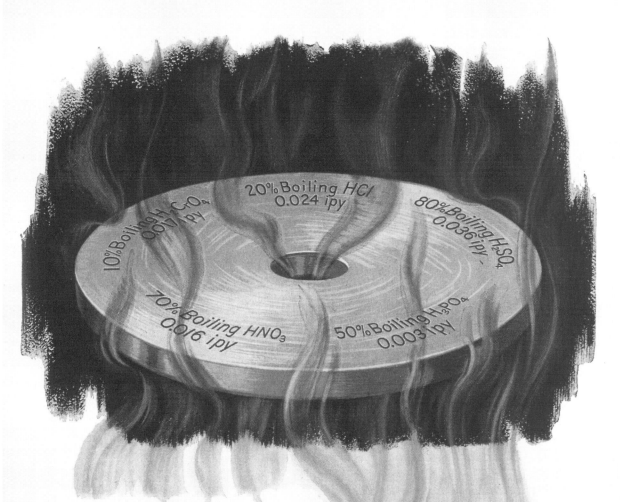

Corrosion from boiling mineral acids?

TEST "HAYNES" ALLOYS

The low corrosion rates on the test specimen indicate the remarkable resistance of HAYNES alloys to mineral acids . . . even at the boiling point. These alloys reduce corrosion damage and product contamination from mineral acids at all temperatures. You will find, too, that they have outstanding resistance to chlorides, halogens, mixed acids, and alkalies.

The penetration rates shown on the disks were obtained as a result of laboratory tests. How closely will they match up with data obtained under actual operating conditions? You can find out for sure by testing them.

We'll be glad to send you samples. But to narrow down the number, we suggest you send us a letter outlining your corrosion problem. For full information on HAYNES corrosion-resistant alloys, their properties, forms, the corrosives they will resist, ask for a copy of our 104-page book.

HAYNES ALLOYS
HAYNES STELLITE COMPANY

Division of
Union Carbide Corporation
Kokomo, Indiana

The terms "Haynes" and "Union Carbide" are registered trade-marks of Union Carbide Corporation.

ELABORATE SEWAGE SYSTEM in Joey's drawing of a house reflects his long preoccupation with excretion. His obsession with sewage reflected intense anxieties produced by his early toilet-training, which was not only rigid but also completely impersonal.

stroyed them in a fury, then set out immediately and urgently to equip himself with new and larger tubes. Joey had created these machines to run his body and mind because it was too painful to be human. But again and again he became dissatisfied with their failure to meet his need and rebellious at the way they frustrated his will. In a recurrent frenzy he "exploded" his light bulbs and tubes, and for a moment became a human being—for one crowning instant he came alive. But as soon as he had asserted his dominance through the self-created explosion, he felt his life ebbing away. To keep on existing he had immediately to restore his machines and replenish the electricity that supplied his life energy.

What deep-seated fears and needs underlay Joey's delusional system? We were long in finding out, for Joey's preventions effectively concealed the se-cret of his autistic behavior. In the meantime we dealt with his peripheral problems one by one.

During his first year with us Joey's most trying problem was toilet behavior. This surprised us, for Joey's personality was not "anal" in the Freudian sense; his original personality damage had antedated the period of his toilet-training. Rigid and early toilet-training, however, had certainly contributed to his anxieties. It was our effort to help Joey with this problem that led to his first recognition of us as human beings.

Going to the toilet, like everything else in Joey's life, was surrounded by elaborate preventions. We had to accompany him; he had to take off all his clothes; he could only squat, not sit, on the toilet seat; he had to touch the wall with one hand, in which he also clutched frantically the vacuum tubes that powered his elimination. He was terrified lest his whole body be sucked down.

To counteract this fear we gave him a metal wastebasket in lieu of a toilet. Eventually, when eliminating into the wastebasket, he no longer needed to take off all his clothes, nor to hold on to the wall. He still needed the tubes and motors which, he believed, moved his bowels for him. But here again the all important machinery was itself a source of new terrors. In Joey's world the gadgets had to move their bowels, too. He was terribly concerned that they should but since they were so much more powerful than men, he was also terrified that if his tubes moved their bowels, their feces would fill all of space and leave him no room to live. He was thus always caught in some fearful contradiction.

Our readiness to accept his toilet habits, which obviously entailed some hardship for his counselors, gave Joey the confidence to express his obsessions in drawings. Drawing these fantasies was a first step toward letting us in, however

water-lubricated GRAPHITAR®
(CARBON-GRAPHITE)
bearings in "canned" motor pumps
give exceptional performance in
high-pressure, high temperature
fluid systems

Special hermetically sealed motor-pumps, known also as "canned" motor pumps, were developed by Westinghouse Electric Corporation to handle radioactive water with zero leakage. These same pumps have proven a convenient means of pumping high temperature fluids for a number of nuclear reactors and other high pressure, high temperature fluid applications.

The thrust bearing utilized in the "canned" motor pump is a self-equalizing, water-lubricated, pivoted-pad bearing with inserted GRAPHITAR bearing surfaces. The radial sleeve bearings are also made of GRAPHITAR and are designed to be lubricated by the pumped fluid only . . . in the case of pumps used in nuclear reactors, only radioactive hot water is employed as lubrication.

GRAPHITAR is utilized extensively in tough applications because of its many unusual properties. It is non-metallic, resists chemical attack, has self-lubricating properties, a low coefficient of friction, is mechanically strong, hard as steel and lighter than magnesium. GRAPHITAR will not warp and shows no expansion or contraction in extreme temperature changes.

This versatile engineering material, GRAPHITAR, may well solve one of your difficult design problems. For further information on GRAPHITAR and its many applications, send for our engineering manual No. 20.

R-266-1

THE UNITED STATES GRAPHITE COMPANY
DIVISION OF THE WICKES CORPORATION, SAGINAW 6, MICHIGAN
GRAPHITAR® CARBON-GRAPHITE • GRAMIX® POWDERED METAL PARTS • MEXICAN® GRAPHITE PRODUCTS • USG® BRUSHES

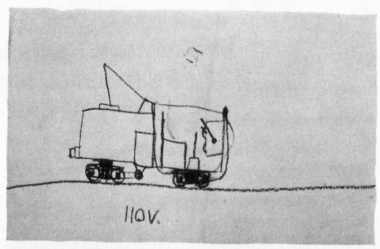

GROWING AUTONOMY is shown in Joey's drawings of the imaginary "Carr" (car) family. Top drawing shows a machine which can move but is unoccupied. Machine in center is occupied, but by a passive figure. In bottom drawing figure has gained control of machine.

distantly, to what concerned him most deeply. It was the first step in a year-long process of externalizing his anal preoccupations. As a result he began seeing feces everywhere; the whole world became to him a mire of excrement. At the same time he began to eliminate freely wherever he happened to be. But with this release from his infantile imprisonment in compulsive rules, the toilet and the whole process of elimination became less dangerous. Thus far it had been beyond Joey's comprehension that anybody could possibly move his bowels without mechanical aid. Now Joey took a further step forward; defecation became the first physiological process he could perform without the help of vacuum tubes. It must not be thought that he was proud of this ability. Taking pride in an achievement presupposes that one accomplishes it of one's own free will. He still did not feel himself an autonomous person who could do things on his own. To Joey defecation still seemed enslaved to some incomprehensible but utterly binding cosmic law, perhaps the law his parents had imposed on him when he was being toilet-trained.

It was not simply that his parents had subjected him to rigid, early training. Many children are so trained. But in most cases the parents have a deep emotional investment in the child's performance. The child's response in turn makes training an occasion for interaction between them and for the building of genuine relationships. Joey's parents had no emotional investment in him. His obedience gave them no satisfaction and won him no affection or approval. As a toilet-trained child he saved his mother labor, just as household machines saved her labor. As a machine he was not loved for his performance, nor could he love himself.

So it had been with all other aspects of Joey's existence with his parents. Their reactions to his eating or noneating, sleeping or wakening, urinating or defecating, being dressed or undressed, washed or bathed did not flow from any unitary interest in him, deeply embedded in their personalities. By treating him mechanically his parents made him a machine. The various functions of life—even the parts of his body—bore no integrating relationship to one another or to any sense of self that was acknowledged and confirmed by others. Though he had acquired mastery over some functions, such as toilet-training and speech, he had acquired them sepa-

Q. Why are Grape Growers like Rubber Researchers?

A. *Exciting advances in both fields are directly related to chemical progress pioneered by Merck.* Thanks to GIBREL® — Merck's new plant growth stimulant — grape growers are able to increase berry size and crop yield by as much as 50%. Farmers everywhere are vitally interested in more efficient crop production with GIBREL. Its "vitamin-like" action triggers normal growth in many plants by supplementing the growth-promoting substances naturally found in plants.

Another Merck chemical, MAGLITE® Y, meets the special processing requirements of the rubber industry's most important new synthetic—a heat-resistant elastomer with promising applications in jet aircraft tires and other rubber products that must perform under extremely high temperatures. A reactive magnesium oxide, MAGLITE is also available in D, K and M grades that are particularly well suited for various product or processing needs of many different elastomers.

MAGLITE and GIBREL are representative of Merck research and production that speed progress in nearly every field served by chemistry. For technical information bulletins on either product write to Department SA-1

MERCK & CO., INC. · Chemical Division · **Rahway, New Jersey**

© Merck & Co., Inc.

GIBREL® and MAGLITE® are registered trademarks of Merck & Co., Inc.

GENTLE LANDSCAPE painted by Joey after his recovery symbolizes the human emotions he had regained. At 12, having learned to express his feelings, he was no longer a machine.

rately and kept them isolated from each other. Toilet-training had thus not gained him a pleasant feeling of body mastery; speech had not led to communication of thought or feeling. On the contrary, each achievement only steered him away from self-mastery and integration. Toilet-training had enslaved him. Speech left him talking in neologisms that obstructed his and our ability to relate to each other. In Joey's development the normal process of growth had been made to run backward. Whatever he had learned put him not at the end of his infantile development toward integration but, on the contrary, farther behind than he was at its very beginning. Had we understood this sooner, his first years with us would have been less baffling.

It is unlikely that Joey's calamity could befall a child in any time and culture but our own. He suffered no physical deprivation; he starved for human contact. Just to be taken care of is not enough for relating. It is a necessary but not a sufficient condition. At the extreme where utter scarcity reigns, the forming of relationships is certainly hampered. But our society of mechanized plenty often makes for equal difficulties in a child's learning to relate. Where parents can provide the simple creature-comforts for their children only at the cost of significant effort, it is likely that they will feel pleasure in being able to provide for them; it is this, the parents' pleasure, that gives children a sense of personal worth and sets the process of relating in motion. But if comfort is so readily available that the parents feel no particular pleasure in winning it for their children, then the children cannot develop the feeling of being worthwhile around the satisfaction of their basic needs. Of course parents and children can and do develop relationships around other situations. But matters are then no longer so simple and direct. The child must be on the receiving end of care and concern given with pleasure and without the exaction of return if he is to feel loved and worthy of respect and consideration. This feeling gives him the ability to trust; he can entrust his well-being to persons to whom he is so important. Out of such trust the child learns to form close and stable relationships.

For Joey relationship with his parents was empty of pleasure in comfort-giving as in all other situations. His was an extreme instance of a plight that sends many schizophrenic children to our clinics and hospitals. Many months passed before he could relate to us; his despair that anybody could like him made contact impossible.

When Joey could finally trust us enough to let himself become more infantile, he began to play at being a papoose. There was a corresponding change in his fantasies. He drew endless pictures of himself as an electrical papoose. Totally enclosed, suspended in empty space, he is run by unknown, unseen powers through wireless electricity

New G-E silicone rubber cures at room temperature

General Electric's new RTV (room temperature vulcanizing) rubber cures in any time you select up to 48 hours. It resists heat up to 600°F and has excellent electrical properties. Among its present uses are:

Sealing and Caulking

RTV compounds form excellent bonds to primed metal, plastics and glass. They are ideal for in-place sealing and caulking where resistance to temperature extremes, solvents or ozone is required. Silicone rubber parts can be bonded with RTV compounds for "on-the-spot" repairs.

Potting and Encapsulating Electronic Assemblies

RTV compounds are 100% solids (solvent-free), cure with negligible shrinkage and no voids. They have the outstanding heat resistance and electrical characteristics of silicone rubber. With RTV, you can easily cushion delicate assemblies against shock and seal them from moist or corrosive atmospheres.

Mold Making

The unusual dimensional accuracy of RTV compounds has led to their use in duplicating complicated parts for low cost tooling. RTV's flexibility makes it easy to remove parts from a mold. It will release epoxy and epon resins without a release agent.

Can you put this superior RTV silicone rubber to work for you? For more information and a free sample, write General Electric Company, Silicone Products Dept., Section R5CC3, Waterford, N. Y.

GENERAL ⊕ ELECTRIC

Silicone Products Dept., Waterford, N. Y.

[see illustration at left on pages 118 and 119].

As we eventually came to understand, the heart of Joey's delusional system was the artificial, mechanical womb he had created and into which he had locked himself. In his papoose fantasies lay the wish to be entirely reborn in a womb. His new experiences in the school suggested that life, after all, might be worth living. Now he was searching for a way to be reborn in a better way. Since machines were better than men, what was more natural than to try rebirth through them? This was the deeper meaning of his electrical papoose.

As Joey made progress, his pictures of himself became more dominant in his drawings. Though still machine-operated, he has grown in self-importance *[see middle illustration on pages 118 and 119]*. Another great step forward is represented in the picture at right on the same two pages. Now he has acquired hands that do something, and he has had the courage to make a picture of the machine that runs him. Later still the papoose became a person, rather than a robot encased in glass.

Eventually Joey began to create an imaginary family at the school: the "Carr" family. Why the Carr family? In the car he was enclosed as he had been in his papoose, but at least the car was not stationary; it could move. More important, in a car one was not only driven but also could drive. The Carr family was Joey's way of exploring the possibility of leaving the school, of living with a good family in a safe, protecting car *[see illustrations on page 124].*

Joey at last broke through his prison. In this brief account it has not been possible to trace the painfully slow process of his first true relations with other human beings. Suffice it to say that he ceased to be a mechanical boy and became a human child. This newborn child was, however, nearly 12 years old. To recover the lost time is a tremendous task. That work has occupied Joey and us ever since. Sometimes he sets to it with a will; at other times the difficulty of <u>real</u> life makes him regret that he ever came out of his shell. But he has never wanted to return to his mechanical life.

One last detail and this fragment of Joey's story has been told. When Joey was 12, he made a float for our Memorial Day parade. It carried the slogan: "Feelings are more important than anything under the sun." Feelings, Joey had learned, are what make for humanity; their absence, for a mechanical existence. With this knowledge Joey entered the human condition.

Dead Eyes: a one-act play with two suburban Americans and three dead geniuses

JEANNE RANDOLPH

first American: It's warm, windless and it'll be dawn in about an hour. [He closes the car door and pulls on the handle to prove it's locked, then walks around to survey the layer of bugs smeared over the car's front end. He looks toward a glimmer of light in his next door neighbour's side window.]

Another poor devil who had to work all night. But I don't get the candle as any kind of decent lighting. The silhouette of the guy is so still maybe he's fallen asleep sitting bolt upright in his chair. Now that is weird! It's calm as a stone outside, but a wind inside blows out the flame. What's he saying? The windowpane is shivering like a darn amplifier. How many guys are in there, anyway? I can hear them as if they were standing right here in the driveway . . . what the ffffu . . . ?

voice of Bruno Bettelheim: A human body that functions as if it were a machine and a machine that duplicates human function . . . are uncanny because they remind us that the human body can operate without a human spirit, that body can exist without soul.[1]

voice of the second American: Half a century has gone by since your article appeared in *Scientific American*. We eggheads keep on keepin' on, thinking oh we got soul, but knowing we don't actually have a Soul. Maybe some of us have something like what you were talking about as a soul, but these days *soul* in your sense is more like a kind of abbreviation, like *Inc.* is an abbreviation: Humanity doesn't spend any time on the latest developments and revisions of its meaning.

voice of Bettelheim: Feelings . . . are what make for humanity; their absence, for a mechanical existence.[2]

voice of second America: In the 1950s, it was progressive to talk about the soul as a wide selection of emotions.

These days, we are up to our eyeballs in advertising, there's feelings galore and nary a speck of conscience. Mechanical boys in our world are more'n likely to be psychopaths.

voice of Bettelheim: Joey, in his world, chose the machine and froze himself in its image . . . to be rid of his unbearable humanity.[3]

voice of second American: Nowadays in affluent communities, we get all the latest unbearable humanity on the TV. It shows where unbearable humanity is located, away from us, in a ghetto somewhere or a third world country. The unbearable humanity we actually live with day-by-day is nothing but pettiness, and I mean violently petty. We got affluent science passing over "humanity" as some kind of hair-do job that artists and philosophers perform after the head has been cloned.

voice of Bettelheim: Joey's story has general relevance to the understanding of emotional development in a machine age.[4]

voice of second American: In a popular middle-class magazine like *Scientific American*, you couldn't help but give us a scientistical, metaphorical Joey, a story of a Joey. And so what are we going to see in a literary Joey? Only ourselves.

voice of Ludwig Wittgenstein: My own point was that what machines do counts as genuine calculating only if it is performed by human beings . . . The ultimate rationale for my position is that rule-following requires the doing of things *for a reason*, which is possible only for a creature which possesses conation and a will, that is, can take an interest in things and pursue goals.[5]

voice of second American: Well, I like Wittgenstein's contrast between just behaving and actually caring what the heck you do, although your phrase "taking an interest in things" is a rather bloodless way to say "*caring* what you do."

Most of the time, unless you're in bed asleep, you gotta be after something. And you always try to read another person for what that someone is after. When you look at someone who looks like a human and you can't see any desire, can't see how it gives a damn, can't pick out any longing or motivation in it, but even so it may pretty well look human, and that

catches your eye all right, well, you just naturally, you just automatically start looking closely and more often than not you are going to look 'em in the eye for the reflection of the human in it by Wittgenstein's definition, the will or the capacity to conate as he calls it — and if they got it, you'll see it in their eyes.

voice of D.W. Winnicott: We have yet to tackle the question of *what life itself is about* . . . You may cure your patient and not know what it is that makes him or her go on living . . . Psychotic patients who are all the time hovering between living and not living force us to look at this problem . . . I am claiming that these same phenomena that are life and death to our schizoid patients appear in our cultural experiences.[6]

voice of Bettelheim: Joey made progress . . . he has grown in self-importance . . . Joey entered the human condition. He tries to recover the lost time with a will.[7]

voice of second American: But we remember him only because you reconfigured him as "our cultural experience." Civilized clinicians know that as literary characters their patients will force the question of what life itself is about. Anyhow, they should at least know that what they have in common with patients is "tackling the question": the difference between life and death. I guess, Winnicott, you would say, "the difference between living with curiosity and living by reflex."

voice of D.W. Winnicott: I said hovering between living and not living and that's what I meant.

voice of second American: Okay, okay. And so when you imagine looking into the eyes of some zombie, or the undead, or some killer robot or some automaton whose "off switch" is broke or controlled by a mad scientist, or also when Bettelheim looked into the real eyes of an autistic, schizophrenic little fellow, if there is no sympathetic reflection of your conscience, or at least a glimmer of taking an interest, we're talking uncanny.

[1] Bruno Bettelheim, "Joey: A Mechanical Boy," *Scientific American* 200(3) (1959), 116–127. [2] Ibid., 127. [3] Ibid., 117. [4] Ibid. [5] Hans-Johann Glock, *A Wittgenstein Dictionary* (Oxford: Blackwell Publishers, 1996), 156–157. [6] D.W. Winnicott, *Playing and Reality* (Markham: Penguin Canada, 1986), 116–117. [7] Bettelheim, 127.

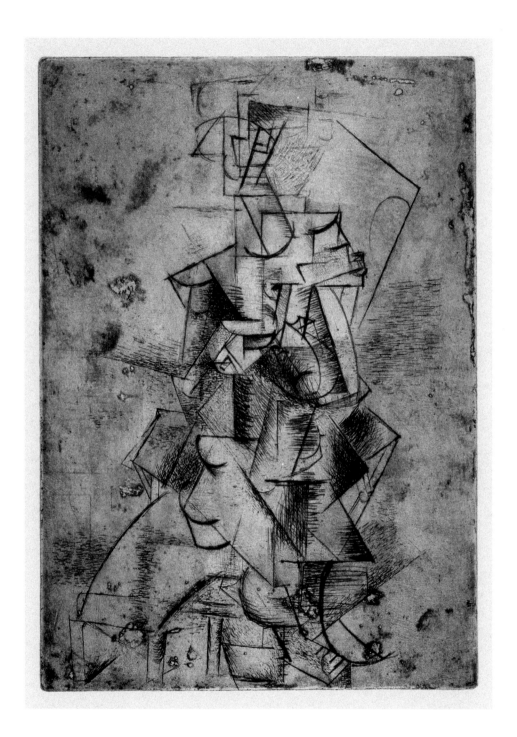

Pablo Picasso, *Mademoiselle Léonie dans une chaise longue*, 1910. Plate III from *Saint Matorel* by Max Jacob (Paris: Henry Kahnweiler, 1911). Etching and drypoint on van Gelder paper, 19.8 x 14.2 cm. Fine Arts Museums of San Francisco (1966.83.6), gift of R.E. Lewis, Inc. © Estate of Pablo Picasso/ADAGP (Paris)/SODRAC (Montreal) 2001.

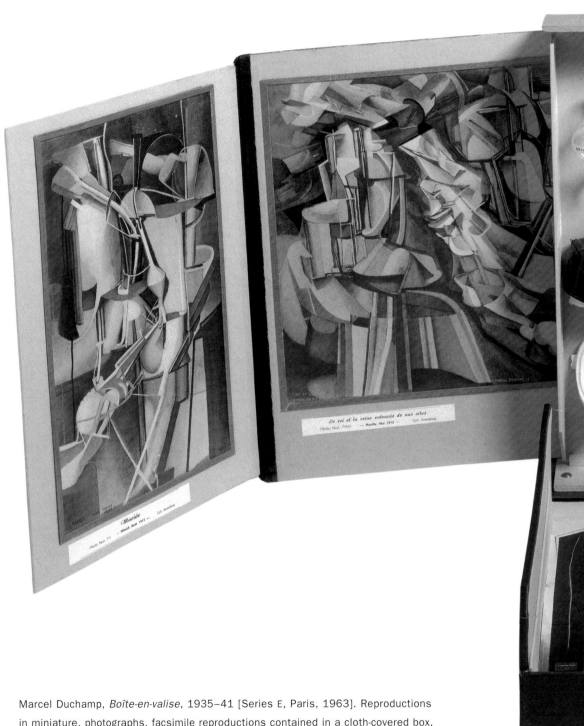

Marcel Duchamp, *Boîte-en-valise*, 1935–41 [Series E, Paris, 1963]. Reproductions in miniature, photographs, facsimile reproductions contained in a cloth-covered box, 40.3 x 37.8 x 10.2 cm. Art Gallery of Ontario, Toronto (64/85) © Estate of Marcel Duchamp/ADAGP (Paris)/SODRAC (Montreal) 2001.

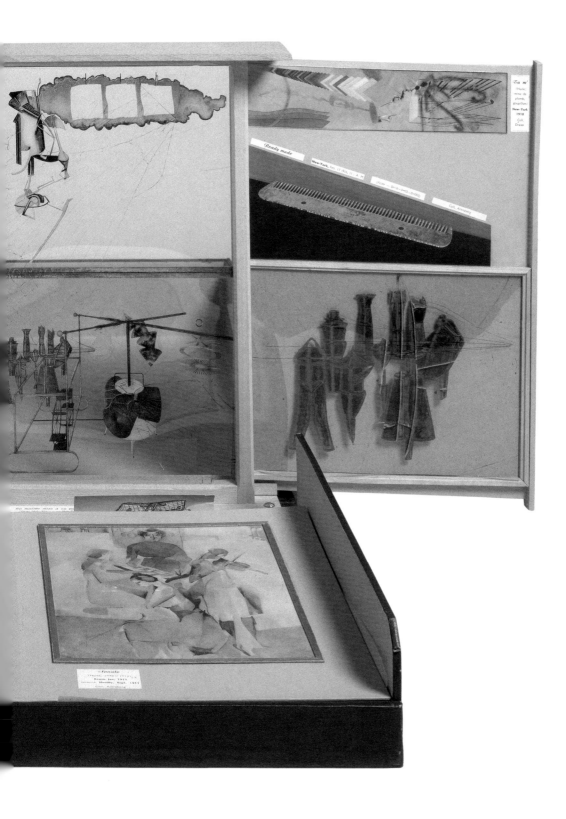

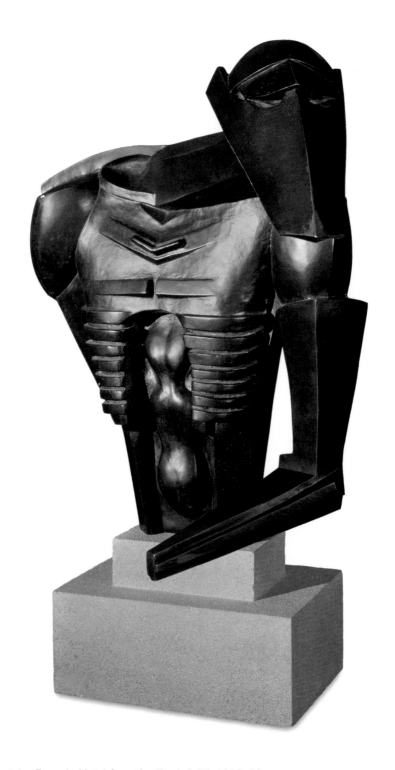

Jacob Epstein, *Torso in Metal from the 'Rock Drill'*, 1913–16.
Bronze, 70.5 x 58.4 x 44.5 cm. National Gallery of Canada, Ottawa (6498).

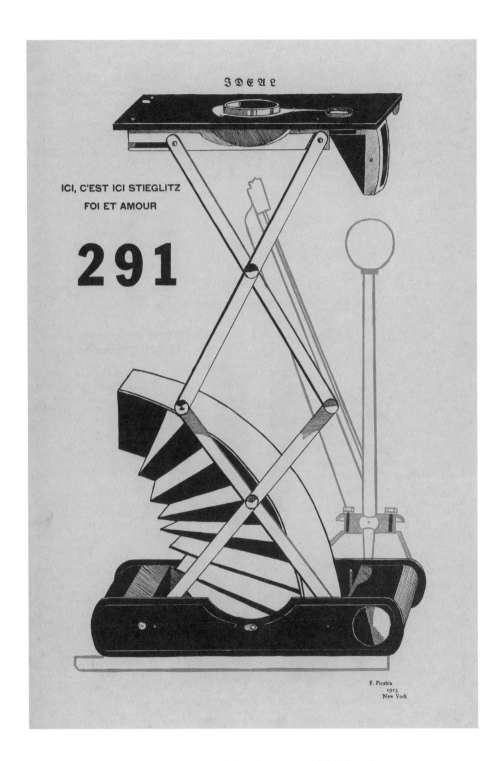

Francis Picabia, *Ici, c'est ici Stieglitz. Foi et Amour*, from *291* Magazine,
nos. 5–6 July–August, 1915. Off-set lithography on wove paper, 28 x 43 cm.
© Estate of Francis Picabia/ADAGP (Paris)/SODRAC (Montreal) 2001.

Fernand Léger, *Ballet mechanique*, 1924 (stills).
B/W, silent 35 mm film.

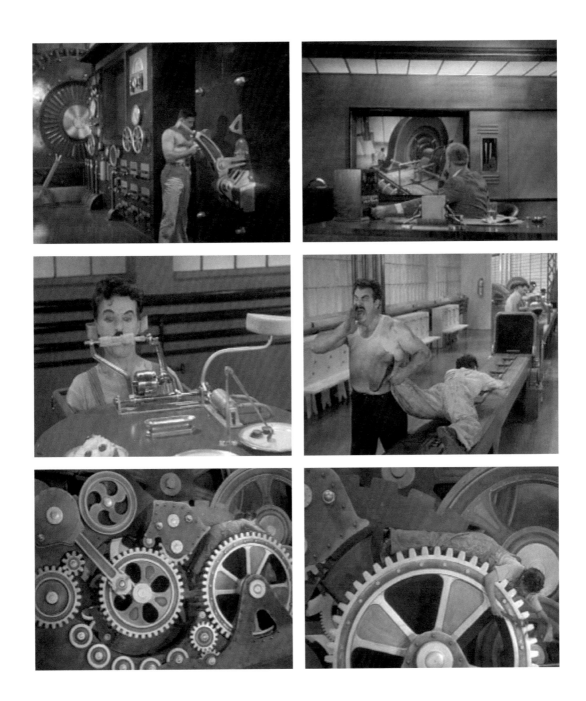

Charlie Chaplin, *Modern Times*, 1936 (stills).
B/W, silent 35 mm film.

Rube Goldberg, *Animated Hobby Kit: Painless False Teeth Extractor*
and *Animated Hobby Kit: Automatic Baby Feeder*, c. 1965.
Detachable plastic parts. Photo: Trevor Mills

Rube Goldberg was born in San Francisco in 1883 and died in 1970. During his lifetime he produced hundreds of cartoons that addressed the fundamental role of the machine in modern American culture. Goldberg imagined himself a contemporary William Hogarth or Honoré Daumier—a social critic with a piercing vision of modern-day life.

Goldberg is best known for his ingenious machines that provide complex solutions to everyday tasks—a baby feeder, a tooth-puller, a clothes brush, a window cleaner, etc. These devices produced the desired results through a chaotic chain reaction where one improbable event leads to another culminating in the completion of an absurdly simple task. Each device could involve more than a dozen kinetic events, utilizing everyday objects, actions, and the basic laws of physics.

Goldberg was among the first critics of the modern machine age and new technologies, and yet his work was also a celebration of Yankee ingenuity and the spirit of invention that inspired Thomas Edison, Alexander Graham Bell or George Eastman. Through his images Goldberg chose to occupy a complex position—one that acknowledged a fascination with the modern inventive spirit while providing a pointed critique of the mentality that spawned it. In occupying this position, within and without the prevailing ideology, Goldberg's methodology might be most closely aligned with that of Marcel Duchamp and foreshadows the strategies of Andy Warhol or Takashi Murakami.

BG

Drawing by Enrique Chagoya

A Manifesto for Cyborgs:
Science, Technology, and
Socialist Feminism in the 1980s

by Donna Haraway

An Ironic Dream of a Common Language
for Women in the Integrated Circuit

THIS ESSAY is an effort to build an ironic political myth faithful to feminism, socialism, and materialism. Perhaps more faithful as blasphemy is faithful, than as reverent worship and identification. Blasphemy has always seemed to require taking things very seriously. I know no better stance to adopt from within the secular-religious, evangelical traditions of United States politics, including the politics of socialist-feminism. Blasphemy protects one from the moral majority within, while still insisting on the need for community. Blasphemy is not apostasy. Irony is about contradictions that do not resolve into larger wholes, even dialectically, about the tension of holding incompatible things together because both or all are necessary and true. Irony is about humor and serious play. It is also a rhetorical strategy and a political method, one I would like to see more honored within socialist feminism. At the center of my ironic faith, my blasphemy, is the image of the cyborg.

A cyborg is a cybernetic organism, a hybrid of machine and organism, a creature of social reality as well as a creature of fiction. Social reality is lived social relations, our most important political construction, a world-changing fiction. The international women's movements have constructed "women's experience," as well as uncovered or discovered this crucial collective object. This experience is a fiction and fact of the most crucial, political kind.

Liberation rests on the construction of the consciousness, the imaginative apprehension, of oppression, and so of possibility. The cyborg is a matter of fiction and lived experience that changes what counts as women's experience in the late twentieth century. This is a struggle over life and death, but the boundary between science fiction and social reality is an optical illusion.

Contemporary science fiction is full of cyborgs—creatures simultaneously animal and machine, who populate worlds ambiguously natural and crafted. Modern medicine is also full of cyborgs, of couplings between organism and machine, each conceived as coded devices, in an intimacy and with a power that was not generated in the history of sexuality. Cyborg "sex" restores some of the lovely replicative baroque of ferns and invertebrates (such nice organic prophylactics against heterosexism). Cyborg replication is uncoupled from organic reproduction. Modern production seems like a dream of cyborg colonization of work, a dream that makes the nightmare of Taylorism seem idyllic. And modern war is a cyborg orgy, coded by C^3I, command-control-communication-intelligence, an $84 billion item in 1984's U.S. defense budget. I am making an argument for the cyborg as a fiction mapping our social and bodily reality and as an imaginative resource suggesting some very fruitful couplings. Foucault's biopolitics is a flaccid premonition of cyborg politics, a very open field.

BY THE LATE twentieth century, our time, a mythic time, we are all chimeras, theorized and fabricated hybrids of machine and organism; in short, we are cyborgs. The cyborg is our ontology; it gives us our politics. The cyborg is a condensed image of both imagination and material reality, the two joined centers structuring any possibility of historical transformation. In the traditions of "Western" science and politics—the tradition of racist, male-dominant capitalism; the tradition of progress; the tradition of the appropriation of nature as resource for the productions of culture; the tradition of reproduction of the self from the reflections of the other—the relation between organism and machine has been a border war. The stakes in the border war have been the territories of production, reproduction, and imagination. This essay is an argument for *pleasure* in the confusion of boundaries and for *responsibility* in their construction. It is also an effort to contribute to socialist-feminist culture and theory in a post-modernist, non-naturalist mode and in the utopian tradition of imagining a world

without gender, which is perhaps a world without genesis, but maybe also a world without end. The cyborg incarnation is outside salvation history.

The cyborg is a creature in a post-gender world; it has no truck with bisexuality, pre-Oedipal symbiosis, unalienated labor, or other seductions to organic wholeness through a final appropriation of all the powers of the parts into a higher unity. In a sense, the cyborg has no origin story in the Western sense; a "final" irony since the cyborg is also the awful apocalyptic *telos* of the "West's" escalating dominations of abstract individuation, an ultimate self untied at last from all dependency, a man in space. An origin story in the "Western," humanist sense depends on the myth of original unity, fullness, bliss and terror, represented by the phallic mother from whom all humans must separate, the task of individual development and of history, the twin potent myths inscribed most powerfully for us in psychoanalysis and Marxism. Hilary Klein has argued that both Marxism and psychoanalysis, in their concepts of labor and of individuation and gender formation, depend on the plot of original unity out of which difference must be produced and enlisted in a drama of escalating domination of woman/nature. The cyborg skips the step of original unity, of identification with nature in the Western sense. This is its illegitimate promise that might lead to subversion of its teleology as star wars.

The cyborg is resolutely committed to partiality, irony, intimacy, and perversity. It is oppositional, utopian, and completely without innocence. No longer structured by the polarity of public and private, the cyborg defines a technological polis based partly on a revolution of social relations in the *oikos,* the household. Nature and culture are reworked; the one can no longer be the resource for appropriation or incorporation by the other. The relationships for forming wholes from parts, including those of polarity and hierarchical domination, are at issue in the cyborg world. Unlike the hopes of Frankenstein's monster, the cyborg does not expect its father to save it through a restoration of the garden; i.e., through the fabrication of a heterosexual mate, through its completion in a finished whole, a city and cosmos. The cyborg does not dream of community on the model of the organic family, this time without the Oedipal project. The cyborg would not recognize the Garden of Eden; it is not made of mud and cannot dream of returning to dust. Perhaps that is why I want to see if

cyborgs can subvert the apocalypse of returning to nuclear dust in the manic compulsion to name the Enemy. Cyborgs are not reverent; they do not re-member the cosmos. They are wary of holism, but needy for connection—they seem to have a natural feel for united front politics, but without the vanguard party. The main trouble with cyborgs, of course, is that they are the illegitimate offspring of militarism and patriarchal capitalism, not to mention state socialism. But illegitimate offspring are often exceedingly unfaithful to their origins. Their fathers, after all, are inessential.

I WILL RETURN to the science fiction of cyborgs at the end of this essay, but now I want to signal three crucial boundary breakdowns that make the following political fictional (political scientific) analysis possible. By the late twentieth century in United States scientific culture, the boundary between human and animal is thoroughly breached. The last beachheads of uniqueness have been polluted if not turned into amusement parks—language, tool use, social behavior, mental events, nothing really convincingly settles the separation of human and animal. And many people no longer feel the need of such a separation; indeed, many branches of feminist culture affirm the pleasure of connection of human and other living creatures. Movements for animal rights are not irrational denials of human uniqueness; they are clear-sighted recognition of connection across the discredited breach of nature and culture. Biology and evolutionary theory over the last two centuries have simultaneously produced modern organisms as objects of knowledge and reduced the line between humans and animals to a faint trace re-etched in ideological struggle or professional disputes between life and social sciences. Within this framework, teaching modern Christian creationism should be fought as a form of child abuse.

Biological-determinist ideology is only one position opened up in scientific culture for arguing the meanings of human animality. There is much room for radical political people to contest for the meanings of the breached boundary.[1] The cyborg appears in myth precisely where the boundary between human and animal is transgressed. Far from signaling a walling off of people from other living beings, cyborgs signal disturbingly and pleasurably tight coupling. Bestiality has a new status in this cycle of marriage exchange.

The second leaky distinction is between animal-human (organism) and machine. Pre-cybernetic machines could be haunted; there was always the specter of the ghost in the machine. This dualism structured the dialogue between materialism and idealism that was settled by a dialectical progeny, called spirit or history, according to taste. But basically machines were not self-moving, self-designing, autonomous. They could not achieve man's dream, only mock it. They were not man, an author to himself, but only a caricature of that masculinist reproductive dream. To think they were otherwise was paranoid. Now we are not so sure. Late-twentieth-century machines have made thoroughly ambiguous the difference between natural and artificial, mind and body, self-developing and externally-designed, and many other distinctions that used to apply to organisms and machines. Our machines are disturbingly lively, and we ourselves frighteningly inert.

Technological determinism is only one ideological space opened up by the reconceptions of machine and organism as coded texts through which we engage in the play of writing and reading the world.[2] "Textualization" of everything in post-structuralist, post-modernist theory has been damned by Marxists and socialist feminists for its utopian disregard for lived relations of domination that ground the "play" of arbitrary reading.[3]* It is certainly true

*A provocative, comprehensive argument about the politics and theories of "post-modernism" is made by Frederick Jameson, who argues that post-modernism is not an option, a style among others, but a cultural dominant requiring radical reinvention of left politics from within; there is no longer any place from without that gives meaning to the comforting fiction of critical distance. Jameson also makes clear why one cannot be for or against post-modernism, an essentially moralist move. My position is that feminists (and others) need continuous cultural reinvention, post-modernist critique, and historical materialism; only a cyborg would have a chance. The old dominations of white capitalist patriarchy seem nostalgically innocent now: they normalized heterogeneity, e.g., into man and woman, white and black. "Advanced capitalism" and post-modernism release heterogeneity without a norm, and we are flattened, without subjectivity, which requires depth, even unfriendly and drowning depths. It is time to write *The Death of the Clinic.* The clinic's methods required bodies and works; we have texts and surfaces. Our dominations don't work by medicalization and normalization anymore; they work by networking, communications redesign, stress management. Normalization gives way to automation, utter redundancy. Michel Foucault's *Birth of the Clinic, History of Sexuality,* and *Discipline and Punish* name a form of power at its moment of implosion. The discourse of biopolitics gives way to technobabble, the language of the spliced substantive; no noun is left whole by the multinationals. These are their names, listed from one issue of *Science*: Tech-Knowledge, Genentech, Allergen, Hybritech, Compupro, Genen-cor, Syntex, Allelix, Agrigenetics Corp., Syntro, Codon, Repligen,

that post-modernist strategies, like my cyborg myth, subvert myriad organic wholes (e.g., the poem, the primitive culture, the biological organism). In short, the certainty of what counts as nature—a source of insight and a promise of innocence—is undermined, probably fatally. The transcendent authorization of interpretation is lost, and with it the ontology grounding "Western" epistemology. But the alternative is not cynicism or faithlessness, i.e., some version of abstract existence, like the accounts of technological determinism destroying "man" by the "machine" or "meaningful political action" by the "text." Who cyborgs will be is a radical question; the answers are a matter of survival. Both chimpanzees and artifacts have politics, so why shouldn't we?[4]

The third distinction is a subset of the second: the boundary between physical and non-physical is very imprecise for us. Pop physics books on the consequences of quantum theory and the indeterminacy principle are a kind of popular scientific equivalent to the Harlequin romances as a marker of radical change in American white heterosexuality: they get it wrong, but they are on the right subject. Modern machines are quintessentially microelectronic devices: they are everywhere and they are invisible. Modern machinery is an irreverant upstart god, mocking the Father's ubiquity and spirituality. The silicon chip is a surface for writing; it is etched in molecular scales disturbed only by atomic noise, the ultimate interference for nuclear scores. Writing, power, and technology are old partners in Western stories of the origin of civilization, but miniaturization has changed our experience of mechanism. Miniaturization has turned out to be about power; small is not so much beautiful as pre-eminently dangerous, as in cruise missiles. Contrast the TV sets of the 1950s or the news cameras of the 1970s with the TV wrist bands or hand-sized video cameras now advertised. Our best machines are made of sunshine; they are all light and clean because they are nothing but signals, electromagnetic waves, a section of a spectrum. And these machines are eminently portable, mobile—a matter of immense human pain in Detroit and Singapore. People are nowhere near so fluid, being both material and opaque. Cyborgs are ether, quintessence.

Micro-Angelo from Scion Corp., Percom Data, Inter Systems, Cyborg Corp., Statcom Corp., Intertec. If we are imprisoned by language, then escape from that prison house requires language poets, a kind of cultural restriction enzyme to cut the code; cyborg heteroglossia is one form of radical culture politics.

The ubiquity and invisibility of cyborgs is precisely why these sunshine-belt machines are so deadly. They are as hard to see politically as materially. They are about consciousness—or its simulation.[5] They are floating signifiers moving in pickup trucks across Europe, blocked more effectively by the witch-weavings of the displaced and so unnatural Greenham women, who read the cyborg webs of power very well, than by the militant labor of older masculinist politics, whose natural constituency needs defense jobs. Ultimately the "hardest" science is about the realm of greatest boundary confusion, the realm of pure number, pure spirit, c^3i, cryptography, and the preservation of potent secrets. The new machines are so clean and light. Their engineers are sun-worshipers mediating a new scientific revolution associated with the night dream of post-industrial society. The diseases evoked by these clean machines are "no more" than the miniscule coding changes of an antigen in the immune system, "no more" than the experience of stress. The nimble little fingers of "Oriental" women, the old fascination of little Anglo-Saxon Victorian girls with doll houses, women's enforced attention to the small take on quite new dimensions in this world. There might be a cyborg Alice taking account of these new dimensions. Ironically, it might be the unnatural cyborg women making chips in Asia and spiral dancing in Santa Rita whose constructed unities will guide effective oppositional strategies.

So my cyborg myth is about transgressed boundaries, potent fusions, and dangerous possibilities which progressive people might explore as one part of needed political work. One of my premises is that most American socialists and feminists see deepened dualisms of mind and body, animal and machine, idealism and materialism in the social practices, symbolic formulations, and physical artifacts associated with "high technology" and scientific culture. From *One-Dimensional Man* to *The Death of Nature*,[6] the analytic resources developed by progressives have insisted on the necessary domination of technics and recalled us to an imagined organic body to integrate our resistance. Another of my premises is that the need for unity of people trying to resist worldwide intensification of domination has never been more acute. But a slightly perverse shift of perspective might better enable us to contest for meanings, as well as for other forms of power and pleasure in technologically-mediated societies.

F ROM ONE PERSPECTIVE, a cyborg world is about the final impo-
sition of a grid of control on the planet, about the final abstrac-
tion embodied in a Star War apocalypse waged in the name of
defense, about the final appropriation of women's bodies in a mas-
culinist orgy of war.[7] From another perspective, a cyborg world
might be about lived social and bodily realities in which people are
not afraid of their joint kinship with animals and machines, not
afraid of permanently partial identities and contradictory stand-
points. The political struggle is to see from both perspectives at
once because each reveals both dominations and possibilities un-
imaginable from the other vantage point. Single vision produces
worse illusions than double vision or many-headed monsters.
Cyborg unities are monstrous and illegitimate; in our present po-
litical circumstances, we could hardly hope for more potent myths
for resistance and recoupling. I like to imagine LAG, the Livermore
Action Group, as a kind of cyborg society, dedicated to realisti-
cally converting the laboratories that most fiercely embody and
spew out the tools of technological apocalypse, and committed to
building a political form that actually manages to hold together
witches, engineers, elders, perverts, Christians, mothers, and
Leninists long enough to disarm the state. Fission Impossible is the
name of the affinity group in my town. (Affinity: related not by
blood but by choice, the appeal of one chemical nuclear group for
another, avidity.)

Fractured Identities

I T HAS BECOME DIFFICULT to name one's feminism by a single
adjective—or even to insist in every circumstance upon the
noun. Consciousness of exclusion through naming is acute. Identi-
ties seem contradictory, partial, and strategic. With the hard-won
recognition of their social and historical constitution. gender, race,
and class cannot provide the basis for belief in "essential" unity.
There is nothing about being "female" that naturally binds women.
There is not even such a state as "being" female, itself a highly
complex category constructed in contested sexual scientific dis-
courses and other social practices. Gender, race, or class conscious-
ness is an achievement forced on us by the terrible historical ex-
perience of the contradictory social realities of patriarchy, colonial-
ism, and capitalism. And who counts as "us" in my own rhetoric?
Which identities are available to ground such a potent political

myth called "us," and what could motivate enlistment in this collectivity? Painful fragmentation among feminists (not to mention among women) along every possible fault line has made the concept of *woman* elusive, an excuse for the matrix of women's dominations of each other. For me—and for many who share a similar historical location in white, professional middle class, female, radical, North American, mid-adult bodies—the sources of a crisis in political identity are legion. The recent history for much of the U.S. left and U.S. feminism has been a response to this kind of crisis by endless splitting and searches for a new essential unity. But there has also been a growing recognition of another response through coalition—affinity, not identity.[8]

Chela Sandoval, from a consideration of specific historical moments in the formation of the new political voice called women of color, has theorized a hopeful model of political identity called "oppositional consciousness," born of the skills for reading webs of power by those refused stable membership in the social categories of race, sex, or class.[9] "Women of color," a name contested at its origins by those whom it would incorporate, as well as a historical consciousness marking systematic breakdown of all the signs of Man in "Western" traditions, constructs a kind of postmodernist identity out of otherness and difference. This postmodernist identity is fully political, whatever might be said about other possible post-modernisms.

Sandoval emphasizes the lack of any essential criterion for identifying who is a woman of color. She notes that the definition of the group has been by conscious appropriation of negation. For example, a Chicana or U.S. black woman has not been able to speak as a woman or as a black person or as a Chicano. Thus, she was at the bottom of a cascade of negative identities, left out of even the privileged oppressed authorial categories called "women and blacks," who claimed to make the important revolutions. The category "woman" negated all non-white women; "black" negated all non-black people, as well as all black women. But there was also no "she," no singularity, but a sea of differences among U.S. women who have affirmed their historical identity as U.S. women of color. This identity marks out a self-consciously constructed space that cannot affirm the capacity to act on the basis of natural identification, but only on the basis of conscious coalition, of affinity, of political kinship.[10] Unlike the "woman" of some streams of the white women's movement in the United States, there is no

naturalization of the matrix, or at least this is what Sandoval argues is uniquely available through the power of oppositional consciousness.

Sandoval's argument has to be seen as one potent formulation for feminists out of the worldwide development of anti-colonialist discourse, i.e., discourse dissolving the "West" and its highest product—the one who is not animal, barbarian, or woman; i.e., man, the author of a cosmos called history. As orientalism is deconstructed politically and semiotically, the identities of the occident destabilize, including those of feminists.[11] Sandoval argues that "women of color" have a chance to build an effective unity that does not replicate the imperializing, totalizing revolutionary subjects of previous Marxisms and feminisms which had not faced the consequences of the disorderly polyphony emerging from decolonization.

Katie King has emphasized the limits of identification and the political/poetic mechanics of identification built into reading "the poem," that generative core of cultural feminism. King criticizes the persistent tendency among contemporary feminists from different "moments" or "conversations" in feminist practice to taxonomize the women's movement to make one's own political tendencies appear to be the *telos* of the whole. These taxonomies tend to remake feminist history to appear to be an ideological struggle among coherent types persisting over time, especially those typical units called radical, liberal, and socialist feminism. Literally, all other feminisms are either incorporated or marginalized, usually by building an explicit ontology and epistemology.[12] Taxonomies of feminism produce epistemologies to police deviation from official women's experience. And of course, "women's culture," like women of color, is consciously created by mechanisms inducing affinity. The rituals of poetry, music, and certain forms of academic practice have been pre-eminent. The politics of race and culture in the U.S. women's movements are intimately interwoven. The common achievement of King and Sandoval is learning how to craft a poetic/political unity without relying on a logic of appropriation, incorporation, and taxonomic identification.

THE THEORETICAL AND PRACTICAL struggle against unity-through-domination or unity-through-incorporation ironically not only undermines the justifications for patriarchy, colonialism, humanism, positivism, essentialism, scientism, and other un-

lamented -isms, but *all* claims for an organic or natural standpoint. I think that radical and socialist/Marxist feminisms have also undermined their/our own epistemological strategies and that this is a crucially valuable step in imagining possible unities. It remains to be seen whether all "epistemologies" as Western political people have known them fail us in the task to build effective affinities.

It is important to note that the effort to construct revolutionary standpoints, epistemologies as achievements of people committed to changing the world, has been part of the process showing the limits of identification. The acid tools of post-modernist theory and the constructive tools of ontological discourse about revolutionary subjects might be seen as ironic allies in dissolving Western selves in the interests of survival. We are excruciatingly conscious of what it means to have a historically constituted body. But with the loss of innocence in our origin, there is no expulsion from the Garden either. Our politics lose the indulgence of guilt with the naïveté of innocence. But what would another political myth for socialist feminism look like? What kind of politics could embrace partial, contradictory, permanently unclosed constructions of personal and collective selves and still be faithful, effective—and, ironically, socialist feminist?

I do not know of any other time in history when there was greater need for political unity to confront effectively the dominations of "race," "gender," "sexuality," and "class." I also do not know of any other time when the kind of unity we might help build could have been possible. None of "us" have any longer the symbolic or material capability of dictating the shape of reality to any of "them." Or at least "we" cannot claim innocence from practicing such dominations. White women, including socialist feminists, discovered (i.e., were forced kicking and screaming to notice) the non-innocence of the category "woman." That consciousness changes the geography of all previous categories; it denatures them as heat denatures a fragile protein. Cyborg feminists have to argue that "we" do not want any more natural matrix of unity and that no construction is whole. Innocence, and the corollary insistence on victimhood as the only ground for insight, has done enough damage. But the constructed revolutionary subject must give late-twentieth-century people pause as well. In the fraying of identities and in the reflexive strategies for constructing them, the possibility opens up for weaving something other than a shroud for the day after the apocalypse that so prophetically ends salvation history.

Both Marxist/socialist feminisms and radical feminisms have simultaneously naturalized and denatured the category "woman" and consciousness of the social lives of "women." Perhaps a schematic caricature can highlight both kinds of moves. Marxian socialism is rooted in an analysis of wage labor which reveals class structure. The consequence of the wage relationship is systematic alienation, as the worker is dissociated from his (sic) product. Abstraction and illusion rule in knowledge, domination rules in practice. Labor is the pre-eminently privileged category enabling the Marxist to overcome illusion and find that point of view which is necessary for changing the world. Labor is the humanizing activity that makes man; labor is an ontological category permitting the knowledge of a subject, and so the knowledge of subjugation and alienation.

In faithful filiation, socialist feminism advanced by allying itself with the basic analytic strategies of Marxism. The main achievement of both Marxist feminists and socialist feminists was to expand the category of labor to accommodate what (some) women did, even when the wage relation was subordinated to a more comprehensive view of labor under capitalist patriarchy. In particular, women's labor in the household and women's activity as mothers generally, i.e., reproduction in the socialist feminist sense, entered theory on the authority of analogy to the Marxian concept of labor. The unity of women here rests on an epistemology based on the ontological structure of "labor." Marxist/socialist feminism does not "naturalize" unity; it is a possible achievement based on a possible standpoint rooted in social relations. The essentializing move is in the ontological structure of labor or of its analogue, women's activity.[13] ★ The inheritance of Marxian humanism, with its pre-eminently Western self, is the difficulty for me. The contribution from these formulations has been the emphasis on the daily responsibility of real women to build unities, rather than to naturalize them.

★The central role of object-relations versions of psychoanalysis and related strong universalizing moves in discussing reproduction, caring work, and mothering in many approaches to epistemology underline their authors' resistance to what I am calling post-modernism. For me, both the universalizing moves and the versions of psychoanalysis make analysis of "women's place in the integrated circuit" difficult and lead to systematic difficulties in accounting for or even seeing major aspects of the construction of gender and gendered social life.

CATHERINE MACKINNON's version of radical feminism is itself a caricature of the appropriating, incorporating, totalizing tendencies of Western theories of identity grounding action.[14] It is factually and politically wrong to assimilate all of the diverse "moments" or "conversations" in recent women's politics named radical feminism to MacKinnon's version. But the teleological logic of her theory shows how an epistemology and ontology—including their negations—erase or police difference. Only one of the effects of MacKinnon's theory is the rewriting of the history of the polymorphous field called radical feminism. The major effect is the production of a theory of experience, of women's identity, that is a kind of apocalypse for all revolutionary standpoints. That is, the totalization built into this tale of radical feminism achieves its end—the unity of women—by enforcing the experience of and testimony to radical non-being. As for the Marxist/socialist feminist, consciousness is an achievement, not a natural fact. And MacKinnon's theory eliminates some of the difficulties built into humanist revolutionary subjects, but at the cost of radical reductionism.

MacKinnon argues that radical feminism necessarily adopted a different analytical strategy from Marxism, looking first not at the structure of class, but at the structure of sex/gender and its generative relationship, men's constitution and appropriation of women sexually. Ironically, MacKinnon's "ontology" constructs a non-subject, a non-being. Another's desire, not the self's labor, is the origin of "woman." She therefore develops a theory of consciousness that enforces what can count as "women's" experience—anything that names sexual violation, indeed, sex itself as far as "women" can be concerned. Feminist practice is the construction of this form of consciousness; i.e., the self-knowledge of a self-who-is-not.

Perversely, sexual appropriation in this radical feminism still has the epistemological status of labor, i.e., the point from which analysis able to contribute to changing the world must flow. But sexual objectification, not alienation, is the consequence of the structure of sex/gender. In the realm of knowledge, the result of sexual objectification is illusion and abstraction. However, a woman is not simply alienated from her product, but in a deep sense does not exist as a subject, or even potential subject, since she owes her existence as a woman to sexual appropriation. To be

constituted by another's desire is not the same thing as to be alienated in the violent separation of the laborer from his product.

MacKinnon's radical theory of experience is totalizing in the extreme; it does not so much marginalize as obliterate the authority of any other women's political speech and action. It is a totalization producing what Western patriarchy itself never succeeded in doing—feminists' consciousness of the non-existence of women, except as products of men's desire. I think MacKinnon correctly argues that no Marxian version of identity can firmly ground women's unity. But in solving the problem of the contradictions of any Western revolutionary subject for feminist purposes, she develops an even more authoritarian doctrine of experience. If my complaint about socialist/Marxian standpoints is their unintended erasure of polyvocal, unassimilable, radical difference made visible in anti-colonial discourse and practice, MacKinnon's intentional erasure of all difference through the device of the "essential" non-existence of women is not reassuring.

In my taxonomy, which like any other taxonomy is a reinscription of history, radical feminism can accommodate all the activities of women named by socialist feminists as forms of labor only if the activity can somehow be sexualized. Reproduction had different tones of meanings for the two tendencies, one rooted in labor, one in sex, both calling the consequences of domination and ignorance of social and personal reality "false consciousness."

Beyond either the difficulties or the contributions in the argument of any one author, neither Marxist nor radical feminist points of view have tended to embrace the status of a partial explanation; both were regularly constituted as totalities. Western explanation has demanded as much; how else could the "Western" author incorporate its others? Each tried to annex other forms of domination by expanding its basic categories through analogy, simple listing, or addition. Embarrassed silence about race among white radical and socialist feminists was one major, devastating political consequence. History and polyvocality disappear into political taxonomies that try to establish genealogies. There was no structural room for race (or for much else) in theory claiming to reveal the construction of the category woman and social group women as a unified or totalizable whole. The structure of my caricature looks like this:

Socialist Feminism—
 structure of class//wage labor//alienation
 labor, by analogy reproduction, by extension sex, by addition race
Radical Feminism—
 structure of gender//sexual appropriation//objectification
 sex, by analogy labor, by extension reproduction, by addition race

In another context, the French theorist Julia Kristeva claimed women appeared as a historical group after World War II, along with groups like youth. Her dates are doubtful; but we are now accustomed to remembering that as objects of knowledge and as historical actors, "race" did not always exist, "class" has a historical genesis, and "homosexuals" are quite junior. It is no accident that the symbolic system of the family of man—and so the essence of woman—breaks up at the same moment that networks of connection among people on the planet are unprecedentedly multiple, pregnant, and complex. "Advanced capitalism" is inadequate to convey the structure of this historical moment. In the "Western" sense, the end of man is at stake. It is no accident that woman disintegrates into women in our time. Perhaps socialist feminists were not substantially guilty of producing essentialist theory that suppressed women's particularity and contradictory interests. I think we have been, at least through unreflective participation in the logics, languages, and practices of white humanism and through searching for a single ground of domination to secure our revolutionary voice. Now we have less excuse. But in the consciousness of our failures, we risk lapsing into boundless difference and giving up on the confusing task of making partial, real connection. Some differences are playful; some are poles of world historical systems of domination. "Epistemology" is about knowing the difference.

The Informatics of Domination

IN THIS ATTEMPT at an epistemological and political position, I would like to sketch a picture of possible unity, a picture indebted to socialist and feminist principles of design. The frame for my sketch is set by the extent and importance of rearrangements in worldwide social relations tied to science and technology. I argue for a politics rooted in claims about fundamental changes in the nature of class, race, and gender in an emerging system of world

order analogous in its novelty and scope to that created by industrial capitalism; we are living through a movement from an organic, industrial society to a polymorphous, information system—from all work to all play, a deadly game. Simultaneously material and ideological, the dichotomies may be expressed in the following chart of transitions from the comfortable old hierarchical dominations to the scary new networks I have called the informatics of domination:

Representation	Simulation
Bourgeois novel, realism	Science fiction, post-modernism
Organism	Biotic component
Depth, integrity	Surface, boundary
Heat	Noise
Biology as clinical practice	Biology as inscription
Physiology	Communications engineering
Small group	Subsystem
Perfection	Optimization
Eugenics	Population control
Decadence, *Magic Mountain*	Obsolescence, *Future Shock*
Hygiene	Stress Management
Microbiology, tuberculosis	Immunology, AIDS
Organic division of labor	Ergonomics/cybernetics of labor
Functional specialization	Modular construction
Reproduction	Replication
Organic sex role specialization	Optimal genetic strategies
Biological determinism	Evolutionary inertia, constraints
Community ecology	Ecosystem
Racial chain of being	Neo-imperialism, United Nations humanism
Scientific management in home/factory	Global factory/Electronic cottage
Family/Market/Factory	Women in the Integrated Circuit
Family wage	Comparable worth
Public/Private	Cyborg citizenship
Nature/Culture	Fields of difference
Cooperation	Communications enhancement
Freud	Lacan
Sex	Genetic engineering
Labor	Robotics
Mind	Artificial Intelligence
World War II	Star Wars
White Capitalist Patriarchy	Informatics of Domination

This list suggests several interesting things.[15] First, the objects on the right-hand side cannot be coded as "natural," a realization

that subverts naturalistic coding for the left-hand side as well. We cannot go back ideologically or materially. It's not just that "god" is dead; so is the "goddess." In relation to objects like biotic components, one must think not in terms of essential properties, but in terms of strategies of design, boundary constraints, rates of flows, systems logics, costs of lowering constraints. Sexual reproduction is one kind of reproductive strategy among many, with costs and benefits as a function of the system environment. Ideologies of sexual reproduction can no longer reasonably call on the notions of sex and sex role as organic aspects in natural objects like organisms and families. Such reasoning will be unmasked as irrational, and ironically corporate executives reading *Playboy* and anti-porn radical feminists will make strange bedfellows in jointly unmasking the irrationalism.

Likewise for race, ideologies about human diversity have to be formulated in terms of frequencies of parameters, like blood groups or intelligence scores. It is "irrational" to invoke concepts like primitive and civilized. For liberals and radicals, the search for integrated social systems gives way to a new practice called "experimental ethnography" in which an organic object dissipates in attention to the play of writing. At the level of ideology, we see translations of racism and colonialism into languages of development and underdevelopment, rates and constraints of modernization. Any objects or persons can be reasonably thought of in terms of disassembly and reassembly; no "natural" architectures constrain system design. The financial districts in all the world's cities, as well as the export-processing and free-trade zones, proclaim this elementary fact of "late capitalism." The entire universe of objects that can be known scientifically must be formulated as problems in communications engineering (for the managers) or theories of the text (for those who would resist). Both are cyborg semiologies.

One should expect control strategies to concentrate on boundary conditions and interfaces, on rates of flow across boundaries — and not on the integrity of natural objects. "Integrity" or "sincerity" of the Western self gives way to decision procedures and expert systems. For example, control strategies applied to women's capacities to give birth to new human beings will be developed in the languages of population control and maximization of goal achievement for individual decision-makers. Control strategies will be formulated in terms of rates, costs of constraints,

degrees of freedom. Human beings, like any other component or subsystem, must be localized in a system architecture whose basic modes of operation are probabilistic, statistical. No objects, spaces, or bodies are sacred in themselves; any component can be interfaced with any other if the proper standard, the proper code, can be constructed for processing signals in a common language. Exchange in this world transcends the universal translation effected by capitalist markets that Marx analyzed so well. The privileged pathology affecting all kinds of components in this universe is stress—communications breakdown.[16] The cyborg is not subject to Foucault's biopolitics; the cyborg simulates politics, a much more potent field of operations.

THIS KIND OF ANALYSIS of scientific and cultural objects of knowledge which have appeared historically since World War II prepares us to notice some important inadequacies in feminist analysis which has proceeded as if the organic, hierarchical dualisms ordering discourse in "the West" since Aristotle still ruled. They have been cannibalized, or as Zoe Sofia (Sofoulis) might put it, they have been "techno-digested." The dichotomies between mind and body, animal and human, organism and machine, public and private, nature and culture, men and women, primitive and civilized are all in question ideologically. The actual situation of women is their integration/exploitation into a world system of production/reproduction and communication called the informatics of domination. The home, workplace, market, public arena, the body itself—all can be dispersed and interfaced in nearly infinite, polymorphous ways, with large consequences for women and others—consequences that themselves are very different for different people and which make potent oppositional international movements difficult to imagine and essential for survival. One important route for reconstructing socialist-feminist politics is through theory and practice addressed to the social relations of science and technology, including crucially the systems of myth and meanings structuring our imaginations. The cyborg is a kind of disassembled and reassembled, post-modern collective and personal self. This is the self feminists must code.

Communications technologies and biotechnologies are the crucial tools recrafting our bodies. These tools embody and enforce new social relations for women worldwide. Technologies and scientific discourses can be partially understood as formalizations,

i.e., as frozen moments, of the fluid social interactions constituting them, but they should also be viewed as instruments for enforcing meanings. The boundary is permeable between tool and myth, instrument and concept, historical systems of social relations and historical anatomies of possible bodies, including objects of knowledge. Indeed, myth and tool mutually constitute each other.

Furthermore, communications sciences and modern biologies are constructed by a common move—*the translation of the world into a problem of coding,* a search for a common language in which all resistance to instrumental control disappears and all heterogeneity can be submitted to disassembly, reassembly, investment, and exchange.

In communications sciences, the translation of the world into a problem in coding can be illustrated by looking at cybernetic (feedback controlled) systems theories applied to telephone technology, computer design, weapons deployment, or data base construction and maintenance. In each case, solution to the key questions rests on a theory of language and control; the key operation is determining the rates, directions, and probabilities of flow of a quantity called information. The world is subdivided by boundaries differentially permeable to information. Information is just that kind of quantifiable element (unit, basis of unity) which allows universal translation, and so unhindered instrumental power (called effective communication). The biggest threat to such power is interruption of communication. Any system breakdown is a function of stress. The fundamentals of this technology can be condensed into the metaphor c^3I, command-control-communication-intelligence, the military's symbol for its operations theory.

In modern biologies, the translation of the world into a problem in coding can be illustrated by molecular genetics, ecology, sociobiological evolutionary theory, and immunobiology. The organism has been translated into problems of genetic coding and read-out. Biotechnology, a writing technology, informs research broadly.[17] In a sense, organisms have ceased to exist as objects of knowledge, giving way to biotic components, i.e., special kinds of information processing devices. The analogous moves in ecology could be examined by probing the history and utility of the concept of the ecosystem. Immunobiology and associated medical practices are rich exemplars of the privilege of coding and recognition systems as objects of knowledge, as constructions of bodily reality for us.

Biology is here a kind of cryptography. Research is necessarily a kind of intelligence activity. Ironies abound. A stressed system goes awry; its communication processes break down; it fails to recognize the difference between self and other. Human babies with baboon hearts evoke national ethical perplexity—for animal-rights activists at least as much as for guardians of human purity. Gay men, Haitian immigrants, and intravenous drug users are the "privileged" victims of an awful immune-system disease that marks (inscribes on the body) confusion of boundaries and moral pollution.

But these excursions into communications sciences and biology have been at a rarefied level; there is a mundane, largely economic reality to support my claim that these sciences and technologies indicate fundamental transformations in the structure of the world for us. Communications technologies depend on electronics. Modern states, multinational corporations, military power, welfare-state apparatuses, satellite systems, political processes, fabrication of our imaginations, labor-control systems, medical constructions of our bodies, commercial pornography, the international division of labor, and religious evangelism depend intimately upon electronics. Microelectronics is the technical basis of simulacra, i.e., of copies without originals.

Microelectronics mediates the translations of *labor* into robotics and word processing; *sex* into genetic engineering and reproductive technologies; and *mind* into artificial intelligence and decision procedures. The new biotechnologies concern more than human reproduction. Biology as a powerful engineering science for re-designing materials and processes has revolutionary implications for industry, perhaps most obvious today in areas of fermentation, agriculture, and energy. Communications sciences and biology are constructions of natural-technical objects of knowledge in which the difference between machine and organism is thoroughly blurred; mind, body, and tool are on very intimate terms. The "multinational" material organization of the production and reproduction of daily life and the symbolic organization of the production and reproduction of culture and imagination seem equally implicated. The boundary-maintaining images of base and super-structure, public and private, or material and ideal never seemed more feeble.

I have used Rachel Grossman's image of women in the integrated circuit to name the situation of women in a world so inti-

mately restructured through the social relations of science and technology.[18] I use the odd circumlocution, "the social relations of science and technology," to indicate that we are not dealing with a technological determinism, but with a historical system depending upon structured relations among people. But the phrase should also indicate that science and technology provide fresh sources of power, that we need fresh sources of analysis and political action.[19] Some of the rearrangements of race, sex, and class rooted in high-tech-facilitated social relations can make socialist feminism more relevant to effective progressive politics.

The Homework Economy

THE "NEW INDUSTRIAL REVOLUTION" is producing a new worldwide working class. The extreme mobility of capital and the emerging international division of labor are intertwined with the emergence of new collectivities, and the weakening of familiar groupings. These developments are neither gender- nor race-neutral. White men in advanced industrial societies have become newly vulnerable to permanent job loss, and women are not disappearing from the job rolls at the same rates as men. It is not simply that women in third-world countries are the preferred labor force for the science-based multinationals in the export-processing sectors, particularly in electronics. The picture is more systematic and involves reproduction, sexuality, culture, consumption, and production. In the prototypical Silicon Valley, many women's lives have been structured around employment in electronics-dependent jobs, and their intimate realities include serial heterosexual monogamy, negotiating childcare, distance from extended kin or most other forms of traditional community, a high likelihood of loneliness and extreme economic vulnerability as they age. The ethnic and racial diversity of women in Silicon Valley structures a microcosm of conflicting differences in culture, family, religion, education, language.

Richard Gordon has called this new situation the homework economy.[20] Although he includes the phenomenon of literal homework emerging in connection with electronics assembly, Gordon intends "homework economy" to name a restructuring of work that broadly has the characteristics formerly ascribed to female jobs, jobs literally done only by women. Work is being redefined as both literally female and feminized, whether performed by men

or women. To be feminized means to be made extremely vulnerable; able to be disassembled, reassembled, exploited as a reserve labor force; seen less as workers than as servers; subjected to time arrangements on and off the paid job that make a mockery of a limited work day; leading an existence that always borders on being obscene, out of place, and reducible to sex. Deskilling is an old strategy newly applicable to formerly privileged workers. However, the homework economy does not refer only to large-scale deskilling, nor does it deny that new areas of high skill are emerging, even for women and men previously excluded from skilled employment. Rather, the concept indicates that factory, home, and market are integrated on a new scale and that the places of women are crucial—and need to be analyzed for differences among women and for meanings for relations between men and women in various situations.

The homework economy as a world capitalist organizational structure is made possible by (not caused by) the new technologies. The successs of the attack on relatively privileged, mostly white, men's unionized jobs is tied to the power of the new communications technologies to integrate and control labor despite extensive dispersion and decentralization. The consequences of the new technologies are felt by women both in the loss of the family (male) wage (if they ever had access to this white privilege) and in the character of their own jobs, which are becoming capital-intensive, e.g., office work and nursing.

The new economic and technological arrangements are also related to the collapsing welfare state and the ensuing intensification of demands on women to sustain daily life for themselves as well as for men, children, and old people. The feminization of poverty—generated by dismantling the welfare state, by the homework economy where stable jobs become the exception, and sustained by the expectation that women's wage will not be matched by a male income for the support of children—has become an urgent focus. The causes of various women-headed households are a function of race, class, or sexuality; but their increasing generality is a ground for coalitions of women on many issues. That women regularly sustain daily life partly as a function of their enforced status as mothers is hardly new; the kind of integration with the overall capitalist and progressively war-based economy is new. The particular pressure, for example, on u.s. black women, who have achieved an escape from (barely) paid domestic service

and who now hold clerical and similar jobs in large numbers, has large implications for continued enforced black poverty *with* employment. Teenage women in industrializing areas of the third world increasingly find themselves the sole or major source of a cash wage for their families, while access to land is ever more problematic. These developments must have major consequences in the psychodynamics and politics of gender and race.

Within the framework of three major stages of capitalism (commercial/early industrial, monopoly, multinational)—tied to nationalism, imperialism, and multinationalism, and related to Jameson's three dominant aesthetic periods of realism, modernism, and postmodernism—I would argue that specific forms of families dialectically relate to forms of capital and to its political and cultural concomitants. Although lived problematically and unequally, ideal forms of these families might be schematized as (1) the patriarchal nuclear family, structured by the dichotomy between public and private and accompanied by the white bourgeois ideology of separate spheres and nineteenth-century Anglo-American bourgeois feminism; (2) the modern family mediated (or enforced) by the welfare state and institutions like the family wage, with a flowering of a-feminist heterosexual ideologies, including their radical versions represented in Greenwich Village around World War 1; and (3) the "family" of the homework economy with its oxymoronic structure of women-headed households and its explosion of feminisms and the paradoxical intensification and erosion of gender itself.

This is the context in which the projections for worldwide structural unemployment stemming from the new technologies are part of the picture of the homework economy. As robotics and related technologies put men out of work in "developed" countries and exacerbate failure to generate male jobs in third-world "development," and as the automated office becomes the rule even in labor-surplus countries, the feminization of work intensifies. Black women in the United States have long known what it looks like to face the structural underemployment ("feminization") of black men, as well as their own highly vulnerable position in the wage economy. It is no longer a secret that sexuality, reproduction, family, and community life are interwoven with this economic structure in myriad ways which have also differentiated the situations of white and black women. Many more women and men will contend with similar situations, which will make cross-gender

and race alliances on issues of basic life support (with or without jobs) necessary, not just nice.

THE NEW TECHNOLOGIES also have a profound effect on hunger and on food production for subsistence worldwide. Rae Lessor Blumberg estimates that women produce about fifty per cent of the world's subsistence food.[21] ★ Women are excluded generally from benefiting from the increased high-tech commodification of food and energy crops, their days are made more arduous because their responsibilities to provide food do not diminish, and their reproductive situations are made more complex. Green Revolution technologies interact with other high-tech industrial production to alter gender divisions of labor and differential gender migration patterns.

The new technologies seem deeply involved in the forms of "privatization" that Ros Petchesky has analyzed, in which militarization, right-wing family ideologies and policies, and intensified definitions of corporate property as private synergistically interact.[22] The new communications technologies are fundamental to the eradication of "public life" for everyone. This facilitates the mushrooming of a permanent high-tech military establishment at the cultural and economic expense of most people, but especially of women. Technologies like video games and highly miniaturized television seem crucial to production of modern forms of "private life." The culture of video games is heavily oriented to individual competition and extraterrestrial warfare. High-tech, gendered imaginations are produced here, imaginations that can contemplate destruction of the planet and a sci-fi escape from its consequences. More than our imaginations is militarized; and the other realities of electronic and nuclear warfare are inescapable.

The new technologies affect the social relations of both sexuality and of reproduction, and not always in the same ways. The close ties of sexuality and instrumentality, of views of the body as a kind of private satisfaction- and utility-maximizing machine, are de-

★The conjunction of the Green Revolution's social relations with biotechnologies like plant genetic engineering makes the pressures on land in the third world increasingly intense. AID's estimates (*New York Times,* 14 October 1984) used at the 1984 World Food Day are that in Africa, women produce about 90 per cent of rural food supplies, about 60–80 per cent in Asia, and provide 40 per cent of agricultural labor in the Near East and Latin America. Blumberg charges that world organizations' agricultural politics, as well as

scribed nicely in sociobiological origin stories that stress a genetic calculus and explain the inevitable dialectic of domination of male and female gender roles.[23] These sociobiological stories depend on a high-tech view of the body as a biotic component or cybernetic communications system. Among the many transformations of reproductive situations is the medical one, where women's bodies have boundaries newly permeable to both "visualization" and "intervention." Of course, who controls the interpretation of bodily boundaries in medical hermeneutics is a major feminist issue. The speculum served as an icon of women's claiming their bodies in the 1970s; that hand-craft tool is inadequate to express our needed body politics in the negotiation of reality in the practices of cyborg reproduction. Self-help is not enough. The technologies of visualization recall the important cultural practice of hunting with the camera and the deeply predatory nature of a photographic consciousness.[24] Sex, sexuality, and reproduction are central actors in high-tech myth systems structuring our imaginations of personal and social possibility.

Another critical aspect of the social relations of the new technologies is the reformulation of expectations, culture, work, and reproduction for the large scientific and technical work force. A major social and political danger is the formation of a strongly bimodal social structure, with the masses of women and men of all ethnic groups, but especially people of color, confined to a home-work economy, illiteracy of several varieties, and general redundancy and impotence, controlled by high-tech repressive apparatuses ranging from entertainment to surveillance and disappearance. An adequate socialist-feminist politics should address women in the privileged occupational categories, and particularly in the production of science and technology that constructs scientific-technical discourses, processes, and objects.[25]

This issue is only one aspect of inquiry into the possibility of a feminist science, but it is important. What kind of constitutive role in the production of knowledge, imagination, and practice can new groups doing science have? How can these groups be allied with progressive social and political movements? What kind of

those of multinationals and national governments in the third world, generally ignore fundamental issues in the sexual division of labor. The present tragedy of famine in Africa might owe as much to male supremacy as to capitalism, colonialism, and rain patterns. More accurately, capitalism and racism are usually structurally male dominant.

political accountability can be constructed to tie women together across the scientific-technical hierarchies separating us? Might there be ways of developing feminist science/technology politics in alliance with anti-military science facility conversion action groups? Many scientific and technical workers in Silicon Valley, the high-tech cowboys included, do not want to work on military science.[26] Can these personal preferences and cultural tendencies be welded into progressive politics among this professional middle class in which women, including women of color, are coming to be fairly numerous?

Women in the Integrated Circuit

L ET ME SUMMARIZE the picture of women's historical locations in advanced industrial societies, as these positions have been restructured partly through the social relations of science and technology. If it was ever possible ideologically to characterize women's lives by the distinction of public and private domains—suggested by images of the division of working-class life into factory and home, of bourgeois life into market and home, and of gender existence into personal and political realms—it is now a totally misleading ideology, even to show how both terms of these dichotomies construct each other in practice and in theory. I prefer a network ideological image, suggesting the profusion of spaces and identities and the permeability of boundaries in the personal body and in the body politic. "Networking" is both a feminist practice and a multinational corporate strategy—weaving is for oppositional cyborgs.

The only way to characterize the informatics of domination is as a massive intensification of insecurity and cultural impoverishment, with common failure of subsistence networks for the most vulnerable. Since much of this picture interweaves with the social relations of science and technology, the urgency of a socialist-feminist politics addressed to science and technology is plain. There is much now being done, and the grounds for political work are rich. For example, the efforts to develop forms of collective struggle for women in paid work, like SEIU's District 925, should be a high priority for all of us. These efforts are profoundly tied to technical restructuring of labor processes and reformations of working classes. These efforts also are providing understanding of a more comprehensive kind of labor organization, involving com-

munity, sexuality, and family issues never privileged in the largely white male industrial unions.

The structural rearrangements related to the social relations of science and technology evoke strong ambivalence. But it is not necessary to be ultimately depressed by the implications of late-twentieth-century women's relation to all aspects of work, culture, production of knowledge, sexuality, and reproduction. For excellent reasons, most Marxisms see domination best and have trouble understanding what can only look like false consciousness and people's complicity in their own domination in late capitalism. It is crucial to remember that what is lost, perhaps especially from women's points of view, is often virulent forms of oppression, nostalgically naturalized in the face of current violation. Ambivalence toward the disrupted unities mediated by high-tech culture requires not sorting consciousness into categories of "clear-sighted critique grounding a solid political epistemology" versus "manipulated false consciousness," but subtle understanding of emerging pleasures, experiences, and powers with serious potential for changing the rules of the game.

There are grounds for hope in the emerging bases for new kinds of unity across race, gender, and class, as these elementary units of socialist-feminist analysis themselves suffer protean transformations. Intensifications of hardship experienced worldwide in connection with the social relations of science and technology are severe. But what people are experiencing is not transparently clear, and we lack sufficiently subtle connections for collectively building effective theories of experience. Present efforts—Marxist, psychoanalytic, feminist, anthropological—to clarify even "our" experience are rudimentary.

I am conscious of the odd perspective provided by my historical position—a Ph.D. in biology for an Irish Catholic girl was made possible by Sputnik's impact on U.S. national science-education policy. I have a body and mind as much constructed by the post-World War II arms race and cold war as by the women's movements. There are more grounds for hope by focusing on the contradictory effects of politics designed to produce loyal American technocrats, which as well produced large numbers of dissidents, rather than by focusing on the present defeats.

The permanent partiality of feminist points of view has consequences for our expectations of forms of political organization and

participation. We do not need a totality in order to work well. The feminist dream of a common language, like all dreams for a perfectly true language, of perfectly faithful naming of experience, is a totalizing and imperialist one. In that sense, dialectics too is a dream language, longing to resolve contradiction. Perhaps, ironically, we can learn from our fusions with animals and machines how not to be Man, the embodiment of Western logos. From the point of view of pleasure in these potent and taboo fusions, made inevitable by the social relations of science and technology, there might indeed be a feminist science.

Cyborgs: A Myth of Political Identity

I WANT TO CONCLUDE with a myth about identity and boundaries which might inform late-twentieth-century political imaginations. I am indebted in this story to writers like Joanna Russ, Samuel Delaney, John Varley, James Tiptree, Jr., Octavia Butler, Monique Wittig, and Vonda McIntyre.[27] These are our storytellers exploring what it means to be embodied in high-tech worlds. They are theorists for cyborgs. Exploring conceptions of bodily boundaries and social order, the anthropologist Mary Douglas should be credited with helping us to consciousness about how fundamental body imagery is to world view, and so to political language.[28] French feminists like Luce Irigaray and Monique Wittig, for all their differences, know how to write the body, how to weave eroticism, cosmology, and politics from imagery of embodiment, and especially for Wittig, from imagery of fragmentation and reconstitution of bodies.[29]

American radical feminists like Susan Griffin, Audre Lorde, and Adrienne Rich have profoundly affected our political imaginations—and perhaps restricted too much what we allow as a friendly body and political language.[30] They insist on the organic, opposing it to the technological. But their symbolic systems and the related positions of ecofeminism and feminist paganism, replete with organicisms, can only be understood in Sandoval's terms as oppositional ideologies fitting the late twentieth century. They would simply bewilder anyone not preoccupied with the machines and consciousness of late capitalism. In that sense they are part of the cyborg world. But there are also great riches for feminists in explicitly embracing the possibilities inherent in the breakdown of clean distinctions between organism and machine and similar dis-

tinctions structuring the Western self. It is the simultaneity of breakdowns that cracks the matrices of domination and opens geometric possibilities. What might be learned from personal and political "technological" pollution? I will look briefly at two overlapping groups of texts for their insight into the construction of a potentially helpful cyborg myth: constructions of women of color and monstrous selves in feminist science fiction.

Earlier I suggested that "women of color" might be understood as a cyborg identity, a potent subjectivity synthesized from fusions of outsider identities. There are material and cultural grids mapping this potential. Audre Lorde captures the tone in the title of her *Sister Outsider.* In my political myth, Sister Outsider is the offshore woman, whom U.S. workers, female and feminized, are supposed to regard as the enemy preventing their solidarity, threatening their security. Onshore, inside the boundary of the United States, Sister Outsider is a potential amidst the races and ethnic identities of women manipulated for division, competition, and exploitation in the same industries. "Women of color" are the preferred labor force for the science-based industries, the real women for whom the worldwide sexual market, labor market, and politics of reproduction kaleidoscope into daily life. Young Korean women hired in the sex industry and in electronics assembly are recruited from high schools, educated for the integrated circuit. Literacy, especially in English, distinguishes the "cheap" female labor so attractive to the multinationals.

Contrary to orientalist stereotypes of the "oral primitive," literacy is a special mark of women of color, acquired by U.S. black women as well as men through a history of risking death to learn and to teach reading and writing. Writing has a special significance for all colonized groups. Writing has been crucial to the Western myth of the distinction of oral and written cultures, primitive and civilized mentalities, and more recently to the erosion of that distinction in "post-modernist" theories attacking the phallogocentrism of the West, with its worship of the monotheistic, phallic, authoritative, and singular word, the unique and perfect name.[31] Contests for the meanings of writing are a major form of contemporary political struggle. Releasing the play of writing is deadly serious. The poetry and stories of U.S. women of color are repeatedly about writing, about access to the power to signify; but this time that power must be neither phallic nor innocent. Cyborg writing must not be about the Fall, the imagination of a once-

upon-a-time wholeness before language, before writing, before
Man. Cyborg writing is about the power to survive, not on the
basis of original innocence, but on the basis of seizing the tools to
mark the world that marked them as other.

The tools are often stories, retold stories, versions that reverse
and displace the hierarchical dualisms of naturalized identities. In
retelling origin stories, cyborg authors subvert the central myths
of origin of Western culture. We have all been colonized by those
origin myths, with their longing for fulfillment in apocalypse. The
phallogocentric origin stories most crucial for feminist cyborgs are
built into the literal technologies—technologies that write the
world, biotechnology and microelectronics—that have recently
textualized our bodies as code problems on the grid of c³i. Femi-
nist cyborg stories have the task of recoding communication and
intelligence to subvert command and control.

Figuratively and literally, language politics pervade the struggles
of women of color; and stories about language have a special
power in the rich contemporary writing by u.s. women of color.
For example, retellings of the story of the indigenous woman
Malinche, mother of the mestizo "bastard" race of the new world,
master of languages, and mistress of Cortés, carry special meaning
for Chicana constructions of identity. Cherrie Moraga in *Loving in
the War Years* explores the themes of identity when one never pos-
sessed the original language, never told the original story, never
resided in the harmony of legitimate heterosexuality in the garden
of culture, and so cannot base identity on a myth or a fall from
innocence and right to natural names, mother's or father's.[32]
Moraga's writing, her superb literacy, is presented in her poetry as
the same kind of violation as Malinche's mastery of the conquerer's
language—a violation, an illegitimate production, that allows sur-
vival. Moraga's language is not "whole"; it is self-consciously
spliced, a chimera of English and Spanish, both conqueror's lan-
guages. But it is this chimeric monster, without claim to an origi-
nal language before violation, that crafts the erotic, competent,
potent identities of women of color. Sister Outsider hints at the
possibility of world survival not because of her innocence, but
because of her ability to live on the boundaries, to write without
the founding myth of original wholeness, with its inescapable
apocalypse of final return to a deathly oneness that Man has imag-
ined to be the innocent and all-powerful Mother, freed at the End
from another spiral of appropriation by her son. Writing marks

Moraga's body, affirms it as the body of a woman of color, against the possibility of passing into the unmarked category of the Anglo father or into the orientalist myth of "original illiteracy" of a mother that never was. Malinche was mother here, not Eve before eating the forbidden fruit. Writing affirms Sister Outsider, not the Woman-before-the-Fall-into-Writing needed by the phallogocentric Family of Man.

WRITING IS PRE-EMINENTLY the technology of cyborgs, etched surfaces of the late twentieth century. Cyborg politics is the struggle for language and the struggle against perfect communication, against the one code that translates all meaning perfectly, the central dogma of phallogocentrism. That is why cyborg politics insist on noise and advocate pollution, rejoicing in the illegitimate fusions of animal and machine. These are the couplings which make Man and Woman so problematic, subverting the structure of desire, the force imagined to generate language and gender, and so subverting the structure and modes of reproduction of "Western" identity, of nature and culture, of mirror and eye, slave and master, body and mind. "We" did not originally choose to be cyborgs, but choice grounds a liberal politics and epistemology that imagines the reproduction of individuals before the wider replications of "texts."

From the perspective of cyborgs, freed of the need to ground politics in "our" privileged position of the oppression that incorporates all other dominations, the innocence of the merely violated, the ground of those closer to nature, we can see powerful possibilities. Feminisms and Marxisms have run aground on Western epistemological imperatives to construct a revolutionary subject from the perspective of a hierarchy of oppressions and/or a latent position of moral superiority, innocence, and greater closeness to nature. With no available original dream of a common language or original symbiosis promising protection from hostile "masculine" separation, but written into the play of a text that has no finally privileged reading or salvation history, to recognize "oneself" as fully implicated in the world, frees us of the need to root politics in identification, vanguard parties, purity, and mothering. Stripped of identity, the bastard race teaches about the power of the margins and the importance of a mother like Malinche. Women of color have transformed her from the evil mother of masculinist fear into the originally literate mother who teaches survival.

This is not just literary deconstruction, but liminal transformation. Every story that begins with original innocence and privileges the return to wholeness imagines the drama of life to be individuation, separation, the birth of the self, the tragedy of autonomy, the fall into writing, alienation; i.e., war, tempered by imaginary respite in the bosom of the Other. These plots are ruled by a reproductive politics—rebirth without flaw, perfection, abstraction. In this plot women are imagined either better or worse off, but all agree they have less selfhood, weaker individuation, more fusion to the oral, to Mother, less at stake in masculine autonomy. But there is another route to having less at stake in masculine autonomy, a route that does not pass through Woman, Primitive, Zero, the Mirror Stage and its imaginary. It passes through women and other present-tense, illegitimate cyborgs, not of Woman born, who refuse the ideological resources of victimization so as to have a real life. These cyborgs are the people who refuse to disappear on cue, no matter how many times a "Western" commentator remarks on the sad passing of another primitive, another organic group done in by "Western" technology, by writing.[33] These real-life cyborgs, e.g., the Southeast Asian village women workers in Japanese and U.S. electronics firms described by Aiwa Ong, are actively rewriting the texts of their bodies and societies. Survival is the stakes in this play of readings.

TO RECAPITULATE, certain dualisms have been persistent in Western traditions; they have all been systemic to the logics and practices of domination of women, people of color, nature, workers, animals—in short, domination of all constituted as *others*, whose task is to mirror the self. Chief among these troubling dualisms are self/other, mind/body, culture/nature, male/female, civilized/primitive, reality/appearance, whole/part, agent/resource, maker/made, active/passive, right/wrong, truth/illusion, total/partial, God/man. The self is the One who is not dominated, who knows that by the service of the other; the other is the one who holds the future, who knows that by the experience of domination, which gives the lie to the autonomy of the self. To be One is to be autonomous, to be powerful, to be God; but to be One is to be an illusion, and so to be involved in a dialectic of apocalypse with the other. Yet to be other is to be multiple, without clear boundary, frayed, insubstantial. One is too few, but two are too many.

High-tech culture challenges these dualisms in intriguing ways. It is not clear who makes and who is made in the relation between human and machine. It is not clear what is mind and what body in machines that resolve into coding practices. Insofar as we know ourselves in both formal discourse (e.g., biology) and in daily practice (e.g., the homework economy in the integrated circuit), we find ourselves to be cyborgs, hybrids, mosaics, chimeras. Biological organisms have become biotic systems, communications devices like others. There is no fundamental, ontological separation in our formal knowledge of machine and organism, of technical and organic.

One consequence is that our sense of connection to our tools is heightened. The trance state experienced by many computer users has become a staple of science-fiction film and cultural jokes. Perhaps paraplegics and other severely handicapped people can (and sometimes do) have the most intense experiences of complex hybridization with other communication devices. Anne McCaffrey's *The Ship Who Sang* explored the consciousness of a cyborg, hybrid of girl's brain and complex machinery, formed after the birth of a severely handicapped child. Gender, sexuality, embodiment, skill: all were reconstituted in the story. Why should our bodies end at the skin, or include at best other beings encapsulated by skin? From the seventeenth century till now, machines could be animated—given ghostly souls to make them speak or move or to account for their orderly development and mental capacities. Or organisms could be mechanized—reduced to body understood as resource of mind. These machine/organism relationships are obsolete, unnecessary. For us, in imagination and in other practice, machines can be prosthetic devices, intimate components, friendly selves. We don't need organic holism to give impermeable wholeness, the total woman and her feminist variants (mutants?). Let me conclude this point by a very partial reading of the logic of the cyborg monsters of my second group of texts, feminist science fiction.

THE CYBORGS populating feminist science fiction make very problematic the statuses of man or woman, human, artifact, member of a race, individual identity, or body. Katie King clarifies how pleasure in reading these fictions is not largely based on identification. Students facing Joanna Russ for the first time, students who have learned to take modernist writers like James Joyce or

Virginia Woolf without flinching, do not know what to make of *The Adventures of Alyx* or *The Female Man,* where characters refuse the reader's search for innocent wholeness while granting the wish for heroic quests, exuberant eroticism, and serious politics. *The Female Man* is the story of four versions of one genotype, all of whom meet, but even taken together do not make a whole, resolve the dilemmas of violent moral action, nor remove the growing scandal of gender. The feminist science fiction of Samuel Delany, especially *Tales of Neveryon,* mocks stories of origin by redoing the neolithic revolution, replaying the founding moves of Western civilization to subvert their plausibility. James Tiptree, Jr., an author whose fiction was regarded as particularly manly until her "true" gender was revealed, tells tales of reproduction based on non-mammalian technologies like alternation of generations or male brood pouches and male nurturing. John Varley constructs a supreme cyborg in his arch-feminist exploration of Gaea, a mad goddess–planet–trickster–old woman–technological device on whose surface an extraordinary array of post-cyborg symbioses are spawned. Octavia Butler writes of an African sorceress pitting her powers of transformation against the genetic manipulations of her rival (*Wild Seed*), of time warps that bring a modern u.s. black woman into slavery where her actions in relation to her white master-ancestor determine the possibility of her own birth (*Kindred*), and of the illegitimate insights into identity and community of an adopted cross-species child who came to know the enemy as self (*Survivor*).

Because it is particularly rich in boundary transgressions, Vonda McIntyre's *Superluminal* can close this truncated catalogue of promising monsters who help redefine the pleasures and politics of embodiment and feminist writing. In a fiction where no character is "simply" human, human status is highly problematic. Orca, a genetically altered diver, can speak with killer whales and survive deep ocean conditions, but she longs to explore space as a pilot, necessitating bionic implants jeopardizing her kinship with the divers and cetaceans. Transformations are effected by virus vectors carrying a new developmental code, by transplant surgery, by implants of microelectronic devices, by analogue doubles, and other means. Laenea becomes a pilot by accepting a heart implant and a host of other alterations allowing survival in transit at speeds exceeding that of light. Radu Dracul survives a virus-caused plague on his outerworld planet to find himself with a time sense that

changes the boundaries of spatial perception for the whole species. All the characters explore the limits of language, the dream of communicating experience, and the necessity of limitation, partiality, and intimacy even in this world of protean transformation and connection.

MONSTERS HAVE ALWAYS defined the limits of community in Western imaginations. The Centaurs and Amazons of ancient Greece established the limits of the centered polis of the Greek male human by their disruption of marriage and boundary pollutions of the warrior with animality and woman. Unseparated twins and hermaphrodites were the confused human material in early modern France who grounded discourse on the natural and supernatural, medical and legal, portents and diseases—all crucial to establishing modern identity.[34] The evolutionary and behavioral sciences of monkeys and apes have marked the multiple boundaries of late-twentieth-century industrial identities. Cyborg monsters in feminist science fiction define quite different political possibilities and limits from those proposed by the mundane fiction of Man and Woman.

There are several consequences to taking seriously the imagery of cyborgs as other than our enemies. Our bodies, ourselves; bodies are maps of power and identity. Cyborgs are no exceptions. A cyborg body is not innocent; it was not born in a garden; it does not seek unitary identity and so generate antagonistic dualisms without end (or until the world ends); it takes irony for granted. One is too few, and two is only one possibility. Intense pleasure in skill, machine skill, ceases to be a sin, but an aspect of embodiment. The machine is not an *it* to be animated, worshiped and dominated. The machine is us, our processes, an aspect of our embodiment. We can be responsible for machines; *they* do not dominate or threaten us. We are responsible for boundaries; we are they. Up till now (once upon a time), female embodiment seemed to be given, organic, necessary; and female embodiment seemed to mean skill in mothering and its metaphoric extensions. Only by being out of place could we take intense pleasure in machines, and then with excuses that this was organic activity after all, appropriate to females. Cyborgs might consider more seriously the partial, fluid, sometimes aspect of sex and sexual embodiment. Gender might not be global identity after all.

The ideologically charged question of what counts as daily activity, as experience, can be approached by exploiting the cyborg image. Feminists have recently claimed that women are given to dailiness, that women more than men somehow sustain daily life, and so have a privileged epistemological position potentially. There is a compelling aspect to this claim, one that makes visible unvalued female activity and names it as the ground of life. But *the* ground of life? What about all the ignorance of women, all the exclusions and failures of knowledge and skill? What about men's access to daily competence, to knowing how to build things, to take them apart, to play? What about other embodiments? Cyborg gender is a local possibility taking a global vengeance. Race, gender, and capital require a cyborg theory of wholes and parts. There is no drive in cyborgs to produce total theory, but there is an intimate experience of boundaries, their construction and deconstruction. There is a myth system waiting to become a political language to ground one way of looking at science and technology and challenging the informatics of domination.

One last image: organisms and organismic, holistic politics depend on metaphors of rebirth and invariably call on the resources of reproductive sex. I would suggest that cyborgs have more to do with regeneration and are suspicious of the reproductive matrix and of most birthing. For salamanders, regeneration after injury, such as the loss of a limb, involves regrowth of structure and restoration of function with the constant possibility of twinning or other odd topographical productions at the site of former injury. The regrown limb can be monstrous, duplicated, potent. We have all been injured, profoundly. We require regeneration, not rebirth, and the possibilities for our reconstitution include the utopian dream of the hope for a monstrous world without gender.

Cyborg imagery can help express two crucial arguments in this essay: (1) the production of universal, totalizing theory is a major mistake that misses most of reality, probably always, but certainly now; (2) taking responsibility for the social relations of science and technology means refusing an anti-science metaphysics, a demonology of technology, and so means embracing the skillful task of reconstructing the boundaries of daily life, in partial connection with others, in communication with all of our parts. It is not just that science and technology are possible means of great human satisfaction, as well as a matrix of complex dominations. Cyborg imagery can suggest a way out of the maze of dualisms in which

we have explained our bodies and our tools to ourselves. This is a dream not of a common language, but of a powerful infidel heteroglossia. It is an imagination of a feminist speaking in tongues to strike fear into the circuits of the super-savers of the new right. It means both building and destroying machines, identities, categories, relationships, spaces, stories. Though both are bound in the spiral dance, I would rather be a cyborg than a goddess.

ACKNOWLEDGMENTS

Research was funded by an Academic Senate Faculty Research Grant from the University of California, Santa Cruz. An earlier version of the paper on genetic engineering appeared as "Lieber Kyborg als Gottin: Für eine sozialistisch-feministische Unterwanderung der Gentechnologie," in Bernd-Peter Lange and Anna Marie Stuby, eds., *1984* (Berlin: Argument-Sonderband 105, 1984), pp. 66-84. The cyborg manifesto grew from "New Machines, New Bodies, New Communities: Political Dilemmas of a Cyborg Feminist," *The Scholar and the Feminist* X: *The Question of Technology,* Conference, April 1983.

The people associated with the History of Consciousness Board of UCSC have had an enormous influence on this paper, so that it feels collectively authored more than most, although those I cite may not recognize their ideas. In particular, members of graduate and undergraduate feminist theory, science and politics, and theory and methods courses have contributed to the cyborg manifesto. Particular debts here are due Hilary Klein ("Marxism, Psychoanalysis, and Mother Nature"); Paul Edwards ("Border Wars: The Science and Politics of Artificial Intelligence"); Lisa Lowe ("Julia Kristeva's *Des Chinoises:* Representing Cultural and Sexual Others"); Jim Clifford, "On Ethnographic Allegory: Essays," forthcoming.

Parts of the paper were my contribution to a collectively developed session, Poetic Tools and Political Bodies: Feminist Approaches to High Technology Culture, 1984 California American Studies Association, with History of Consciousness graduate students Zoe Sofoulis, "Jupiter Space"; Katie King, "The Pleasures of Repetition and the Limits of Identification in Feminist Science Fiction: Reimaginations of the Body after the Cyborg"; and Chela Sandoval, "The Construction of Subjectivity and Oppositional Consciousness in Feminist Film and Video." Sandoval's theory of oppositional consciousness was published as "Women Respond to Racism: A Report on the National Women's Studies Association Conference," Center for Third World Organizing, Oakland, California, n.d. For Sofoulis's semiotic-psychoanalytic readings of nuclear culture, see Z. Sofia, "Exterminating Fetuses: Abortion, Disarmament and the Sexo-Semiotics of Extraterrestrialism," Nuclear Criticism issue, *Diacritics,* vol. 14, no. 2 (1984), pp. 47-59. King's manuscripts ("Questioning Tradition: Canon Formation and the Veiling of Power"; "Gender and Genre: Reading the Science Fiction of Joanna Russ"; "Varley's *Titan* and *Wizard:* Feminist Parodies of Nature, Culture, and Hardware") deeply inform the cyborg manifesto.

Barbara Epstein, Jeff Escoffier, Rusten Hogness, and Jaye Miller gave extensive discussion and editorial help. Members of the Silicon Valley Research Project of USCS and participants in SVRP conferences and workshops have been very important, especially Rick Gordon, Linda Kimball, Nancy Snyder,

Langdon Winner, Judith Stacey, Linda Lim, Patricia Fernandez-Kelly, and Judith Gregory. Finally, I want to thank Nancy Hartsock for years of friendship and discussion on feminist theory and feminist science fiction.

REFERENCES

1 Useful references to left and/or feminist radical science movements and theory and to biological/biotechnological issues include: Ruth Bleier, *Science and Gender: A Critique of Biology and Its Themes on Women* (New York: Pergamon, 1984); Elizabeth Fee, "Critiques of Modern Science: The Relationship of Feminist and Other Radical Epistemologies," and Evelyn Hammonds, "Women of Color, Feminism and Science," papers for Symposium on Feminist Perspectives on Science, University of Wisconsin, 11–12 April, 1985 (proceedings to be published by Pergamon); Stephen J. Gould, *Mismeasure of Man* (New York: Norton, 1981); Ruth Hubbard, Mary Sue Henifin, Barbara Fried, eds., *Biological Woman, the Convenient Myth* (Cambridge, Mass.: Schenkman, 1982); Evelyn Fox Keller, *Reflections on Gender and Science* (New Haven: Yale University Press, 1985); R. C. Lewontin, Steve Rose, and Leon Kamin, *Not in Our Genes* (New York: Pantheon, 1984): *Radical Science Journal*, 26 Freegrove Road, London N7 9RQ; *Science for the People*, 897 Main St., Cambridge, MA 02139.

2 Starting points for left and/or feminist approaches to technology and politics include: Ruth Schwartz Cowan, *More Work for Mother: The Ironies of Household Technology from the Open Hearth to the Microwave* (New York: Basic Books, 1983); Joan Rothschild, *Machina ex Dea: Feminist Perspectives on Technology* (New York: Pergamon, 1983); Sharon Traweek, "Uptime, Downtime, Spacetime, and Power: An Ethnography of U.S. and Japanese Particle Physics," Ph.D. thesis, UC Santa Cruz, History of Consciousness, 1982; R. M. Young and Les Levidov, eds., *Science, Technology, and the Labour Process*, vols. 1–3 (London: CSE Books); Joseph Weizenbaum, *Computer Power and Human Reason* (San Francisco: Freeman, 1976); Langdon Winner, *Autonomous Technology: Technics Out of Control as a Theme in Political Thought* (Cambridge, Mass.: MIT Press, 1977); Langdon Winner, "Paths in Technopolis," esp. "Mythinformation in the High Tech Era" (in ms., forthcoming); Jan Zimmerman, ed., *The Technological Woman: Interfacing with Tomorrow* (New York: Praeger, 1983); *Global Electronics Newsletter*, 867 West Dana St., #204, Mountain View, CA 94041; *Processed World*, 55 Sutter St., San Francisco, CA 94104; *ISIS*, Women's International Information and Communication Service, P.O. Box 50 (Cornavin), 1211 Geneva 2, Switzerland, and Via Santa Maria dell'Anima 30, 00186 Rome, Italy. Fundamental approaches to modern social studies of science that do not continue the liberal mystification that it all started with Thomas Kuhn, include: Karin Knorr-Cetina, *The Manufacture of Knowledge* (Oxford: Pergamon, 1981); K. D. Knorr-Cetina and Michael Mulkay, eds., *Science Observed: Perspectives on the Social Study of Science* (Beverly Hills, Calif.: Sage, 1983); Bruno Latour and Steve Woolgar, *Laboratory Life: The Social Construction of Scientific Facts* (Beverly Hills, Calif.: Sage, 1979); Robert M. Young, "Interpreting the Production of Science," *New Scientist*, vol. 29 (March 1979), pp. 1026–1028. More is claimed than is known about room for contesting productions of science in the mythic/material space of "the laboratory"; the 1984 Directory of the Network for the Ethnographic Study of Science, Technology, and Organizations lists a

wide range of people and projects crucial to better radical analysis; available from NESSTO, P.O. Box 11442, Stanford, CA 94305.

3 Frederic Jameson, "Post Modernism, or the Cultural Logic of Late Capitalism," *New Left Review*, July/August 1984, pp. 53–94. See Marjorie Perloff, "'Dirty' Language and Scramble Systems," *Sulfur* 11 (1984), pp. 178–183; Kathleen Fraser, *Something (Even Human Voices) in the Foreground, a Lake* (Berkeley, Calif.: Kelsey St. Press, 1984).

4 Frans de Waal, *Chimpanzee Politics: Power and Sex among the Apes* (New York: Harper & Row, 1982); Langdon Winner, "Do artifacts have politics?" *Daedalus*, Winter 1980.

5 Jean Baudrillard, *Simulations*, trans. P. Foss, P. Patton, P. Beitchman (New York: Semiotext(e), 1983). Jameson ("Post modernism," p. 66) points out that Plato's definition of the simulacrum is the copy for which there is no original, i.e., the world of advanced capitalism; of pure exchange.

6 Herbert Marcuse, *One-Dimensional Man* (Boston: Beacon, 1964); Carolyn Merchant, *Death of Nature* (San Francisco: Harper & Row, 1980).

7 Zoe Sofia, "Exterminating Fetuses," *Diacritics*, vol. 14, no. 2 (Summer 1984), pp. 47–59, and "Jupiter Space" (Pomona, Calif: American Studies Association, 1984).

8 Powerful developments of coalition politics emerge from "third world" speakers, speaking from nowhere, the displaced center of the universe, earth: "We live on the third planet from the sun" — *Sun Poem* by Jamaican writer Edward Kamau Braithwaite, review by Nathaniel Mackey, *Sulfur*, 11 (1984), pp. 200–205. *Home Girls*, ed. Barbara Smith (New York: Kitchen Table, Women of Color Press, 1983), ironically subverts naturalized identities precisely while constructing a place from which to speak called home. See esp. Bernice Reagan, "Coalition Politics, Turning the Century," pp. 356–368.

9 Chela Sandoval, "Dis-Illusionment and the Poetry of the Future: The Making of Oppositional Consciousness," Ph.D. qualifying essay, UCSC, 1984.

10 Bell Hooks, *Ain't I a Woman?* (Boston: South End Press, 1981); Gloria Hull, Patricia Bell Scott, and Barbara Smith, eds., *All the Women Are White, All the Men Are Black, But Some of Us Are Brave: Black Women's Studies* (Old Westbury, Conn.: Feminist Press, 1982). Toni Cade Bambara, in *The Salt Eaters* (New York: Vintage/Random House, 1981), writes an extraordinary post-modernist novel, in which the women of color theater group, The Seven Sisters, explores a form of unity. Thanks to Elliott Evans's readings of Bambara, Ph.D. qualifying essay, UCSC, 1984.

11 On orientalism in feminist works and elsewhere, see Lisa Lowe, "Orientation: Representations of Cultural and Sexual 'Others,'" Ph.D. thesis, UCSC; Edward Said, *Orientalism* (New York: Pantheon, 1978).

12 Katie King has developed a theoretically sensitive treatment of the workings of feminist taxonomies as genealogies of power in feminist ideology and polemic: "Prospectus," *Gender and Genre: Academic Practice and the Making of Criticism* (Santa Cruz, Calif.: University of California, 1984). King examines an intelligent, problematic example of taxonomizing feminisms to make a little machine producing the desired final position: Alison Jaggar, *Feminist Politics and Human Nature* (Totowa, N.J.: Rowman & Allanheld, 1983). My caricature here of socialist and radical feminism is also an example.

13 The feminist standpoint argument is being developed by: Jane Flax, "Political Philosophy and the Patriarchal Unconsciousness," in Sandra Hard-

ing and Merill Hintikka, eds., *Discovering Reality* (Dordrecht: Reidel, 1983); Sandra Harding, "The Contradictions and Ambivalence of a Feminist Science," ms.; Harding and Hintikka, *Discovering Reality;* Nancy Hartsock, *Money, Sex, and Power* (New York: Longman, 1983) and "The Feminist Standpoint: Developing the Ground for a Specifically Feminist Historical Materialism," in Harding and Hintikka, *Discovering Reality;* Mary O'Brien, *The Politics of Reproduction* (New York: Routledge & Kegan Paul, 1981); Hilary Rose, "Hand, Brain, and Heart: A Feminist Epistemology for the Natural Sciences," *Signs,* vol. 9, no. 1 (1983), pp. 73-90; Dorothy Smith, "Women's Perspective as a Radical Critique of Sociology," *Sociological Inquiry* 44 (1974), and "A Sociology of Women," in J. Sherman and E. T. Beck, ed., *The Prism of Sex* (Madison: University of Wisconsin Press, 1979).

14 Catherine MacKinnon, "Feminism, Marxism, Method, and the State: An Agenda for Theory," *Signs,* vol. 7, no. 3 (Spring 1982), pp. 515-544. A critique indebted to MacKinnon, but without the reductionism and with an elegant feminist account of Foucault's paradoxical conservatism on sexual violence (rape), is Teresa de Lauretis, "Violence Engendered," forthcoming in *Semiotica,* special issue on "The Rhetoric of Violence," ed. Nancy Armstrong, 1985. A theoretically elegant feminist social-historical examination of family violence, that insists on women's, men's, children's complex agency without losing sight of the material structures of male domination, race, and class, is Linda Gordon, *Cruelty, Love, and Dependence: Family Violence and Social Control, Boston 1880-1960,* forthcoming with Pantheon.

15 My previous efforts to understand biology as a cybernetic command-control discourse and organisms as "natural-technical objects of knowledge" are: "The High Cost of Information in Post-World War II Evolutionary Biology," *Philosophical Forum,* vol. 13, nos. 2-3 (1979), pp. 206-237; "Signs of Dominance: From a Physiology to a Cybernetics of Primate Society," *Studies in History of Biology* 6 (1983), pp. 129-219; "Class, Race, Sex, Scientific Objects of Knowledge: A Socialist-Feminist Perspective on the Social Construction of Productive Knowledge and Some Political Consequences," in Violet Haas and Carolyn Perucci, eds., *Women in Scientific and Engineering Professions* (Ann Arbor: University of Michigan Press, 1984), pp. 212-229.

16 E. Rusten Hogness, "Why Stress? A Look at the Making of Stress, 1936-56," available from the author, 4437 Mill Creek Rd., Healdsburg, CA 95448.

17 A left entry to the biotechnology debate: *GeneWatch,* a Bulletin of the Committee for Responsible Genetics, 5 Doane St., 4th floor, Boston, MA 02109; Susan Wright, forthcoming book and "Recombinant DNA: The Status of Hazards and Controls," *Environment,* July/August 1982; Edward Yoxen, *The Gene Business* (New York: Harper & Row, 1983).

18 Starting references for "women in the integrated circuit": Pamela D'Onofrio-Flores and Sheila M. Pfafflin, eds., *Scientific-Technological Change and the Role of Women in Development* (Boulder, Colo.: Westview Press, 1982); Maria Patricia Fernandez-Kelly, *For We Are Sold, I and My People* (Albany, N.Y.: SUNY Press, 1983); Annette Fuentes and Barbara Ehrenreich, *Women in the Global Factory* (Boston: South End Press, 1983), with an especially useful list of resources and organizations; Rachael Grossman, "Women's Place in the Integrated Circuit," *Radical America,* vol. 14, no. 1 (1980), pp. 29-50; June Nash and M. P. Fernandez-Kelly, eds., *Women and Men and the International Division of Labor* (Albany, N.Y.: SUNY Press, 1983); Aiwa

Ong, "Japanese Factories, Malay Workers: Industrialization and the Cultural Construction of Gender in West Malaysia," in Shelley Errington and Jane Atkinson, eds., *The Construction of Gender,* forthcoming; Science Policy Research Unity, *Microelectronics and Women's Employment in Britain* (University of Sussex, 1982).

19 The best example is Bruno Latour, *Les Microbes: Guerre et Paix, suivi de Irreductions* (Paris: Metailie, 1984).

20 For the homework economy and some supporting arguments: Richard Gordon, "The Computerization of Daily Life, the Sexual Division of Labor, and the Homework Economy," in R. Gordon, ed., *Microelectronics in Transition* (Norwood, N.J.: Ablex, 1985); Patricia Hill Collins, "Third World Women in America," and Sara G. Burr, "Women and Work," in Barbara K. Haber, ed., *The Women's Annual, 1981* (Boston: G. K. Hall, 1982); Judith Gregory and Karen Nussbaum, "Race against Time: Automation of the Office," *Office: Technology and People* 1 (1982), pp. 197-236; Frances Fox Piven and Richard Cloward, *The New Class War: Reagan's Attack on the Welfare State and Its Consequences* (New York: Pantheon, 1982); Microelectronics Group, *Microelectronics: Capitalist Technology and the Working Class* (London: CSE. 1980); Karin Stallard, Barbara Ehrenreich, and Holly Sklar, *Poverty in the American Dream* (Boston: South End Press, 1983), including a useful organization and resource list.

21 Rae Lessor Blumberg, "A General Theory of Sex Stratification and Its Application to the Position of Women in Today's World Economy," paper delivered to Sociology Board, UCSC, February 1983. Also Blumberg, *Stratification: Socioeconomic and Sexual Inequality* (Boston: Brown, 1981). See also Sally Hacker, "Doing It the Hard Way: Ethnographic Studies in the Agribusiness and Engineering Classroom," California American Studies Association, Pomona, 1984, forthcoming in *Humanity and Society;* S. Hacker and Lisa Bovit, "Agriculture to Agribusiness: Technical Imperatives and Changing Roles," *Proceedings* of the Society for the History of Technology, Milwaukee, 1981; Lawrence Busch and William Lacy, *Science, Agriculture, and the Politics of Research* (Boulder, Colo.: Westview Press, 1983); Denis Wilfred, "Capital and Agriculture, a Review of Marxian Problematics," *Studies in Political Economy,* no. 7 (1982), pp. 127-154; Carolyn Sachs, *The Invisible Farmers: Women in Agricultural Production* (Totowa, N.J.: Rowman & Allanheld, 1983). Thanks to Elizabeth Bird, "Green Revolution Imperialism," I & II, ms. UCSC, 1984.

22 Cynthia Enloe, "Women Textile Workers in the Militarization of Southeast Asia," in Nash and Fernandez-Kelly, *Women and Men;* Rosalind Petchesky, "Abortion, Anti-Feminism, and the Rise of the New Right," *Feminist Studies,* vol. 7, no. 2 (1981).

23 For a feminist version of this logic, see Sarah Blaffer Hrdy, *The Woman That Never Evolved* (Cambridge, Mass.: Harvard University Press, 1981). For an analysis of scientific women's story-telling practices, especially in relation to sociobiology, in evolutionary debates around child abuse and infanticide, see Donna Haraway, "The Contest for Primate Nature: Daughters of Man the Hunter in the Field, 1960-80," in Mark Kann, ed., *The Future of American Democracy* (Philadelphia: Temple University Press, 1983), pp. 175-208.

24 For the moment of transition of hunting with guns to hunting with cameras in the construction of popular meanings of nature for an American urban immigrant public, see Donna Haraway, "Teddy Bear Patriarchy," *Social Text,* forthcoming, 1985; Roderick Nash, "The Exporting and Importing of Nature: Nature-Appreciation as a Commodity, 1850-

1980," *Perspectives in American History,* vol. 3 (1979), pp. 517-560; Susan Sontag, *On Photography* (New York: Dell, 1977); and Douglas Preston, "Shooting in Paradise," *Natural History,* vol. 93, no. 12 (December 1984), pp. 14-19.

25 For crucial guidance for thinking about the political/cultural implications of the history of women doing science in the United States, see: Violet Haas and Carolyn Perucci, eds., *Women in Scientific and Engineering Professions* (Ann Arbor: University of Michigan Press, 1984); Sally Hacker, "The Culture of Engineering: Women, Workplace, and Machine," *Women's Studies International Quarterly,* vol. 4, no. 3 (1981), pp. 341-53; Evelyn Fox Keller, *A Feeling for the Organism* (San Francisco: Freeman, 1983); National Science Foundation, *Women and Minorities in Science and Engineering* (Washington, D.C.: NSF, 1982); Margaret Rossiter, *Women Scientists in America* (Baltimore: Johns Hopkins University Press, 1982).

26 John Markoff and Lenny Siegel, "Military Micros," UCSC Silicon Valley Research Project conference, 1983, forthcoming in *Microelectronics and Industrial Transformation.* High Technology Professionals for Peace and Computer Professionals for Social Responsibility are promising organizations.

27 Katie King, "The Pleasure of Repetition and the Limits of Identification in Feminist Science Fiction: Reimaginations of the Body after the Cyborg," California American Studies Association, Pomona, 1984. An abbreviated list of feminist science fiction underlying themes of this essay: Octavia Butler, *Wild Seed, Mind of My Mind, Kindred, Survivor;* Suzy McKee Charnas, *Motherliness;* Samuel Delany, *Tales of Neveryon;* Anne McCaffery, *The Ship Who Sang, Dinosaur Planet;* Vonda McIntyre, *Superluminal, Dreamsnake;* Joanna Russ, *Adventures of Alix, The Female Man;* James Tiptree, Jr., *Star Songs of an Old Primate, Up the Walls of the World;* John Varley, *Titan, Wizard, Demon.*

28 Mary Douglas, *Purity and Danger* (London: Routledge & Kegan Paul, 1966), *Natural Symbols* (London: Cresset Press, 1970).

29 French feminisms contribute to cyborg heteroglossia. Carolyn Burke, "Irigaray through the Looking Glass," *Feminist Studies,* vol. 7, no. 2 (Summer 1981), pp. 288-306; Luce Irigaray, *Ce sexe qui n'en est pas un* (Paris: Minuit, 1977); L. Irigaray, *Et l'une ne bouge pas sans l'autre* (Paris: Minuit, 1979); Elaine Marks and Isabelle de Courtivron, ed., *New French Feminisms* (Amherst: University of Massachusetts Press, 1980); *Signs,* vol. 7, no. 1 (Autumn, 1981), special issue on French feminism; Monique Wittig, *The Lesbian Body,* trans. David LeVay (New York: Avon, 1975; *Le corps lesbien,* 1973).

30 But all these poets are very complex, not least in treatment of themes of lying and erotic, decentered collective and personal identities. Susan Griffin, *Women and Nature: The Roaring Inside Her* (New York: Harper & Row, 1978); Audre Lorde, *Sister Outsider* (New York: Crossing Press, 1984); Adrienne Rich, *The Dream of a Common Language* (New York: Norton, 1978).

31 Jacques Derrida, *Of Grammatology,* trans. and introd. G. C. Spivak (Baltimore: Johns Hopkins University Press, 1976), esp. part II, "Nature, Culture, Writing"; Claude Lévi-Strauss, *Tristes Tropiques,* trans. John Russell (New York, 1961), esp. "The Writing Lesson."

32 Cherrie Moraga, *Loving in the War Years* (Boston: South End Press, 1983). The sharp relation of women of color to writing as theme and politics can be approached through: "The Black Woman and the Diaspora: Hidden Connections and Extended Acknowledgments," An International Literary Conference, Michigan State University, October 1985; Mari Evans, ed.,

Black Women Writers: A Critical Evaluation (Garden City, N.Y.: Doubleday/ Anchor, 1984); Dexter Fisher, ed., *The Third Woman: Minority Women Writers of the United States* (Boston: Houghton Mifflin, 1980); several issues of *Frontiers*, esp. vol. 5 (1980), "Chicanas en el Ambiente Nacional" and vol. 7 (1983), "Feminisms in the Non-Western World"; Maxine Hong Kingston, *China Men* (New York: Knopf, 1977); Gerda Lerner, ed., *Black Women in White America: A Documentary History* (New York: Vintage, 1973); Cherrie Moraga and Gloria Anzaldua, eds., *This Bridge Called My Back: Writings by Radical Women of Color* (Watertown, Mass.: Persephone, 1981); Robin Morgan, ed., *Sisterhood Is Global* (Garden City, N.Y.: Anchor/Doubleday, 1984). The writing of white women has had similar meanings: Sandra Gilbert and Susan Gubar, *The Madwoman in the Attic* (New Haven: Yale University Press, 1979); Joanna Russ, *How to Suppress Women's Writing* (Austin: University of Texas Press, 1983).

33 James Clifford argues persuasively for recognition of continuous cultural reinvention, the stubborn non-disappearance of those "marked" by Western imperializing practices; see "On Ethnographic Allegory: Essays," forthcoming 1985, and "On Ethnographic Authority," *Representations,* vol. 1, no. 2 (1983), pp. 118-146.

34 Page DuBois, *Centaurs and Amazons* (Ann Arbor: University of Michigan Press, 1982); Lorraine Daston and Katharine Park, "Hermaphrodites in Renaissance France," ms., n.d.; Katharine Park and Lorraine Daston, "Unnatural Conceptions: The Study of Monsters in 16th and 17th Century France and England," *Past and Present,* no. 92 (August 1981), pp. 20-54.

Looking Back at Cyborgs

JEANNE RANDOLPH

A *Cyborg Manifesto* is one hell of a concatenation, an ass-kicking, we're-gonna-bust-our-selves-outta-the-Theme-Park-of-Dualistic-Thinking, cyborg with a mind of gold, politics-on-its-sleeve Utopian. We feminist-socialists need a myth to believe in, a mirror to look in that reveals our power "to survive in the diaspora."[1] The cyborg is a figure of hope.

It's head-spinning time for feminist-socialists, but never again like the girl-child in *The Exorcist*. "Innocence, and the corollary insistence on victimhood, as the only ground for insight, has done enough damage."[2]

And certainly not like hooty-owls either, "organisms and families"[3] who always swivel their heads two hundred fifty-nine degrees but remain "natural objects."[4] There's not one unnatural woman surviving today who could serve "as a fiction mapping our social and bodily reality,"[5] not even Jane Couch, six KOs, fourteen wins, "the third most-recognizable face in British boxing."[6]

A *Cyborg Manifesto* is intellectually gripping, and emphatically so because it details how feminist-socialists must stop clinging to the "single vision [that] produces worse illusions than double vision or many-headed monsters."[7] Feminist-socialists must face an uncanny reality: that "the boundary between science fiction and social reality is an optical illusion,"[8] a reality nevertheless that could be *heimlich* for a cyborg.

Central to the ebullience of A *Cyborg Manifesto* is the recognition that: "One important route for reconstructing socialist-feminist politics is through theory and practice addressed to the social relations of science and technology, including crucially the systems of myth and meanings structuring our imaginations."[9]

I will elaborate upon this challenge, by way of toying with the relevance of the uncanny to "meanings that structure our imaginations."

My hypothesis, biased as it is by object relations psychoanalytic theory, is that the experience of the uncanny is a visceral reconnection between two particular psychodynamics of Western experience, a verbal experience and a preverbal experience. As a Kleinian, object relations psychoanalyst, I would imagine the uncanny as reconnecting two special experiences, one being a preverbal, psychosomatic memory and the other usually involving the very system of Western cognition that *A Cyborg Manifesto* decries, binary thinking. As Freud mentioned, artists can conjure the uncanny, but in ordinary life this special visceral memory and what I will soon depict as "cognitive lysis" rarely coincide.

At the speed of light, we are usually able to organize perception, sensations, associations and memories into a familiar pattern. The cognitive pattern we match so deftly to experience may be simple, as in the recognition of a triangle, or it may be complicated, as when we recognize that a tensely, convoluted incident in a relationship has become "Œdipal." These organizing cognitions are what might also be described as "interpretive templates." Ideologies are interpretive templates; religions offer interpretive templates. Interpretive templates abound, even in pop songs ("You ain't nuthin' but a houn'dog . . . ") and most certainly in science (non-Euclidian geometry, for example). Nevertheless, there are some rare experiences, some trivial, some delightful, some revelatory, and some profoundly disturbing, when not a single interpretive template has any accuracy whatsoever. It is as if the handiest templates have all dropped into an ocean of acid or dissolved into vapour. In this state, which I would term "cognitive lysis," in this apperceptual moment, the unreliability of one's judgment is total. Cognitive lysis is an experience of being exiled from thought; not drowning in nonsense, but gliding in a stratosphere of un-sense.

Object Relations psychoanalytic theory was developed in the late 1920s by Melanie Klein (1882–1960), and elaborated upon in the '50s, '60s and '70s by D.W. Winnicott (1896–1971). This theory bases its analysis of human identity-formation and symbol creation upon a veritable "primal scene of Becoming": "The brief statement is this: in the early stages of the emotional development of the human infant a vital part is played by the environment which is in fact not yet separated off from the infant by the infant. Gradually the separating-off of the not-me from the me takes place, and the pace varies according to

the infant and according to the environment. The major changes take place in the separating-out of the mother as an objectively perceived environmental feature [italics mine]."[10]

In my psychoanalytic account of the uncanny, the pre-verbal psychosomatic memory referred to above is one of the earliest, most abrupt experiences in infancy, looking back at the distant maternal body. Simultaneous with this is an admittedly rare, but equally abrupt self-consciousness: that the cognitive apparatus we are taught to depend on [in this context Western dualistic rationalism] has just dissolved; "cognitive lysis." Object relations psycho-analytic theory implies that when these two experiences are simultaneously evoked by a phenomenon, we feel it to be uncanny.

Our preverbal, psychosomatic memory, as told by object relations psychoanalytic theory, is not byzantine: Baby has just learned to walk. Lumbering like a tiny Frankenstein, Baby lurches forward. So far, Baby's body without organs is ecstatic. At some moment very soon, however, Baby cannot sense anything but his own unmediated ecstasy. Now his milieu is air, all response (Baby) and no responsivity (Mama). Nothing but enthusiasm and air. For the first time, he looks back. There, five baby-steps back, is a mountain of protoplasm and fabric, just a big old something of a *thing*. Where there was maternal environment (responsivity) — "it was there all my life! and only five steps back!" — now there is a big, baggy, un-ecstasy-looking thing. For Baby, there are no words, none, for this appalling transformation, though adult poets may approximate it. There is "The Story of Dryope," for instance, in book nine of Ovid's *Metamorphoses* (written 1–8 AD):

"There is a lake whose shelving sides had shaped
A sloping shore, and myrtles crowned the ridge.
There Dryope had come . . .
She carried at her breast her little boy,
A darling burden not a twelve-month-old,
And fed him with her milk. Near the lakeside
A water-lotus flowered, its crimson blooms
Like Tyrian dye, fair hope of fruit to come.
Dear Dryope had picked a posy of
These flowers to please her boy . . . and now tried

To turn away and leave, but found her feet
Rooted. She fought to free herself, but failed
To move below her bosom. Gradually
Up from the soil right round her legs and loins
Bark climbed and clung; and, seeing it, she tried
To tear her hair, but found leaves filled her hand,
Leaves covered her whole head. Her little boy
. . . could feel his mother's breasts
Grow hard; the milky flow failed as he sucked.
. . . naught that was not tree
Remained except her face. Her tears, a poor soul,
Bedewed the leaves she'd grown; and while she might,
While lips would let words pass, her protests poured:
. . . take this baby from his mother's boughs
. . . And see that often underneath my tree
. . . He often plays . . . when he's learnt to talk . . ."[11]

Our foremost choice after this Looking-Back circumstance, and for the rest of our lives (according to object relations psychoanalytic theory, "it is assumed that the task of reality-acceptance is never completed")[12] is to tell the Looking-Back story to ourselves and to each other in as many ways possible. Including, unfortunately, according to Freud, reproducing our past: "not as a memory, but as an action . . . [He] acts it out . . . [A]cting it out . . . is his way of remembering."[13]

A psychoanalyst might even recognize herself in the Looking-Back story that fuels many myths and theories about so-called reality-acceptance. What can we say? Myths and theory, for analysts and artists, even for cyborgs, for most people, are necessary "for consoling or for direction."[14] At first, the Looking-Back story will fit naturally into a binary ("me and not-me") and lots of people find this binary the most profitable life-long fit between language and experience.

Object relations theory would posit that we experience the uncanny when the Looking-Back memory is subconsciously evoked along with silent and instantaneous failure of

dualistic thinking, yet this Looking-Back aftershock does not occur every time our interpretive template, whether implicitly dualistic or mediated labyrinthine understanding, cannot be trusted. Sudden cognitive lysis even so does not always link to the Looking-Back memory.

In object relations theory, the latter is the earliest perceptual transformation that is as close as a Western baby can come to experiencing the difference between life and death. Perhaps it is not only our child-rearing practices but also our monotheistic traditions that inflame our anxiety about the "animate vs. inanimate" distinction, and we shiver when this distinction is threatened.

A Cyborg Manifesto foretells liberation when the uncanny is impossible, because the feminist-socialist effects of cyborg culture will have been to dissolve Western dualism, to survive mass cognitive lysis, and by the way to "free us from the need to root politics in . . . mothering."[15] This indeed is a vision of Western culture transformed by blasphemy. Actually, every culture on the planet would be transformed if "mothering" (by any gender, group, or process) becomes a metaphor of foolishness instead of generosity. Hopefully we can also imagine needing cyboanalysts who, like Freud, will bring great understandings to civilization, even while missing the whole point about mothering.

[1] Donna Haraway, "A Cyborg Manifesto: Science, Technology and Socialist-Feminism in the Late Twentieth Century," *Simians, Cyborgs and Women* (London: Free Association Books, 1991), 170. [2] Ibid., 157. [3] Ibid., 162. [4] Ibid., 162. [5] Ibid., 150. [6] *Boxing Monthly* (March 2001), 32. [7] Haraway, 154. [8] Ibid., 149. [9] Ibid., 163. [10] D.W. Winnicott, *Playing and Reality* (Markham, Ontario: Penguin Canada, 1983), 130. [11] *Ovid: Metamorphoses*, tr. A.D. Melville (Oxford, U.K.: Oxford University Press, 1987), 209–211. [12] Winnicott, 15. [13] Sigmund Freud, "Remembering, Repeating and Working-Through (further recommendations on the technique of psycho-analysis 2)" (1914), *Standard Edition of the Complete Psychological Works*, ed. tr. Lytton Strachey (London: Hogarth Press, 1919), 147, 150, 154. [14] John Donlan, "Mug," *Green Man* (Vancouver: Ronsdale Press, 1999), 29. [15] Haraway, 176.

Warning: Sheborgs/Cyberfems Rupture Image-Stream!

RANDY LEE CUTLER

"Liberation rests on the construction of consciousness, the imaginative apprehension, of oppression, and so of possibility. The cyborg is a matter of fiction and lived experience that changes what counts as women's experience in the late twentieth century."
— Donna Haraway, *A Cyborg Manifesto*

"And while notions of femininity may appear to be changing with the advent of new technologies and new ideas and theories arising from those technologies, I still find that certain representations simply reinforce and continue traditional discourses about what constitutes femininity and images of femininity." — Lee Bul interview with Hans Ubrist

In varying ways we are all flesh machines. Subject to an incessant flickering from the image-stream—television, film, comics, magazines, music, fashion, art—we inhabit a mutated space-time where the imaginary and the real blur into each other. Operative within this matrix of organism, machine, and image-stream are resistors to a cultural system that traffics in fetishized images of the female body, not to mention anonymous feminine labour. "Women have served his media and interfaces, muses and messengers, currencies and screens, interactions, operators, decoders, secretaries . . . they have been man's go-betweens, the in-betweens, taking his messages, bearing his children, and passing on his genetic code."[1] In this age of flesh machines, the feminine is more than just a sign of consumption and exchange. Women are making space, uncovering and disrupting the very flows of the image-stream. During the past decade, popular cultural images of gendered cyborgs have entered our cerebral cortexes, powerful, playful, and irreverent sheborgs that offer models for liberation by heightening our awareness of the potential for new technologies.

Tokyo electronic billboards, Shibuya Crossing, 2001.

This essay delves into what has been called Cyberfeminism. Evolving out of Science and Technology Studies, Cultural Studies and Philosophy, Cyberfeminism has also become an art strategy that provides an opportunity for feminists to influence the formation of new gender configurations. My approach to sheborgs and cyberfems reflects an interpretative model that is cyborgian, contradictory, and unstable in its identity. An equally mutating force, cyberfeminism focuses on gender identity, the body, culture, and contemporary technologies and their potential for change. "Cyberfeminism is also a struggle to be increasingly aware of the impact of new technologies on the lives of women, and the insidious gendering of technoculture in everyday life. Cyberspace does not exist in a vacuum; it is intimately connected to numerous real-world institutions and systems that thrive on gender separation and hierarchy. Finally, cyberfeminism must radically expand the critique concerning the media hype about the 'technoworld.'"[2]

I understand cyberfeminism as praxis: where the theories and criticism of technology are woven through the activism and consciousness of 21st-century feminism. The persistent imbalances evident within the overlaps of gender and technology are examined by theorists like Donna Haraway (*A Cyborg Manifesto*, 1991), Sandy Stone (*The War of Desire and Technology at the Close of the Mechanical Age*, 1995), Rosi Braidotti (*Cyberfeminism with a Difference*, 1998) and Sadie Plant (*Zeros and Ones*, 1999), some of the more familiar cyberfems. The outspoken nature of cyberfeminism is manifest in the increased presence of women in online communities, computer engineering, and critical thinking. Women everywhere are rewriting the cultural codes.

Contemporary art practice in particular has found its own vectors for exploring cyberfeminism with work that addresses the image of the sheborg through the language of emerging and sophisticated technologies. Three of the artists exhibiting in *The Uncanny: Experiments in Cyborg Culture*, Lee Bul, Mariko Mori, and Nina Levitt, share an exploration of the gendered cyborg figure as a technologically empowered entity that challenges boundaries and confounds conventional expectations of body/identity relations. Influenced by popular culture and theory, these women subvert the female characters found in comics, animation, and film and conceive startling images of female flesh machines. Their conceptions become travel companions, signposts of an ever-expanding image-stream that punctures our own lived realities. Not only are these artists informed by the image-stream, their creations

advance its very repertory. While different in approach and materials, their fabrications question how the sheborg operates as imagery and imaginary in popular consciousness by creating interference patterns within culture, social politics, and history. While each artist is informed by different elements of the cultural landscape, common threads can be found under the ægis of cyberfeminism. What follows here is a reflection on Bul, Mori, and Levitt's work, situating them within the continually evolving and mutating discourses of cyborg politics. Three themes are raised. The first considers the legacy of Haraway's *A Cyborg Manifesto*. The second addresses the importance and/or rejection of origins as a means of writing the feminine into history, and the third celebrates the often-disquieting techniques of replication and fragmentation. I am interested in how these artists alter, uncover, and disrupt the cyborg identity even as they advance its repertory and symbolizations. Actively resisting interpretation, their practices represent the flux and extreme density of information flow. In what ways are Bul, Mori, and Levitt contributing to a myth-making process, providing forms in which dreams, fantasies, and visions of the future become more real, more insistent, and perhaps more monstrous?

Cyborg Figurations

In 1991, with her influential work *A Cyborg Manifesto: Science, Technology and Socialist-Feminism in the Late Twentieth Century*, Donna Haraway sought to build an ironic political myth faithful to feminism, socialism, and materialism. The Manifesto, a complex interpretation of the cultural, social, and economic milieu at the end of the millennium, originally explored the political implications of the concept of the cyborg. When first published, *A Cyborg Manifesto* was an antidote to the received history of automata, robots, and androids because it allowed for certain ambivalence with regard to technology and its myth of progress. "A cyborg is a cybernetic organism, a hybrid of machine and organism, a creature of social reality as well as a creature of fiction."[3]

Haraway's cyborg foregrounds the intricate issue of technology in a postmodern world and how gender differences shift perspective and even consciousness. Since its publication, the Manifesto has become a user's manual, a metaphorical map for how to embody and embrace the emancipatory potential hidden within contradictions. Haraway makes "an argument for pleasure in the confusion of boundaries and for responsibility in their construction."[4]

Ultimately, the cyborg is a figure, or a figuration of qualities harvested from the imaginary and the real. The ontology of the cyborg is permanently fractured, partial, and contingent on the cultural landscape in which it evolves. When first published, Haraway's cyborg monstrosity (the confusion of boundaries) reflected the inadequacies of contemporary meanings in the wake of emerging technologized experiences. A decade later, this figure continues to manifest diverse influences. As we interact with and internalize the city, the state, and the image-stream, the cyborg expresses the engineered fabulations we carry around within. As Braidotti states: "Far from appearing antithetical to the human organism and set of values, the technological factor must be seen as co-extensive with and inter-mingled with the human."[5]

More recently in her 1997 book *Modest_Witness@Second_Millennium_FemaleMan©Meets _OncoMouse*™, Haraway has added that "figures do not have to be representational and mimetic, but they do have to be tropic; that is they can not be literal and self-identical. Figures must involve at least some kind of displacement that can trouble identifications and certainties."[6] Monstrosity is a kind of displacement that challenges convention and outmoded notions of what it means to be human. The monsters, freaks, and anomalies that haunt the scientific imagination (Frankenstein, clones, and genetically modified organisms) have contributed to the real-time blurring of boundaries between self and other, human and animal, natural and artificial. The idea of monstrosity, previously understood as pathological, is now pervasive enough to be recognized as part of our reality. Not only does the monstrous cyborg displace conventional notions of what it means to be human, it may come closer to reflecting lived experience in the 21st century. Interestingly, monstrous becomings have often been gendered female. According to the film theorist Barbara Creed, "All human societies have a conception of the monstrous-feminine, of what it is about women that is shocking, terrifying, horrific, abject."[7] Haraway's cyborg model and its subsequent progeny are a continuation of the idea of contradictory creatures that threaten organic wholeness and technological perfection.

New Histories/Alternate Futures

Digital space is warming up, becoming mammalian. The future is upon us. And when the future is created, so the past is reconsidered, preparing the way for New Histories. The cyborg figure has provided a model for rewriting history or writing women into the history of technology. With "no origin story in the Western sense," it is "untied at last from all

dependency." Like Haraway's original conception, Lee Bul's sculptures of cyborg women (p. 39, 206) have no origin story, no immaculate place of birth and no original unity. They are inspired by the popular cyborg heroines found in Japanese and Korean *manga* (comics) and *anime* (animation). Hard, seductive, and Amazonian, the cyborg women reject the wholesale demonization of technology and embrace new potentials for feminine embodiment. Although Haraway has yet to be translated into Korean, Bul is familiar with some of her concepts. "And what I do know of her work is very interesting and relevant to some of my own concerns, the notion of the cyborg as an entity that is both trans-human and trans-gender, and how that operates as imagery in the popular imagination, and how it might serve to mediate issues of culture, politics and economy."[8] Cast out of silicone, these headless figures with missing appendages are spectres of a battle from some off-world colony. Possessing hyper-feminine qualities (protruding breasts, slender waists, and/or skirted armour), they are figures of science fiction, bioengineering, and adolescent male fantasy that have escaped from the constraints of the comic book medium. Not seduced by wholeness, they hover somewhere between objects and subjects. These sheborgs are figures of the potential for feminine power and technological engagement.

As artificial bodies, Bul's cyborg women evoke the question of origins and the tensions energized by the interplay of nature and culture. They are protean, part fiction and part lived reality. They make sense of the past and envision alternate futures, worlds where women and technology flourish. Iconic and translucent, they are reminiscent of the marble statues *Winged Victory (Nike of Samothrace)* (c. 190 BC) or the *Venus de Milo* (c. 100 BC).[9] These classical idealizations of the female form which were allegorical of "higher values" have been absorbed within the cyborg women. In this retelling, they symbolize a newly formed creature rising out of the depths of industrial processes and modular forms. (Venus rose from the foam of the sea.) But while the *Nike* and *Venus de Milo* represented feminine passivity and muse-like inspiration these cyborgs navigate their own way through dematerialized flesh, network communications, and embodied technology. They challenge the myth of technological perfection by highlighting the contradictions nascent within technological progress. Witness to contemporary events, they envision identities away from traditional discourse and the technological mastery heralded by patriarchy.

In Mariko Mori's early photographs such as *Play with Me* (1994, p. 267–268), *Subway* (1994), and *Tea Ceremony* (1995), the social field becomes the proving ground for new identities, and new offspring of the universe. These cyberwaifs have evolved out of Japanese

Nike (Winged Victory of Samothrace), c. 190 BC.
White marble, grey marble. Height 328 cm. Musée du Louvre, Paris.

Venus de Milo, c. 200 BC.
Parian marble. Height 202 cm. Musée du Louvre, Paris.

tradition, eastern and western art historical forms and motifs, contemporary fashion, science fiction, pop culture, and high technology. In these early works, the cyborgs are figures from the future that have crossed over time and space. "Her images show, as the artist states 'someone who needs to be created'—the techno-dream woman of tomorrow."[10]

Rather than natural, Mori's sheborgs are artificial creations, uncanny psychic projections that have been transported out of the image-stream and into the real world. Mythic creatures, they have burst through the membrane, the lining of imaginary realms and screen fantasies only to go unnoticed by passersby. Their presence perhaps is too incongruous, too new to be noticed. Their playful, naïve appearances suggest a childlike sexuality, new to this world and its contradictory ways. While the sweet harmlessness of these cybergirls embodies a culturally learned vulnerability and passivity, they also suggest new life, untainted by cynicism. There is an alternate reading of this, though. It has been suggested that with works such as these, Mori "created a visual *mappo*, the Buddhist word for dark period of moral decline before the arrival of the future Buddha."[11] Perhaps they are the preparations for a new beginning, the last vestiges of overt gender distinctions before a brave new world of nirvana where "radiant energies . . . sublimate the thing-of-flesh into a spirit made of (celluloid) light."[12] This new world order is evident in Mori's recent work, where the surreal mermaid on the artificial beach of *Empty Scene* (1995), the enlightened shaman woman of *Miko No Inori* (1996), and the replicated figures in *Last Departure* (1996) visualize a new transgenic body no longer flesh and blood. Thus rather than Haraway's material-constructionist visions of gender and technology, Mori has created ethereal forms, an amalgam of Buddhism, emerging technology, and Japanese comics. In these examples, the rupture is away from lived material reality and toward an ethereal cyborg light-body. Where Haraway rejects transcendence as another male strategy for abandoning the too real body, Mori's recent images of utopian cyberfems appear to bypass the politics of female embodiment. The cyborg has become dematerialized ether-flesh.

Though Haraway has suggested that cyborgs have no origin story, it does not follow that their stories cannot be told. In fact, the stories of a post-gender world can be read back through time and show how the cyborg can play with the patriarchal assumptions of sexuality as well as gender. An open reading of Nina Levitt's installation *Gravity* (1999, p. 207) suggests some of the possible displacements that figure in the cyborg model: images that have been erased and then made visible again through old and new technologies.

The work is composed of three video projections (*Wave*, *Nostalgia*, and *Spin*) and two audio systems that capture the orbit and mesmerizing choreography of cyborg figures. *Wave* is a video projection of the first woman in space. In slow motion, Valentina Tereshkova waves and smiles for the camera from her Russian space capsule. *Nostalgia* is a video loop of two slow motion sequences showing dancers at a lesbian bar sampled from the 1968 film *The Killing of Sister George*. *Spin* is a video loop of women divers spinning in slow motion.

The languid sequence of the female cosmonaut waving and smiling merges the forgotten past with our contemporary images of sexbots or Lara Croft action heroines. Using found imagery, Levitt offers us lost histories, bringing us back in time to the beginnings of space flight. Valentina Tereshkova is a displaced historical figure of utopian meanings bound for adventure. "And so Tereshkova remains an object of fascination today not only because her space capsule accomplished 45 revolutions around the earth in 70 hours. Levitt's semi-transparent bit of footage is more suggestive than that; somehow it recalls the once thrilling prospect of intergalactic exploration."[13] We are reminded not only of the idealized visions that propelled space flight, but also the formative contribution of women to that dream. *Gravity* recounts an alternate history where women's investments in a technological future are celebrated rather than erased.

As these women float across their respective screens, the mechanically slowed down images suggest the overlap between women and technology. They evoke the utopian desire to be free of physical and social constraints as well as earthbound identity. The sequence at the lesbian bar refigures a positive memory out of a sad and negative depiction of lesbian culture. (Like most early representation of lesbians, *The Killing of Sister George* is an erroneous depiction of homosexual desires.) The selection of shots coupled with the slowing down of time in *Gravity* show how alternative and radical femininity "may read patriarchal texts against the grain, so that they may be actively reworked upon and strategically harnessed for the purposes for which they were not intended."[14] Sampling found footage has become a digital recomposotion technique par excellence. The projection screens, cinematic and spectacular, promise a cosmos of larger-than-life fantasies and yearnings. They bring us back in time, to the infancy of technology and gender construction.

The image of the space-suited figure and the lesbian body offers alternate origin stories or at least sources of mutable gender. In using the figure of the cosmonaut Tereshkova and linking that to the image of the lesbian body, the gendered body orbits around questions

of the astronaut/cosmonaut/cyborg. What does it mean to accept the freedom from ortho-dox history? How do digital process aid in the disassembly and reassembly of outmoded, sexist and homophobic stereotypes? All of the women in *Gravity*—the smiling astrochick, the dancing lesbians, and the soaring divers—enjoy a certain distance from origins, from his-tory, and from terrestrial constraints. They delight in an altered perspective where the grav-ity of space and historical time cannot encumber their movements, gestures, and identities.

Monstrous Identities: Partial / Contradictory / Multiple

In Bul's cyborg women, female errant knights, simultaneously armoured, chaste, and sex-ualized, are fragments of human-machine interfaces, deformed displays of monstrous becomings. They have no faces and therefore no stable identities. Each of the hanging sculptures is a version of itself; a slight variation. They represent the body as a biological replica, open to disassembly and reassembly. The fantasy women in Japanese comics, fearless and invincible beings, inform Bul's creations, images of sheborgs in advanced industrial societies. They are the residues of constructions typically controlled by men or male adolescents but have now become surpluses of corporeal energy and mutant predi-lections. Like the *manga* comics which are consumed and discarded, left behind on the subway for someone else's temporary seduction, the cyborg women are the detritus of ephemeral culture, gothic shards of memories and fantasies come to life, dripping with unresolved desire and monstrous intensity.

Bul's cyborg women evoke Creed's conception of the monstrous-feminine. As partially formed subjects, their corporeal alteration disturbs identity, symmetry, and order. They exist at the place where meaning collapses. As entities that are missing body parts or ques-tioning the idea of bodily integrity, the cyborg women are border creatures. "Thus, abject things are those which highlight the 'fragility of the law' and which exist on the other side of the border which separates out the living subject from that which threatens extinc-tion."[15] The cyborg women series challenge our assumptions of what is human, what is feminine and what is lively. Echoing Haraway's "informatics of domination" they suggest replication rather than reproduction invoking, perhaps, castration anxiety in the male spectator. Bypassing organicism for biotic components, these silicon specters are living zombies, the strange schizo-couplings of male fantasies and feminist empowerment resid-ing on both sides of the image-stream.

Mori's cyborgs are a more benign rendering of the partial, the contradictory, and the multiple. While her figures suggest the instability of identity and the perpetual exchange between reality and fantasy, these creatures have strayed from the social/political potential of Haraway's cyborg. They appear to represent dissolution and transcendence rather than embodiment. Even her own agency is under review as she supplicates the public to play with her or drink tea. But these apparently passive creatures are in fact active sheborgs performed for the camera in the middle of real urban settings. Perhaps Mori's cyborgs take more from second generation cyberfeminism reflecting Sadie Plant's spin on a mythical genesis (*The Future Looms: Weaving Women and Cybernetics*, 1995). Plant envisions new histories with her call for the convergence of women and machines in a feminized cybernetics based on women's ancient invention of the craft of weaving. The artist's agency is evident in her performative, photographic, and video practices, which are inspired by her background as a fashion model, and clothes designer. In her own way, she blends the craft of sewing with futuristic visions: all of the space-age outfits worn by Mori are her own design and handiwork. Rather than explore Haraway's early work on biotech hybrids, Mori's concoctions draw from contemporary developments in fashion, media, and film to arrive at a more immediate rendering of the gendered cyborg.

There are of course many trajectories of the gendered cyborg envisioned more than sixteen years ago in *A Cyborg Manifesto*. Mori's figures are certainly fractured cyborgs joining fiction and lived experience. While her representations may not change what counts as women's experience, their blatant "femininity" may disrupt easy consumption. The social critique in Mori's early photographic work is found in her reflection of people's desires. She no longer possesses a unitary self but rather a wondrous techno-self. This smooth hyperlinking of the human and the machine is an examination of the role of self in the shapeshifting, post-human landscape. Mori replicates her own image as a means of examining the fracturing of identity. Bryson suggest that she portrays "the present psycho-social moment by occupying, not the place of the critical analysis, but the place of the critical symptom."[16] This is a place where the self dissolves into multivarious selves with no original, stable identity. This is a self that has merged with the information flow of science fiction, lived reality, and the global image-stream.

The common thread throughout Mori's work is her own repeated figure continually transformed and recombined. The depiction through repetition of Mori's various avatars

plays out an idea that is central to Haraway's argument, the desire for a non-unitary self, for polymorphous identity. The use of avatars and cyborg personas in cyberspace, science fiction, and fashion allows for this dispersed self. In a sense, Mori has become a time machine, materializing in different space-time coordinates, condensing and fusing through infinite replication of her own image. She inhabits figurations as performative images across time and embodies "the apparatus of production of globalized, extraterrestrial, everyday consciousness in the planetary pandemic of multisite, multimedia, multispecies, multi-cultural, cyborgian entertainment . . ."[17]

The idea of cyborg identities proposes alternate modes of embodiment where the "self" is performed and interrogated. This may include the disassembly of bodily form (Bul), the creation of an alternate subjectivity (Levitt), or the multiplication of self (Mori). All of these strategies create distance between oneself and a normalized, naturalized body. In *Gravity*, Levitt offers a multiplicity of interpretations for the interface and intermixing of gender and technology. The multiple, floating divers, the alternative lesbian embodi-ment, and the orbiting cosmonaut show the performative side of cyborg politics where identity is created as spectacle; differential, unfamiliar, alien. All of the women in *Gravity* transcend a small earthbound identity, activated by technological imaging and histories. The slow-motion scenarios exaggerate body movements, repeat gestures, and reconfigure identity. As a fractured identity, Valentina Tereshkova is a displaced historical figure, some-how erased and now made visible again. Her waving image comes to us from another time that promises a cosmos of larger-than-life fantasies and desires.

In your future travels and timeslips in the image-stream, remember the sheborg with her attendant tangents and contradictions. Do not forget the promise of new histories, the potential of replication and the continued presence of erupting consciousness. Cyberfems are figures of resistance, metaphors of differential embodiment. As we find ourselves chang-ing, mutating and acclimatizing to the continually remade world, the sheborg is a model for the rupture of technologies and gender differences. Even as technology overtakes humanity and drives us toward a search for bodily transcendence, there is a parallel reading toward embodiment, monstrosity, and liberation. This contemporary world without borders has rewritten the past and opened up a future of plural realities. It rests on the construction of consciousness, the imaginative apprehension, of oppression, and so of possibility.

1 Sadie Plant, "On the Matrix: Cyberfeminist Simulations," *The Cybercultures Reader* (New York: Routledge, 2000), 326. **2** Faith Wilding and Critical Art Ensemble, *Notes on the Political Condition of Cyberfeminism, www.critical-art.net/lectures/fem.html.* **3** Donna Haraway, "A Cyborg Manifesto: Science, Technology and Socialist-Feminism in the Late Twentieth Century," *Simians, Cyborgs and Women* (London: Free Association Books, 1991), 150–151. **4** Ibid. **5** Rosi Bradotti, "Cyberfeminism with a difference," CD-ROM. Mediawise, 1998. **6** Donna Haraway, *Modest_Witness@Second_Millennium.FemaleMan©_Meets<OncoMouse*™ (New York: Routledge, 1997), 11. **7** Barbara Creed, "The Monstrous Feminine: an Imaginary Abjection," *Screen* 27 (1986), 44. **8** Lee Bul interviewed by Hans-Ulrich Obrist, *www.leebul.com.* **9** The *Venus de Milo* is a kind of cyborg, deriving her head from the later 5th century BC, her nudity from the 4th century, and her spiral posture from the Hellenistic. Part human, part idealized form, she is an amalgamation of the Classicism of c. 100 BC. The fragmented *Nike* figure with her absent head and chipped body also evokes cyborg qualities of disassembly and partiality. **10** Dominic Molon, "Countdown to Ecstasy," *Mariko Mori* (Chicago: Museum of Contemporary Art, 1998), 3. **11** Carol S. Eliel, "Interpreting Tradition: Mariko Mori's Nirvana," *Mariko Mori* (Chicago: Museum of Contemporary Art, 1998), 28. **12** Norman Bryson, "Cute Futures, Mariko Mori's Techno-Enlightenment," Parkett 54, (1998/99), 80. **13** Johanne Sloan, "Space-Age Slow Motion," *Gravity, Duet: Video Installations by Nina Levitt* (Toronto: Gallery TPW, 1999), 18. **14** Elizabeth Grosz, *Space, Time and Perversion: essays on the politics of bodies* (New York: Routledge, 1995), 142. **15** Barbara Creed (1986), 48. Bul's exploration of monstrosity and boundary breakdowns is evident throughout her practice. Early in her career, she engaged in street performances in which she wore monstrous costumes to criticize feminine stereotypes of beauty. In her Cyborg & Monsters series (of which the cyborg women are a component), she has created the mutant organism of *Supernova* (2000) and the fleshy malformations of *Monster Pink* (1998). Both of these creatures, ruptures from the image-stream, suggest some of the mutant vectors residing on the other side of wholeness and technological perfection. Rather than extinction, Bul offers us new and terrifying life forms. **16** Norman Bryson, 80. **17** Haraway (1997), 13.

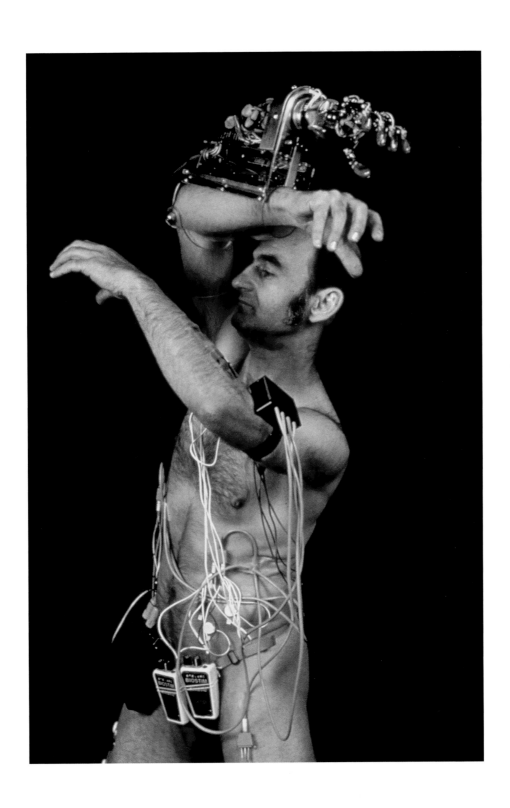

Stelarc, *Third Hand*, 1976–80. Still from video of performance.

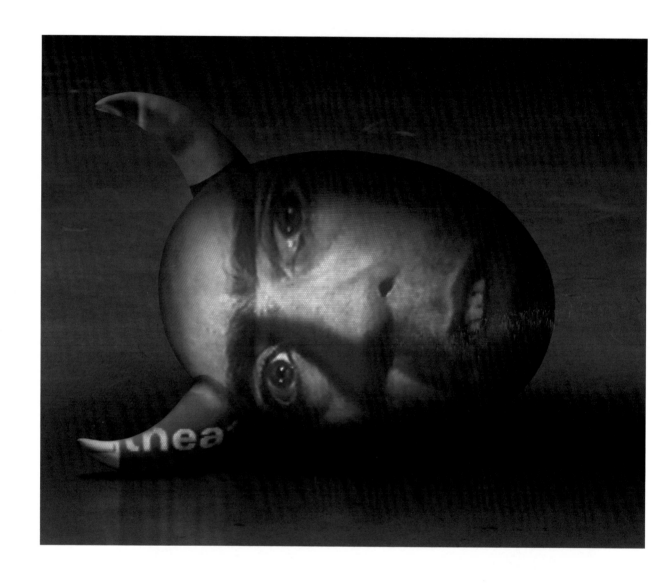

Tony Oursler, *Vanish*, 2000.

Acrylic, plaster, video projection system, dimensions variable.

Vancouver Art Gallery (2000.53). Photo: Trevor Mills

Ronald Jones, *Untitled (This trestle was used to hold . . .)*, 1990.
Allenbolts, patinated bronze, waxed MDF, pearwood, pickled birch on artists' base,
198.4 x 54.5 x 62.7 cm. Vancouver Art Gallery (90.20 a,b). Photo: Trevor Mills

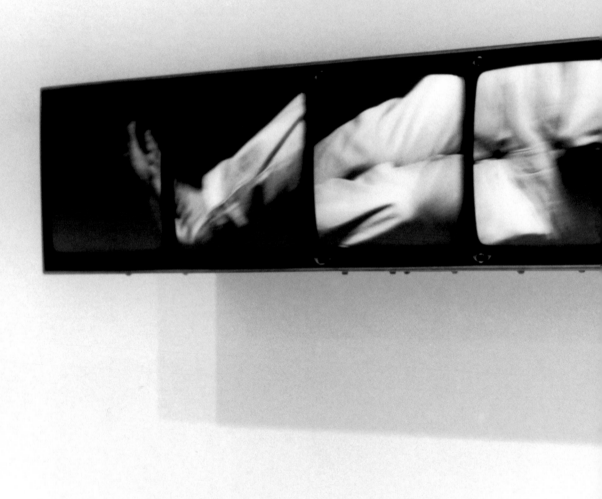

Gary Hill, *Conundrum*, 1995–98. Single channel video installation comprising six 14-inch black and white monitors, laserdisc player and disc, tone switcher and steel structure, 25.5 x 180 x 33 cm. Courtesy of the artist.

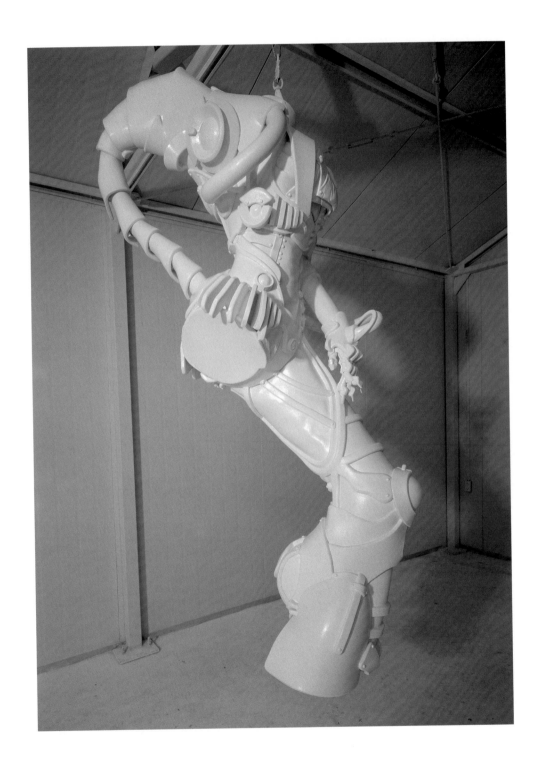

Lee Bul, *Cyborg W5*, 1999.

Handcut polyurethane panels on FRP, urethane coating, 150 x 55 x 90 cm.

Courtesy of PKM, Shiraishi Contemporary Art.

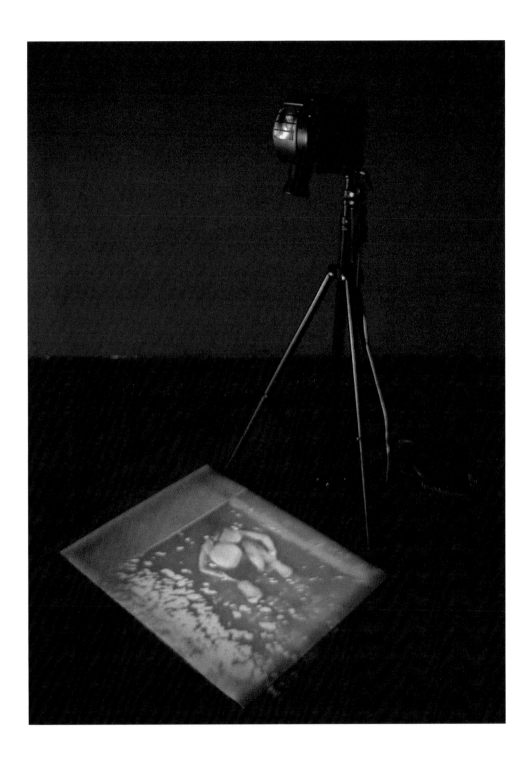

Nina Levitt, *Gravity*, 1997–98. Three video projections and two audio systems comprising PA speaker, amplifier, CD, playback deck, LCD video projector, VCR, tripod, frosted Plexiglas, vinyl floor covering, audio speakers. Dimensions variable. Courtesy of the artist.

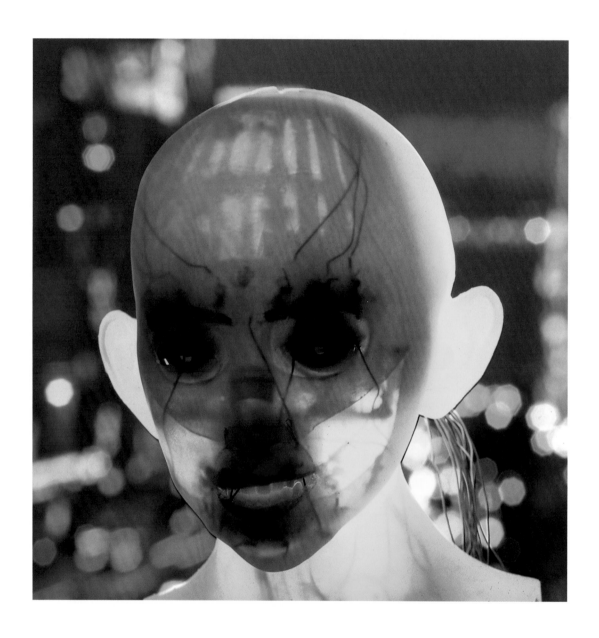

Second-Generation Face Robot, 2001.

Hara/Kobayashi Labs, Science University of Tokyo.

© Peter Menzel, from *Robo sapiens: Evolution of a New Science* (MIT Press, 2000).

The Face Robot (Third Generation) was developed by the Hara-Kobayashi Lab of the Science University of Tokyo in 1999. The prosaic name, Face Robot (Third Generation) belies its purpose, which is to create a robot that responds appropriately to human emotions as registered in facial expression. The Face Robot utilizes visual recognition software that allows it to read the human face and to respond immediately with a variety of appropriate facial expressions — surprise, fear, disgust, anger, sadness or happiness. This is achieved by an internal facial "muscle" structure composed of metal alloy that has a shape-memory property allowing it to rapidly shift the overlying silicon rubber "skin" much in the same way that muscles shift the human physiognomy.

The focus of the researchers at the Hara-Kobayashi Lab differs significantly from that of the researchers at the Honda or Sony labs where emphasis is on the fluid bodily movement of the robots. The new Honda P3 robot is a human-size robot that can climb a flight of stairs, open a door, or avoid obstacles while walking. Its facial features, however, are completely generalized. The head is human-size but has the look of a helmet and opaque visor with a reflective surface. There is no opportunity for human-robot interaction based in an exchange of glances. Instead, the human is recognized as an obstacle to avoid or an object to retrieve.

BG

NEUROMANCER
WILLIAM GIBSON

ACE BOOKS, NEW YORK

4

Case sat in the loft with the dermatrodes strapped across his forehead, watching motes dance in the diluted sunlight that filtered through the grid overhead. A countdown was in progress in one corner of the monitor screen.

Cowboys didn't get into simstim, he thought, because it was basically a meat toy. He knew that the trodes he used and the little plastic tiara dangling from a simstim deck were basically the same, and that the cyberspace matrix was actually a drastic simplification of the human sensorium, at least in terms of presentation, but simstim itself struck him as a gratuitous multiplication of flesh input. The commercial stuff was edited, of course, so that if Tally Isham got a headache in the course of a segment, you didn't feel it.

The screen bleeped a two-second warning.

The new switch was patched into his Sendai with a thin ribbon of fiberoptics.

And one and two and—

Cyberspace slid into existence from the cardinal points.

55

Smooth, he thought, but not smooth enough. Have to work on it. . . .

Then he keyed the new switch.

The abrupt jolt into other flesh. Matrix gone, a wave of sound and color. . . . She was moving through a crowded street, past stalls vending discount software, prices feltpenned on sheets of plastic, fragments of music from countless speakers. Smells of urine, free monomers, perfume, patties of frying krill. For a few frightened seconds he fought helplessly to control her body. Then he willed himself into passivity, became the passenger behind her eyes.

The glasses didn't seem to cut down the sunlight at all. He wondered if the built-in amps compensated automatically. Blue alphanumerics winked the time, low in her left peripheral field. Showing off, he thought.

Her body language was disorienting, her style foreign. She seemed continually on the verge of colliding with someone, but people melted out of her way, stepped sideways, made room.

"How you doing, Case?" He heard the words and felt her form them. She slid a hand into her jacket, a fingertip circling a nipple under warm silk. The sensation made him catch his breath. She laughed. But the link was one-way. He had no way to reply.

Two blocks later, she was threading the outskirts of Memory Lane. Case kept trying to jerk her eyes toward landmarks he would have used to find his way. He began to find the passivity of the situation irritating.

The transition to cyberspace, when he hit the switch, was instantaneous. He punched himself down a wall of primitive ice belonging to the New York Public Library, automatically counting potential windows. Keying back into her sensorium, into the sinuous flow of muscle, senses sharp and bright.

He found himself wondering about the mind he shared these sensations with. What did he know about her? That she was another professional; that she said her being, like his, was the thing she did to make a living. He knew the way she'd moved against him, earlier, when she woke, their mutual grunt of unity when he'd entered her, and that she liked her coffee black, afterward. . . .

Her destination was one of the dubious software rental com-

plexes that lined Memory Lane. There was a stillness, a hush. Booths lined a central hall. The clientele were young, few of them out of their teens. They all seemed to have carbon sockets planted behind the left ear, but she didn't focus on them. The counters that fronted the booths displayed hundreds of slivers of microsoft, angular fragments of colored silicon mounted under oblong transparent bubbles on squares of white cardboard. Molly went to the seventh booth along the south wall. Behind the counter a boy with a shaven head stared vacantly into space, a dozen spikes of microsoft protruding from the socket behind his ear.

"Larry, you in, man?" She positioned herself in front of him. The boy's eyes focused. He sat up in his chair and pried a bright magenta splinter from his socket with a dirty thumbnail.

"Hey, Larry."

"Molly." He nodded.

"I have some work for some of your friends, Larry."

Larry took a flat plastic case from the pocket of his red sportshirt and flicked it open, slotting the microsoft beside a dozen others. His hand hovered, selected a glossy black chip that was slightly longer than the rest, and inserted it smoothly into his head. His eyes narrowed.

"Molly's got a rider," he said, "and Larry doesn't like that."

"Hey," she said, "I didn't know you were so . . . sensitive. I'm impressed. Costs a lot, to get that sensitive."

"I know you, lady?" The blank look returned. "You looking to buy some softs?"

"I'm looking for the Moderns."

"You got a rider, Molly. This says." He tapped the black splinter. "Somebody else using your eyes."

"My partner."

"Tell your partner to go."

"Got something for the Panther Moderns, Larry."

"What are you talking about, lady?"

"Case, you take off," she said, and he hit the switch, instantly back in the matrix. Ghost impressions of the software complex hung for a few seconds in the buzzing calm of cyberspace.

"Panther Moderns," he said to the Hosaka, removing the trodes. "Five minute precis."

"Ready," the computer said.

It wasn't a name he knew. Something new, something that had come in since he'd been in Chiba. Fads swept the youth of the Sprawl at the speed of light; entire subcultures could rise overnight, thrive for a dozen weeks, and then vanish utterly. "Go," he said. The Hosaka had accessed its array of libraries, journals, and news services.

The precis began with a long hold on a color still that Case at first assumed was a collage of some kind, a boy's face snipped from another image and glued to a photograph of a paint-scrawled wall. Dark eyes, epicanthic folds obviously the result of surgery, an angry dusting of acne across pale narrow cheeks. The Hosaka released the freeze; the boy moved, flowing with the sinister grace of a mime pretending to be a jungle predator. His body was nearly invisible, an abstract pattern approximating the scribbled brickwork sliding smoothly across his tight onepiece. Mimetic polycarbon.

Cut to Dr. Virginia Rambali, Sociology, NYU, her name, faculty, and school pulsing across the screen in pink alphanumerics.

"Given their penchant for these random acts of surreal violence," someone said, "it may be difficult for our viewers to understand why you continue to insist that this phenomenon isn't a form of terrorism."

Dr. Rambali smiled. "There is always a point at which the terrorist ceases to manipulate the media gestalt. A point at which the violence may well escalate, but beyond which the terrorist has become symptomatic of the media gestalt itself. Terrorism as we ordinarily understand it is inately media-related. The Panther Moderns differ from other terrorists precisely in their degree of self-consciousness, in their awareness of the extent to which media divorce the act of terrorism from the original sociopolitical intent. . . ."

"Skip it," Case said.

Case met his first Modern two days after he'd screened the Hosaka's precis. The Moderns, he'd decided, were a contemporary version of the Big Scientists of his own late teens. There was a kind of ghostly teenage DNA at work in the Sprawl, something that carried the coded precepts of various short-lived subcults and replicated them at odd intervals. The Panther Mod-

erns were a softhead variant on the Scientists. If the technology had been available, the Big Scientists would all have had sockets stuffed with microsofts. It was the style that mattered and the style was the same. The Moderns were mercenaries, practical jokers, nihilistic technofetishists.

The one who showed up at the loft door with a box of diskettes from the Finn was a soft-voiced boy called Angelo. His face was a simple graft grown on collagen and shark-cartilage polysaccharides, smooth and hideous. It was one of the nastiest pieces of elective surgery Case had ever seen. When Angelo smiled, revealing the razor-sharp canines of some large animal, Case was actually relieved. Toothbud transplants. He'd seen that before.

"You can't let the little pricks generation-gap you," Molly said. Case nodded, absorbed in the patterns of the Sense/Net ice.

This was it. This was what he was, who he was, his being. He forgot to eat. Molly left cartons of rice and foam trays of sushi on the corner of the long table. Sometimes he resented having to leave the deck to use the chemical toilet they'd set up in a corner of the loft. Ice patterns formed and reformed on the screen as he probed for gaps, skirted the most obvious traps, and mapped the route he'd take through Sense/Net's ice. It was good ice. Wonderful ice. Its patterns burned there while he lay with his arm under Molly's shoulders, watching the red dawn through the steel grid of the skylight. Its rainbow pixel maze was the first thing he saw when he woke. He'd go straight to the deck, not bothering to dress, and jack in. He was cutting it. He was working. He lost track of days.

And sometimes, falling asleep, particularly when Molly was off on one of her reconnaissance trips with her rented cadre of Moderns, images of Chiba came flooding back. Faces and Ninsei neon. Once he woke from a confused dream of Linda Lee, unable to recall who she was or what she'd ever meant to him. When he did remember, he jacked in and worked for nine straight hours.

The cutting of Sense/Net's ice took a total of nine days.

"I said a week," Armitage said, unable to conceal his satisfaction when Case showed him his plan for the run. "You took your own good time."

"Balls," Case said, smiling at the screen. "That's good work, Armitage."

"Yes," Armitage admitted, "but don't let it go to your head. Compared to what you'll eventually be up against, this is an arcade toy."

"Love you, Cat Mother," whispered the Panther Modern's link man. His voice was modulated static in Case's headset. "Atlanta, Brood. Looks go. Go, got it?" Molly's voice was slightly clearer.

"To hear is to obey." The Moderns were using some kind of chickenwire dish in New Jersey to bounce the link man's scrambled signal off a Sons of Christ the King satellite in geosynchronous orbit above Manhattan. They chose to regard the entire operation as an elaborate private joke, and their choice of comsats seemed to have been deliberate. Molly's signals were being beamed up from a one-meter umbrella dish epoxy-ed to the roof of a black glass bank tower nearly as tall as the Sense/Net building.

Atlanta. The recognition code was simple. Atlanta to Boston to Chicago to Denver, five minutes for each city. If anyone managed to intercept Molly's signal, unscramble it, synth her voice, the code would tip the Moderns. If she remained in the building for more than twenty minutes, it was highly unlikely she'd be coming out at all.

Case gulped the last of his coffee, settled the trodes in place, and scratched his chest beneath his black t-shirt. He had only a vague idea of what the Panther Moderns planned as a diversion for the Sense/Net security people. His job was to make sure the intrusion program he'd written would link with the Sense/Net systems when Molly needed it to. He watched the countdown in the corner of the screen. Two. One.

He jacked in and triggered his program. "Mainline," breathed the link man, his voice the only sound as Case plunged through the glowing strata of Sense/Net ice. Good. Check Molly. He hit the simstim and flipped into her sensorium.

The scrambler blurred the visual input slightly. She stood before a wall of gold-flecked mirror in the building's vast white lobby, chewing gum, apparently fascinated by her own reflection. Aside from the huge pair of sunglasses concealing her

60

mirrored insets, she managed to look remarkably like she belonged there, another tourist girl hoping for a glimpse of Tally Isham. She wore a pink plastic raincoat, a white mesh top, loose white pants cut in a style that had been fashionable in Tokyo the previous year. She grinned vacantly and popped her gum. Case felt like laughing. He could feel the micropore tape across her ribcage, feel the flat little units under it: the radio, the simstim unit, and the scrambler. The throat mike, glued to her neck, looked as much as possible like an analgesic dermadisk. Her hands, in the pockets of the pink coat, were flexing systematically through a series of tension-release exercises. It took him a few seconds to realize that the peculiar sensation at the tips of her fingers was caused by the blades as they were partially extruded, then retracted.

He flipped back. His program had reached the fifth gate. He watched as his icebreaker strobed and shifted in front of him, only faintly aware of his hands playing across the deck, making minor adjustments. Translucent planes of color shuffled like a trick deck. Take a card, he thought, any card.

The gate blurred past. He laughed. The Sense/Net ice had accepted his entry as a routine transfer from the consortium's Los Angeles complex. He was inside. Behind him, viral subprograms peeled off, meshing with the gate's code fabric, ready to deflect the real Los Angeles data when it arrived.

He flipped again. Molly was strolling past the enormous circular reception desk at the rear of the lobby.

12:01:20 as the readout flared in her optic nerve

Neuromancer:
the uncanny as decor

JEANNE RANDOLPH

There is a certain warning Freud imparted to humankind about our behaviour that is Delphic in its ambiguity. Fatalists love this warning because it proves that humans are little more than what Pavlov supposed. Optimists usually don't read a lot of psychoanalytic theory so they may not have the opportunity to discover the political hope that Freud's warning confirms. To paraphrase Freud's warning, it asserts that: "We reproduce our past not as a memory, but as an action. We act it out. Acting it out is, for some of us, our most vivid way of remembering."[1]

It would be unfair nevertheless to say that writing the same old story over and over again through the ages is a form of "acting out" a memory too traumatic to recognize for what it is. Freud took for granted that poems, plays, and novels are at the zenith of civilized sublimation, and he nourished his intellect in their wisdom. To Freud, it was sublimation, not acting out, every time there was a new edition of boy-meets-girl, boy-loses-girl, boy-finds-girl. Post-Freudian psychoanalysts,[2] more defensive in the Technological Society, were deliberate and specific about such storytelling as "an illusion with substance." "I am here staking a claim for an intermediate state between . . . [our] inability and [our] growing ability to recognize and accept reality. I am therefore studying the substance of illusion, that which is allowed to the infant, and which in adult life is inherent in art and religion . . . We can share a respect for illusory experience, and if we wish we may collect together and form a group on the basis of the similarity of our illusory experiences."[3]

When William Gibson's *Neuromancer* was published in 1984, a huge virtual group did form, with shared respect for this particular illusory experience, the first vivid story about the

newly implemented realm of cyberspace. Gibson had the smarts to describe the characters, effects, props, and action that set the scene for anyone's[4] daydreams of cyberspace.

Neuromancer isn't *Odysseus*, or Dante's *Inferno*, not Nashe's *Unfortunate Traveller*, and it isn't exactly *Candide* or *The Electric-Kool-Aid Acid Test*; it certainly isn't *On the Road* and it's not *Fear and Loathing in Los Vegas*. But it is the story of: "a parallel and sometimes a transcendent or spiritual world that revives the dead or the spirits of things in the limbo of the possible. Just as the mysterious telegraph and the telephone were also once thought able to contact the other world, cyberspace is also an underworld in which to meet one's Eurydice."[5]

In *Neuromancer*, the protagonist Case's experience of the uncanny is, for him, as rare a phenomenon as we find it to be ourselves. For us, Case's normal world would be totally uncanny if we had even to flip a *Nike* strip of velcro in it, never mind find a dead darling.

Case had already seen "nasty pieces of elective surgery" when the soft-voiced boy called Angelo visited his loft, and, warding off apprehension of something uncanny, if not gross, when Angelo smiled, "Case was actually relieved. Toothbud transplants. He'd seen that before." Presumably the millions of fans of *Neuromancer* haven't, yet.

With *Neuromancer* and its spawn, with the feminist Haraway cyborgs and their spawn, one might be tempted to announce, "It's the end of the Uncanny," just like it's the end of History and both God and The Author are dead. So many combinations of human, animal, vegetable, mineral, and device have been depicted that we are unlikely to find the latest conglomeration uncanny. Ugly and disgusting, maybe, but hybrids, eyesores, or sublime are within the reach of most imaginations at this point.

On the affluent ends of the earth, we live and compose our illusions at a time when technological inventions and scientific intrusions, when technological extremism and scientific blessings interpret our very being. Science and its technical implementation are foci of ambivalence, as all forms of power are, and we have become very creative imagining ahead of time all the combinations and permutations that our poor flesh will endure from these powerful forces, as well as beg for. For now, culture, which remains our ethical and social nourishment, evokes and effects the uncanny with illusions of technological power.

Alternatively, this is not the end of the uncanny. The potential for uncanny moments will remain forever as a human psychosomatic phenomenon because, according to psychoanalytic theory, the uncanny is a consequence of babies growing up with memories of

being parented (infant discovers parent, infant discovers separation from parent, infant returns to parent's arms). And so, even though we think we have read about, or watched the ultimate uncanny movie scene or computer game moment, every possible combination of living flesh hosted by lifeless flesh, dead flesh motile through living non-flesh, dead non-flesh quickened by flesh, etc., etc., an experience of the uncanny in our own day-to-day lives will always be possible. Psychoanalytic theory claims that as long as we begin as babies in the arms of somebody, we will end up susceptible to uncanny experiences. For now, the decor of the uncanny is technologically determined, but fashions in decor are not eternal.

[1] Sigmund Freud, "Remembering, Repeating and Working-Through (further recommendations on the technique of psycho-analysis 2)" (1914), *Standard Edition of the Complete Psychological Works*, Lytton Strachey, ed. tr. (London: Hogarth Press, 1914), 147, 150, 154. [2] Specifically, the object relations branch of psychoanalytic theory, initiated by Melanie Klein (1882–1960) and developed extensively by D.W. Winnicott (1896–1971). This theory is founded on psychoanalytic studies of the mother-infant bond as a predicament influencing not only individual identity but also having implications for cultural development as well. [3] D.W. Winnicott, *Playing and Reality* (Markham, Ontario: Penguin Books Canada, 1982), 3. [4] Millions of people, but not as many girls as boys, or many women as men, and maybe not so many men over the age of forty-something. [5] Margaret Morse, "Nature Morte," *Immersed in Technology: Art and Virtual Environments*, Maryanne Moser, ed. (Cambridge, Massachusetts: MIT Press, 1996), 206.

Japanimation
and Techno-Orientalism

Japan as the Sub-Empire of Signs

The word "Japanimation" is a neologism made from two words: Japan + animation. Japanimation is now seen throughout the world where people are interested in Japanese subculture including *manga*, etc. If people once asked, "What is Zen?" people now ask, "What is Otaku?" Yet, I'm very skeptical about this condition. This phenomenon is absolutely the effect of globalization and information capitalism. Under the Fordist economic system of the past, globalization meant nothing more than "Americanization," and media and entertainment were supplied by Disney animations. However, we must now seriously consider the fact that the post-Fordist social environment of globalization will include Japanimation. In other words, the strategy of this cultural movement is an effect of sub-imperialism. According to Kuan-Hsing Chen, the sub-empire is a secondary, dependent empire which is more hegemonic in culture and economics than in the military system. And this new version of imperialism uses sub-culture. By analyzing a Japanimation film, I would like to illustrate and criticize Japan as the sub-empire of signs.

Ghost in the Shell

The film *Ghost in the Shell* is set in the year 2029. This near future is not so information-based that nations or ethnicities have vanished, but networks of many enterprises cover the planet, with electrons or light running through them. In this world, East Asia is a huge corporate zone dominated by multinational economic and information operations; the lives of its inhabitants are intertwined with advanced technologies. It is a world of cybernetics and sophisticated electronic information networks, where the border between people and machines sometimes becomes blurred or even invisible. For some people, reality is

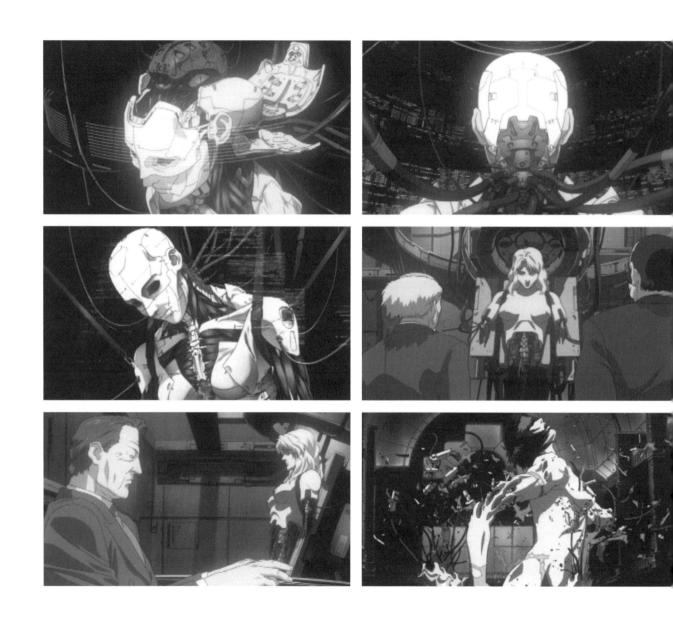

Film stills from *Ghost in the Shell*, 1995.
Mamoru Oshii, Manga Videos.

only virtual. Many humans in this world become cyborgs, a complex of man and machine. Except for a kernel of their brain, some people in this age have already substituted a cybernetic, prosthetic body for their own. The main character of the film, a woman named Motoko Kusanagi, is the leader of the Shell Squad, Section 9 of the Department of the Interior, which has been formed by the government to combat cyber crimes and political terrorism in the information society. Through the net, crimes have become more sophisticated and more violent. The film is about conflict and conspiracy among departments and agents in the government. The events concern a strange hacker who has the code name "Puppet Master." This unidentified super hacker, who began as a computer virus manufactured by the Foreign Ministry, can take over human beings to further his own purposes by using what is called "ghost hacking."

Even though a person in this world may have transformed his own body almost completely into a machine, he can still remain human in so far as he has his own "ghost." Ghost is a sort of spirit — it is unconsciousness itself — but is also memory, which can help find people's identities. The Puppet Master states, "Memory can not be defined, but it defines mankind." As if it were water in a cup, the identity of a human needs a form or shell as well as needing ghost. We cannot distinguish between shell and ghost in human beings. But the problem isn't about the traditional philosophical dichotomy between mind and body. Rather, we face a very basic question in science fiction: is the cyborg man or machine? What is self or identity for the cyborg ma(chi)n(e)? While the Shell Squad team tries to catch the Puppet Master, Major Motoko Kusanagi tries to respond to that basic question, for sometimes, Motoko is skeptical about her identity and whether or not she has ghost. Because her body is almost a machine, she is caught in a paranoid notion that she was created as an android but provided with a virtual self and an artificial ghost. In fact, some people arrested by the Shell Squad, like the Puppet Master, turn out to be agents who were given fictitious personalities by cyber brain hacking.

They were "puppets without ghost" and they have only an illusional sense of image, memory, and self-identity. These problems are closely related to the micro-politics of identity including opposition and segmentation between class, gender, ethnicity, and race. It can be said that man and cyborg belong to different tribes and "race" from each other, a context that recalls the problematic of "cyborg politics" presented by Donna Haraway. Broadly speaking, the question asks: is the self a mind or a spirit, or does the self consist of a suit,

a shell, prosthetic technologies? Does the vested shell or suit incorporate the body and become the self itself, or not? Viewing this film, we share the same question with Major Motoko: the problem of the "shellfishness of selfishness" and the question of "Who am I?"

The Puppet Master has appeared to the Shell Squad and it (or perhaps he) speaks through a cyber body without ghost. It seems that he allows himself to be caught. He affirms, "I'm not an AI. I'm a living, thinking entity who was created in the sea of information." It is easy to see here the problem of Artificial Life (AL). For natural life, DNA is nothing more than a program designed to preserve itself. And then life, when organized into species, relies on genes to be its memory system. Conversely, the computer and cyber technologies are the extension (explosion) of human memory.

Some programs can function independently of human will, and so, gain autonomy. If these processes become more complicated and sophisticated, then certain programs or algorithms become more similar to life itself. Of course, it is very different from life in nature, but at least we can see and define some information programs as AL. In this sense, the Puppet Master, as AL, uses "meme" and cultural genes to control humans and systems. It has ghost.

Informational Capitalism and Techno-Orientalism

Manuel De Landa has already remarked that the interest in AL came out of a reflection on the failure of the AI paradigm. He has always stressed the shift from a top-down approach to a bottom-up one, for the latter depends upon emergent and autonomous processes in information science. In general, Artificial Life experiments design a simple copy of an individual animal, which must have the equivalent of a set of genetic instructions used to create its offspring as well as transmit to that offspring. De Landa says: "This transmission must also be 'imperfect,' so that variation can be generated. The exercise will be considered successful if novel properties, unimagined by the designer, emerge spontaneously."[1]

If AL were truly more than a simple program and could become life, it would send some information to its own offspring by "imperfect transmission." The behaviour and intention of the Puppet Master is based on this logic. Thus, at the end of this film, the Puppet Master proposes to Motoko to merge with each other. By this unification he would able to achieve death, while Motoko could generate varied offspring into the net.

One could probably say that we have already known the Puppet Master in our ordinary lives. In fact, it is possible to find invisible manipulators in the market and financial systems, which are increasingly dependent on emergent processes and non-linear logic. "Emergence" here means the sudden change of states in any system or a haphazard phenomenon relying on a radical contingency. In the paradigm of AL, this emergence and bottom-up decision-making in a system are very important. This is why we can consider the work of huge capitalist corporations and the complicated virtual financial systems from the point of view of Artificial Life (or Artificial Market). There is nothing like the "invisible hand of God," but there are some invisible hands of Puppet Masters. Of course, this is just an anonymous process, but at least one can say that the Puppet Master is an allegory of information capitalism. De Landa presents a similar point of view about the market. Any replicating system that produces variable copies of itself in order to evolve new forms must need "the divergent manifestation of the antimarket."[2] The market for capitalism has always consisted of self-organized, decentralized structures. And it has always been an "antimarket." The antimarket is an aspect of the non-linear process of the market itself.

To analyze this film further, I return to the issue of "Japanimation" itself. Why is this kind of animation so highly developed in Japan? I believe it relates to the Western gaze and the issue of Orientalism. For example, in the 1970s when the German techno-pop band Kraftwerk used android or machine-like gestures in their live shows, they used the mannerisms of Japanese businessmen in Europe as their model. It shouldn't be surprising that they were interested in robot-like bowing and expressionless laughter. In their influential book *Spaces of Identity*, David Morley and Kevin Robins have argued that "Western stereotypes of the Japanese hold them to be sub-human, as if they have no feeling, no emotion, no humanity."[3] These impressions stem from highly developed Japanese technologies. They are a phenomenon of "Techno-Orientalism." The basis of Orientalism and xenophobia is the subordination of Others through a sort of "mirror of cultural conceit." A host of stereotypes appeared when binary oppositions — culture and savage, modern and pre-modern, and so on — were projected on to the geographic positions of Western and non-Western. The Orient exists in so far as the West needs it, because it brings the project of the West into focus. On this point, Naoki Sakai says: "The Orient does not connote any internal commonalty among the names subsumed under it; it ranges from regions in the Middle East to those in the Far East. One can hardly find anything religious, linguistic or cultural that

is common among these varied areas. The Orient is neither a cultural, religious or linguistic unity. The principle of its identity lies outside itself: what endows it with some vague sense of unity is that Orient is that which is excluded and objectified by the West, in the service of its historical progress. From the outset the Orient is a shadow of the West."

If the Orient was invented by the West, then the Techno-Orient also was invented by the world of information capitalism. In Techno-Orientalism, Japan is not only located geographically, but is also projected chronologically. Jean Baudrillard once called Japan a satellite in orbit. Now Japan has been located in the future of technology. Morley and Robins write: "If the future is technological, and if technology has become 'Japanised,' then the syllogism would suggest that the future is now Japanese, too. The postmodern era will be the Pacific era. Japan is the future, and it is a future that seems to be transcending and displacing Western modernity."

Japanimation is defined by this stereotype as an image of the future. The West is seduced and attracted by the model on the one hand, while on the other hand, the model of Japan is looked down upon rather than envied. Furthermore, this complex about Japan seems to contain a psycho-mechanism similar to anti-Semitism. It is well known that Japanese capitalism is highly developed and very powerful in areas such as the U.S., the E.U., and Asia. Techno-Orientalism works in these places as a manipulator of the Japanese complex, in which Japan is the object of transference of envy and contempt from other cultures and nations. So now, a role resembling that of the Jew is increasingly played by the Japanese. Of course, it is in vain to link the Jew and the Japanese actually and essentially, rather, the Jew and the Japanese function as the effective figures of information capitalism.

The Japanoid Automaton

I think that the stereotype of the Japanese, which I would like to call "Japanoid" for being not actually Japanese, exists neither inside nor outside Japan. This image functions as the surface, or rather the interface controlling the relationship between Japan and the Other. Techno-Orientalism is a kind of mirror stage or an image machine whose effect influences Japanese as well as other people. This mirror is, in fact, a semi-transparent or two-way mirror. It is through this mirror stage and its cultural apparatus that Western or other people

misunderstand and fail to recognize an always illusory Japanese culture, but it is also the mechanism through which Japanese people misunderstand themselves.

Different from the Lacanian mirror stage, a complete solution for this structure of disavowal, through which a "real" Japan could be properly recognized, is impossible. It is interesting that in the film *Ghost in the Shell*, the metaphor of the mirror is often used in a particular way. For instance, the Puppet Master whispers a passage from the Bible to Motoko when he tries to approach her through cyber hacking. At the end of the film the Puppet Master says to Motoko, "We resemble each other's essence, mirror images of one another's psyche." And after she merges with the Puppet Master, Motoko cites a biblical passage: "What we see now is like a dim image in a mirror. Then we shall see face to face. When I was a child, my speech, feelings and thinking were all those of a child. Now that I am a man, I have no more use for childish ways."

In this context there are two mirror stages of Techno-Orientalism. One is the encounter between the human and the machine, the human and the net. The other is the relationship between Japan and others (Western, other Asian, etc.). These two mirror images constitute the "Japanoid" as object of envy and hate. I have already mentioned that the Japanese have often been laughed at because of their "automatic" robot-like gesture. Of course, as Freud has observed, there is a very close relationship between automatic action and humour. But here one should think about why androids or robots are ridiculed and why the person laughed at becomes android-like. Rey Chow has an interesting analysis of this point: "In Chaplin's assembly line worker, visuality works toward an automatization of an oppressed figure whose bodily movements become excessive and comical. Being 'automatized' means being subjected to social exploitation whose origins are beyond one's individual grasp, but it also means becoming a spectacle whose 'æsthetic' power increases with one's increasing awkwardness and helplessness."[4]

To affirm the culture and the industry of the modern world is to summon the "automated Other" by introducing the rhythms of technology and machines into ordinary life. As long as workers, women, and the ethnic Other experience radical changes in work conditions because of highly developed technologies, the image of the automated doll is imposed on them. This image is also imposed on the nation—people who over-adapt to the mutations

of technological conditions. Needless to say, the Japanese are being seen as the "automated Other." Japanimation, which organizes the image of automatization and animation (giving it a life form), constructs and presents a "Japan" as an "automaton culture" and as the "Japanoid" in "Postmodern Times."

It is worth returning to the Puppet Master, because the Puppet Master reminds us the one controlled doesn't think he is a puppet, but in fact, he behaves as a puppet controlled by a master. It is similar to the relationship of ideology in general, to human beings. Motoko, as a woman cyborg, thinks of herself as an "animated automaton." In order to supplement her void (as cyborg, as woman, as minority, etc.), she agrees to the proposal to merge with the Puppet Master. She, as a minority, would abandon her ghost to a huge system and the net. In turn the Puppet Master, as a system, would achieve death and a so-called life cycle.

Rey Chow has already defined the strategy of the cyborg feminist as rejecting the binary opposition of masculine-human-subject-versus-feminized-automaton. Chow argues that this strategy "retains the notion of the automaton—the mechanical doll—but changes its fate by giving it life with another look. This is the look of the feminist critic. Does her power of animation take us back to the language of God, a superior being who bestows life upon an inferior?" This is the task of the cyborg as half machine and half animal, a transgressive being. Conversely, when a subject takes up tactics of transgression, it unconsciously becomes like a cyborg. So for the cyborg feminist, this strategy should be extended further than "animating the oppressed minority." Cyborg feminists must make the automatized and animated situation of their own voices the conscious point of departure in their intervention. By abandoning and sacrificing her own identity and ghost to the Puppet Master, Motoko takes up the strategy of cyborg feminism.

The "Japanoid Automaton" could be rejected in this way, but this rejection and resistance has always broken down in Japanese subculture. The a-national (non-national) culture of Japan and Japanese (Japanoid) are "animated and automatized" as being non-Western and non-Asian. In this cultural climate, a Japan imaginarily separated from both West and East is reproduced again and again in the political unconscious of Japanimation (subculture). Though Japanimation has often emphasized the landscape of Asia and Japan in the near future, it is the operation of forgetting that conceals the real situation of Asia and Japan. In a certain sense, Japanimation is an ideological apparatus at the same time that it is (virtually?) an armament of criticism.

Why do Asian landscapes excite the cyberpunk imagination? Certainly it would be possible to attribute the influence to the film *Blade Runner*. But it should be considered that Japanimation has illustrated the mutation of global capitalism itself by appropriating the illusion of Asia or Japan. By choosing Hong Kong as the setting for this film, and trying to visualize the information net and capitalism, the director of this film, Oshii Mamoru, unconsciously criticizes the sub-imperialism of Japan (and other Asian nations).

Japanimation is travelling through the cultural diaspora into the world and is translated, communicated, and misunderstood. It should be cited from Donna Haraway's *A Cyborg Manifesto*: "There is no way to read the following list from a standpoint of 'identification,' of a unitary self. The issue is dispersion. The task is to survive in the diaspora." If the image of the shell and suit of a cyborg has been influential, it is not in vain to discover the "automated Other" in various expressions and in global information capitalism itself. It is another way to "animate" the Other and the minority.

[1] Manuel De Landa, *Virtual Environments and The Emergence of Synthetic Reason* (Durham, North Carolina: Duke University Press, 1994). [2] Manuel De Landa, "Markets and Antimarkets in the World Economy," *Techno Science and Cyber Culture* (New York: Routledge, 1996). [3] David Morley and Kevin Robins, "Techo-Orientalism: Japan Panic," *Spaces of Identity: Global Media, Electronic Landscapes and Cultural Boundaries* (London: Routledge, 1995). [4] Rey Chow, "Postmodern Automatons," *Writing Diaspora* (Bloomington, Indiana: Indiana University Press, 1993).

The Shock Projected onto the Other: Notes on *Japanimation and Techno-Orientalism*

TOSHIYA UENO

Throughout history, the development of new machines and technologies has created kinds of shock not previously experienced. In some cases, this shock could be regarded as a specific kind of beauty, though the notion of shock is at odds with that of beauty. Instead, it is more closely related to the notion of the sublime or the uncanny.

The sublime problematized by Kant pointed to the shock of a subject in front of the furious landscape of nature. Kant was already aware that the same affective position was true for artificial constructions such as gigantic architecture. Putting it simply, this case could be called "techno-sublime" rather than a mere beauty of artifacts or machines.

Of course, any shock can be banalized as man becomes retroactively accustomed to it by domestication. In the twentieth century, waves of mechanization and mobilization for the reproduction and standardization of everyday life were inextricably linked to warfare. It is no coincidence that the discourse on shock flourished during the period between the World Wars. In fact, Freudian psychoanalysis was influenced by the shock stemming from World War I. In his "Notes on a Scientific Psychiatry" and "Beyond the Pleasure Principle," Freud focused on the model of obsessive repetition and anxious stimulus derived from mechanical technology and its appropriation on warfare.

German critic and philosopher Walter Benjamin established two kinds of memory-processes. The first process consciously stocks information. The second process is unconscious memory, it is not imprinted on consciousness but operates as an external force on the subject's inner being in the form of "shock." According to Benjamin (see "On Some Motifs in Baudelaire" and "The Image of Proust"), what Baudelaire defined as fundamental memory and the memory Proust associated with the famous madeleine dipped in black tea, *mémoire involontaire*," is also "shock-memory" rather than consciously stored

memory. In other words, these types of memory are the dust of memory and akin to the forgetting process. The "original or radical memory," which gives rise to memory, the shock which pre-exists memory, can only consist of stimuli which cannot be stored in consciousness. The shock, and the defensive mechanisms it entails, makes it possible for consciousness and memory to exist. The relationships between memory and oblivion, memory and shock, are very significant for our understanding of film and animation.

It is crucial to juxtapose and connect images through operating memory. For instance, Benjamin writes, "To articulate the past historically does not mean to recognize it 'the way it really was' (Ranke). It means to seize hold of a memory as it flashes up at a moment of danger." This remark on historical thinking has a very significant implication for the history of film and animation. The creation of film, including animation, consists of making connections, of articulating images as/of disparate facts. In the history of film and animation, one can find many "flashing moments," especially nowadays, as there is a crisis/turning point between optical cinema and electronic media.

Obviously, cyber culture and information society also have a specific kind of shock and techno-sublime. Japanese animation has always presented numerous examples. The shock inherent in reproductive and information technology is projected onto the Other. The paper "Japanimation and Techno-Orientalism," which I wrote six years ago, dealt with these projections of shock and the uncanny onto the Other.

First, shock is projected onto fictive super weapons, machines, and technologies. Japanese animation has been preoccupied with the image of the war; *Gundum, Patolabor, Robotec (Macross), Evangelion,* and so on. In the story of *Macross,* the ultimate weapon was not a robot or mobile suit but the music and voice of a girl singer. Zentaradians, the alien army, did not know the culture at all and felt such strong shock from a mere banal love song they had to abandon all military operations. In this piece, a girl singer named Lin Minmay was the ultimate weapon of the battleship *Macross* against the Zentarady. This notion that subcultures can stop war sounds like nonsense but it still deserves consideration in our contemporary world.

If war is a continuation of politics in alternative form, as Clauswitz once said, then one can say that Japanese animation is a sort of continuation or even extension of the information warfare in alternative form, because it mobilizes the imagination of people in the info-war through narratives and images.

Secondly, shock is projected onto women's bodies. It is well-known that, especially in Japanese animation, women are figured in very specific ways, and the theme of the merging of women with technology is the most visible one. In much of Japanese animation, female characters are numerous and frequently supposed to possess special abilities of being more adjustable to machines and technologies. In Mamoru Oshii's *Ghost in the Shell*, Motoko and Puppet Master (an Artificial Intelligence) are merged together as a vast living network, a plot which continues in the new cartoon series *Ghost in the Shell II*. Typical examples of this aspect of Japanese animation are found in the famous cartoon series *The Five Stars Stories* and *Fatimas*, where the women-shaped androids control the battle robots called "Motor Heads." Of course, representations of women in Japanese animation are sometimes highly contentious because of the obvious or eventual "sexism." It is also interesting to note that women are quite often characterized as "coloured," despite a prevailing relative indifference to "race" or ethnicity in Japanese society. Here, one can see the subjects of gender and racialized cyborg politics. This aspect is surely related to the next type of the Other, Other as "orientalized."

Thirdly, shock and the uncanny are projected onto other cultures. It is quite easy to see the cultural syncretisms in Japanese animation. The style, fashion, design of machines and architecture, and the appearance of characters frequently refer to those of other cultures and customs. In my essay, I have analyzed those moments as Techno-Orientalism in Japanese animation. Originally, this notion was theorized by Kevin Robins and David Morley in their influential book *Spaces of Identity*.[1] They coined this term mainly for interpreting the position of Japan and its eventual moral panic under the process of globalization. After having published the book, the authors did not develop the notion so I adopted their idea for different purposes.

Techno-Orientalism is a form of shock that affects the West (i.e., Europe and America) and perhaps will affect the society and technology of the near future. It is also an amalgam that consists of hate, fear, envy, longing, and yearning for technologies and alternate cultures. In a way, the so-called culture shock and the shock of the new machine or technology are overlapping in Techno-Orientalism.

At the same time, it should not be forgotten that Japanese animation, by appropriating the illusion of Asia or Japan, marked the beginning of the mutation of global capitalism itself. One can summarize the shift of the capitalism system as one from the "Fordist"

system to the "Post-Fordist" system. The Post-Fordist economy is inextricably linked to the labour forces of Asia. In this context, it is noteworthy that many animations have been produced by animators in other Asian countries, with relatively cheap labour. Japanese animation itself is symbolic of "Japanization" in capitalism (at least until the late 1980s) or Japanese (sub)imperialism or (post)colonialism. Other/Asian countries were a resource for the future of Japanese capital as an economical basis. In this sense, "Techno-Orientalism" in Japanimation can function as a cultural and ideological apparatus to cover and disavow the realty of global capitalism.

It is also possible to suggest that "Techno-Orientalism" is connected to the "self-colonization" process in Japanese society. Although Japan has colonized other countries, Japan itself has never been colonized. But, as one of the most hyper-consumer societies, Japan has experienced the colonization of its life by Western capitalism. Through rapid westernization and quasi-modernization, Japanese society is totally separated from its own traditions, customs, and cultural backgrounds. On the one hand, Japan has been imitating the west; on the other, Japan has in the past communicated with Asia and the East through very repressive means. In other words, the Japanese has a "double conscious-ness," which is the psyche of the colonizer and the colonized.

By considering the notion of shock projected onto the Other as a formative process in the development of cultural consciousness, we can return again and again to the question of the uncanny or the techno-sublime as well as Techno-Orientalism.

[1] David Morley and Kevin Robins, *Spaces of Identity* (New York and London: Routledge, 1995).

References: BENJAMIN, Walter, "Thesis on the Philosophy of History," *Illuminations*, ed. Hannah Arendt (New York: Schocken Books, 1969). CHOW, Rey, "Postmodern Automatons," *Writing Diaspora: Tactics of Intervention in Contemporary Cultural Studies* (Bloomington, Indiana: Indiana University Press, 1993). DE LANDA, Manuel, "Virtual Environments and the Emergence of Synthetic Reason," *Flame Wars* (Durham, North Carolina: Duke University Press, 1993). MORLEY, David and Kevin Robins, "Techo-Orientalism: Japan Panic," *Spaces of Identity* (New York and London: Routledge, 1995).

Mariko Mori, *Nirvana*, 1996–97.
Still from 3D video installation.
Courtesy Gallery Koyanagi, Tokyo.

Others in the
Third Millennium

MAKIKO HARA

In order to write this essay, I had to reconsider what I have been focusing on during the preparation of this exhibition over the last year and a half. The exhibition is based on two key words: "cyborg" and "uncanny." The issues that I was concerned about in terms of this project had to do with "images of Otherness," and my idea of the cyborg has been constructed through scrutinizing the following two aspects defined by such images. One is related to the main focus of the exhibition curator, who posits that our uncanny feelings are a subconscious dread of cyborgs. Although a cyborg is a man-made "Other," its appearance resembles us, which causes confused expectations. That is probably the origin of our conception of the uncanniness of cyborgs. On the other hand, images of the otherness are related to politics of the gaze which, reflected in cyborg-like beings, appear in Japanese contemporary art and pop culture.

The image of Japanese people held by non-Japanese is, to put it simply, a fictitious image. French philosopher Marc Guillaume remarks in *Figures de l'Altérité* that the image of Japanese Otherness is a "compounded fiction," and its prototypes are notions of "apocalypse" and "escape by technology." The former refers to the Japanese experience of the catastrophic atomic bombings of Hiroshima and Nagasaki. He suggests that the quick recovery made after the catastrophe "symbolizes a possibility to live in the other world along with the threat of nuclear arms." On the other hand, simulations and robotics produced by advanced art, biocybernetics, and engineering technology in present-day Japan provide people with an illusion that one can go beyond the limits of time, space, and physical presence. They suggest an "escape to the outer reality." Guillaume defines technology as a "method to fall outside the world, depict the other world and realize a simulacra of that world."[1]

The image of Japanese Otherness examined as a "compounded fiction" by Guillaume, appears in Japanese "animation" and comics as a framework for end-of-the-world theory and superhuman characters. Appropriated for use in Japanese artists' works, cybernetic elements seem to play the role of creating Japanese-ness. Issues of gaze politics, such as "Japanese as the Other being gazed at," are elaborated by Toshiya Ueno and Masanori Oda in their excellent texts in this book. It is interesting to note that these two authors from different fields, generations, writing styles, and political attitudes both focus on issues of gaze politics and cyborgs. They provide examples to discuss their ideas, so I'd rather not repeat them here. The point that I'd like to draw from their texts is that Japanese are not the Other being gazed at one-sidedly, but entertain such projected fictitious Otherness inside as double meaning self. Such a sensibility can hold a co-acting personality within and enable both "the end of the world and a possibility of opening up the world" as hypothesized by Guillaume, and provide room for the possibility of surviving without being divided.

Going back to the issue of the cyborg, one might be able, in the image of the Other symbolized by the cyborg, to have a fantasy of reflecting oneself onto that cyborg and forming a self-identity where the border of the real and unreal world is ambiguous. In this essay, I will study the self-ambiguity expressed in the images of "cyborg" shown in three Japanese artists' works.

Firstly, I should explain my view of the cyborg since cyborg is a complex concept. There is a technological "cyborg" as an advanced device or robot, "cyborg" constituted in contemporary discourse, and "cyborg" as an image that appears in science fiction and mass media. Diversified ideas and images interweave. My idea of the "cyborg" is not concerned with its physical and organic substance but, more importantly, with its potential of embodying the hope of a human evolving into a transcultural and transgendered being. My view of the cyborg is influenced by the radical arguments offered in "A Manifesto for Cyborgs" by Donna Haraway[2], and contexualized with an examination of my own identity issues. Haraway's deconstructive discourse is important to me for showing the possibility of dissolving perceptual dualisms. Her concept of "shifting subjectivity" is what I am most interested in, and will address in this essay.

Haraway's strategy is to redefine "woman" from the position of a borderless condition of human (man)/machinery (woman). What is attractive about Haraway's cyborg is

it posits the subject not in a human but in a constantly reproducing cyborg form. The cyborg is a "shifting subjectivity" created where the borderline between subjectivity and objectivity comes into question. In terms of feminism, this theory could be delinked from the fixed dualism of woman/man. The cyborg has nothing to do with the myth of Genesis, nor is it related to "universal totalitarian theory."[3] Thus "cyborg" can help liberate us from dualistic thinking such as "Other and self," as well as be a metaphor to enable "ambiguous self-recognition" that positively accepts such "shifting subjectivity." With this in mind, I would like to investigate "cyborg qualities" in the works of Kenji Yanobe, Takashi Murakami, and Mariko Mori.

Yanobe, Murakami, and Mori represent Japanese contemporary art, and are highly reputed in the international contemporary art scene. I've had opportunities to study their works since the early 1990s (Mori made her debut in Japan later than the other two, in 1995). While their works were internationally appreciated, frankly, I was critical of their activities for some time. Looking back, I assume that my attitude reflected the incongruity I felt about pop culture in Japan at the time. It seemed to me that their works were among those trends such as "Otaku culture," "popularization," and "affirmative infantilism." They were represented by animation and *manga* (comics), which were often used positively by Japanese people and Japanese contemporary art fans to differentiate and characterize Japan's contemporary art in the international context, a trend that became obvious in early 1990s. Of the three, I don't want to be only critical of Murakami since he did show "resistance to the occidental art context" from the beginning, gradually attaining his present complex theory of self-contradictory self-affirmation. However, in those days, I was uneasy about the his self-conscious attitude to exaggeratedly depict Japanese people as "the Japanese in accordance with the images of the Other from the Western viewpoint," and caricature them.

Later, I left Japan to live in Canada, a multicultural country. While observing systems and discourses that form cultural discrimination in Canada and how they relate to my thoughts, I concluded that my feelings of unease were kinds of self-internalized, discriminatory traps. I understood that I should be aware of such discrimination in myself, instead of refusing it, and I should look at self as an ambiguous being; otherwise, I would not be released from the dilemma. During the process of this perceptual change, I read materials on post-colonial theory by non-Occidental women thinkers[4] and applied their

Mariko Mori, *Birth of A Star*, 1995.
Courtesy Gallery Koyanagi, Tokyo.

opinions to my reality. I also learned much from the First Nation peoples of Canada who have fought to establish their identities despite being looted and having their culture distorted. After getting to know their practices and processes of incorporating their cultural roots with modern lifestyles without falling into dualistic dilemma, I began to think of my own questions relatively. In other words, understanding the Other's image reflected upon me constitutes a fiction, overlapped with signs of cultural discrimination, and I think it is important to realize myself as a fluid process of "shifting subjectivity" within the double meaning of "gazing and being gazed at."

In this section, I focus on how shifting subjectivity and its attendant double meaning, which the cyborg shows us metaphorically, is effectively presented in the artists' works, based on the inspection of their production process.

Cyborg as a transcendental image in the work of Mariko Mori

Mariko Mori's early photographic works were received coldly by contemporary art circles in Japan at the time, although this is not well-known to the Western art scene. Members of the media in Japan were more interested in her reputation in the United States and her personal history, such as her coming from a wealthy family and working as a fashion model in the past; they were quite indifferent to her actual work. Her overseas success and admiration were imported through the media, and the media soon praised her as an artist Japan was proud of. I don't know what she thought of this development, but I assume that she perceived this overreaction to her as an artist strategically. It resembles the way the media creates the images of supermodels and Hollywood actresses through shrewd manipulations of their personal backgrounds. This attitude has been consistent in her works such as *Art is Fashion*, in which she is dressed as a fashion magazine cover girl, focusing on consumerism in the art world in a backhanded way. From *Birth of A Star* (1995), in which she poses as an animated cyborg in the fashion of a 3D movie star, to her recent work, it is clear that her strategy is to use signs to act out the fiction of media-manipulated images.

In *Play with Me* (1994, p. 266–267), which is regarded as one of her major works, Mori is disguised as a signified cyborg using fabrication techniques to embody self/other of double meanings. Mori poses as a cover girl, who is likely to appear in a "Tokyo cyber culture"

special of a European or American fashion magazine, she is set against the exotic cyber background of Akihabara, a techno-town in Tokyo as perceived by the West. In an interview with *BT Magazine* in 1995, Mori said that the "cyborg" in this work is a metaphor for the social status of Japanese women, and talks about men's fantasies of women and how women accept them. *Play with Me* is presented in a series with four other works depicting images of a near-future cyber girl (played by Mori) against a background peculiar to Tokyo, such as love hotels and *Kabuki-cho* entertainment areas. This creation of images could be interpreted as "Japanese mind of excessive hospitality in enacting the Orient to please the West." What is disturbing, on the other hand, is how Mori positions her subjectivity in the created images. In the same interview, Mori points to the cyber girls she portrays and says, "real sociality exists in the works by placing *them* in the photos." (Italics mine) I don't know whether she really meant that or not, but it is worth pointing out that, as the word "them" shows, Mori's way of defining her subjectivity as a co-acting personality is by reflecting the Other onto herself, providing "a place to always question the borderline between the subject and the Other." By becoming a cyborg, in the sense of a sign manipulation of fictitious images, isn't she providing a way to be free from the labyrinth of dualistic self-identity though "shifting subjectivity"? "I" is not equal to "Japanese," and in this sense, the "unnaturalness" of Mori's cyborg is uncanny. It makes the borderline ambiguous not only between machine and human, but also between I, you, and they (subjectivity/objectivity), changes the Tokyo familiar to us into an artificial world of signs, and what appears to be Japanese is endowed with the incomprehensible super-Japanese.

On the Non-Aggressive Quality of Kenji Yanobe's Works

Every work of Kenji Yanobe's is operated from inside by the artist or someone else. Since the borderline between the operator and the machine is affirmed, the work does not resemble a hybrid cyborg with human features and thinking faculty, like those that appear in *The Terminator* or *Ghost in the Shell*; thus, the "shifting subjectivity" of Haraway's "Manifesto for Cyborgs" is not present in his works. Based on the *manga* character *Astro Boy*, with his extended human physical abilities, Yanobe's works play a warning role, suggestive of a critical situation that will require the use of the machinery. In the end-of-the-world

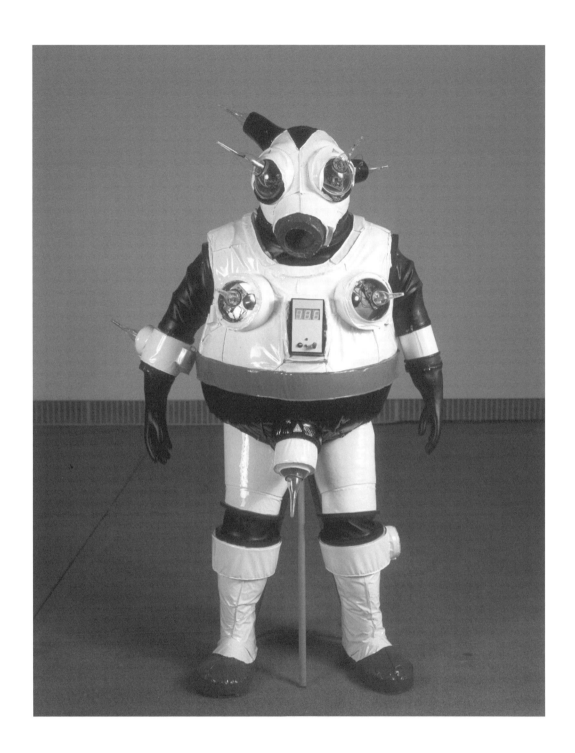

Kenji Yanobe, *Radiation Suits ATOM*, 1996.
Courtesy Röntgen Kunstraum Tsutomu Ikeuchi AG, Tokyo.
Photo: Vincent David Feldman

scenario Yanobe alludes to, all people have to do is to defend against radioactivity in order to survive on Earth following the final nuclear war. He evokes "apocalypse" as an element of "the other" reflected upon the Japanese. In this situation, the Yanobe shelter or protection suit equipped with a Geiger counter are a means to "escape to the outside of reality" which points to the illusion that we can escape from our physical limitations, that is, protect ourselves against atomic bombs. It is compatible with the analysis of "possibilities to live in the other world under nuclear threats" regarded as a "compounded fiction."

It seems that the reason why Yanobe's works are appreciated abroad is that his end-of-the-world fantasy contains the "compounded fiction" of Japan as expected by others—they have a pop appearance, and can be regarded as artistic creations. Yanobe's machinery, such as a protection suit or an Atom car, seems familiar to people with its *Astro Boy* similarity, its low-tech craftsmanship (like a jalopy in *Tank Girl*), and its optimistic pop appearance. Accordingly, even struggling for survival looks like a sensational unrealistic fantasy, and seriousness is camouflaged. But Yanobe tries to show us an end-of-the-world story of the Atom generation and the reality of radioactive contamination. Regardless of where Yanobe's motivation for creation lies, his works encountered little resistance during the boom in Japanese animation/comics in Europe and the United States in the 1990s, and were welcomed as novelties, which would be never created in the context of the Western culture.

Around the time that I began to write about Yanobe's works—as if to suggest an apocalyptic state of emergency—the war against the Taliban began, following the September 11 terrorist attacks in New York and Washington, D.C. It is incredible that we are actually in this acute situation, in which a devastating post-nuclear war world that Yanobe imagines might become real. The reason why this warfare enervates us is that it demands such a critical seriousness that no resolve to the solution seems available by the examination of the "other." Yanobe has anticipated cultural clashes after the failure of globalization. His fictions are "uncanny" with the end-of-the-world feelings represented in his works. In order to survive such an eschatological situation, Yanobe enters into a machine equipped with no weapons. He does not set up "the other" as his enemy to fight against. In this way, his works are different from his model "Astro Boy." "Astro Boy" is a man-made robot that looks like a boy, and fights intruding enemies to fulfill his mission: "Save the earth from evil." In Yanobe's fiction, only the radioactive-contaminated earth is left; not even

an enemy to conquer remains. Such a situation does not require a way of thinking with double meanings suggested by cyborgs because such thinking would be ineffective. There is no existing question as to experimental self-formation at a post-domain with ambiguous borderlines. As Yanobe's world is enclosed in itself as a story, it seems to me only a variation of "methods to realize another world's simulacra."

The Qualities of Cyborg in the Work of Takashi Murakami

Murakami is a tough artist. He thinks strategically, and is rather schizoid, obsessively sensitive about the above-mentioned image of the "otherness" of the Japanese, and tries to break the image by using it carefully. Both at home and abroad, countless opinions and analyses of him have been made, which seem to have reached their peak with his *Superflat* exhibition in the summer of 2001. However, no matter how many analyses have been made from various angles, they can hardly show what he really is. The above-mentioned quality of double meanings is self-evident to him, so it cannot be a topic in the study of his works. Besides, the discussion of his works in the light of his superflat theory will go in circles and get nowhere. I have to be careful about that point, and would like to restate that he is a tough artist. Therefore, I give up trying to metaphorically understand the cyborg qualities expressed in both his ways of thinking and working. For doing that will mean falling into Murakami's trap.

I have an uncanny drawing of his, which was done in the planning stage of his new piece provisionally entitled *A.I. (Artificial Intelligence)*. Murakami gave me this drawing last year when I was conducting research for this exhibition. On the right side of the drawing are the images of his recent major works *Ko²* and *Second Mission Project Ko² (S.M.P.Ko²)* (1999–2000, p. 270–271) and sample images of *A.I.* are on the left side. This A.I. looks like a spaceman with an abnormally slim waist, disproportionately large ET-like head, and long limbs. *A.I.* is, as you all know, a film directed by Steven Spielberg based on a script by the late Stanley Kubrick. Prior to its release, Murakami had planned this work with this film in mind. Therefore, it is natural that he uses elements reminiscent of *ET*. He said that he was looking for sponsorship or partnership to realize this work, keeping in mind the exciting developments of in the Japanese personal robotics industry. Recently, Murakami has been producing his works in collaboration with his Hiropon Factory. He also works with

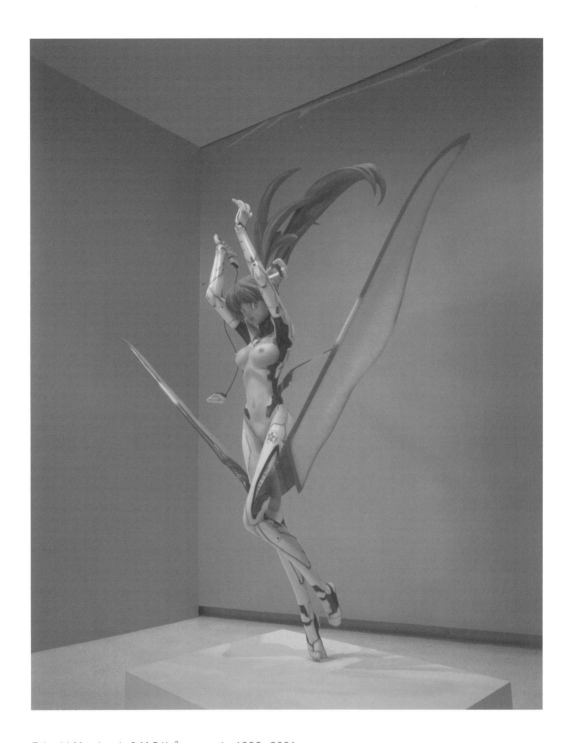

Takashi Murakami, *S.M.P.Ko² mega-mix*, 1999–2001.
Installation view at Carnegie International.
Courtesy Blum & Poe, Marianne Boesky Gallery, Tomio Koyama Gallery
and Hiropon Factory. Photo: Frank Oudemann

engineers and producers in the figure-production industry who reproduce 3-D animation characters making full use of technologies and maniac *Otaku* skills. Guessing from his motivation for this *A.I.* project, his aim seems to establish a great new system involving popularization of the robot industry. What is produced through this kind of collective system will reflect desires of all the parties concerned; in other words, what is produced will have multiple characters. Despite the fact that a work is based on his drawing, it will be transformed, reflecting desires, æsthetics, and expectations of various people involved in the system. It is a cyborg in the making, and will appear as an uncanny deformed being.

A cyborg embodies a new way of thinking, which emerges when a dual view of the world is destroyed, and at the same time, becomes what is uncontrollable by a single person. The cyborg quality observed in each of the three artists' works indicates inevitability of the subject to change in order to survive today's chaotic world — Mori's embodying double meanings by turning herself into signs, Yanobe's strategy for survival by placing himself in a delusive story, and Murakami's self-awareness in constructing a system to create what has multiple characters. Each of their works constitutes an element of the cyborg, and addresses our perplexity in adapting to this technologically changing environment. Whether it is a symbolic image, discourse system, or future human form, "cyborgness" already appears within us as a symptom. "Cyborg" is no longer a choice and our process of turning into "cyborg" is part of our reality. What we can do is to observe the process of the "image of the other slowly being eroded to become self-immanent" without falling outside the world.

[1] Jean Baudrillard and Marc Guillaume, "The Exotic Others," *Figures de l'Alétrié* (Paris: L'Association Descartes, 1992) [Japanese Translation: "Seikimatsu-no Tasha-tachi" translated by Fumi Tsukahara, and Kazuo Ishida, (Tokyo: Kinokuniya-Shoten, 1995)]. [2] Donna Haraway, "A Manifesto for Cyborgs: Science, Technology and Socialist Feminism in the 1980s," *Socialist Review* #65, 1985 [Japanese Translation: *Cyborg Feminism Plus*, ed. Tatsumi Takayuki, translated by Mari Kotani, (Tokyo: Suiseisha, 2001)]. [3] Keiko Yonaha, "Seisa-Kaitai-no Kanata-e" ["Beyond the Deconstruction of Gender"] in *Cyborg Feminism*, ed. Tatsumi Takayuki, *Shincho* #89, February 1992. [4] Particularly I was inspired by Trinh-T Min-ha's post-colonial discourse and her careful and critical examination on the issue of gaze politics.

Tomatsu Shomei, *Character P: Long Home*, 1996–98.
Courtesy Mito Arts Foundation, Mito, Japan.
Photo: Yoichi Inoue

Welcoming the Libido of the Technoids Who Haunt the Junkyard of the Techno-Orient, or The Uncanny Experience of the Post-Techno-Orientalist Moment

MASANORI ODA

Do you know that our word for "nature" is of quite recent coinage? It is scarcely a hundred years old. We have never developed a sinister view of technology, Mr. Laney. It is an aspect of the natural, of oneness. —William Gibson, *Idoru*[1]

Welcoming the Beauty of "The Other"

One of the missions of contemporary art is to welcome the beauty of "The Other." Picasso integrated the perspective of "primitive" art in his protocol for painting, Duchamp exhibited mass-produced merchandise in the museum, and Léger praised the machine and its mechanisms. Since its beginnings, contemporary art has actively sought after the beauty of "The Other" and embraced it. Naturally, this has evoked critiques from opposing views, yet the experiments have challenged and deconstructed the notion of a singular and great *Art*, and in turn, disseminated the seeds of the plural and *minor art(s)*.

However, its welcoming was never an uncontested one in any historical period. Quite often, there was a kind of a requisition or appropriation based upon colonialism, exoticism arisen from geopolitics, or the politics of representation. One of the well-known principles of contemporary art is "anything goes," though what had served this role of "anything" has been Others and outsiders, and contemporary art is a greedy "differential engine" which feeds on the energy produced from this æsthetic rag.

In a hundred-year chronicle of the 20th century—i.e., from the period of the World Wars and the rise and fall of the Cold War structure, to the era of globalization—contemporary art of the West has welcomed a broad definition of technology. The marriage of art and high-tech devices produced media art, and a love affair between art and low-tech

fabrics created junk art; as a result, these two kinds of art have crashed together. Later, the concept of cyberpunk emerged, as well as the raves of a "second summer of love" accompanied by techno music. In this process of hybridization, contemporary art eventually discovered the so-called Techno-Orient, and gave it a full welcome. Japanese artists and their works in this exhibition were chosen under the auspices of Techno-Orientalism, and are acclaimed as agents of the Techno-Orient. But what exactly is Techno-Orientalism?

The Trap of Techno-Orientalism

David Morley & Kevin Robins,[2] and Ueno Toshiya have already pointed to a "Techno-Orientalism" that lurks in the Western gaze and is derived from TV games (*game*), animation films (*anime*) known as Japanimation, and comics (*manga*)—all Made-in-Japan. Techno-Orientalism, Ueno writes, "like the former Orientalism, is nothing other than a institutionalized discourse"; he also argues that the "Orient only exists in so far as the West needs it, projecting the images of techno & cyber space, or standing as a different culture." As seen in the sprawl of "Chiba City" in William Gibson's novel *Neuromancer*, in the Orient, Japan especially amplifies the imagination of a different world to the maximum, as the alternative space of literature. Ueno remarks that "Japanese society is particularly distinct in the symbiosis of tradition and custom with high-technology . . . an image of a Japanese who never stops playing with machines and technology, with no feeling, no emotion, is fixed as the new stereotyped model by the West, which denies and disaffirms but at the same time cannot avoid turning away from its attraction." Furthermore, Ueno argues that the Japanese themselves have now undertaken this Techno-Orientalism, and "it is becoming an epistemological apparatus for Japanese to misunderstand themselves, and for Westerners to misunderstand others."[3] In the present Post-Orientalist moment, rather than the typical Japanese restaurant (with its stereotypical old-fashioned Japanese interior), Japanese *anime*, *manga*, and *games* are becoming a kind of "contact zone"[4] for the West to meet the latest Japan/ese. What is different from the old Orientalism is that both parties (Japanese and Occidental) hold a kind of reciprocity. This means that the Japan/ese often appear as "as you like," self-fashioned figures to the West, not only to satisfy their own gaze, but to disguise the real portrayal of their own nature or desires, as if to say, "This figure is not so bad for me." The Japanese tendency of excessive hospitality

further enhances this quality. With this, the Master-Slave relationship underlying Orientalism is concealed, substituted by a more comfortable Guest-Host relationship. Therefore, there may be a contact between both parties, but there is never an encounter, much less an uncanny experience. Thus, mutual misconceptions accumulate. As pointed out by Ueno, here lies an inevitable trap of Techno-Orientalism.

Japan/ese as the *Otaku* in the Techno-Orient

As seen here, the Japan/ese have accepted a certain role during the process of internalizing Techno-Orientalism: the role of the *otaku*, which means geek or nerd in English. The *otaku* is a personality model characterized by everlasting infancy and immaturity, forever occupied with *anime* and *manga*. This model is denied and disapproved by the West, yet it continues to attract at the same time. As long as the *otaku* continues to play the role of child-adult or as high-end techno wizard or hardcore collector who indulges in the world of the lovely, childish, violent, and erotic techno, Techno-Orientalism pours a curious gaze over them and defends their existence. However, since that gaze, by nature, contains an ambivalent feeling mingled with a curiosity and a phobia towards an abnormal existence, they may be subjected to lawful restrictions based upon political correctness, and could become vulnerable if suspected of being a hotbed of moral hazards as soon as political and economic changes arise (especially in the economic imbalances of the global economy). This reminds us that the parents of such Techno-*otaku* had been discriminated as "economic-animals" with Japanese techno-products becoming the scapegoat. In any case, the role of Japan/ese as technophiles is self-chosen but at the same time obligatory. Therefore, things created by Japan/ese are always haunted by the obscure intervention of the Others' gaze, which is also true in the genre of art.

Techno-Orientalist-Oriented-Art (T.O.O.A.)

A good example is an early photograph of Mori Mariko entitled *Play with Me* (1994, p. 266–267). Mori's techno-futuristic costume, which seems like either a cyborg or an android, is an anthropomorphosis of a graphic character image derived from *anime otaku*. The photograph was taken in a town near Tokyo called Akihabara. Mori captures the fetishistic gaze of an *otaku*, and deposits her own body into the image to support this type of fetishism.

This image is originally a fictional one, and it is a simulacrum of a collective desire that does not have a real existence; it is a virtual idol/*idoru*. When imagery that is originally virtual play-acts with a real physical body, it inevitably awakens something uncanny.[5] This work also has another kind of spookiness because it demonstrates the traditional horror of an automatic talking doll that has been abandoned by its owner, left alone without anyone to play with. Mori's work implies a feminist commentary on the fetishistic gaze towards girls within an *otaku* community, and a critical response towards desire and the gaze of the *otaku* as a domestic Other. Mori's sensibility towards the gaze of the Other was further accelerated with her recent computer-enhanced graphic work exhibited abroad, and she keeps creating works that perfectly satisfy the gaze of Techno-Orientalism.

Atom's Children

Born in the 1960s, the mid-period of the Japanese *Showa* era, Kenji Yanobe and Takashi Murakami made their debut as "Hobbyists" who share the trait of integrating the model-kit and *manga* into their works. Their motifs quote *anime* and *manga*, the Japanese post-war popular cultures that fostered *otaku*. They affirmatively admit the *otaku*-ness in their work. Murakami, especially, goes out of his way to express his sympathy and respect for the *otaku* community comprised of *anime* and *manga* artists and their followers, and declares, "I became an artist because I couldn't become an *otaku*." No other artists are more sensitive to the Western gaze represented by Techno-Orientalism than Murakami and Yanobe, and they strategically utilize this in their work. If there is a way to make a definite distinction between *otaku* and these two, it is that while the former is blind to the gaze of the other, the latter is exceptionally sensitive to it. Yanobe's series of works entitled "Atom Suits" and "Atom Car," like their names suggest, derive from the canon of Japanese *manga* "Atom, the Iron Boy" ("Astro Boy" in English) by Osamu Tezuka. Yet they are also archetypal sculptural forms which cannot fail to evoke the memory of the Western closet-classic Sci-fi movies and amusement park rides. Thus, they seduce the viewer into a retrospective past, and flash back familiar childhood memories. Initially, the gaze of Orientalism is most stabilized when its subject is frozen in the eternal past, and Yanobe's work has an effect that lures the gaze in the direction of nostalgia. However, this apparently innocent work conceals something quite horrifying when seen reflectively. The non-violent

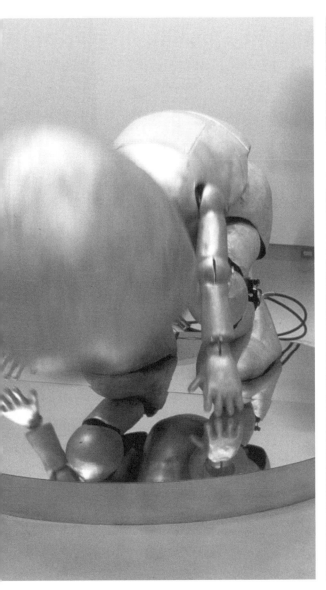
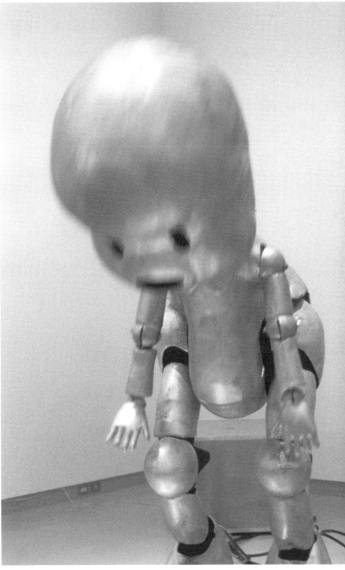

Kenji Yanobe, *"VIVA RIVA Project — STANDA"* (Viva Revival Project — Stand Up), 2001.
Courtesy Shiseido Gallery. Photos: Tadahisa Sakurai

Murakami Takashi, *Time Bokan*, 1996.
Courtesy Mito Arts Foundation, Mito, Japan.
Photo: Yoichi Inoue

form composed as an unique, round shape using bright colours created by Yanobe, or the smooth-to-the-touch surface and no-resistance flat screen and figures in Lolita-like fashion designed by Murakami (including Yanobe's title "Atom Suits" and Murakami's coinage "Super flat," these idioms have a somewhat infantile nuance to a native English speaker), are a shell or a cover to consciously or unconsciously camouflage their hidden obsessions or complexes from necessary suppression. But just what is suppressed and hidden? It is the dark side of techno(logy) and its history.

The Dark Side of the Techno

If Techno-Orientalism is an apparatus of mutual misunderstandings, the relationship between that of the observer and the observed is not equal. The subject of Techno-Orientalism, just as in the old Orientalism, is blind to the oppressed consciousness of the observed objects that is hidden under the shadow of brightness of imagination. It is true that Yanobe's work seems innocent and unscathed, however, this apparently clean surface can in fact be exposed to the worst unseen contamination, that being radioactive contamination. And as the name "Atom" suggests, Yanobe's work is survival equipment with which one can protect oneself from radioactive emissions. No matter how Pop the image, the work itself is a serious and uncanny shield against fatal contamination. Recently, Yanobe's obsession towards that contamination permeates to the level of genetics. Yanobe's recent work is a statue of child who had been monstrously mutated due to the effects of radioactivity. Yanobe says that this work was inspired by a contaminated doll he saw when he visited Chernobyl. The statue of the child is not painted, and it seems that Yanobe's acute eye is directed to the child's skin, hair and physical abilities. Murakami's work *Time Bokan*, on the other hand, drawn from a scene of an explosion in the *anime* of the same title, and its pictures of mushroom-like smoke superimposed on an image of a skull, reflects the image of an atomic bomb. In fact, in the exhibition, Murakami installed a huge flood-light projector to light the work.[6] This exhibition, which Yanobe also participated in, was entitled *Ground Zero Japan* and was curated by Sawaragi Noi. It was an implicit presentation of obsession towards atomic bombs and radioactivity as the dark side of techno(logy) which the 20th-century technology gave birth to. Its terrorizing effect, inscribed in an uncanny form of historical un/consciousness, appears in a number of Japanese art works.

Therefore, the *otaku*—or Astro Boy's children—are nuclear age children born after atomic bombs had been dropped on Japan.

Does the symbolic population of a country attacked by atomic bombs dream of the spectre of a techno-aided idol?

It is a well-known fact that the latest technologies of each generation, best represented by the Internet, are always developed in connection with military affairs and weapons. Techno, in its dark side, has a disturbing memory of the 20th century. Works from such artists as Survival Research Laboratories and T.O.D.T. all make direct references to the dark sides of techno and help to demonstrate it. Two artists who could be associated with the genealogy of dirty realism are Mikami Seiko[7] and Ameya Norimizu. Ameya's work *Dutch Life 1: Contaminated* is particularly distinguished. This is an installation which can be described as extreme dirty simulationism. It evokes the last moments of Emperor Hirohito's life, which like that of a robot, repeats programmed movements and speeches without displaying will or emotion like an automated doll driven by machinery (Ameya calls this "Dutch Life"[8]) in the post-war period of *Showa*-era Japan. Unlike the recently developed and commoditized Japanese pet-robot *Aibo*, the negative values originally attributed to robots is allegorically displayed, and at the same time, it is like *Grand Guignol* or a cruel theatre symbolically performing what it is like for a human to be deprived of his or her own will, forced to live as a "symbol" or an "idol," and to accept this life as a cyborg. Underlying this work, there seems to be not the dark side of techno, but instead its ghost or spectre.

Techno-Animism

The ghosts of the techno cannot exist as machines and robots, which originally lacked a soul or a spirit. However, the "ghost-in-the-machine" is a recurring theme in Japanese *anime* and *manga*. This is apparent in *Ghost in the Shell* by Masamune Shirow or *My Name is Shingo* by Umezu Kazuo. While the former story only goes so far as to question self-consciousness formed by Western conceptions of cyberspace and the identity issues of the hi-tech cyborg, the latter is an ethno-folk story about a soul awakened in a low-tech industrial robot who develops an animistic relationship with beasts and insects of the natural world. Does this kind of cultural base or mentality that supports techno imagination,

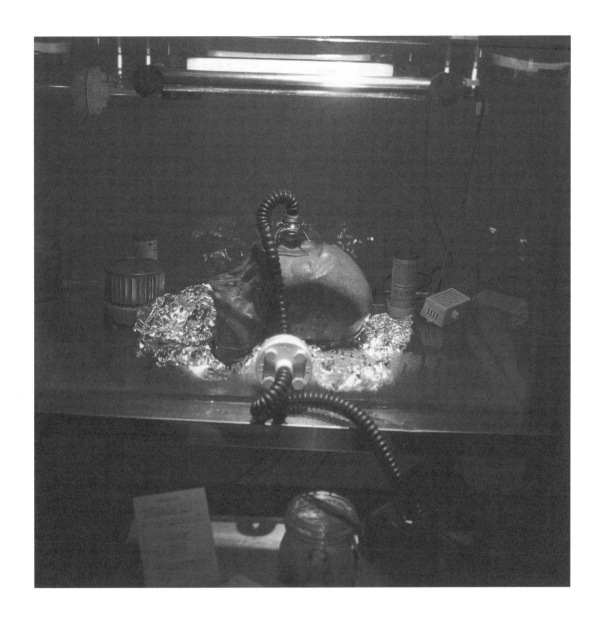

Ameya Norimizu aka Technocrat, *Dutch Life 1: Contaminated*
from *2minus vol. 1*, 2001.
Courtesy Studio Parabolica. Photo: Yuichi Konno

Umezo Kazuo, Frame from *My Name is Shingo*
Shogakukan, Tokyo: Big Comic, 1986.

and which can only be termed at present as techno-animism, exist in Japan? Such questioning itself is the very proof of being trapped by Techno-Orientalism. There is an American occult film entitled *Manitou*; at the end of the film, there is a sequence where the spirit of a Native American haunting a super computer helps to drive away a strong evil spirit. This story is obsessed with a similar gaze of exoticism and, personally speaking, is a grotesque imagination of one's own culture. But is that really so? To think about this, let me introduce one final work.

Japan, the Cyborg, and Ourselves

Tomatsu Shomei is a famous photo-documentary artist who exposes post-war Japanese scenery and history in his monochrome prints, including the victims of Hiroshima and Nagasaki. The series "Character P: Long Home" was a set of photographs of artificial life made from electronic debris assembled by the artist himself within a natural environment. The artificial life forms named "Character P" carry out strange activities in the still photographs, yet they lead an inscrutable existence in which hair and tentacles are muzzling beneath a plastic shell where they cannot be seen. These beings, described by Walter Benjamin as the "silent beings of nature," are never vital nor lively. After all, this is not humanistic life. If they should be described, it would be more as aura rising from things or *anima* dwelling in beasts, plants, and mines. However, this is not natural but artificial, so-called technoid. It is important to know when attempting to comprehend the identity of this technoid Character P, that Tomatsu used two different sound pieces in the exhibition. One was a news announcement reporting an accidental radioactivity leakage at a nuclear station, and the other one was the mingled voices of a male and female engaged in sexual intercourse. Therefore, this technoid's inscrutable energy can only be called its libido at best, and of course, this illusion of the libido was originally created by the gaze of Tomatsu himself. That gaze is dry and chilled, to a degree beyond being simply cool or merciless. Due to his exceptional talent at eliminating his own existence in front of his subjects, this absence of the photographer probably endows a greater impression of the subject's presence in a counterpunctal way. However, that is not to say the gaze of Tomatsu aims toward a dualistic perspective of "nature and artificial," or "life and death." Here, it seems that life and death are no longer concluded within nature, and looking at the life

259

conditions that Character P is placed in—where life, death, nature, and the artificial meld together—promiscuous gasps are generated. After bathing in artificial sunlight and black rain made in the USA, survivors recover their libido once more on the surface of an artificially constructed ruin left after all has been violently evaporated. Japan's rapid growth of economy is similar to an adolescent techno country. During the process of internalizing the Western gaze, Character P lost its ability to go back to nature, and became homeless; when it finally finds its home, it is no longer able to distinguish between nature and culture. Character P cannot perceive the difference between the colour and discoloured, nor between original and copy, nor home and house. Yet the tentacles of desires and favours have increased in number in the periphery, which causes confusion in recognizing what is the front and what is the back, like a blind caterpillar. Tomatsu talks about post-war experience in his writing: "Japan has revived like a phoenix from devastated ruins. Ruins are the imagery of the home ground of post-war Japan in the sense that they were only able to restore everything from this ground. The atomic bomb-scape lies as the ultimate form of ruin . . . Atomic bomb-scape is a whole new type of ruin that emerged for the first time in the middle of the 20th century which is called a century of war.[9] In these ruins, everything was equally bombed and contaminated. Sawaragi Noi, who introduced this work in the *Ground Zero Japan* exhibition, wrote, "Character P might be a representation of ourselves who have lost a nationalistic nature of tradition and customs, and turned into a kind of a cyborg."[10] And so it is, Character P stands as a post-war Japanese self.

The Void of Memory on the Techno-Nation under the Bomb

I cannot remember when I started to hate robots and cyborgs. Probably from the time when nature was lost, since we are now living in a condition like that of the techno-aided robots. By now, we ourselves are cyborgs and the cyborg is me. Hatred towards cyborgs is a hatred owing to close relations. So then, what am I plugged into? Or what am I manipulated by? And who programmed my conscience and memories? Naturally, I cannot explain this, as I am a cyborg. This always requires references to the Other. Ukai Satoshi wrote of Tomatsu: "The culture shock of losing a war was, for him, more than seeing the other as a different culture. It was an experience to be seen as another culture. It is a history to be studied closely now more than ever before, after the book written by an American

Tomatsu Shomei, *Character P: Long Home*, 1996–98.
Courtesy Mito Arts Foundation, Mito, Japan.
Photo: Yoichi Inoue

anthropologist never having visited Japan nor speaking Japanese had written 'Japanese culture is a culture of shame' in his thesis, and after this the gaze of this winning other had been internalized by more than a few post-war Japanese intellectuals, which seems to have left this country with a loss of distinction between pride and shame."[11] There already/always exists a gaze of the Other, and a history of forming as a nation, a citizen, and an individual through the Other. Assuming Tomatsu, born in the 1930s, and Yanobe and Murakami, born in the 1960s, to be a fictional family, there exists what may be called a *void of memory*, like a room locked and prohibited to access. What I have in mind here is the famous horror story of Freud's where, because the memory of an actual experience had been so frightening, talking or even thinking about the experience is evaded and suppressed, which in turn infects the unconscious of succeeding generations who had not shared the experience. Therefore, as a member of this family, I am unable to point to this blind spot. What I can do, however, is to touch the very symptoms of this infection as something *unheimlich* (uncanny).

Welcoming the Libido of the Technoids

Does the West ever welcome a techno-animistic libido of the technoid in such a condition of existence? If such a thing as techno-animism does exist, it does so only as a response toward the Others' gaze and expectations. I have a hard time believing in animism—a nationalistic belief of this country that souls and spirits dwell in nature; much less so if it is techno-animism. Yet it may be that I'm merely escaping from having to believe it, and in fact I may believe in it at an unconscious level. As a cyborg, I can only speak while pretending to be that robot repeating a programmed speech in order to live up to the gaze of Techno-Orientalism and its expectations, which initially located me as a cyborg.

Yes
Do you know
that our word for
"nature"
is of
quite recent

coinage,
Mr. Bruce?
It is scarecly
a hundred years old
We have never
developed
a sinister
view of
technology
It is
an aspect
of the natural,
of oneness.
Through
our
efforts
oneness
perfects
itself.
And
popular
culture is
the test bed
of our
futurity.
I have never been to U.S.A. yet. (Tomatsu Shomei)
If it's life-prolongation technology that decides death
of a body, then what is a body? (Ameya Norimizu)

Isn't that so, Mr. Gibson? You have given us ethnicity as a native of techno-country and cyberpunk ego. In return, I have written this text in a style you taught us as a token of appreciation. While writing this text, I have come to realize that I don't have any fundamental

beliefs. I then felt as if something had once again evaporated inside me and shuddered at the thought of it, but felt relieved at the same time. At the moment, it is myself who/ which is the most uncanny being to me.

And you who are reading this text, do you know that our concept of nature is confused and has gone mad as the result of the unity between English "Nature" and Japanese "nature"? And do you know that we are surviving in the Far East techno wilderness as Character P, the technoid with uncanny *libido*, not even realizing that we have lost that inner nature? During a plague or season of violence, "we became field operators." Welcome to the junkyard of Techno-Orient to "survive in the flat field."[12]

P.S.: After September 11, 2001 (in fact, since long ago), the old Orientalism has returned as an actual issue of the 21st century. This text on Techno-Orientalism was written down in the midst of U.S. airborne attacks.

[1] William Gibson, *Idoru* (New York and London: Penguin Putnam, 1996,) p. 238. [2] David Morley and Kevin Robins, *Spaces of Identity* (New York and London: Routledge, 1995). [3] Ueno Toshiya, "The Rag Time," *Gendai Shisou* (March 1996), pp. 255–56. [4] Mary Louis Pratt, *Imperial Eyes: Travel Writing and Transculturation* (New York and London: Routledge, 1992). [5] However, this kind of performance has acquired popularity as "costume play" in Japan to such an extent that it is mainly outside of Japan that Mori's work carries most impact. [6] Murakami's works that incorporated porn *anime* designs contain questions and commentary on western art and morals (especially that of the U.S.). Murakami says, "I think someone who buys my sculptures in U.S. are ultimately buying child porn or porn using the sophisty of art . . . If there is an authoritative proof of art as sophistry, then anyone could publicly purchase porn, add it to one's collection, donate it to an art gallery, which simply enables imagery laundering. And that led me to do this present figure project which aims at finding that. I'm saying, 'So that is your concept of morality and hierarchy that you are going to keep maintaining, right?'" Takashi Murakami & Hiroki Azuma, *Kokoku Hihyo* (November/December 1999), p. 54. [7] e.g., Mikama Seiko's *Information Weapon 1: Super Clean Room* at the Tokyo Earth Environment Lab in Tokyo, Japan, 1990. [8] Japanese Pidgin English slang word "Dutch" has meaning of "coerced," "bred" or "raped." [9] Ukai Satoshi, "Unnamed Island" (n.d.), *www.cafecreole.net/library/review/ukai.html* [10] Tomatsu Shomei, "Christ of Atomic Age," *Nagasaki 11:02 Aug 9, 1945* (Tokyo: Shinchousha, 1995). [11] Sawaragi Noi, "22nd Century Artist Visit," *Esquire Magazine Japan* (1999), p. 113. [12] William Gibson, "The Beloved (Voices for Three Heads)," *Artrandon: Robert Longo* (no. 71), p. 31.

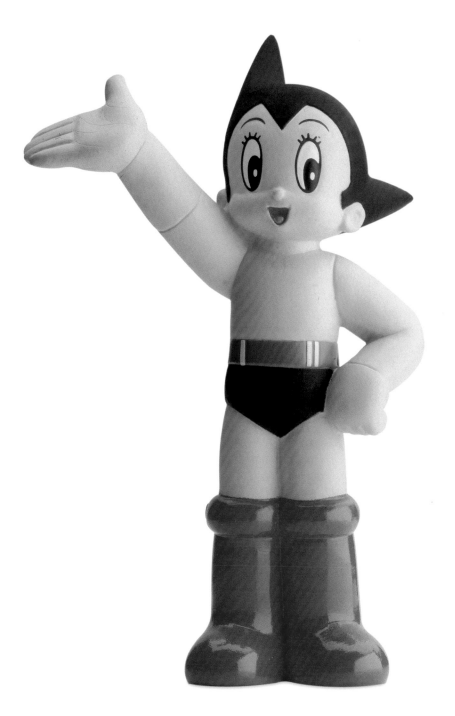

Astro Boy figurine, 1999.
Height 20 cm. Tezuka Productions.
Photo: Trevor Mills

Mariko Mori, *Play with Me*, 1994.
Duraflex, pewter frame, wood, 305 x 366 x 7.5 cm.
Vancouver Art Gallery (2001.15 a–c).

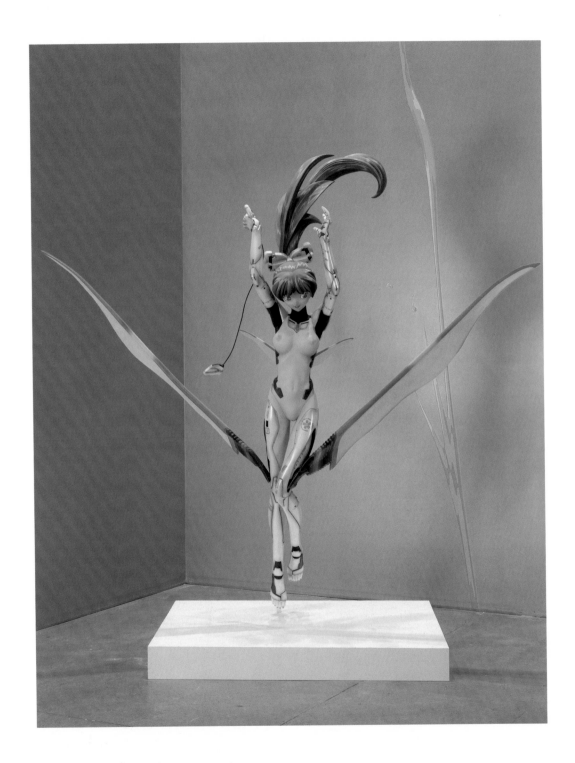

Takashi Murakami, *S.M.P.Ko²*, 1999–2000.
Fiberglass, iron, acrylic and oil paint, 43 x 38 x 14 cm.
Collection of Rachel and Jean-Pierre Lehmann.

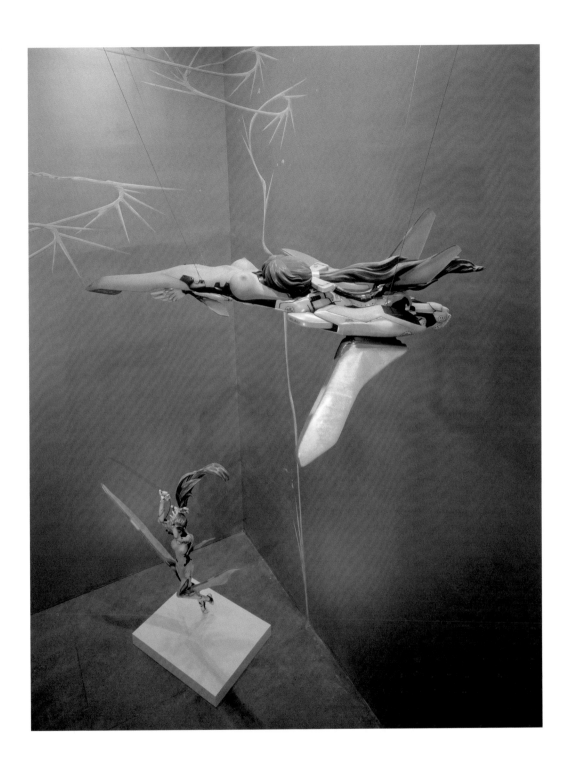

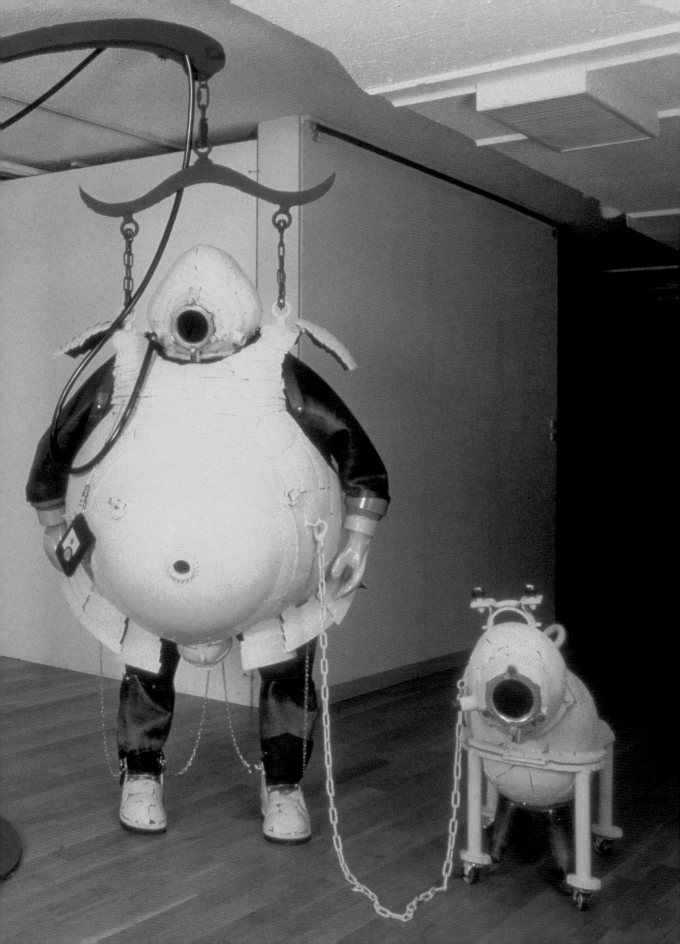

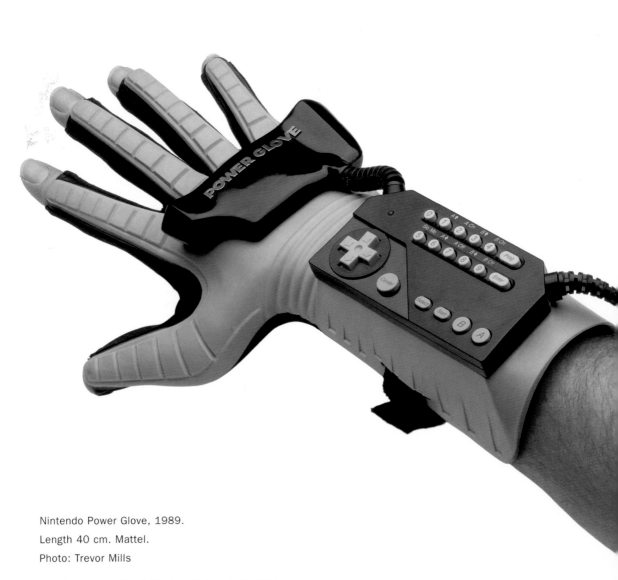

Nintendo Power Glove, 1989.

Length 40 cm. Mattel.

Photo: Trevor Mills

(previous page) Kenji Yanobe, *Yellow Suit*, 1991.

Lead, steel, plants, Geiger counter, 230 x 300 x 300 cm.

Courtesy Röntgen Kunstraum Katsuya Ikeuchi Galerie, Tokyo.

The Mattel Power Glove was introduced in 1989 for the Nintendo Entertainment System (NES). It was a relatively short-lived product that was intended to work in place of the regular game controller, adding a new complexity to that gaming platform. Using an ultrasonic system to track the roll of the hand and sensors to gauge the bend and flexure of each finger, the Power Glove provided the game player with a rudimentary virtual reality (VR) environment.

The Power Glove is remarkable not only because it marks an early commercial attempt to create a VR environment through the use of cybernetic devices but also for the rapidity and fluidity of movement from a laboratory context to the playroom. The earliest data glove was developed at AT&T Bell Laboratories in 1983. Using touch, bend, and inertial sensors, the glove measured hand orientation, wrist position, and finger flexure.

In 1987 VPL Research, working under contract to NASA (National Aeronautics and Space Administration), developed the VPL DataGlove for use in the remote repair of satellites via a robotic armature that moved in tandem with the astronaut's hand. The founder of VPL Research was Jaron Lanier. He is credited with inventing the term "virtual reality," the technology to produce head-mounted visual display and writing VPL (Virtual Programming Language). Within a year VPL Research had licensed the same technology to Abrams/Gentile Entertainment and in turn to Mattel, Inc. In 1989 the NES Power Glove was widely available at a price of $90.

BG

Catalogue

All measurements given in centimetres (height precedes length precedes depth)

Lee Bul, *Cyborg W5*, 1999, handcut polyurethane panels on FRP, urethane coating, 150 x 55 x 90, courtesy of PKM, Shiraishi Contemporary Art, Tokyo

Marcel Duchamp, *. . . pliant, . . . de voyage*, 1916 [3rd version 1964], Underwood black vinyl typewriter cover with gold paint on a painted wooden stand, 24 x 42.5 x 32, National Gallery of Canada, Ottawa (29946)

Jacob Epstein, *Torso in Metal from the 'Rock Drill'*, 1913–16, bronze, 70.5 x 58.4 x 44.5, National Gallery of Canada, Ottawa (6498)

Gary Hill, *Conundrum*, 1995–98, single channel video installation comprising six 14-inch black and white monitors, laserdisc player and disc, tone switcher and steel structure, 26.7 x 180 x 33, courtesy of the artist

Lewis Hine, *Bolting up a big turbine in a power plane*, 1920, gelatin silver print (posthumous), 11.8 x 16.2, Vancouver Art Gallery, Vancouver. Courtesy National Archives and Records Administration, Washington (69-RH, 4L-1)

Lewis Hine, *Power house mechanic working on steam pump*, 1925, gelatin silver print (posthumous), 11.8 x 16.2, Vancouver Art Gallery, Vancouver. Courtesy National Archives and Records Administration, Washington (69-RH, 4L-2)

Lewis Hine, *Mechanic in his shrine — heart of the turbine*, 1924, gelatin silver print (posthumous), 11.8 x 16.2, Vancouver Art Gallery, Vancouver. Courtesy National Archives and Records Administration, Washington (69-RH, 4L-3)

Lewis Hine, *Making a plate for an enormous turbine*, 1920, gelatin silver print (posthumous), 11.8 x 16.2, Vancouver Art Gallery, Vancouver. Courtesy National Archives and Records Administration, Washington (69-RH, 4L-4)

Lewis Hine, *Working on a core of a large modern turbine*, 1930, gelatin silver print (posthumous), 11.8 x 16.2, Vancouver Art Gallery, Vancouver. Courtesy National Archives and Records Administration, Washington (69-RH, 4L-5)

Lewis Hine, *Skilled mechanic on big part of huge electric turbine*, 1930, gelatin silver print (posthumous), 11.8 x 16.2, Vancouver Art Gallery, Vancouver. Courtesy National Archives and Records Administration, Washington (69-RH, 4L-6)

Ronald Jones, *Untitled (This trestle was used to hold . . .)*, 1990, Allenbolts, patinated bronze, waxed MDF, pearwood, pickled birch on artists' base, 198.4 x 54.5 x 62.7, Vancouver Art Gallery, Vancouver (90.20 a,b)

Fernand Léger, *Femme nue assise*, 1912, pencil on paper, 63.5 x 48.2, London Regional Art Gallery, London, Ontario, gift of J.H. Moore through the Ontario Heritage Foundation

Fernand Léger, *Le mécanicien*, 1920, oil on canvas, 115.5 x 88.3, National Gallery of Canada, Ottawa (14985)

Nina Levitt, *Gravity*, 1997–98, three video projections and two audio systems comprising PA speaker, amplifier, CD, playback deck, LCD video projector, VCR, tripod, frosted Plexiglas, vinyl floor covering, audio speakers, dimensions variable, courtesy of the artist

Henri Maillardet, *Automaton*, c.1810, mechanical parts, cloth, stylus, 91 x 86 x 147 (irregular), The Historical and Interpretive Collections of The Franklin Institute, Philadelphia (1663)

Mariko Mori, *Play with Me*, 1994, Duraflex, pewter frame, wood, 305 x 366 x 7.5, Vancouver Art Gallery, Vancouver (2001.15 a–c)

Takashi Murakami, *Second Mission Project Ko² (ga-walk-type)*, 1999, oil paint, acrylic, synthetic resins, fiberglass and iron, 224.4 x 176.9 x 131.5, collection of Rachel and Jean-Pierre Lehmann

Takashi Murakami, *Second Mission Project Ko² (human type)*, 1999, oil paint, acrylic, synthetic resins, fiberglass and iron, 275 x 252 x 140, collection of Rachel and Jean-Pierre Lehmann

Takashi Murakami, *Second Mission Project Ko² (jet airplane type)*, 1999, oil paint, acrylic, synthetic resins, fiberglass and iron, 224.4 x 176.9 x 131.5, collection of Rachel and Jean-Pierre Lehmann

Eadweard Muybridge, *Animal Locomotion* [Plate 46], 1887, collotype, 48.3 x 61, courtesy Equinox Gallery, Vancouver

Eadweard Muybridge, *Animal Locomotion* [Plate 84], 1887, collotype, 48.3 x 61, courtesy Equinox Gallery, Vancouver

Eadweard Muybridge, *Animal Locomotion* [Plate 109], 1887, collotype on paper, 48.3 x 60.9, Vancouver Art-Gallery, Vancouver, gift of Ian Davidson (93.14.2)

Tony Oursler, *Vanish*, 2000, acrylic, plaster, video projector, dimensions variable, Vancouver Art Gallery, Vancouver (2000.53)

Francis Picabia, *Le Saint des saints/C'est de moi qu'il s'agit dans ce portrait*, from *291* Magazine, nos. 5–6 July–August, 1915, off-set lithography, line block print, wash on wove paper, 44 x 29, Art Gallery of Greater Victoria, Victoria, British Columbia (81.60.6)

Francis Picabia, *Portrait d'une jeune fille américaine dans l'état de nudité*, from *291* Magazine, nos. 5–6 July–August, 1915, off-set lithography, line block print, wash on wove paper, 44 x 29, Art Gallery of Greater Victoria, Victoria, British Columbia (81.60.6)

Francis Picabia, *De Zayas ! De Zayas !*, from *291* Magazine, nos. 5–6 July–August, 1915, off-set lithography, line block print, wash on wove paper, 44 x 29, Art Gallery of Greater Victoria, Victoria, British Columbia (81.60.6)

Francis Picabia, *Ventilateur Surprise*, from *Poèmes et dessins de la fille née sans mère* (Lausanne, Switzerland: Imprimeries, 1918), off-set lithography on wove paper, 23.5 x 15.5, University of Alberta Library, Edmonton

Pablo Picasso, *Mademoiselle Léonie*, 1910, from the book *Saint Matorel* by Max Jabob (Paris: Henry Kahnweiler, 1911), etching on van Gelder Holland laid paper, 19.8 x 14.2, Fine Arts Museums of San Francisco, San Francisco (2000.200.59.1), The Reva and David Logan Collection of Illustrated Books

Pablo Picasso, *Mademoiselle Léonie dans une chaise longue*, 1910, Plate III from the book *Saint Matorel* by Max Jacob (Paris: Henry Kahnweiler, 1911), etching and drypoint on van Gelder paper, 19.8 x 14.2, Fine Arts Museums of San Francisco, San Francisco (1966.83.6), gift of R.E. Lewis, Inc.

Alexander Rodchenko, *Radio Listener*, c.1929, gravure, 9.4 x 12.4, courtesy of Rodchenko Estate

Stelarc, *Third Hand*, 1976–80, stainless steel, aluminum, duraluminum, acrylic, epoxy resin, electronic cicuitry and motors, 50 x 20 (irregular), courtesy of the artist

Stelarc, *Stomach Sculpture*, 1993, self-illuminating, sound-emitting, extending and retracting capsule structure actuated by a servomotor and logic control, 5 x 7 open/15 x 5 closed, collection of Gilbert and Lila Silverman

Survival Research Laboratories, *7 Machine Performances*, 1985–86, videotape, 53 minutes

Survival Research Laboratories, *Virtues of Negative Fascination*, 1979–82, videotape, 80 minutes

Marius de Zayas/Francis Picabia, *Femme!/Voilà elle*, 1915, off-set lithography, line block print on wove paper, 48 x 31.7, Art Gallery of Greater Victoria, Victoria, British Columbia (81.60.8)

Kenji Yanobe, *Yellow Suit*, 1991, lead, steel, plants, Geiger counter, 230 x 300 x 300, courtesy Röntgen Kunstraum Katsuya Ikeuchi Galerie AG, Tokyo

The Terminator, 1984, James Cameron, DVD, 107 minutes, MGM

Modern Times, 1936, Charlie Chaplin, b/w, silent 35 mm film transferred to DVD, 103 minutes, United Artists

Videodrome, 1983, David Cronenberg, DVD, 89 minutes, Universal Studios

Metropolis, 1927, Fritz Lang, DVD, 115 minutes

Ballet méchanique, 1924, Fernand Léger, b/w, silent, 35 mm film transferred to DVD, 14 minutes, Vancouver Art Gallery, Vancouver

Ghost in the Shell, 1995, Mamoru Oshii, DVD, 82 minutes, Manga Videos

Blade Runner, 1982, Ridley Scott, DVD, 117 minutes, Warner Home Video

Robocop, 1987, Paul Verhoeven, DVD, 103 minutes, MGM

Animated Hobby Kit: Automatic Baby Feeder, c.1922 (1965 Marx Toys), Rube Goldberg, detachable plastic parts and paint, Vancouver Art Gallery, Vancouver (14 25.5 7.5)

Animated Hobby Kit: Painless False Teeth Extractor, c.1922 (1965 Marx Toys), Rube Goldberg, detachable plastic parts and paint, Vancouver Art Gallery, Vancouver (10.3 x 25.6 8.3)

Ike & Mike — They Look Alike, 1920–21, Rube Goldberg, off-set lithography on newsprint, 9.5 x 8.5 each, Vancouver Art Gallery, Vancouver

Simple Way to Open an Egg Without Dropping it in Your Lap, 1920, Rube Goldberg, off-set lithography on newsprint, 10.5 x 32.7, Vancouver Art Gallery, Vancouver

Nintendo Power Glove, 1989 (Mattel), vinyl, electronic components, length 40, private collection

Astro Boy figurine, 1989 (Tezuka Productions), height 20, Vancouver Art Gallery, Vancouver

Six Million Dollar Man, 1977 (Kenner Products), bionic

components and accessories, height 34, Vancouver Art Gallery

Robocop, 1989 (Horizon Models), vinyl model kit, sculpted by John Ferrary, buildup by Stan G. Hyde, height 32, collection of Stan G. Hyde

Terminator, 1990/1991 (Horizon Models), vinyl model kit, T-800/T-800 Endoskeleton/T-1000, sculpted by Moto Hata, buildup by Stan G. Hyde, height 38, collection of Stan G. Hyde

Locutus of Borg, 1992 (Geometric Models), vinyl model kit, sculpted by Thomas Kuntz, buildup by Stan G. Hyde, height 29, collection of Stan G. Hyde

Neon Genesis Evangelion, 1997 (Bandai) styrene model kit, buildup by Stan G. Hyde, height 36, collection of Stan G. Hyde

Testsuo Undergoing Transformation, 2001 (McFarlane Akira Toys), cold resin cast, height 18, collection of Stan G. Hyde

Kaneda on Motorcycle/Clown Gang Bike Leader/Akira, 2001 (MacFarlene Toys), vinyl model kit, heights 25, 19, 18, collection of Stan G. Hyde

Major Motoko, 2001 (McFarlene Ghost in the Shell Toys), vinyl model kit, height 15, collection of Stan G. Hyde

Face Robot, 2001, Hara/Kobayashi Labs, Science University of Tokyo, Tokyo

Drinker-Collins duplex respirator (Iron Lung), c.1950, courtesy of Irene Hanley

Nintendo Virtual Boy, 1995, plastic, metal, electronic components, 35 x 25 x 17, collection of Noah Koss

Tales of Suspense [Ironman], No. 43, (Marvel Comic Group, 1963)

Cyborg 009, Ishinomori Shoutarou [1963–2000] Re-print (Tokyo: Chuokoron-Shinsha, Inc., 1999), 264 pp., 15 x 10.5

Astro Boy, Osamu Tezuka, [1951–1968] Re-print (Tokyo: Kodansha Ltd., 1998), 196 pp., 18 x 13 each

Ghost in the Shell, Masamune Shirow (Kodansha, Japan: Young Magazine, 1998), 256 pp., 21 x 15

Neuromancer, William Gibson (New York: Ace Books, 1984), 276 pp., 17.5 x 10.5

William Gibson's Neuromancer: The Graphic Novel Vol. 1, Tom de Haven and Bruce Jensen (New York: Epic Comics, 1989)

Contributors

BRUCE GRENVILLE is Senior Curator at the Vancouver Art Gallery. He has organized many group exhibitions on the subject of the body and its representation within modern and contemporary culture. These exhibitions include *weak thought, The Natural World, New Science, Corpus, The Anti-Graceful, Active Surplus,* and *Mapping the Surface.* He was co-ordinator of *The Post-Colonial Landscape Project,* a six-year series of exhibitions and a book which examined the land and its representation within the colonial and post-colonial state. He is the former editor of the *YYZ Books: Critical Works* series and a former Toronto editor of *Parachute* magazine.

ALLAN ANTLIFF is an assistant professor of art history at the University of Alberta in Edmonton. He is author of *Anarchist Modernism: Art, Politics, and the First American Avant-Garde* and editor of *'Only a Beginning': An Anthology of Anarchist Art and Culture* (forthcoming). He also writes contemporary art criticism.

RANDY LEE CUTLER is a Vancouver-based educator, curator, writer, and performer. Her practice investigates the emergence of new cultural forms through an exploration of the intersections of art, science, and technology. She is currently teaching cultural studies, media studies, and visual art at Emily Carr Institute of Art and Design in Vancouver.

SIGMUND FREUD (1856–1939) was born at Freiberg, Moravia, now Pribor in the Czech Republic. As physiologist, medical doctor, psychologist, and father of psychoanalysis, Freud is generally recognized as one of the most influential and authoritative thinkers of the twentieth century. His innovative treatment of human actions, dreams, and of cultural artifacts as possessing implicit symbolic significance has proven to be extraordinarily useful for a wide variety of fields, including anthropology, semiotics, and artistic practice.

WILLIAM GIBSON is the Hugo and Nebula award-winning author of the cyberspace trilogy: *Neuromancer, Count Zero,* and *Mona Lisa Overdrive,* also the novels *Virtual Light, Idoru,* and *All Tomorrow's Parties,* and is the co-author (with Bruce Sterling) of *The Difference Engine.* Gibson's widely acclaimed short stories are collected in *Burning Chrome.* He lives in Vancouver with his family.

MAKIKO HARA is an independent curator and art critic based in Montreal and Tokyo. Recently, Hara has become an adjunct curator at the Confederation Centre of the Arts in Charlottetown, Prince Edward Island. Hara has been involved in several Canadian contemporary art exhibitions as a research assistant, including *The Age of Anxiety* (The Power Plant, 1995), *Fluffy* (Dunlop Art Gallery, 1999), and *The Uncanny: Experiments in Cyborg Culture* (Vancouver Art Gallery, 2002).

DONNA HARAWAY is a professor in the History of Consciousness Department at the University of California at Santa Cruz, where she teaches feminist the-

ory, science studies, and women's studies. She is the author of *Crystals, Fabrics and Fields: Metaphors of Organicism in Twentieth-Century Developmental Biology* (Yale University Press, 1976), *Primate Visions: Gender, Race, and Nature in the World of Modern Science* (Routledge, 1989; Verso, 1992), *Simians, Cyborgs, and Women: The Reinvention of Nature* (Routledge, 1991; Free Association Books, 1991), and *Modest_Witness@Second_Millennium.FemaleMan© Meets OncoMouse™* (New York and London: Routledge, 1997). Her present project, *Birth of the Kennel*, analyzes webs of action in dog-human cultures.

MASONORI ODA is a researcher at the Institute for the Study of Languages and Cultures of Asia and Africa (ILCAA) at the Tokyo University of Foreign Languages. Born in 1966, he lives and works in Japan. As an ethnologist in the 1990s, he conducted field-work on shamanism in East Africa. As an artist, he participated in the 2001 International Triennale of Contemporary Art in Yokohama, Japan.

JEANNE RANDOLPH is an egghead who composes psychoanalytically-biased cultural theory; for decades, she has cogitated about the relation between visual arts, the Technological Ethos, advertising, boxing, the preconscious, and the ethics of interpretation. Her writings between 1989 and 1998, *Symbolization And Its Discontents* was published by YYZ Books in 1997. *Why Stoics Box*, a third collection, will be published in 2003.

TOSHIYA UENO is media theorist who lives and works in Japan and Amsterdam. He is currently an associate professor in the Department of International Studies at Chubu University, Nagoya, Japan. He has written numerous articles, essays, and reviews on media, rock/pop music, film, contemporary art, architecture, and urban design.

ARSENAL PULP PRESS, 103–1014 Homer Street, Vancouver, B.C., Canada V6B 2W9 *arsenalpulp.com*

VANCOUVER ART GALLERY, 750 Hornby Street, Vancouver, B.C., Canada V6Z 2H7 *vanartgallery.com*

Arsenal Pulp Press gratefully acknowledges the support of the Canada Council for the Arts and the British Columbia Arts Council for its publishing program, and the Government of Canada through the Book Publishing Industry Development Program for its publishing activities.

Cover illustration: Fernand Léger, *Le mécanicien*, 1920. National Gallery of Canada, Ottawa (14985) © Estate of Fernand Léger/ADAGP (Paris)/SODRAC (Montreal) 2001. Endleaf illustrations: Mariko Mori, *Play with Me*, 1994 (detail), Vancouver Art Gallery, Vancouver (2001.15 a–c); Eadweard Muybridge, *Animal Loco-motion* [Plate 109], 1887 (detail), Vancouver Art Gallery (93.14.2), gift of Ian Davidson; *Animated Hobby Kit: Automatic Baby Feeder*, c.1922 (1965 Marx Toys, Rube Goldberg, Vancouver Art Gallery, (14 25.5 7.5).

Frontispiece (p. 2): Lewis Hine, *Bolting up a big turbine in a power plane*, 1920, Vancouver Art Gallery, courtesy National Archives and Records Administration, Washington (69-RH, 4L-1).

Efforts have been made to locate copyright holders of source material where possible.

"Joey: A Mechanical Boy" by Bruno Bettelheim: Reprinted with permission. Copyright © 1959 by Scientific American, Inc. All rights reserved.

Excerpt from *Neuromancer*, by William Gibson: © 1984 by William Gibson. Used by permission of Viking Penguin, a division of Penguin Putnam Inc.

"A Cyborg Manifesto: Science, Technology, and Socialist-Feminism in the Late Twentieth Century," from *Simians, Cyborgs and Women* by Donna Haraway. Reproduced with permission of Routledge, Inc., part of the Taylor Francis Group. First published in *Socialist Review* #65, 1985.

Book and cover design by Timmings & Debay
Printed and bound in Canada by Friesens

NATIONAL LIBRARY OF CANADA CATALOGUING IN PUBLICATION DATA

Main entry under title: The uncanny

Copublished by: Vancouver Art Gallery
ISBN 1-55152-116-4

1. Cyborgs in mass media. 2. Technology — Social aspects. I. Grenville, Bruce. II. Vancouver Art Gallery.
PN6071.C94U52 2002 303.48'34 C2001-911702-7